VAN DOESBURG
& THE INTERNATIONAL AVANT-GARDE

CONSTRUCTING A NEW WORLD

EDITED BY GLADYS FABRE & DORIS WINTGENS HÖTTE
CONSULTANT EDITOR MICHAEL WHITE

WITH ESSAYS BY MARC DACHY, HENK ENGEL, GLADYS FABRE,
KRISZTINA PASSUTH, MICHAEL WHITE, DORIS WINTGENS HÖTTE

TATE PUBLISHING

Exhibition at both venues supported by:
Mondriaan Foundation, which supports visual arts,
design and cultural heritage projects
Prince Bernhard Cultural Foundation (Straver Foundation)

Exhibition at Stedelijk Museum De Lakenhal supported by:
Turing Foundation
Stichting VSBfonds
The Municipality of Leiden
Cultuurfonds Leiden

This catalogue is published on behalf of both venues
with the support of:
Embassy of the Kingdom of the Netherlands
Dedalus Foundation, Inc.
SNS Reaal Fonds

First published 2009 by order of the Tate Trustees
by Tate Publishing, a division of Tate Enterprises Ltd
Millbank, London SW1P 4RG
www.tate.org.uk/publishing

On the occasion of the exhibition

Van Doesburg and the International Avant-Garde
Constructing a New World

Stedelijk Museum De Lakenhal, Leiden
20 October 2009 – 3 January 2010

Tate Modern, London
4 February – 16 May 2010

British Library Cataloguing in Publication Data
A catalogue record for this book is available from the British Library

ISBN 978 1 85437 872 9

Distributed in the United States and Canada
by Harry N. Abrams, Inc., New York

Library of Congress Cataloging in Publication Data
Library of Congress Control Number: 2009928896

Artist's writings on pp.77, 125, 161, 187 translated by Michael White
Designed by The Studio of Fernando Gutiérrez
Colour reproduction by DL Interactive Ltd, London
Printed in Belgium by Die Keure

Front cover design: The Studio of Fernando Gutiérrez
Back cover: Theo van Doesburg, *Je Suis Contre Tout et Tous*
Page 1: The International Congress of Progressive Artists in Düsseldorf,
May 1922 (detail, fig.3)

Measurements of artworks are given in centimetres, height before width

CONTENTS

The touring exhibition *van Doesburg and the International Avant-Garde* focuses on the multiple facets, international activities and contributions of a unique artist, Theo van Doesburg (1883–1931). Van Doesburg was an instigator who strove to find a contemporary form of expression, a new, radical style based on principles that applied to all plastic arts (painting, sculpture, architecture), with the ultimate aim of developing a 'total work of art'. History, as he perceived it, was evolving towards non-objective art, a process of development which he believed would continue indefinitely. The elementary vocabulary he advocated was limited to the straight line, the square and the rectangle (and later the diagonal). By identifying these basic principles of a universal geometric abstraction and applying them to painting, architecture, urban planning, industrial design and typography, he, and his peers in De Stijl, believed the new abstract art could effect change in society. Though many of their utopian ideals never came to pass, van Doesburg's call for collaboration between the different visual arts and his combined artistic and social vision have held sway with successive generations of artists.

During 1916–1921 while based in Leiden, van Doesburg was connected to distinct modernising projects within the Netherlands, advocating collective enterprise rather than individualism. Equally, van Doesburg was a tireless propagandist for the 'Dutch contribution to International Modernism'. A self-publicist, networker and strategist, he travelled extensively in Europe after 1921 promoting this cause. Not only was he the founder of and ambassador for De Stijl, but also he simultaneously created Dadaist work and poetry under the pseudonym I.K. Bonset, forged links between the International Constructivists and Dadaists, taught an alternative De Stijl course in Weimar to challenge the Bauhaus and, towards the end of his short life, established the group Art Concret. *Van Doesburg and the International Avant-Garde: Constructing a New World* seeks to place van Doesburg's radical and experimental approach in the context of his avant-garde contemporaries, not only other De Stijl collaborators, but artists associated with a plethora of groups from Dada, the Bauhaus, Russian Constructivism and International Constructivism, to Art Concret and Abstraction-Création.

This publication and exhibition tour seek to reveal van Doesburg's connections with artists such as El Lissitzky, Kurt Schwitters, Hans Richter, László Moholy-Nagy, Raoul Hausmann, Hans (Jean) Arp, Sophie Taeuber, Karl Peter Röhl, Walter Dexel, Sándor Bortnyik, Werner Graeff, Viking Eggeling, Hannah Höch, César Domela, Friedrich Vordemberge-Gildewart, Jean Hélion, Otto Carlsund, Léon Tutundjian and key members of De Stijl including Bart van der Leck, Vilmos Huszár, Piet Mondrian, J.J.P. Oud, Gerrit Rietveld, Cornelis van Eesteren and Georges Vantongerloo. Works by these artists, amongst others, have also been presented alongside van Doesburg's own, highlighting their exchanges, dialogue, and in some cases collaboration, in the areas of film, typography, graphic design, music, plastic arts and architecture.

Van Doesburg extended his ideas and influence into wide-ranging areas, often acting as a catalyst for change, instigating new concepts in one area by destroying traditions in another. His multi-disciplinary practice spanned painting, architecture, design, poetry and typography. His philosophy had a theoretical impact on the international art scene at the time. Posthumously, it has been for his architectural ideas that he has been particularly praised, specifically the architectural representation of the fourth dimension, time. However, it is difficult to define van Doesburg's single contribution. His creativity, as Gladys Fabre illustrates in this publication, lay in his ability to move between disciplines and to construct and enrich each field by deconstructing the specifics of another, such as designing stained glass using the equivalents of music and rhythm, and transforming his paintings and notions of architectural space through the discipline of working with standardized elements, like brick or tiles, in his applied art compositions. Such inter-relationships are the key to understanding van Doesburg's contribution in his wide-ranging activities.

Too often, it seems, the De Stijl movement has been seen as a rigid entity, too often van Doesburg overshadowed by and underestimated in comparison to Piet Mondrian. Nevertheless, van Doesburg differs from his friend by his early attraction to science and the fourth dimension and his will to express dynamism, as confirmed in 1926 by the emergence of the diagonal in van Doesburg's new theory and practice of 'Elementarism'. This new 'ism' consecrated his rupture with Mondrian's 'Neoplasticism'. This exhibition seeks to redress this and re-evaluate van Doesburg's importance. Unlike Mondrian, van Doesburg saw art not on a singular course, but opening to multiple possibilities, as a bridge from the present to the future. Many of van Doesburg's innovations in the visual arts prefigure the serial and mathematical concerns of later tendencies such as Arte Concreto or Minimalism. Shortly before his death, van Doesburg published a manifesto in the one and only issue of Art Concret (1930), which proposed the 'self-referential' quality of art often represented as one of the key elements of Modernism.

The exhibition is a bold re-examination of van Doesburg's remarkable contribution to Modernism. Additionally, it is a ground-breaking collaboration between two museums: Stedelijk Museum De Lakenhal in Leiden and Tate Modern in London. To our pleasant surprise, both De Lakenhal and Tate Modern had been independently preparing exhibitions devoted to van Doesburg and his role in relation to the international avant-garde. Hence – when this coincidence became clear – both museums decided to join forces to work cooperatively. Too often large arts institutions work in partnership with similarly sized organisations. This project rejects such a hierarchy and demonstrates a commitment by both De Lakenhal and Tate Modern to place art and ideas at the centre of our programming. Our ambition for the project is to show that energy and imagination supersede resources, profile or reputation. The exhibition, which begins in the university town of Leiden – where De Stijl was launched and van Doesburg lived from late 1916 until leaving for Germany in 1921 – also embraces the international arena in which van Doesburg operated through its presentation in London.

In 1981 Wies van Moorsel, niece of Nelly van Doesburg-van Moorsel, granted the van Doesburg estate to the Dutch State. Subsequently the Dutch State granted many of these works for permanent loan to Dutch museums, including De Lakenhal. This loan was the incentive for De Lakenhal to collect other works by van Doesburg, and by contemporary artists who had particular connections with him. Although van Doesburg positioned himself as a leader of the International Avant-garde, initially his roots were in Leiden where he founded De Stijl and where, together with artists from the region, he strove to achieve a new way of working. Among these were local artists such as Harm Kamerlingh Onnes, Hendrik Valk and the architect J.J.P. Oud. Of equal importance to van Doesburg were foreign artists like Georges Vantongerloo, Vilmos Huszár and Emil Filla living in the nearby towns of The Hague and Amsterdam. In 1999, De Lakenhal mounted an exhibition titled *Dawn of Modern Art. Leiden and Surroundings 1890 – 1940* which shed new light on the complicated pattern of relations and influences between the artists in and around the city of Leiden, particularly van Doesburg. The research for this exhibition gave impetus to De Lakenhal to facilitate the Dutch art historian Alied Ottevanger's work on the correspondence between Theo van Doesburg and J.J.P. Oud. At the same time De Lakenhal developed plans to organise an exhibition of van Doesburg's international contacts after he left the city of Leiden. The book *De vervolgjaren van De Stijl 1922–1932*, edited by Carel Blotkamp (1996) was an important basis for these plans as was the kaleidoscopic exhibition *Theo van Doesburg. Architect Painter Poet*, held in 2000 at the Centraal Museum, Utrecht and the Kröller-Müller Museum, Otterlo which also gave rise to an excellent oeuvre catalogue. With the exhibition *Van Doesburg and the International Avant-Garde: Constructing a New World*, De Lakenhal hosts works from collections around the world, many of which have never been on display in the Netherlands before.

For Tate Modern, this exhibition forms part of a sequence of exhibitions conceived by Tate to re-examine similar periods in early Modernism, which, rather than taking the form of retrospective monographic presentations or traditional movement-based shows, approach this period and these artists from the perspective of exchange, dialogue, collaboration, contrasts and correspondences. *Albers and Moholy-Nagy: From the Bauhaus to the New World* (9 March – 4 June 2006) examined the relationship between two of Modernism's great pioneers. *Duchamp, Man Ray, Picabia: The Moment Art Changed Forever* (21 February – 26 May 2008) explored the affinities and parallels between these three anarchic avant-garde figureheads. *Rodchenko & Popova: Defining Constructivism* (12 February – 17 May 2009) shed new light on the achievements of two key leaders of the Russian avant-garde. Now, *Van Doesburg and the International Avant-Garde: Constructing a New World* (4 February – 16 May 2010) provides a reappraisal of the development of non-figurative art highlighting van Doesburg's central role and his inter-relationships with the European avant-garde. Finally, this exhibition is a unique and exciting opportunity to bring van Doesburg's practice for the first time to British audiences.

Both De Lakenhal and Tate are organisations with very different histories, audiences and methodologies. This is an extraordinary partnership, which has resulted in not only a remarkable exhibition, but also in a lasting impact on both museums. Specifically, bringing together the expertise and resources from two diverse museums has produced rich curatorial debate. De Lakenhal's Curator Doris Wintgens Hötte has enriched the curatorial process with her expertise and insights into the context in which van Doesburg flourished and his strategic approach. Independent Curator and art historian Gladys Fabre, has brought her extensive knowledge of the European avant-garde together with new scholarly research into van Doesburg's interdisciplinary practice, with particular focus on film and the fourth dimension. Doris Wintgens Hötte and Gladys Fabre, editors of this publication, have brought together fascinating new perspectives on the subject. Juliet Bingham, Tate Modern Curator, has unified and managed the team, forging links with institutional and private lenders, negotiating loans and steering the project through its complex route to realisation. We thank Michael White, Consultant Curator, for his advice throughout the exhibition's gestation, for his input as consultant editor and for his incisive essay which sheds light on van Doesburg's many identities. Van Doesburg was an instigator, polemicist and tireless debater, who sought international exchange and dialogue. The collaboration between Stedelijk Museum De Lakenhal and Tate Modern reflects this spirit of debate and interaction.

Theo van Doesburg remains a fascinating artist to scholars, artists and the public alike. This exhibition offers a unique opportunity to experience the scope not only of his work, but his exchanges with over eighty artists of the European avant-garde.

EDWIN JACOBS
Former Director, Stedelijk Museum De Lakenhal

VICENTE TODOLÍ
Director, Tate Modern

ACKNOWLEDGEMENTS

Both Stedelijk Museum De Lakenhal and Tate Modern are deeply indebted to the many museums and private individuals who have supported this project with so many significant works, from paintings, sculptures, works on paper and film, to furniture, typography and architectural plans and models. Alongside these works, we are delighted to have been able to show such an extensive and illuminating array of books, journals and archival material. We express our deep gratitude to all lenders to the exhibition and formally credit each lender at the close of this catalogue.

A special note of thanks is due to a number of Dutch institutions whose wonderful and extensive holdings of Theo van Doesburg's paintings, works on paper and documents, in addition to works by De Stijl artists amongst others, have enabled us to realise this exhibition. Our heartfelt thanks go in particular to: Centraal Museum, Utrecht; Fries Museum, Leeuwarden; Gemeentemuseum, The Hague; Kröller-Müller Museum, Otterlo; Netherlands Architecture Institute (NAI), Rotterdam; Netherlands Institute for Art History (RKD), The Hague; Netherlands Institute for Cultural Heritage (ICN), Amsterdam/Rijswijk; and the Stedelijk Museum Amsterdam. We sincerely thank the directors, curators, registrars and conservators at these institutions who have supported our concept and facilitated the loans.

The scope of this exhibition gives space not only to van Doesburg's works, but to those of many key artists of the European avant-garde, and has led us to important institutional and private collections throughout Europe and America. Directors and Trustees of these collections have embraced the project, in some cases removing works from display from their own permanent collections or making exceptions to loans moratoria. For these reasons, we particularly wish to thank: Bibliothèque Kandinsky, Paris; Centre Pompidou, Paris, Musée national d'art moderne / Centre de création industrielle; Fondation Custodia, Paris; IVAM Institut Valencia d'Arte Modern; Klassik Stiftung Weimar Museums; Muzeum Sztuki, Łódź; Kunstmuseum Basel; Kunstmuseum Winterthur; Musée d'Art Moderne de la Ville de Paris; Museo Thyssen-Bornemisza, Madrid; The Museum of Modern Art, New York; Staatliche Museen zu Berlin, Nationalgalerie; and Yale University Art Gallery.

We thank Wies van Moorsel, for her advice and enthusiastic response to our project and the many artists' estates and organisations who have helped with our preparations, including: Art Acquest LLC; Deutsche Kinemathek – Museum für Film und Fernsehen, Berlin; Estate of Werner Graeff, Mülheim an der Ruhr; Mrs Jacqueline Hélion and Mr Nicola Hélion; Stiftung Bauhaus Dessau; Friedrick and Lillian Kiesler Private Foundation, Vienna; Eva Riehl; LTM Recordings; Peter Beijersbergen van Henegouwen; Corinne Schweizer and Peter Böhm; Snip & Disselhoff VOF; Re:voir Films; Rietveld Schröder Archive at Centraal Museum Utrecht; and VPRO.

We are also extremely grateful to Merrill C. Berman and the many private individuals who have parted with works that form a vital part of their collections and have accommodated our many demands.

The curatorial team would like to thank in particular art historians, institutional colleagues and friends who have helped to locate works, including: Jan Torsten Alhstrand; Guy Brett; Elaine Lustig Cohen; Gilles Gheerbrant; Gilles Giovanni Lista; Els Hoek; Rainer Mason; Teresa Miller; Herbert Molderings; Norbert Nobis; Karin Orchard; Karolina Peterson; Volker Rattemeyer; Margit Rowell; Katharina Schmidt; and Andrzej Turowski. The valued support of gallery owners has also been greatly appreciated: Ms Anisabelle Berès-Montanari; Kent Belenius; Hendrik Berinson; Patrick Bongers; Patrick Derom; Alain Le Gaillard; Krystyna Gmurzynska; David Juda; Denise René; Nathalie Seroussi; and Ronny Van de Velde.

An exhibition of this ambition and complexity, with over 400 objects and more than 100 international lenders, could not have been staged without the contributions of many individuals at both Stedelijk Museum De Lakenhal and Tate, and although impossible to name everyone personally, there are some who deserve special mention.

Following Edwin Jacob's departure in April 2009 as Director of Stedelijk Museum De Lakenhal to take up the Directorship of Centraal Museum, Peter Berns ably stepped into the role of Interim Director, until the recent appointment of Meta Knol as the new Director. Both have enthusiastically embraced the show's curatorial aims and international ambitions and their encouragement and belief in De Lakenhal's curator Doris Wintgens Hötte has been vital in driving the project forward. Paul van der Kamp has expertly overseen the financial aspects of the exhibition and exhibition registrar Andrea Hakkaart has carefully managed the administration of loans. Mia van Iterson, Saskia Bekke — Proost and Marloes van Dommele have enthusiastically led the public relations and educational aspects of the exhibition at De Lakenhal. Of course, the secretarial department has provided vital support on behalf of this exhibition. Ramin Visch and Katja van Stiphout — rising to the challenge of van Doesburg's own affinity with architecture and graphic design — have dedicated themselves to the exhibition architecture, the graphic design of the exhibition and the marketing campaign.

Tate Modern's curatorial team — Gladys Fabre, Vicente Todolí and Juliet Bingham, with Consultant Curator Michael White — has been remarkably fortunate to have such dedicated colleagues at Tate supporting this exhibition. We particularly thank Iria Candela, Curatorial Researcher, for her contributions and research towards the exhibition and illuminating chronology for the catalogue. Assistant Curator Cliff Lauson has calmly and conscientiously managed the administration of loans and the delivery of all aspects of the exhibition. Curatorial Assistant Wenny Teo has located works and conducted detailed provenance research for loans. The curatorial team at Tate has been supported at various stages by highly committed curatorial interns who have proved invaluable to the project, primarily Claudia Segura and Bridget Donlon, with additional assistance from Anneka French, both in terms of research and administration. Stephen Mellor has expertly overseen the logistical aspects of the exhibition and installation, with Stephanie Bush co-ordinating the complex transport and courier arrangements and Phil Monk managing the installation at Tate Modern with a dedicated and professional team.

We wish to thank the authors — Marc Dachy, Henk Engel, Gladys Fabre, Krisztina Passuth, Michael White and Doris Wintgens Hötte — for their insightful contributions to this catalogue, which shed new light on van Doesburg's life and international exchanges, his Dada activities, and his innovations in the plastic arts. Van Doesburg's own affinity with design make this an enticing exhibition for graphic designers, and Fernando Gutiérrez and Ali Esen of The Studio of Fernando Gutiérrez have brought great vision to the catalogue design, and, at Tate, to exhibition and marketing design. As Project Editor, Nicola Bion has admirably overseen the realisation of this catalogue, aided by dedicated colleagues at Tate Publishing: Sarah Derry, Tim Holton, Emma Woodiwiss and Roz Young.

This exhibition has been made possible with the assistance of the British Government Indemnity Scheme, which is provided by DCMS and administered by MLA, and the Dutch Indemnity Scheme. We thank both governments for their support, without which it would be inconceivable to mount such ambitious international exhibitions.

Finally, we gratefully acknowledge the funders who have enabled both Stedelijk Museum De Lakenhal and Tate Modern to realise this substantial and timely exhibition. For supporting our international collaboration and the core transport costs for both venues, we principally thank the Mondriaan Foundation, which supports visual arts, design and cultural heritage projects, and the Prince Bernhard Cultural Foundation (Straver Foundation).

Stedelijk Museum de Lakenhal especially thanks the partners, Stichting VSBfonds and the municipality of Leiden and the principle sponsor, the Turing Foundation. Additional support is given by Cultuurfonds Leiden.

This catalogue is published on behalf of both venues with the kind support of the Embassy of the kingdom of the Netherlands, Dedalus Foundation, Inc., and SNS Reaal Fonds.

EDWIN JACOBS
Former Director, Stedelijk Museum De Lakenhal

VICENTE TODOLÍ
Director, Tate Modern

VAN DOESBURG TACKLES THE CONTINENT: PASSION, DRIVE & CALCULATION

DORIS WINTGENS HÖTTE

'It is impossible to breathe any new life into Holland. I am therefore focusing particularly on other countries.'[1] With these words to his friend, the architect J.J.P. Oud, the energetic and driven Theo van Doesburg (1883–1931) announced in April 1920 that he wanted to shift his activities abroad in the near future. Holland was too confining for him. Europe beckoned. Now that the First World War was over, it seemed possible for him to work energetically to realise his dream of a major international art movement.

By this time van Doesburg had already blossomed into an incredibly versatile artist. In 1916 he moved to Leiden to be near his new lover, Lena Millius. Here he completely abandoned representative depiction, and launched himself into the process of 'abstraction' from a recognisable motif. Naturalistic drawings of the most everyday objects were, as he called it, 'destroyed' at various stages and underwent a step by step metamorphosis until only abstract compositions of rectangles and colours remained.

As an artist he not only worked in painting, but also in poetry, literature, typography, architecture and stained glass. He was a born organiser and was acutely aware of the importance of good contacts. From 1920 onwards he saw his network grow, particularly abroad amongst the international avant-garde. Creating art, and establishing and maintaining an international network of kindred spirits, formed the two important pillars of the van Doesburg phenomenon.

In 1921 van Doesburg moved abroad permanently in order to propagate the ideas of De Stijl and to link up with the international avant-garde. As a true strategist the combative van Doesburg carved a path through the European art world of the 1920s with the aim of establishing both De Stijl and his own name. He sought to fulfil his ideal of changing both art and the world.

De Stijl

Van Doesburg launched the magazine *De Stijl* in 1917 in Leiden together with Piet Mondrian, Bart van der Leck, Vilmos Huszár and J.J.P. Oud amongst others. They were a group of painters, architects and designers who were striving for an autonomous, universal art. Their philosophy was intended to play a steering role in their struggle for a new humanity and a new society.

Van Doesburg and Oud in particular were very interested in the integration of painting and architecture. They had already earned their spurs in this field in the immediate vicinity of Leiden.[2]

De Stijl – this 'little magazine', as it was described in the first issue – was published once a month on average during the early years and never exceeded fifteen pages. Yet the magazine occupied a significant position at home and abroad from the start. Theo van Doesburg was the initiator and driving force and played an important role as the only editor of De Stijl. Right from the start he strove to make De Stijl a magazine with international appeal.

In the opinion of De Stijl's contributors, the First World War permanently destroyed the old world in which individualism had dominated. With the signing of the armistice on 11 November 1918, a new era was beginning, with a new consciousness in which the universal was most important. At the same time, van Doesburg saw opportunities to make his mark abroad now that the frontiers were reopening. That November, De Stijl magazine published a manifesto in four languages in which progressive artists from all over the world were exhorted to 'work for the formation of an international unity in Life, Art and Culture'.[3] In an enthusiastic response to the first manifesto, the Italian Futurist F.T. Marinetti immediately sent van Doesburg a parcel of books and magazines. Contacts with Germany, France and Belgium also became more intensive, and van Doesburg was invited by Jozef Peeters of the Modern Art Circle in Antwerp to give a lecture there on 13 February 1920. Via Brussels he then travelled to Paris where he visited Mondrian, who had returned there in 1919. There he made contacts including Alexander Archipenko, Léopold Survage and Thorwald Hellesen, committee members and member respectively of the international Cubist artists' group La Section d'Or. Van Doesburg was invited to join them and in 1920 organised its group exhibitions in Rotterdam, The Hague, Arnhem and Amsterdam. Tour (Marthe) Donas, Archipenko's girlfriend and one of the first women to produce abstract art, spent a few days staying at van Doesburg's house in Leiden.[4] Through La Section d'Or van Doesburg also came into contact with Enrico Prampolini, who had many contacts as an artist and organiser in Italy. This was a role to which van Doesburg also aspired.

The first contacts in Germany

There was a particularly positive response to De Stijl magazine in Germany.[5] On the advice of the important Berlin art critic Adolph Behne, van Doesburg travelled to Berlin on 20 December 1920 in order to observe similar trends in the work of a number of German artists and architects. He was enthused by the work of Viking Eggeling and Hans Richter. Their ideas about abstract films, where geometric shapes became larger and smaller and passed in front of and behind one another as if they were a moving painting, greatly intrigued van Doesburg. He also met a host of leading lights in the fields of art and architecture. In the first days of 1921 he was in Weimar, where he spent a significant amount of time with the teachers from the Bauhaus, which was founded in 1919 under the leadership of Walter Gropius. But van Doesburg would

not have been van Doesburg if he had not had some criticisms of this new institute. Back in Leiden he wrote, in a letter to his friend Antony Kok,[6] that he had turned everything upside down in Weimar and 'scattered the poison of the New Spirit everywhere there'.[7] A postcard to Antony Kok with a picture of the Bauhaus, on which van Doesburg has scribbled the revealing text 'being bombarded by a dimensional Stijl battery', makes it clear that De Stijl – and particularly van Doesburg – had the Bauhaus in its sights.[8]

Van Doesburg saw opportunities in Weimar to propagate the vision of De Stijl and disseminate his own ideas about a synthesis of architecture and painting. After all, Walter Gropius theoretically also believed that the collaboration between architecture and art should result in a Gesamtkunstwerk or total work of art. However, little had yet come of this in practice. Expressionist tendencies and craftsmanship were still predominant within the Bauhaus in the period. In other words, Weimar offered ample scope for missionary work for De Stijl. Van Doesburg therefore intended to teach masters and students that the future belonged to a clear rational striving and a new type of artist.

Until around 1921 van Doesburg, Mondrian and Oud were the dominant figures within De Stijl. Theo van Doesburg, however, was at the same time the driving force and pace-setter. However, the initial fervour within the ranks of De Stijl was beginning to fade a little, and personal and artistic differences also arose within the group. Mondrian had returned to Paris in 1919 and the ideas of De Stijl were now sufficiently crystallised to be disseminated more widely. Van Doesburg felt that 'In Leiden: everything is dead. Lonely. Constricting. Bourgeois.'[9] Weimar on the other hand aroused high expectations. What was there to stop him from actually realising his international ambitions abroad? So off to Weimar he went.

At the end of April 1921 van Doesburg arrived in Weimar after a one-and-a-half-month tour through Europe visiting a host of avant-garde artists in Belgium, France, Italy, Switzerland, Austria and Germany. He settled in Germany, accompanied by his new lover, the pianist Nelly van Moorsel, who would later become his third wife.[10] The editorial offices of De Stijl also officially moved to Weimar. From that moment on, Theo van Doesburg was the person who – even more than before – shaped the look and image of De Stijl. Until 1922 it was mainly Dutch painters and architects who wrote for the magazine, with the occasional contribution from abroad. After 1922 van Doesburg – still the sole editor of the magazine – recruited contributors from a wide circle of kindred spirits abroad. Some contributors from the early days continued to write for the magazine occasionally, but De Stijl increasingly became a reflection of van Doesburg's contacts abroad and of his vision, his sympathies and antipathies.

The 'Van Doesburg virus' in Weimar, 1921-3

The ideas emanating from Theo van Doesburg and De Stijl did not go unnoticed at the Bauhaus in Weimar. They spread like a virus, infecting people with enthusiasm or sparking fierce resistance. Van Doesburg's radical abstraction offered a clear ☞

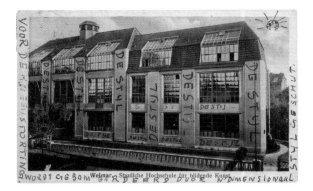

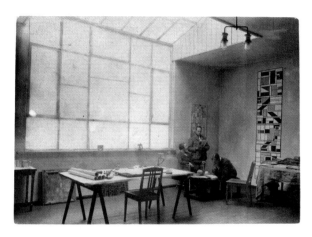

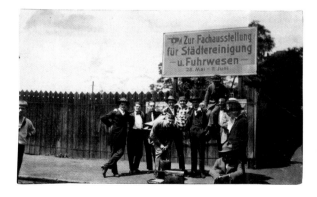

Fig.1
Postcard of the studio wing of the Bauhaus, sent to Antony Kok by Theo van Doesburg, 12 September 1921

Fig.2
Theo and Nelly van Doesburg with Harry Scheibe in van Doesburg's studio in Weimar in 1922

Fig.3
The International Congress of Progressive Artists in Düsseldorf, May 1922. From left to right: Werner Graeff, Raoul Hausmann, Theo van Doesburg, Cornelis van Eesteren, Hans Richter, Nelly van Doesburg, Marcel Janco [?], El Lissitzky, Ruggero Vasari, Otto Freundlich, Hannah Höch, Franz Wilhelm Seiwert, Stanislaw Kubicki

alternative to the Bauhaus, which was still focused on expressionism and individual craftsmanship.

In the summer of 1921 van Doesburg organised soirées on Saturday evenings for students and masters from the Bauhaus. Attendees included Karl Peter Röhl, Werner Graeff, Adolf Meyer, Lyonel Feininger and Alfred Forbát. In the winter of 1921–2 van Doesburg gave a private De Stijl course in his studio at Schanzengraben (with Karl Peter Röhl and Werner Graeff amongst others) and in March 1922 there followed a De Stijl course for Bauhaus students and interested parties with an open registration.[11] The list of those attending included Andreas Weininger, Max Burchartz, Werner Graeff, Karl Peter Röhl, Farkas Molnár and Egon Engelien. The course was publicised on the school noticeboard at the Bauhaus,[12] suggesting a good relationship between the parties, yet there are documents which testify to the enormous disquiet and opposition which van Doesburg came to encounter within the Bauhaus. Students who attended the De Stijl course were said to be impeded at the Bauhaus or were told that the De Stijl course was dangerous.

Nonetheless, van Doesburg's influence on the Bauhaus is undeniable. Herbert Bayer's architectural designs clearly show the influence of De Stijl in their colourful planes. The same applies to the posters for the Bauhaus exhibition designed in 1923 by Kurt Schmidt and Dörthe Helm and to Oskar Schlemmer's exhibition brochure. A chair by Marcel Breuer from 1924 appears to have been directly inspired by Gerrit Rietveld. The lighting in Walter Gropius's directorial office at the Bauhaus is also almost unimaginable without Rietveld, and J.J.P. Oud's influence can be seen in the architecture. Hinnerk Scheper manifests himself as a follower of De Stijl with his experiments with large coloured rectangles in the architecture of the Landesmuseum in Weimar. A group of Hungarian Bauhaus artists, all from van Doesburg's inner circle, formed the KURI group – Konstruktiv, Utilitär, Rational, International (Constructive, Utilitarian, Rational, International) – inside the Bauhaus. They strove to make Constructivist *Gesamtkunstwerken* within the Bauhaus. Members included the architects Farkas Molnár and Alfred Forbát (they applied, almost word for word, the 'basic elements of architecture' which van Doesburg taught), the painters Andor Weininger and Peter Keler (they often entitled their paintings 'Stijl') and the designers Gyula Pap and Marcel Breuer. Van Doesburg's ideas infiltrated virtually all areas of the Bauhaus. The French architect Le Corbusier expressly noted De Stijl's great influence on the Bauhaus in his review of the catalogue of the 1923 Bauhaus exhibition.[13] Oskar Schlemmer, a master at the Bauhaus, noted that many Bauhaus students were in thrall to van Doesburg,[14] and described them later as 'van Doesburg offshoots'.[15] Finally, the Bauhaus edition of *Principles of Neo-Plastic Art*, written by Theo van Doesburg and published in 1925 as Part 6 in the series of Bauhaus Books, also points to appreciation for van Doesburg's ideas.[16]

But this influence was not far-reaching or extensive enough for van Doesburg. He felt that his philosophy was being adopted only on an ad hoc basis by both masters and students,

and not in an integrated way. In practice, masters and students did mix all sorts of theories together, and the Bauhaus encouraged broadly based development, aiming to be more like a university than a dedicated art school. They therefore found van Doesburg too dogmatic, too focused on one all-embracing style, and not in keeping with the ethos of the school. Van Doesburg's ideas were mainly reduced to formal rules and were not appreciated for their visionary value. But Theo van Doesburg did give a major impetus to a change in direction for the Bauhaus: from individual expressionism to a rational approach; from hand-crafting to the use of technology and machines. This change, which took place around 1923 partly due to van Doesburg's influence, was not only one of style, but also of attitude: from the romantic bohemian philosophy focused on the individual and the hand-crafted, to the artist as the shaper of the universal through the integration of technology, and towards the idea of the artist providing direction in a new society. These new attitudes also required appropriate garb, and here too van Doesburg gave the lead. He dressed impersonally and exquisitely in off-the-peg suits in black and white. His appearance was in strong contrast to the bohemian look of the romantic, 'free' artist which Bauhaus master Johannes Itten promoted. Van Doesburg's studio also radiated sobriety: spacious, clean-lined, sparingly furnished and painted completely white. ☛

Fig.4
The Congress of Constructivists and Dadaists, Weimar, September 1922 Front row, from left to right: Werner Graeff, Hans Richter, Tristan Tzara, Nini Smith, Hans Arp Middle row, from left to right: Max Burchartz, Alexa Röhl, Harry Scheibe, Nelly and Theo van Doesburg, Hans Vogel, Karl Peter Röhl Back row, from left to right: Lotte Burchartz, El Lissitzky, Cornelis van Eesteren, Bernhard Sturtzkopf

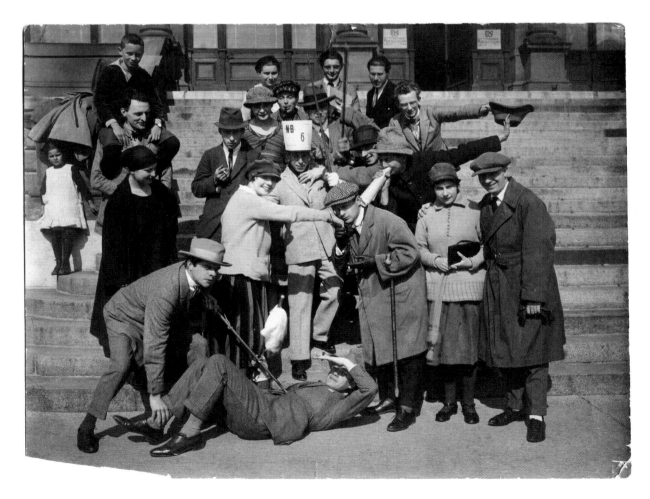

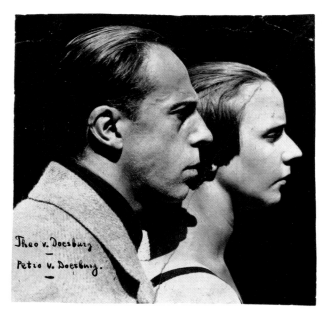

Fig.5
Theo and Nelly van Doesburg, Weimar 1921

Constructivism

Outside the walls of the Bauhaus van Doesburg's influence can be seen in the *Constructivist* exhibition which took place between 22 August and 15 September 1923 in Weimar at almost exactly the same time as the Bauhaus exhibition. The *Constructivist* show was organised by Karl Peter Röhl, Walter Dexel, Max Burchartz and the architect Jozef Zachmann, who all attended courses run by van Doesburg and were artists in his sphere of influence. The intriguing photograph accompanying the article by Röhl in the tenth anniversary issue of *De Stijl*, with the caption 'Party room in honour of *De Stijl*, Memory of the Master Theo van Doesburg and Pétro [Nelly van Doesburg], organised by the Stijl Group'[17] probably depicts this exhibition (fig.6).[18]

In around 1922 van Doesburg also found a source of support in the Russian Constructivism that was on the rise in Germany after the arrival in 1921 of its important representative El Lissitzky in Berlin, and through the *First Russian Art Exhibition* in Berlin in 1922. This saw a host of works by Russian Constructivist artists being shown in the West for the first time. In Constructivism van Doesburg saw an allied artistic vision. Like the founders of De Stijl, the Constructivists felt that it should be possible to apply the basic principles of the new abstract art to architecture, urban planning, industrial design and typography. However, van Doesburg did not share their belief that art must be politically engaged.

Conferences and activities in Germany

The Bauhaus as an incubator for young talent was an important, but not the only, reason for van Doesburg's move to Germany. At the time, Germany was a meeting place for modernist artists from various countries, and van Doesburg formulated plans with Hans Richter from the spring of 1922 to found an international artists' collective along the same lines as the socialist *Internationale*

which was to unite the workers. A meeting took place in van Doesburg's studio in Weimar on 26 May 1922 between van Doesburg, Richter, El Lissitzky and Karl Peter Röhl, Werner Graeff and Cornelis van Eesteren.[19] Here they devised plans for the IFdK, the International Fraktion der Konstruktivisten (International Faction of Constructivist Artists) and presented themselves jointly for the first time at the International Congress of Progressive Artists organised by the association of artists known as Das Junge Rheinland in Düsseldorf from 29 to 31 May 1922. Partly thanks to van Doesburg and his group, the congress descended into chaos on the second day. Following van Doesburg, Werner Graeff gave a speech in which he said that he felt the congress was insufficiently international and insufficiently progressive. 'Amidst strong protests from one side and whistling and applause from the other side, the IFdK, the Futurists, the Dadaists and many others then left the Regierungsgebäude in Düsseldorf.'[20] Once outside, they posed for a photograph and plans were probably formulated straight away for a new congress, the Congress of Constructivists and Dadaists, which was to take place in Weimar on 25 September 1922.

The relationship between van Doesburg and the Bauhaus was at an absolute nadir in the summer of 1922. The choice of Weimar as the venue for the proposed September congress can therefore be considered a provocation. Attendees at the congress in Weimar included Nelly and Theo van Doesburg, Lucia and László Moholy-Nagy, Hans Richter, Tristan Tzara, Hans Arp, Kurt Schwitters, Cornelis van Eesteren and El Lissitzky together with students from van Doesburg's De Stijl course, including Max and Lotte Burchartz, Karl Peter and Alexa Röhl, Werner Graeff, Bernhard Sturtzkopf, Harry Scheibe and Hans Vogel. The Dadaist contingent – Kurt Schwitters, Hans Arp and particularly Tristan Tzara, who trod heavily on the Constructivists' toes – stunned the Constructivists during the congress. Tzara's attacks on

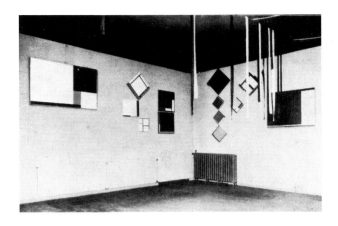

Fig.6
**Party room in honour of De Stijl
Karl Peter Röhl's paintings in the
Constructivist Exhibition, Weimar 1923**

collectivism, rational logic and universal means of expression undermined everything the Constructivists stood for. Van Doesburg had invited Tzara personally and the sabotage that could be expected was probably just what van Doesburg had in mind.[21] All this did not prevent van Doesburg from making plans for the founding of the KI (Konstruktivistische Internationale Schöpferische Arbeitsgemeinschaft or International Union of Neoplastic Constructivists). Its manifesto, which focuses on 'neoplasticism with universal means of expression promoted by the consciousness of time', was included in German, French and Dutch in the August 1922 issue of *De Stijl* (which actually only appeared in October 1922) and was signed by Theo van Doesburg (Holland), Hans Richter (Germany), El Lissitzky (Russia), Karel Maes (Belgium) and Max Burchartz (Germany).[22] The aim described in the statutes is less exalted than one might expect from the manifesto: 'to promote the idealistic and material interests of the associated artists'.[23] With their battle against the conservatives in the artistic and political field but also with the aim of propagating the work of associated artists outside the existing system of dealers, the KI is reminiscent of La Section d'Or. However, the KI organised just a few exhibitions for a handful of members. Van Doesburg's disciples, Max Burchartz, Walter Dexel and Karl Peter Röhl, always made up the core of the group.

Van Doesburg travelled to many cities in Germany from his base in Weimar. His frequently delivered lecture 'The Will to Style' not only brought him into contact with El Lissitzky in Berlin in 1922, but also with the Hungarian artist Moholy-Nagy.[24] Moholy-Nagy was an important source of information for van Doesburg. He was also the bridge to the Hungarian magazine *MA* (Today), which was published by Lajos Kassák, a Hungarian exile in Vienna. *MA* devoted a special issue to van Doesburg in May 1922. Van Doesburg wrote about Kassák and his associates – including Sándor Bortnyik – in *De Stijl*. *MA* and *De Stijl* both advertised in one another's magazines. Moholy-Nagy and El Lissitzky were powerful personalities, and van Doesburg limited their role within the KI in order to avoid rivalry. Through Moholy-Nagy, van Doesburg met the Hungarian László Péri, who fanned van Doesburg's interest in the representation of space and time with his *Raumkonstruktionen*, concrete reliefs and drawings for wall paintings.

In Jena, the 'Will to Style' lecture brought van Doesburg into contact with Walter Dexel, who was the leader there of the society of artists. Dexel started producing abstract work in the spirit of De Stijl from 1922 onwards. In Hanover, van Doesburg made a firm friendship with Kurt Schwitters, with whom he discovered a shared anarchist and Dadaist mentality. Here van Doesburg's alter ego came into his own: that of the Dadaist van Doesburg who published sound poems under the pseudonym of I.K. Bonset and who published the Dadaist magazine *Mécano*, featuring groundbreaking typography. In Hanover van Doesburg also became enthusiastic about the abstract work produced by Friedrich Vordemberge-Gildewart.

Italy: Prampolini, Sartoris and Valori Plastici
Enrico Prampolini's attendance at the Düsseldorf International Congress of Progressive Artists in 1922 led to van Doesburg re-establishing his contacts with Italian artists. Right from the start van Doesburg showed an interest in Italian art. The artist Gino Severini, who was living in Paris at the time, was *De Stijl*'s Paris correspondent in 1917. Prampolini was the Italian contact for La Section d'Or in 1920 and as an 'artist-networker' he was a shining example for van Doesburg. Van Doesburg met Prampolini in 1920 in Geneva where Prampolini was the curator for the Italian contribution to the *International Exhibition of Modern Art* in the Palais Electoral.[25] In 1921 *De Stijl* covered the Italian group Valori Plastici.[26] Van Doesburg had already been in contact with the editor of the magazine of the same name, Mario Broglio, during the First World War. He in turn disseminated the ideas of De Stijl in Italy. In the summer of 1926 van Doesburg spent two months in Rome where he met Balla, Marinetti, Prampolini, Marchi, Benedetta, Vasari and Pannaggi amongst others. The Italian architect Alberto Sartoris (1901–1998) was clearly inspired by the De Stijl architecture of van Doesburg and van Eesteren after van Doesburg sent him the 'Dossier architecture Groupe De Stijl', containing thirty-one photographs, at the end of 1928.

Belgium: The Modern Art Circle in Antwerp
Van Doesburg devoted a significant amount of time to conquering the art worlds of Weimar and later France, but he also ▰

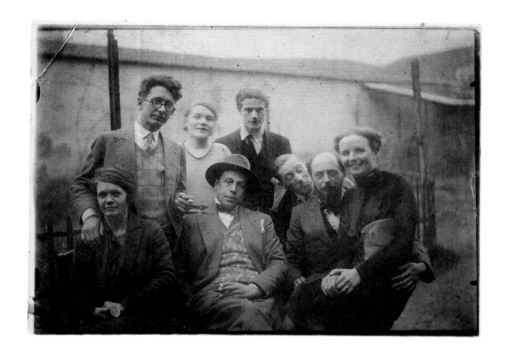

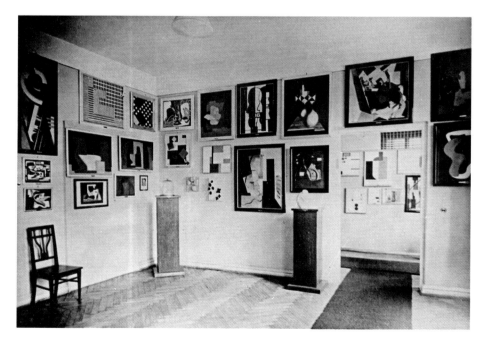

Fig.7
**Members of the Art Concret group in Léon Tutundijan's studio c.1929
From left to right: Mrs Hélion, Jean Hélion, Mrs Tutundijan, Theo van Doesburg
Marcel Wantz, Léon Tutundijan, Otto Carlslund, Nelly van Doesburg**

Fig.8
**Exhibition in 1931 of the Łódź municipal collection of works donated by Polish
artists and the international avant-garde living in Paris. Their goal was to bring
nations closer together by this most precious of possessions, works of art**

made an impact in Belgium. In 1920–1 he gave three lectures there. The lecture *Classic, Baroque, Modern* was published in Dutch and French by Eugène de Bock, who was the contact for *De Stijl* in Belgium. Van Doesburg maintained contacts with Tour (Marthe) Donas, Karel Maes, Jozef Peeters, Michel Seuphor, Victor Servranckx and Georges Vantongerloo. Van Doesburg gave Jozef Peeters, founder of the Modern Art Circle in Antwerp, all sorts of addresses of magazines and artists with whom he was in contact and Peeters made grateful use of these connections, returning the favour when van Doesburg was in Belgium. But apart from the fact that Peeters was a useful contact, there was little love lost between them. Through van Doesburg's international contacts, however, Peeters organised congresses in Belgium which in turn offered van Doesburg the opportunity to promote De Stijl.

Architecture and the move to France

During his time in Weimar van Doesburg's interest increasingly shifted towards architecture. His De Stijl course covered architecture and the architect C.R. de Boer commissioned him to design stained glass windows for the Agricultural College in Drachten and colour designs for middle-class homes there. Bauhaus teacher Oskar Schlemmer remarked in a letter that the art of painting hardly existed for van Doesburg and that he was interested only in architecture.[27] His interest in the representation and experience of space developed strongly, partly through his meetings with El Lissitzky and László Péri. In 1923, disappointed in his attempts to collaborate with the Bauhaus and fleeing roaring inflation in Germany, van Doesburg moved to Paris. The invitation from Léonce Rosenberg, owner of Galerie de l'Effort Moderne in Paris, to design a house-cum-gallery for him provided an enormous incentive to go there. His association with Rosenberg ultimately resulted in an exhibition of architectural models at Rosenberg's gallery in 1923 under the title *Architects of the De Stijl Group*. Van Doesburg's designs for Rosenberg's exhibition were produced in collaboration with Cornelis van Eesteren, a Dutch architect who had sought out van Doesburg in Weimar. In him van Doesburg saw a welcome replacement for the architect J.J.P. Oud with whom he had fallen out in 1922. However, the relationship with van Eesteren also broke down in 1926.

The exhibition at Galerie de l'Effort Moderne was restaged in 1924 at the Ecole Spéciale d'Architecture. The architecture of De Stijl was again in vogue at the exhibition of the Comité Nancy–Paris in Nancy in 1926.[28] Germany, Belgium, the Netherlands, Switzerland, Austria and France submitted works for this exhibition in the fields of painting, sculpture and architecture. Alongside current De Stijl members van Eesteren and Rietveld, van Doesburg also called upon former De Stijl members Jan Wils, Robert van 't Hoff and Oud together with non-members Willem Verschoor and Mart Stam. Van Doesburg felt that it was important to make a statement as group and therefore swept old conflicts, however temporarily, under the carpet.

France was, however, not an easy place for van Doesburg. The post-war 'call to order' in art, and above all Surrealism, were predominant trends in Paris. Yet a shift seemed in the offing. At the end of 1925 the exhibition *The Art of Today* took place, organised by the Polish artist Victor Poznanski.[29] This exhibition of abstract artists can be viewed as a challenge to the 'call to order'. The exhibition – and the work of De Stijl in particular – received a good press. The French painter Felix del Marle was especially full of praise for Mondrian, van Doesburg, Domela and Huszár in the magazine *Vouloir*.[30] Relations between Mondrian and van Doesburg were gradually deteriorating during this time. Issues of personality and principle became intermingled, and the friendship finally ended in September 1925. However, van Doesburg appears to have found a new ally in the Austrian artist Friedrich Kiesler.[31] Kiesler, who exhibited at the *International Exhibition of Decorative and Industrial Modern Art* in Paris in 1925, created utopian spatial constructions which were as detached as possible from the ground and with no static axis. With these he hoped to inspire new ways of living, and thus a new society.

Van Doesburg continued to be involved in other architectural projects. In 1926 Hans Arp and his wife Sophie Taeuber-Arp were commissioned to remodel and redesign the interior of the right wing of the eighteenth-century Aubette building in Strasbourg, and they asked van Doesburg to help. He soon took charge and designed the most important rooms down to the smallest detail. He created a masterpiece: an architectural representation of the fourth dimension, time, beyond the boundaries of the three-dimensional space. He designed the Aubette as a dynamic arena for eating, drinking, dancing and film shows. He also designed the tables, ashtrays and graphics. His architectural projects brought van Doesburg so much fame that he was invited to give a number of lectures in Madrid and Barcelona between 30 April and mid-May 1930. In Madrid Theo and Nelly van Doesburg were welcomed like royalty, and in Barcelona they enjoyed a standing ovation with cheers of 'Doesbourg, Doesbourg!'[32] His own house in Meudon (1927–1930) was the only one of his architectural designs actually to be built.

Paris, Art Concret and Abstraction-Création

Van Doesburg was struggling to gather a group of like-minded artists in Paris. For tactical reasons van Doesburg first approached established artists whom he held in high regard such as Brancusi and Kupka. He publicised their work in *De Stijl*.[33] However, in forming a new group as a counter-offensive against Surrealism he was heavily handicapped by his reputation for dogmatism. Established artists were unwilling to conform to his ideas. As a result, plans to form a new group with Joaquin Torres-García (with potential members including Vantongerloo, Brancusi, Kupka, Mondrian and Vordemberge-Gildewart) died an early death, not least because van Doesburg wanted to split the artists into groups: class A – those who were not (yet) working in an entirely abstract style, and class B – those creating purely abstract works. Such a split – which would clearly involve the disqualification of artists in group A – was not accepted. In the end van Doesburg was able to unite the less well-known ➤

artists Jean Hélion, Léon Arthur Tutundjian, Marcel Wantz and the Swede Otto-Gustaf Carlsund in the abstract-geometric oriented artists' group Art Concret in 1929. Their manifesto, signed by the four, was published in the first and only issue of the magazine of the same name. It declares that art must be universal and conceived in advance and that the artwork must be composed of purely pictorial elements and clear, exact shapes which refer only to themselves. On the one hand this manifesto confirmed van Doesburg's new theories regarding 'elementarism', and on the other hand it is clearly directed against Surrealism with its impulsive way of working and multiple meanings. Walmar Shwab was peripherally involved in Art Concret, but Mondrian refused to join a group that attached such importance to a systematic approach.

Torres-García, van Doesburg's former confidante, also established the artists' group Cercle et Carré in 1929 with the Belgian artist Michel Seuphor, who had been living in Paris since 1925. They adopted a more sensible approach by opening the group up to all artists who produced abstract work. Both established artists and former De Stijl sympathisers such as Mondrian, Huszár, Vordemberge-Gildewart, Vantongerloo, Arp, Taeuber-Arp, Hoste and Schwitters joined Cercle et Carré. Seuphor's ill health meant that the group and the eponymous magazine only lasted a year. However, it did open van Doesburg's eyes. He realised that the time of rigid manifestos and rules had passed. On Arp's initiative van Doesburg, Arp, Herbin, Hélion and Giacometti set up the new group Abstraction-Création at van Doesburg's house in Meudon on 12 February 1931. This group — more or less born out of the ashes of De Stijl, Cercle et Carré and Art Concret — brought together artists with diverse philosophies and styles. Once again former supporters of De Stijl such as Mondrian, Domela, Vantongerloo and Vordemberge-Gildewart joined, together with a younger cadre of abstract artists such as Hélion, Gorin and Marlow Moss. These younger artists sometimes showed themselves to be devoted followers of De Stijl. However, van Doesburg was to experience little of Abstraction-Création. A month after the group was founded he died of a heart attack on 7 March 1931 whilst recovering from a bout of asthmatic bronchitis in Davos.

Passion, Drive and Calculation

Theo van Doesburg devoted himself to the propagation of the ideas of De Stijl like a true missionary. It was a role that was made for him. He was not a man who could work in solitude, locked in a studio. He much preferred to gather kindred spirits around him to exchange ideas and formulate plans. This is evidenced by the seven groups and two magazines that he founded, the congresses that he organised, his many personal contacts and the correspondence he conducted with important foreign artists.

Van Doesburg is not De Stijl and De Stijl is not van Doesburg, but when van Doesburg started his nomadic existence in 1921, he presented himself as the representative and spokesman for De Stijl and developed into the leading proponent of De Stijl abroad. A driven man, he worked to greatly expand his

network within the circles of the avant-garde. He was very conscious of the need to establish and maintain good connections in order to realise his ambitions. He approached contacts in a focused way, gave lectures, ran courses, wrote articles, organised exhibitions and as sole editor of *De Stijl* occupied a position of authority in the art world. As a militant proponent of De Stijl he gradually became an ambassador for modern art in general. He turned out to be a successful organiser and managed to inspire many people. He seized opportunities wherever they presented themselves, often ad hoc, and his flamboyant personality made him an outstanding pace-setter. He also remained active as an artist. This combination of progressive artist, organiser, editor and driving force was highly effective and because he was part of the avant-garde, he found it fairly easy to interest other progressive artists in his plans and magazines. He had something to offer other artists and their associations were often mutually beneficial.

The fact that De Stijl had already long fallen apart by 1923 did not stop van Doesburg from stubbornly persisting with its promotion and — if it suited him — presenting De Stijl as a coherent whole. Behind the facade of a united struggle to advance De Stijl's cause there had long been friction and disagreement. Nonetheless, van Doesburg wrote to all De Stijl's contributors and former contributors in 1927 to ask for a contribution to the issue to be published to mark *De Stijl*'s tenth anniversary in 1928. Van Doesburg did, incidentally, explain in this issue that the ideas which originally underpinned De Stijl had now changed. He now spoke about the De Stijl idea as a 'mouvement perpetuel': once something is established, it must be displaced by the opposite.[34] This was a personal idea of van Doesburg's which was not endorsed by many former De Stijl artists. Yet nearly all the former contributors to *De Stijl* came together one more time after van Doesburg's death in 1931 in the final issue of the magazine, which was published as a sort of liber amicorum at the start of 1932. Apparently they still felt that he was the linchpin of the movement.

NOTES

1 Letter from Theo van Doesburg to J.J.P. Oud, undated [April 1920], Fondation Custodia Paris.

2 J.J.P. Oud and Theo van Doesburg put their nascent theories about the conjunction of architecture and art into practice near Leiden at Villa Allegonda in Katwijk aan Zee (1917) and at the De Vonk House in Noordwijkerhout (1917–18).

3 Theo van Doesburg, Robert van 't Hoff, Vilmos Huszár, Antony Kok, Piet Mondrian, Georges Vantongerloo, Jan Wils, 'Manifest I van "De Stijl", 1918', *De Stijl*, no.1, November 1918, pp.2–5.

4 Wies van Moorsel, *De doorsnee is mij niet genoeg: Nelly van Doesburg 1899–1975*, Nijmegen 2000, p.43.

5 An enthusiastic response from the art critic F.M. Huebner of 24 May 1919 was published as a reader's letter: Friedrich Markus Huebner, 'Sehr geehrter Herr van Doesburg', *De Stijl*, no.8, June 1919, pp.94–5. Huebner also wrote an article about De Stijl: F.M. Huebner, 'Die Holländische "Styl" Gruppe', *Feuer*, no.1, 1921, pp.267–78.

6 Lifelong friend Antony Kok was a railway official whom Theo van Doesburg met during his mobilisation in Tilburg in 1914. Alongside his official career, Kok worked as a poet and pianist.

7 Letter from Theo van Doesburg to Antony Kok, 7 January 1921, Instituut Collectie Nederland (ICN), van Doesburg Archive, van Moorsel bequest, on long-term loan to Rijksbureau Kunsthistorische Documentatie (RKD), The Hague.

8 Postcard from van Doesburg to Kok, 12 September 1921, ibid.

9 Letter from van Doesburg to Kok, 9 February 1922, quoted in van Moorsel 2000, p.66.

10 Van Doesburg met the conservatoire student Nelly van Moorsel in July 1920 in The Hague. Shortly after Nelly ran away from home and van Doesburg arranged a room for her in Leiden. In March 1921 van Doesburg departed for Weimar with Nelly. Nelly regularly played piano music by contemporary composers at his lectures and at Dadaist performances. They married in 1928.

11 List of attendees on the De Stijl course, Weimar, 8 March–8 July 1922, ICN, van Doesburg Archive (see note 7).

12 Annemarie Jaeggi, *Adolf Meyer Der zweite Mann*, exh. cat., Bauhaus-Archiv, Berlin 1994, p.473.

13 Le Corbusier, 'Pédagogie', *L'Esprit Nouveau*, no.19, December 1923, unpag.

14 Letter from Oskar Schlemmer to Otto Meyer-Amden, late March 1922. Tut Schlemmer, *Oskar Schlemmer: Briefe und Tagebücher*, reissue, Berlin [1958], p.125.

15 'Ableger van Doesburgs.' Letter from Oskar Schlemmer to Otto Meyer-Amden, 19 December 1922, ibid., p.143.

16 Theo van Doesburg, 'Grondbegrippen van de nieuwe beeldente kunst', in: *Tijdschrift voor Wijsbegeerte*, jrg.13, 1919, nr.1, pp.30–49, en nr.2, pp.169–188. German edition no.6 of Bauhausbücher, Walter Gropius, László Moholy-Nagy (ed.), *Theo van Doesburg: Grundbegriffe der neuen gestaltenden Kunst*, München 1925

17 'Festsaal zu Ehren des Stijl's, Erinnerung an den Meister Theo van Doesburg und Petro, veranstaltet von der Gruppe Stijl. Weimar.' Karl Peter Röhl, 'Der Beginn und die Entwickelung des Stil's 1921 in Weimar', *De Stijl*, nos.79–84, 1927, pp.103–5, repr. p.104.

18 Sjarel Ex, 'De blik naar het Oosten: De Stijl in Duitsland en Oost-Europa', in Carel Blotkamp (ed.), *De vervolgjaren van de Stijl 1922–1932*, Amsterdam 1996, p.110.

19 Craig Eliason, 'De conferenties van 1922: Tristan Tzara als van Doesburgs saboteur', *Jong Holland* no.2, 2000, p.35.

20 [Theo van Doesburg], 'Kort overzicht der handelingen van het Internationale Kunstenaarscongres te Düsseldorf (29–31 Mai 1922)', *De Stijl*, no.4, April 1922, p.52.

21 Letter from van Doesburg to Tzara, Weimar, 6 June 1922. Reproduced in Marguerite Tuijn, *Mon cher ami… Lieber Does: Theo van Doesburg en de praktijk van de internationale avant-garde*, Amsterdam 2003, pp.177–8.

22 'K.I. Konstruktivistische Internationale schöpferische Arbeitsgemeinschaft', *De Stijl*, no.8, 1922, pp.113–19.

23 Tuijn 2003, note 118, p.69. Statut der internationalen Vereinigung der Expressionisten, Futuristen, Kubisten und Konstruktivisten e. V. [eingetragener Verein], undated typescript, ICN, van Doesburg Archive (see note 7, above), doss. 1233.

24 Theo van Doesburg, 'Der Wille zum Stil', *De Stijl*, no.3, March 1922, pp.33–41.

25 The correspondence which van Doesburg and Prampolini started in 1921 suggests that they had not met before then. However, a photograph taken in Geneva in December 1920 showing both artists indicates otherwise. See Giovanni Lista, 'Van Doesburg et les Futuristes', in Serge Lemoine (ed.), *Theo van Doesburg: Peinture, architecture, theorie*, Paris 1990, repr. p.153.

26 [Theo van Doesburg], 'Rondblik. Italië. Casa d'Arte Italiana (Roma)', *De Stijl*, no.2, February 1921, pp.26–8.

27 Schlemmer to Otto Meyer-Amden, late March 1922, Schlemmer 1958, p.125.

28 *Deuxième Exposition Annuelle* (Comité Nancy–Paris), 12–31 March 1926, Galeries Poirel, Nancy.

29 International exhibition *L'Art d'Aujourd'hui*, 18 Rue de la Ville-L'Eveque, Paris, 1–21 December 1925.

30 Nicolette Gast, 'De blik naar het zuiden: De Stijl in België en Frankrijk', in Carel Blotkamp (ed.), *De vervolgjaren van De Stijl*, Amsterdam 1996, p.177.

31 W. Vitt, *Hommage à Dexel*, Starnberg 1980, p.96.

32 Van Moorsel 2000, p.131.

33 Depictions of work by Brancusi: *De Stijl*, no.8, 1924, p.120; *De Stijl*, no.77, 1926, p.69; *De Stijl*, nos.79–84, 1927 pp.81–4. Picture of Kupka: *De Stijl*, nos.73–4, 1926, p.10.

34 [Van Doesburg], '10 jaren Stijl. Algemeene inleiding', *De Stijl*, nos.79–84, 1928, p.3.

DE STIJL AND THE EAST-WEST AVANT-GARDE: MAGAZINES & THE FORMATION OF INTERNATIONAL NETWORKS

KRISZTINA PASSUTH

It was most probably 1921 when Theo van Doesburg, the founder of the magazine De Stijl, wrote a letter to the uncrowned king of the Dada movement, Tristan Tzara. Mailed from Berlin, the letter solicited the donation of magazines, or rather, an exchange of magazines. The Dutch artist told Tzara, who was of Romanian descent, that he had a table packed with Dadaist and other avant-garde magazines in his studio for the enjoyment of his visitors with a penchant for modern art. He placed the most revolutionary of these magazines, Staatliches Bauhaus, Weimar, at the centre of the pile. He had a similar arrangement in a separate room for the benefit of his students. 'So please, send us a few publications to the address given!' he added.[1] But why were magazines so important to him?

To answer this question one should bear in mind that, short of a personal encounter, magazines constituted almost the only possible channel of communication between artists at the time. And the representatives of avant-garde art in both western and eastern Europe in the early 1920s needed communication almost as much as they needed their daily bread. The various avant-garde groups emerged with unprecedented speed and dynamism. Putting aside any personal and professional conflicts, writers, painters, publishers and editors were all anxious to make contact with each other in order to hear of any new discoveries or nascent ideas. But they were just as eager to air their own ideas, and were immediately on the lookout for the possibility of debate or controversy. Of course, all this could have been achieved through correspondence, and indeed van Doesburg was among the most ardent of letter writers: we only need to mention his exchanges of ideas with Frantisek Kupka or László Moholy-Nagy, for example. But to stay in touch by post required good personal relations and a great deal of time. More to the point, such correspondences were never made public. It was a public forum that this generation of artists needed more than anything. It was vitally important that all those concerned – newspaper editors, artists, writers, cinematographers – should be able to hear not just about new theories but also magazines, joint conferences, exhibitions and manifestos. It was also important that anybody reading a magazine should immediately be in the position to react to the

issues raised, hopefully with a counter-article accompanied with drawings or illustrations. The table in van Doesburg's studio had been placed there in the service of publicity, and of international publicity at that, since most of his guests were representatives of the international avant-garde.

Magazine editors wanted to know about each other's work, and in most cases wanted to work in co-operation. As a result, the formation of social networks was extremely rapid: similarities in the format, visual presentation and content of some magazines testify to that. But despite the visual similarities, their contents differed significantly. *De Stijl*, for example (along with most of the magazines in western Europe, for that matter), was not necessarily politically committed. By contrast, the Hungarian magazine *MA* and the Serbian *Zenit*, along with the Russian *Veshch, Gegenstand, Objet*, and the Polish *Blok* and *Dzwignia*, were all very much politicised: they had strong left-wing, radical and anti-establishment tendencies. This was especially true for the magazines published by Hungarian émigrés, who all pinned their hopes on the outbreak of another revolution, one that would this time succeed. With this in mind, the Hungarian artistic community remained either in Vienna (which was close to Budapest), moved to Berlin (the most active and revolutionary centre of the avant-garde), or even set up shop in Moscow. The Italian Futurists, on the other hand, had political views that were decidedly different or sometimes even diametrically opposed. But from the standpoint of their social networks, politics hardly mattered at all. Regardless of their political positions, these artists were essential to each other if they were to succeed in promoting their ideas internationally. Immediately after the First World War, it was the goal of avant-garde artists to break away from their national issues and prejudices and compete with each other in a broader, international context, regardless of which side of the trenches they had stood a couple of years earlier. The politically exacerbated hostilities and the war crimes committed on both sides perhaps provided even greater reason for artists to come together after 1918. It was in fact the sometimes right-wing Futurists and anarchistic Dadaists who exerted the most powerful and stirring formal influence on the left-leaning publications of the eastern Europeans.

Typography, design and images
In 1921 or 1922 there was a fundamental change in the appearance of avant-garde magazines across almost all of Europe and in the United States. Title pages attained the status of individual artworks, and also began to function as advertisements or posters in themselves. Words, fragments of words and letters, and later on, photographic fragments were effectively used in the composition of title pages, cover pages and blocks of text. To break the monotony of boring typesetting and grey lines, new elements were incorporated into the texts, introducing movement and dynamism. The Italian Futurists, the international Dadaists from Zurich and the Russian Constructivists were the first to discover the hidden possibilities in typography, before the Germans,

Czechs, Poles and Hungarians went on to squeeze every last drop out of those possibilities. When the magazine *De Stijl* was first published in 1917, it, too, appeared in a more or less traditional format, and it was to be four more years before it completed a thorough transformation. Primarily yielding to Dadaist influence, the characteristic and enigmatic red letters 'NB' appeared, along with colourful inscriptions and diagonal arrangements. In any case, throughout its long history (1917–32), *De Stijl* remained an elegant, restrained and harmonious publication, one that, despite van Doesburg's continuous search for innovation, never really experimented with absolutely new forms.

The reproductions published in *De Stijl* were integral to each issue of the magazine. Nevertheless, pictures were occasionally re-published in other magazines or almanacs. For example, thirteen typical De Stijl images were reproduced in the almanac entitled *Buch neuer Künstler*, published in 1922 by *MA* and edited by Lajos Kassák and László Moholy-Nagy, and were significant in defining its character. The images included works by De Stijl artists, photographs of the largest American aircraft hangar, a punching machine and a racing car — symbolic of the modern visual experience. In fact, reproductions depicting the world of modern machinery, the circus, the latest construction projects, theatres, movies and Charlie Chaplin, were shared by magazines emerging from various nations and a broad range of intellectual movements, and swiftly entered the mainstream.[2]

De Stijl and the rival it created for itself: Mécano
With its stern and mostly geometrical, orthogonal structure, the cover pages of *De Stijl* usually stood apart from that of the more modern magazines. To explain its austere appearance, we should point out that it was conceived before most of the other avant-garde periodicals. By 1917, when it was first published, only the Italian Futurists had explored any form of typographical innovation or irregularity. The spirit of patriotism that ran high in various European countries between 1914 and 1918 had not been favourable to a more liberated, anarchistic and international approach. With its full-blown pathos, realistic presentation, when put to the service of war propaganda, had proved much more favourable. However, *De Stijl* belonged to neither of these two categories. The black-and-white design of its cover was the work of the Hungarian artist Vilmos Huszár, who was among the founding members of the De Stijl group. The same title page was kept for three years running. According to Kees Broos, 'Typographically, the first three volumes of the monthly periodical *De Stijl* are not very remarkable... Only in the cover and in a few advertisements do we perceive some deviations from the classic typographical image.'[3] This seems to suggest that at that time the outward appearance of the magazine did not hint at the artistic revolution that would follow.

De Stijl's truly important contribution to typography found its inspiration from abroad. It was the special issue entitled 'Of 2 Squares', van Doesburg's adaptation for the Dutch public of the children's book by the Russian artist El Lissitzky, which had just been published in Berlin.[4] El Lissitzky could achieve

something that van Doesburg still could not: he was able to lend a dynamism and a certain soaring quality to letters and geometrical forms, far surpassing traditional typography. By 1922, El Lissitzky had set down roots in the western world, where he took the lion's share in organising a large, representative exhibition of Russian and Soviet art at the Galerie van Diemen in Berlin. He had already taken a leading role in writing, editing and graphically designing the Russian propaganda magazine *Veshch, Gegenstand, Objet*. The artist himself became the model of the versatile intellectual, linking East with West. His talents would play a prominent part in the rejuvenation of typography, in the creation of innovative urban plans, in the execution of the *Proun* paintings and graphic works, 'proun' interiors, and the organisation of exhibitions. Naturally, El Lissitzky's personal presence in Germany explains the incredible speed with which his ideas became the common language and practice of the avant-garde in Berlin, Düsseldorf or Weimar. But in order for the newest ideas to have a lasting impact and a broader appeal, there was a need for an accessible printed medium carrying as much information as possible. There was no alternative portable form at the time.

El Lissitzky's title page in the 'Of 2 Squares' issue of *De Stijl* combined humour and freedom with a sense of infinite space and a longing for flight. Lissitzky came to Berlin from Russia, already stimulated by the dynamism of the Russian revolution. When humour and freedom became evident in the work of van Doesburg — along with other Futurist and Dadaist influences — not only did he change his typography, but he also used another name: he became I.K. Bonset, a bold and unpredictable artist and a true anarchist, as demonstrated by his magazine *Mécano*, founded in 1922. Elsewhere, too, there were artists who went through a similar metamorphosis, although perhaps not in the same spectacular manner: this was evident in the case of Lajos Kassák, who had retained the traditional, figurative design of the Hungarian magazine *MA* right up until 1919 and the fall of the Council Republic in Hungary. During the first years of his subsequent Viennese exile, he introduced revolutionary changes not only in the magazine's content, but also in its outward appearance. The red-and-black design, the future trademark of *Bildarchitektur* (picture-architecture, a new form of geometric abstract art), was born.

With its folded pages and strikingly original format, colours and content, *Mécano* was produced by the same van Doesburg as *De Stijl* magazine. In fact, after 1922 the two magazines were published in parallel. However, they greatly differed in essence. While the title page of 'Of 2 Squares' above else expressed the spirit of El Lissitzky,[5] *Mécano* reflected the playfulness and anarchy of Dadaism and Futurism, along with a natural congruity between typography and imagery. *Mécano* aimed to be an international publication. Nevertheless, the small and playfully rotated picture planes mainly represented the work of Dutch, German and French artists (the only exceptions being the Romanian Tristan Tzara, the Russian Charchoune and the Hungarian László Moholy-Nagy, whose *Nickel-Plastic* and *Relief S* were selected for the 'Blue' issue of 1922). The Blue issue had a decidedly Dadaist

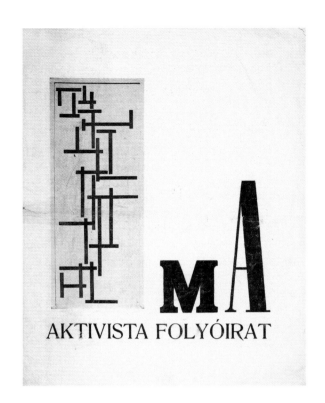

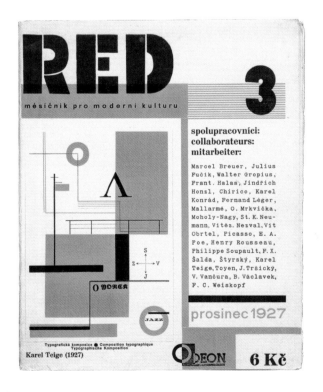

Fig.9
'MA', July 1922, cover designed by Lajos Kassák

Fig.10
'Red' No.3, 1927, cover designed by Karel Teige with a typo-composition

character, which was especially evident in the texts. In Moholy-Nagy's case, *Nickel-Plastic* and *Relief S*, along with his contributions to the German magazine *Der Sturm* of 1922, were his earliest international publications. Nothing about *Mécano* was regular or constant: every issue was different from all the others, even in outward appearance. Van Doesburg contributed as an artist, a writer and an editor under the name of I.K. Bonset. Lajos Kassák produced his pictorial poems, followed by the first examples of his picture-architecture. The Dadaist sculptor Hans Arp wrote Dadaist poems, while Karel Teige, who was the driving force behind the Czech avant-garde, created poetic collages, along with literary texts and some theoretical writings. The same applied to the German Kurt Schwitters, who invented an individual form of Dada, 'Merz', which had everything in it: collage, assemblage, poetry, music and theatre. And what could be more natural than Arp and Schwitters both contributing to I.K. Bonset's *Mécano*, along with Tristan Tzara and many others.[6]

The intellectual background of De Stijl and related magazines

At the start, *De Stijl* had a circulation of 1,000, which was sufficient for the tiny avant-garde art scene in a small country. Van Doesburg originally wanted to limit the focus of the magazine to fine and applied art. He was of the opinion, however, that once the format proved successful, he would broaden its scope considerably, incorporating music, theatre and more. The public expected something like that from him, he thought. In this regard, the concept of *MA* was radically different. From 1916, the Hungarian magazine considered anti-war propaganda, and the promotion of art and literature from countries at war with their monarchy, to be its first and foremost concern.

Together with the Romanian magazine *Contimporanul*, and *MA* and *Der Sturm*, *De Stijl* was among the avant-garde magazines with the longest lifespan. In contrast with *De Stijl* and *MA*, however, *Contimporanul* could only be regarded as an avant-garde magazine for the brief period between 1922 and 1925. As early as 1924, other Romanian magazines began to take over the lead: *Punct*, *Integral* and *75HP*. Who were the people who created them, how were they operated, and to what extent, if at all, did they relate to *De Stijl*?

These avant-garde magazines were, almost without exception, the work of individuals: the person who acted as editor and publisher also corresponded with authors, wrote and designed material, found financial resources and organised the circulation. Great personal dedication or even obsession was required from anyone who undertook such a job. Van Doesburg, who was capable of such obsession, proved equal to the task. But in order to be able to play this role, he had to come a long way.

Van Doesburg's international contacts

Much before his experiments with Dada, van Doesburg joined the Italian magazine *Valori Plastici*, which aimed to create 'ordre plastique, ordre moral, ordre politique'. Van Doesburg published a series of articles in the magazine, in which he analysed the Dutch tradition from van Eyck right up to the present. In these articles he propounded the view that the only tradition in Dutch art was a contempt for art which has nothing to do with the representation of the space-view shared by the proponents of Valori Plastici.[7]

As early as 1921, van Doesburg was in close contact and regular correspondence with Enrico Prampolini, an enthusiastic promoter of Futurism. The two planned to produce a joint publication. They also made plans for the publisher Voce to publish a selection of works by De Stijl artists.[8] Co-operation with the Italians became even more important in 1926 when the Futurists, and most notably Prampolini, were expressly seeking contact with foreign artists. The 1927 issue of the Romanian magazine *Integral* reproduced photographs of Futurists on its title page. *Integral* also carried an advertisement for *De Stijl*. Van Doesburg and Prampolini's communication was bolstered by a personal encounter: in 1926 van Doesburg spent two months in Rome, where he built relationships with the Futurists. He purchased the painting *Vitesse abstrait + bruit* (1913–14) by Balla, a choice that acquired additional significance later, when he started to apply diagonals in his own compositions under the influence of Balla's dynamism. At the same time, he edited 'The Call to Elementary Art', in which van Doesburg stated the principle of 'transformation perpetuelle': in other words, he made direct use of Marinetti's words in his own text, which was eventually published in a Milan magazine entitled *Antenna*. In this way, the Futurist influence was manifested in both his art and his writing.[9]

Van Doesburg assigned great importance to the avant-garde movements of central Europe, and he primarily sought contacts with Hungarian and Polish artists.[10] Through frequent meetings with László Moholy-Nagy, first in Berlin and then in Weimar, he maintained contact with those involved in the Hungarian magazine *MA*. The earliest contact between van Doesburg and Lajos Kassák, the editor of *MA*, was mentioned in a letter to van Doesburg dated March 1921, in which Kassák talked about their future relationship.[11] This probably led to the publication of van Doesburg's poem *X-Images*, under the pseudonym I.K. Bonset, in the April 1921 issue of *MA* in Vienna. Van Doesburg's true importance was underscored in the July 1922 issue of *MA* (fig.9), which not only featured the Dutch artist on the title page, but also included eleven more of his works inside the magazine. With the exception of *Card Players*, all the works were typical abstract compositions. *MA* dedicated a full page to van Doesburg's essay entitled 'Architecture as a Synthetic Art', in which the author considered monumental art to be the modern synthesis of architecture and painting. The van Doesburg issue marked one of the high points in the history of *MA*. It clearly indicated that, like the Berlin resident Moholy-Nagy, the Vienna-based Lajos Kassák also attributed great significance to the Dutch artist.

The aim of *MA* was to give an overview of the most important movements in the international avant-garde. In the spirit of co-operation, the 4 October 1921 issue of *De Stijl* published 'The Call to Elementary Art', whose signatories, including ➤

Hausmann, Arp, Pougny and Moholy-Nagy, had had their work published in *MA*. In July 1922, simultaneously with the van Doesburg issue of *MA*, *De Stijl* published one of Moholy-Nagy's early writings of outstanding importance, 'Produktion-Reproduktion', illustrated with his own works and with works by Kassák and László Péri, a Hungarian sculptor of the Constructivist school. At least in a cursory fashion, the three most important representatives of Hungarian Constructivism were therefore represented. But the spirit of co-operation between *De Stijl* and *MA* did not last long: the disagreements between the various groups turned acrimonious at the Congress of Constructivists and Dadaists organised by van Doesburg in Weimar in September 1922.[12] In September 1923, the art critic Ernst Kállai, a proponent of Constructivism who regularly contributed to *MA* (and later also to the Bauhaus magazine), wrote an essay entitled 'Correction! For the Attention of De Stijl', in which the concept of De Stijl was mercilessly dissected.

Among those who attended the Weimar conference were the representatives of De Stijl, the Dadaists Tristan Tzara and Hans Arp, El Lissitzky and Ilja Ehrenburg (the editors of *Veshch, Gegenstand, Objet*), the German Hans Richter (who later became the editor of the magazine *G*), László Moholy-Nagy, and many

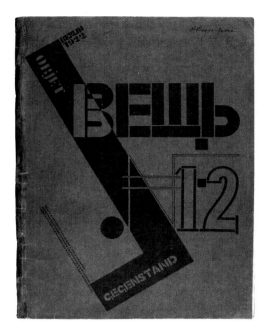

Fig.12
**Cover of 'Veshch, Gegenstand,
Objet', no.1-2, 1922, designed
by El Lissitzky and Ilia Ehrenberg**

Fig.13
'G', no.5-6, April 1926

others. Van Doesburg's influence was extensive. 'Because he was representing De Stijl, no one suspected him of being I.K.Bonset, the Dada poet, so van Doesburg was able to settle the controversies.'[13] In reality, it was not really a secret for anybody in this company. The opening phrases of van Doesburg's text, published in *De Stijl* in 1923, clearly stated: 'You probably will be sceptical of learning something about dada from someone who is innocent of dada and who is non-dadaist.'[14] The Hungarian Communist critic János Mácza explained in a contemporaneous article about the Weimar conference, 'The chance for reconciliation was there, but the members of the conference failed to come to an agreement on the question of worldview... And so the whole project came to nothing.'[15]

The Weimar conference demonstrated that the international avant-garde was made up of separate groups who could occasionally co-operate for the purpose of holding an exhibition or publishing a magazine, soon to become fractured by opposing ideology. Yet the conference produced some results, irrespective of the overall failure. Inspired by van Doesburg, and with El Lissitzky's collaboration, Hans Richter launched the magazine *G, Material zur Elementaren Gestaltung* in Berlin, backed financially by Mies van der Rohe. *G* represented Constructivists who had resolved to start from the beginning, by returning to the most elementary and basic concepts and building something entirely new.[16] Thanks to Hans Richter, *G* offered a colourful and versatile assemblage of photos, films, fashion, railway stations, streamlined automobiles, machine parts, aircraft hangars and designs from the Bauhaus.[17] Usually, the pictures and texts were closely connected, for example in one of van Doesburg's articles, in which the author wrote about spirituality and the universe in connection with one of his abstract compositions.[18]

Similarly to its Russian-edited counter-part *Veshch, Gegenstand, Objet*, *G* maintained close links with Berlin and with El Lissitzky, and hoped to hook up with the international avant-garde. As the result of the recent understanding between van Doesburg and El Lissitzky, *Veshch* published Van Doesburg's theoretical article on monumental art, complete with three geometrical drawings that illustrated his ideas on the foundations of the new painting, sculpture and architecture.[19] Through El Lissitzky and *Veshch*, van Doesburg was able to build a network of contacts in eastern and central Europe to supplement his relationships with artists and editors in Berlin and with *MA* and its editor Lajos Kassák in Vienna.[20] At the Weimar conference the Hungarian painter Sándor Bortnyik also 'developed a personal relationship with van Doesburg.'[21]

Van Doesburg's contacts with the Romanian and Serbian avant-garde were less intensive, but the Romanian painter Marcel Janco did sign the Düsseldorf declaration of the Constructivist International, which *De Stijl* published in 1922. Primarily, the Serbian magazine *Zenit* had good relations with Russian and German artists, but it did publish an article on 'The Architecture of Mendelsohn, van Doesburg and van Eesteren.'[22] In 1926 *Zenit* also published 'The Call to Elementary Art' on its cover. 🖎

But the connection was apparently rather one-sided: van Doesburg was not quite as interested in supporting the activities of *Zenit*.

By contrast, greater affinity seems to have existed between Polish Constructivism and De Stijl, despite the distance between Warsaw and Berlin or Weimar. Strong similarities existed both in artistic concept and in style. Van Doesburg's theory of Elementarism had a significant influence on the Hungarians, while the Poles were more interested in van Doesburg's later theory concerning architecture: 'architecture is the synthesis of a new type of creation', as van Doesburg had put it in an article published in the 1924 issue of the Polish magazine *Blok*.[23] *Blok* was launched in 1924, a little later than other avant-garde magazines. It was edited by Mieczysław Szczuka and Teresa Żarnower. In terms of both typography and content, *Blok* was considerably more resolved than either *MA* or *De Stijl* had been at its inception. The essay 'What is Constructivism?', jointly written by a group of Polish Constructivists, with typographical design by Szczuka, later came to be regarded as a statement of the group's artistic programme, and was published in issues six and seven of the 1924 volume. In the section dedicated to colours, van Doesburg wrote: 'New architecture uses colour (not painting), throws it into light, displays with it the changes of shape and space. Without colour we would have no play of shapes... Colour (it must be made clear to architects — enemies of colour) — is not an ornament or embellishment — it is an essential element, organically belonging to architecture like glass and iron.'[24] A lively correspondence and debate emerged between the Dutch and Polish groups. The latter came to be represented by the magazine *Praesens*. The two groups were always aware of the activities of each other and *Blok* never missed a chance to advertise *De Stijl* in its pages.

In 1926 *Blok* was replaced by *Praesens*. Published by Szymon Syrkus, the magazine had only two issues, in June 1926 and May 1930. The first contained an article by Kasimir Malevich on the non-objective world, and another by van Doesburg on Elementarism.[25] Van Doesburg exerted a profound influence on the artists of the Polish avant-garde, and none more so than on the sculptor Katarzyna Kobro. In their search for new possibilities, the artists increasingly turned to architecture. According to surviving letters, van Doesburg was firmly resolved on holding a lecture series in Warsaw, while the *Praesens* group wanted to organise an exhibition for van Doesburg.[26] As it so often happens with plans, it came to nothing in the end.

Van Doesburg eventually shifted his attention to his network of connections in France, as he gradually turned away from the avant-garde tendencies of central Europe. The Moscow-Berlin axis in art became relegated to the background after 1925–6, to be replaced by something entirely different, as France, where Surrealism flourished, increasingly became the centre of European artistic activity.

Fig.14
SÁNDOR BORTNYIK
Untitled 1924

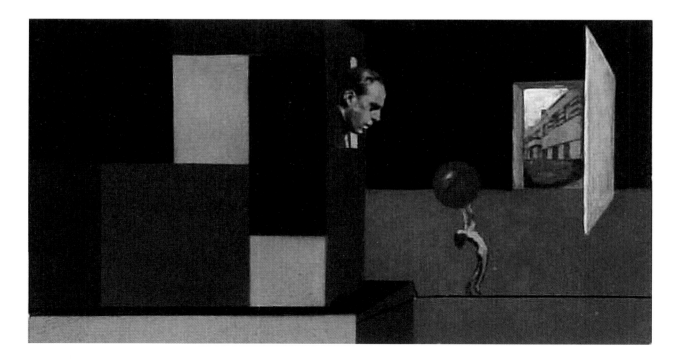

NOTES

1 'Maintenant j'ai mis dans mon atelier une table avec toutes les revues d' avant-garde et de dada pour les amis de l'esprit moderne. Le centre, le plus révolutionnaire est: Statliches /sic/ Bauhaus. Weimar. Il y a une chambre spéciale de revues pour les étudiants, Envoyez donc quelques publications a cette adresse ...' Theo van Doesburg, *Qu'est-ce que Dada?*, préambule de Marc Dachy, Paris 1992, pp.44–5.

2 Publications included *Zivot II* and *Pasmo, Red* (Czech), *Blok, Praesens* (Polish), *MA* (Hungarian), *L'Esprit Nouveau, Manometre, Vouloir, Bulletin de l'Effort Moderne* (French) and *LEF* (Russian).

3 Kees Broos, 'From De Stijl to a New Typography', in Mildred Friedmann (ed.), *De Stijl 1917–1931: Visions of Utopia*, Walker Art Center, New York 1982, p.149.

4 Broos 1982, p.159.

5 El Lissitzky, single page from 'Of 2 Squares', 1922, in *De Stijl*, nos.10–11, vol.5, 1922.

6 Hans Arp, 'Die Schwalben hode III. Für Theo van Doesburg', *Mécano*: white issue, no.4–5, 1923, n.p., Kurt Schwitters, Sonate, op.cit., n.p.

7 Fanette Roche, 'Ordre plastique, order moral, order politique', in *Le Retour a l'ordre: Ordre dans les arts plastiques et l'architecture, 1919–1925*, Université de Saint-Etienne, Travaux 8, St Etienne 1975, p.231.Van Doesburg published in *Valori Plastici Rivista d'Arte* (Rome, edited by Mario Broglio) in no.3, 1919 and no.1, 1921. See *Valori Plastici*, vol.8, Quadriennale, Roma, Genf-Milano, 1998.

8 Enrico Prampolini, letter to Theo van Doesburg, May 1921, edited by Enrico Prampolini, in Giovanni Lista (ed.), *Carteggio Futurista*, Rome 1992, p.209.

9 Giovanni Lista, *Le Journal des futurismes*, Paris 2008, p.308.

10 Krisztina Passuth, 'Théo van Doesburg et le mouvement d'avantgarde hongroise', in Serge Lemoine (ed.), *Theo van Doesburg*, Paris 1990, p.164.

11 Letter written by Lajos Kassák to van Doesburg, manuscript, Instituut Collectie Nederland (ICN), van Doesburg Archive, van Moorsel bequest, on long-term loan to Rijksbureau Kunsthistorische Documentatie (RKD), The Hague, published in Passuth 1990, pp.165, 171.

12 Julia Szabó, *A magyar aktivizmus művészete* (The History of Hungarian Activism), Budapest 1981, p.126.

13 Joost Baljeu, *Theo van Doesburg*, London 1974, p.53.

14 Baljeu 1974, p.131.

15 János Mácza, *A mai Európa művészete: 1924 –1926* (The Art of Europe Today), exh. cat., Petőfi Irodalmi Múzeum, Budapest 1978, p.114.

16 With this optimistic goal, '*G* joined the ranks of other post-war avant-garde journals such as *De Stijl, L'Esprit Nouveau, Bestch, Ma* and *Merz*', Marion von Hofacker, reprint of the magazine *G*.

17 'The writings and experiments of the abstract film-makers Hans Richter and Viking Eggeling, whom van Doesburg met in Germany in 1920, were an important stimulus for his ideas about the machine aesthetic.' Paul Overy, *De Stijl*, London 1991, p.15.

18 Theo van Doesburg, [No title], *G*, June 1924, p.48.

19 Theo van Doesburg, 'Monumentalnoe iskustvo', in *Veshch, Gegenstand, Objet?*, nos.1–2, March–April 1922, pp.14–15. Van Doesburg published another short piece of writing in *Veshch, Gegenstand, Objet*, nos.1–2, Berlin, 1922, p.20.

20 Lajos Kassák and Van Doesburg were in contact after all, as proven materially by Lajos Kassák's *Construction*, 1922. 'The painting in the collection of Galerie Gmurzynska, was originally owned by Mrs Nelly van Doesburg, in *Kassák 1887–1967*, exh. cat., Magyar Nemzeti Galéria, Budapest (Hungarian National Gallery), 1987,p.175, note 161.

21 Oliver A.I. Botar, *Technical Detours: The Early Moholy-Nagy Reconsidered*, exh. cat., The Art Gallery of the Graduate Center, The City University of New York, New York 2006, p.151.

22 Zenit *and the Avant-garde of the Twenties*, exh. cat., National Museum Institute of Literature and Art, Belgrade 1983, p.65.

23 Theo van Doesburg, 'Odnowienie architektury', in *Blok*, no.5, 1924. See Andrzej Turowski, 'L'avant-garde polonaise et Théo van Doesburg', in Lemoine 1990, p.173.

24 'Co to jest konstruktywizm' (What is Constructivim?), *Blok*, nos.6–7, 1924, quoted in *Constructivism in Poland 1923–1936: Blok, Praesens a.r.*, exh. cat., Museum Folkwang, Essen 1973, pp.78–9.

25 Andrei Nakov, *Abstrait/Concret*, Paris 1981, p.275.

26 Andrzej Turowski, in Lemoine 1990, p.175.

'LIFE IS AN EXTRAORDINARY INVENTION': DOESBURG THE DADAIST

MARC DACHY

In view of van Doesburg's immensely varied career, his Dada activities might appear minimal and even, to believers in pure plastic art, little more than a sideline. However, the Dadaist side of his personality deserves to be re-examined in detail, and for several reasons. Not content with improvising a Dada review, *Mécano* (1922–3)[1], Doesburg was wholeheartedly Dadaist as a painter, with a handful of major works (assemblages, collages), as a poet (Dada poems/manifestos), as the instigator of a skilful rapprochement between Dada and Constructivism at Weimar in September 1922, and as the initiator of a Dada tour in the Low Countries in the following year.

The extent of his commitment to Dadaism can be gauged by the fact that it owed much to the friendship and artistic co-operation of Kurt Schwitters — a relationship extended by their work together on a children's book, *Die Scheuche* [2] — and later to his collaboration with Arp and Sophie Taeuber-Arp on the design for the Aubette building in Strasbourg. His enthusiasm, though possibly dating from earlier, first took written form on 25 October 1921 in a letter to Tristan Tzara: 'The Dadaist spirit pleases me more and more. There is a desire for something new similar to that with which we proclaimed the modernist ideal. It is only the means that are different. It's a great pity that M. Picabia has withdrawn. I know why, but I believe in the possibility of really meaningful contact (and synthesis) between Dada and developments in "serious modern" art.'[3] This was a portentous declaration, a presentiment that could only grow stronger in the face of adversity, and which reveals, on Doesburg's part, a strategic awareness which comes as no great surprise. The relationship between Tzara and van Doesburg was already cemented by the spring of 1920, though the two appear not to have actually met until the following April during a stay in Paris by Theo van Doesburg and Nelly van Moorsel, his third wife. In addition, van Doesburg and Hausmann became acquainted in late 1920.

It was Theo himself who first contacted Tzara by letter in June and December 1920 as part of his fascination with Dada. We note with amusement from his first correspondence that June — *Mécano* would appear in February 1922 — van Doesburg's fictional literary collaborator I.K. Bonset was anxious to publish a Dadaist

review. He declared that the Low Countries 'needed a touch of Dada', criticising them as 'too flat', and wanted to buy or receive a copy of the fourth issue of the review *Proverbe*,[4] thereby promoting himself as a closely attentive reader of Dada material published in Paris. Was he already distancing himself from the statement in his December letter when he proclaimed himself Dada's only defender in Holland? Not really. It amounted to denying Bonset's existence, but van Doesburg announced the forthcoming appearance of an article on Dada in the *Nieuwe Amsterdammer*, and 'Bonset' had never spoken publicly in favour of the movement.

In the spring of 1921, *De Stijl* marked its interest in Dada by publishing two of Raoul Hausmann's Dadaist manifestos – 'Dada Is More than Dada' and 'PREsentismus' – followed by texts by Georges Ribemont-Dessaignes, poems by Clément Pansaers, and, in the autumn of 1921, the seminal 'Call to Elementary Art' signed by Raoul Hausmann, Hans Arp, Jean Pougny (Ivan Puni) and László Moholy-Nagy. These were little more than preludes to the events that would follow.

Van Doesburg's interest in Dada once more struck Tzara when, in the autumn of 1921, the painter questioned him about the death of Dada as proclaimed by the poet Clément Pansaers on the cover of a special French-language magazine published in Antwerp, *Ça ira!*, at the same time requesting his collaboration on *Mécano*. Van Doesburg's meticulous record-keeping has proved a blessing to historians as Tzara, stung by Pansaers's initiative, produced a thunderous and emotional response. This is the sole document to throw light on relations between Tzara and Pansaers, while those of Aragon, Breton, Picabia and Soupault are no secret. The name of Clément Pansaers does not appear here by chance. Van Doesburg had been delighted by his poems *Le Pan-pan au cul du nu nègre* and *Bar Nicanor*. 'These', he writes, 'are eminently modern works in which new concepts are translated into language with admirable talent. They, and others like them, reveal the electrically charged field of our modern imagination with an inspiring precision.'[5]

At this juncture Theo van Doesburg, as a result of his geostrategic and linguistic situation, became one of the few artists of the period directly involved with every aspect of Dadaism. It is also significant that he was present at the riot during the performance of Tristan Tzara's play *Coeur à gaz* on 6 July 1923, generally regarded as the end of Dada, or at least as marking the disintegration of the Parisian nucleus that had formed around Tzara since his arrival in the French capital early in 1920. Once again, van Doesburg's memoir – one of the few extant testimonies – is invaluable, with its expression of anger and indignation. He bitterly condemns the 'murderous' charge and the attempt to physically assault Tzara on that fateful occasion. Not content to remain a bystander, van Doesburg was personally involved in the event, producing scenery for interpretations of Ilya Zdanevitch's *Zaoum* poems by the dancer Lizica Codreano, with costumes by Sonia Delaunay.[6]

Schwitters and van Doesburg were responsible for the two 'heresies' associated with *Mécano* and Merz: Schwitters was the dissident par excellence, inventor of the Merz offshoot of Dadaism, while van Doesburg invented I.K. Bonset in order to give expression to his alter ego, the side of his personality unacceptable to De Stijl.

'The Call for Elementary Art', though not signed by van Doesburg, must have enthused him tremendously. It trumpeted a daring innovation, a renascence, an art that was the child of its times, an elementary art that had no truck with philosophy, which constructed itself from its very own elements, the artist being 'the interpreter of energies that shape the world's elements'. The manifesto demanded a solidarity in favour of art, against styles but for style, untainted by plagiarism. 'Art', it proclaimed, 'is something pure which, freed from utility and beauty, springs, in its elementary form, from the individual.'[7] Elementary art as announced in Berlin in October 1921, included at the time the entire collection of multidisciplinary experiments carried out in the same surge of enthusiasm by Hausmann, Schwitters, van Doesburg and Lissitzky who were simultaneously poets, architects, typographers, backers or publishers of journals or men of the theatre. They pursued an identical task on many fronts.

Meanwhile, typography, in the sense of the plastic conception of a page, became of primary interest to van Doesburg as both editor of *De Stijl* and artist. Particularly fascinating for him was how the printed page could be used to make a literary, visual transcription of sound effects, producing a vibratory visual tension. He was drawn even closer to Dada when he published the poet Antony Kok, the poetess Til Brugman or I.K. Bonset himself. In July 1921 he printed some of Schwitters's 'elementary' poems consisting entirely of an arrangement of figures; the figures themselves did not appear in *De Stijl*, rather their transliteration, the aim being to reveal their sound value or *klankwaarde*, a Dutch term recalling the title of poems in multiple-style characters issued by Bonset: *Letterklankbeelden*, literally 'sound images of letters'.

The Weimar Congress

Thanks to Moholy-Nagy's vital evidence in *Vision in Motion*, the Congress of Constructivists and Dadaists in Weimar in September 1922 is the best-documented Dada convention. There was, however, an earlier gathering at the end of May in that year. The International Congress of Progressive Artists in Düsseldorf brought together notably Hans Richter, Werner Graeff, Raoul Hausmann, Hannah Höch, Otto Freundlich, Franz Seiwert, Theo and Nelly van Doesburg, Cornelis van Eesteren, El Lissitzky, Ruggero Vasari, Stanislas Kubicki and Tomoyoshi Murayama. Hausmann was present, but not Schwitters – though he travelled to Weimar a few months later. Van Doesburg became bored with the proceedings. He wrote to Tzara: 'I was at Düsseldorf for the International Congress of Progressive Artists. I left with my friends; the whole gathering protested. It was a completely idiotic ambience! And so reactionary!'[8]

This disappointment did little to deter van Doesburg who, giving art courses at his own and Karl Peter Röhl's studio from spring 1922 to the end of the year, took the initiative and arranged a second event at Weimar. This time, two of the founders

Fig.15
THEO VAN DOESBURG
La Matière Dénaturisée
Destruction 2 1923

of Dada – Tzara and Arp – took part, not without some fallout among the Constructivist clan. Tzara initiated Moholy-Nagy into the use of photograms or 'rayographs', showing him Man Ray's *Champs délicieux*,[9] and the Bauhaus undertook to commission a volume by Tzara for its collection.[10] Van Doesburg apart, others attending included Schwitters, El Lissitzky (a close collaborator on the magazines *De Stijl* and *Merz*), the painter and photographer Max Burchartz, the Dutch architect Cornelis van Eesteren, cinematographer Werner Graeff, painter and graphic artist Karl Peter Röhl, László Moholy-Nagy (painter, co-editor of the review *MA*, lecturer at the Bauhaus some months later) and the third Dadaist of the initial Zurich group, Hans Richter.

It seems certain that this meeting between the factions was deliberately staged by van Doesburg. Moholy-Nagy recalls their 'great amusement' at the surprise encounter with 'the Dadaists Hans Arp and Tristan Tzara', whose presence triggered 'a rebellion' against van Doesburg. 'We saw in Dadaism a destructive force, outdated in view of the new Constructivist perspectives', admits Moholy-Nagy, but 'Doesburg, an impressive personality' calmed the storm. The younger members of the Bauhaus, the 'purists', gradually beat a retreat; at first they watched 'in consternation', only to be finally won over, as the congress turned into a Dadaist performance.

'At the time', adds Moholy, 'we had no idea that Doesburg himself was at once Constructivist and Dadaist, writing Dada poems under the pseudonym "I.K. Bonset".'[11] In all honesty, it is impossible to reconstruct the background to this fiction, or discover when or how the truth came out. During the congress, van Doesburg – even to a Dadaist so worthy of trust as Tzara – continued to maintain the fiction of the Dutch poet Bonset. When Tzara sought the latter's collaboration on the *Dadaglobe* project, van Doesburg told him: 'I'm pretty sure he'll accept... Bonset shares our ideas, but he's a funny chap, never showing himself.' At Weimar, he left (or invited) Arp and Tzara to write a letter to Bonset, on the back of which he added, not without humour: 'You see how your reputation for invisibility is attracting ever more followers.'[12]

Nonetheless, reading Tzara's letter, countersigned by Arp – the former was expert with heteronyms and word-plays – we may wonder how far he was actually taken in.

> My dear-dear Bonbon-set [a pun on bonbon, sweet], Our excellent friend van Doesburg, the Dutch bollock [a pun on caille/couille, quail/testicle] stuffed with swallow's muscles [see note 12], has told such amusing, wonderful things about you, all full of balls [lies?], that I am writing you with the ❤ from our ✋ W. Closets; and [we think] your (shall I say ...) ballsy criticisms – not to be confused with a woman's pickle and mustard [scolding/virulent rants?] – are an invention as important as life itself. Arp is here. He has worked out the balls. We thought of you, and bore your effigy in triumph among

the corpses of the present teachers. Love more than ever from your ALWAYS Tristan Tzara. Yours. Hans Arp.

Van Doesburg, laughing up his sleeve, was far less bored than he was in Düsseldorf.

Bonset was in fact not the only one of his heteronyms. Under the name of Aldo Camini, sometimes wrongly imagined to be to an Italian Futurist – the name sounds Italian – van Doesburg wrote several articles in *De Stijl*. He carefully concealed his assumed identities even from his close friends,[13] to the point that Mondrian himself was unaware that van Doesburg was I.K. Bonset. In a letter to J.J.P. Oud dated 1 August 1922, Mondrian complained of an overdose of Bonset in *De Stijl*, despite the interesting Dada element.[14]

Manifesto (against) proletarian art

It is a matter of debate whether the 'Proletarian Art Manifesto' should be linked with the major *First Russian Art Exhibtion* in Berlin in late 1922, which unleashed the Russian theory of non-objective art onto the European artistic scene.[15] The manifesto was countersigned by van Doesburg, Schwitters, Spengemann (friend and spokesman of Schwitters in Hanover), Arp and Tzara in The Hague in March 1923, at the moment when Schwitters and van Doesburg were about to undertake a joint tour of Holland with their Merz-Dada soirees. It is difficult to envisage any other reason why, at this point, it was necessary to issue a declaration on a subject that, if truth be told, was in no way new to the signatories. It is perhaps possible that they had got wind of the difficulties the recently formed Soviet state had placed in the way of exporting the Suprematist works of Malevich and his circle (difficulties smoothed over thanks to the diplomacy of Willi Münzenberg). There are few other obvious explanations for this blunt warning about the dangers of a 'Communist dictatorship'. The 'Proletarian Art Manifesto' affirmed once and for all, in striking and unmistakable terms, the freedom and autonomy of art. There could be no countenancing attempts at extraneous intervention in issues that were the sole concern of the plastic arts. Although differing in subject matter, it can be compared to 'The Call for Elementary Art' of October 1921. (Arp alone signed both documents.)

By an irony of history, it fell to Schwitters – who would have been judged too apolitical by Berlin's Dada Club in 1918 – to take the initiative, or at least undertake the editing of this brilliant and aggressive manifesto with its excoriation of the outmoded and bourgeois tastes of the working classes in matters of art. The document was a landmark, at once the endpoint of relations between the German avant-garde and the extreme left – the most virulent critics of the First International Dada Fair held in Berlin in June 1920 – and a warning against Soviet inclinations to subordinate art to politics.

Harbouring no illusions about the absence of workers' sympathy for a truly revolutionary art, the manifesto drew a picture of a disturbing situation from which the Nazis would 🐦

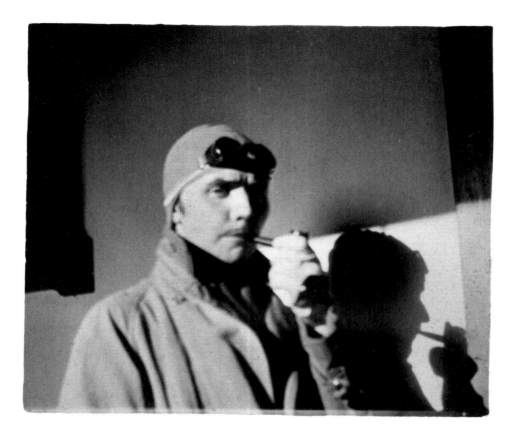

Fig.16
**Portrait of I.K. Bonset
(Nelly van Doesburg in disguise)** c.1927

later reap advantage when they came to vent their hatred of the avant-garde at exhibitions of, in their ideology, 'degenerate' art. Dada, then, walks a tightrope between the reactionary hostility that led Germany into a disastrous war and the incomprehension of the revolutionaries. Indeed, Dada's function was to show that the revolution meant a transformation of the aesthetic and psychological zeitgeist that would prevent the resulting social upheaval from becoming entangled with politics and a return to the old, narrow bourgeois ideals.

Mécano

The first yellow-covered issue of *Mécano*, ready in autumn 1921, only appeared the following February. It was the complete prototype of the modest Dada-Constructivist review and became the platform for van Doesburg's Dada contacts, welcoming poems by Arp, drawings by Charchoune, paintings by Man Ray, Hausmann's manifestos and collages, plus various poems and texts by Schwitters and articles by Tzara and Ribemont-Dessaignes. Constructivism was represented by a Georges Vantongerloo sculpture, reliefs by Moholy-Nagy and Röhl's drawings, amongst others. For Theo van Doesburg, *Mécano* was a metaphor for war: 'Dada is bankrupting Holland.'

As for Schwitters, in January 1923 he published the first issue of his review *Merz* under the title *Holland Dada*. Was this an attempt to take over from Mécano, whose last issue (nos.4–5) also appeared in 1923, announcing, as we have mentioned, that Dada was 'bankrupting Holland'? In any case, van Doesburg had reached the end of the line with *Mécano*, whose existence was

bound to be brief. Kurt Schwitters, on the other hand, would continue with *Merz* until 1932.

Van Doesburg had at his disposal in *De Stijl* a purely Constructivist review; *Mécano* satisfied his guilt-ridden, quasi-clandestine leanings toward Dada. The pseudonym he adopted – I.K. Bonset – probably derives from the Dutch 'Ik ben zot' (I am foolish). With regard to *Mécano*, I.K. Bonset was the literary editor and Theo van Doesburg the 'plastic mechanic'. *Mécano* was an innovative organ dedicated to derision and liberty, a fact clearly perceptible in Bonset's 'Manifesto 0,96013':

> I am nameless trunkless without importance
> I am all and nothing without sex without ambition
> I am a might-have-been Rasta a Bandit and isolated
> With my feet my pipe my cigar my gloves and my shoes
> I spit on all the young who have the imbecility to believe
> in love art or science I hate these three dimensions of
> the idiocy of vacuous worlds and precocious children
> with their celluloid craniums
> I spit on philosofers that bunch of syphologists
> I spit upon God-Jesus-Marx with their priests bamboo
> eunuchs more repulsive [still] like the little corpses of
> cats in the Dutch canals
> I spit on all the moralist urinals of Christianity
> I spit on the knickknack and papier-mâché artists who
> want to make a world of soft chocolate and perfumed shit
> I spit I spit on all the revolutionary Cockatoos with their
> nickel brains
> The World is a little
> Sperm Machine
> Life – a venereal disease
> All my prayers are dedicated to St Venerica

The Dada tour of the Low Countries

The idea of organising Dada soirees in the Low Countries took shape in the summer of 1922 when Vilmos Huszár was visiting Theo van Doesburg. Invitations were sent to Tzara, Ribemont-Dessaignes, Arp and Hausmann, who all declined. Van Doesburg therefore set up the tour with, beside himself, Kurt Schwitters, Vilmos Huszár and Nelly van Doesburg.

The success of the first evenings, in The Hague and Haarlem, encouraged van Doesburg to book a hall in Amsterdam. On 12 January, a group known as the Independents placed its facilities at his disposal, and a week later the capital had its first glimpse of Dada. This led van Doesburg to entrust the organisation of further performances to a theatre company which, however, appears to have defaulted on payments, so that the initial successes petered out. During the Dada evening at the Théâtre Luxor in Den Bosch on 25 January 1923, only Kurt Schwitters and Nelly van Doesburg were on stage. On 6 February they were in Rotterdam, but they were never to receive a penny in the future from the organisers of their tour.

Back in 1922, van Doesburg and Kurt Schwitters had

Fig.17
**L.J. Jordaan's article 'Dada in Amsterdam',
in 'Het Leven', 23 January 1923
Bottom left: Nelly van Doesburg, the
pianist, holding a copy of 'What is Dada?'**

designed a square poster for the tour headed 'Little Dada Evening'. It announced an introduction ('Dadasofie') by van Doesburg, the 'Glorious Revolution in Revon' by Schwitters, with some of the latter's abstract poetry or sound poems ('Urlaute', later published as *Ursonate*) and his 'Banalities'. There were to be synchronised mechanical dances by Vilmos Huszár and a *Dada Ragtime* by Erik Satie – a reprise of the *Ragtime* from the famous *Parade* of 1917 – performed with projections of Chinese Shadows using groups of mechanical silhouettes designed by Huszár. Vittorio Rieti had composed three marches for animals (Nelly van Doesburg at the piano), including funeral music for a sparrow and a crocodile. With typography in red and black, the characters are reminiscent of nothing so much as a wood engraving; yet this square poster turned out to be one of the highlights of Dada iconography.[16]

Though the *Ursonate* caused something of an uproar during the Dutch tour, the ground was prepared at Drachten. Schwitters was listened to attentively, and one report reads: 'Now we know what the Dadaists are after. When they take power, every magistrate will be given a kiddies' scooter to play chase in the courtroom. Teachers will wear a green wig and the pastor give lessons in preparing caramel bonbons. People will probably smoke newspaper writers. A bit like a zoo.'

In an article paying homage to van Doesburg after his premature death, Schwitters recalls: 'At the end of 1922, Theo van Doesburg invited the leading Dadaists to participate in a congress in Holland the next year. We underestimated the welcome we would receive there, with the result that I was the only Dadaist, Doesburg excepted, to appear at the trial evening at the Arts Circle in The Hague. Doesburg made a speech introducing Dadaism, and I was supposed to give an illustration of the movement. Standing on the stage in his tuxedo, with an elegant black dicky and a white bow tie, wearing his white powder and monocle, his features maintaining an imperturbable seriousness, Doesburg already seemed every inch the Dadaist, illustrating his own maxim, "Life is an extraordinary invention."'[17]

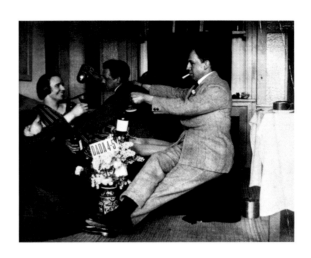

Fig.18
Helma Schwitters, Nelly van Doesburg, Kurt Schwitters and Theo van Doesburg in The Hague in January 1923 with Dada 4–5 between the flowers

Fig.19
Programme of Nelly van Doesburg's recital at the Lili Green Dance Institute, The Hague 4 April 1923

NOTES

1 *Mécano* (1922–3). Reprint with preface by Jan Leering, Vaduz 1979.

2 Käte Steinitz, 'Der Apossverlag und *Die Scheuche*', in *Kurt Schwitters: Erinnerungen aus den Jahren* 1918–1930, Zurich 1963 and 1965. Expanded American edition: *Kurt Schwitters: A Portrait from Life*, Berkeley and Los Angeles 1968.

3 Theo van Doesburg, *'Qu'est-ce que Dada?'*, with preface by Marc Dachy: 'Dr Doesburg, Mr Bonset le petit chien Dada', followed by letters from Theo van Doesburg to Tristan Tzara (1920–2) and from Kurt Schwitters, in March Dachy (ed.), *Van Doesburg*, Paris 1992 and 2005, p.39.

4 Published 1920–1 by Paul Eluard, new ed. with preface by Dominique Rabourdin, Paris 2008.

5 Theo van Doesburg, 'Revue der Avant-Garde', *Het Getij*, no.2, 1921. See Clément Pansaers, *Bar Nicanor, et autres textes dada*, ed. by Marc Dachy, Paris 1986.

6 See Evert van Straaten, *Jong Holland*, 3, 1987, 4, pp.24–31: 'Ze hebben Tzara bijna doodgeslagen! Theo van Doesburg als ooggetuige van de Soirée du Coeur à Barbe.' (They almost killed Tzara! Theo van Doesburg, witness of the Soirée du Cœur à Barbe.) The title of the text comes from a letter addressed by van Doesburg to Antony Kok. See Marc Dachy, *Archives Dada/Chronique*, Paris 2005, p.340.

7 'Aufruf zur Elementaren Kunst', *De Stijl*, no.10, vol.4, October 1921, p.156.

8 Postcard to Tzara, June 1922, in van Doesburg, *'Qu'est-ce que Dada?'*, p.48 (see note 3, above). The congress took place from 29 to 31 May 1922. See Bernd Finkeldey et al. (eds.), *Konstruktivistische internationale Schöpferische Arbeitsgemeinschaft 1922–1927*, exh. cat., Kunstsammlung Nordrhein-Westfalen, Düsseldorf 1992.

9 Letter from El Lissitzky (15 September 1925) to Sophie Küppers concerning Tzara's revelation of Man Ray's rayographs to Moholy-Nagy, in Krisztina Passuth, *Moholy-Nagy*, Paris 1984, p.388.

10 The project never materialised; see Passuth 1984, p.45.

11 László Moholy-Nagy, *Vision in Motion*, Chicago 1947, p.315.

12 Letter of 27 September 1922 in Evert van Straaten, *Theo van Doesburg 1883–1931: Een documentaire op basis van materiaal uit de schenking van Moorsel*, introduction by Wies van Moorsel and Jan Leering, Staatsuitgeverij, 's-Gravenhage 1983, p.110. The beginning of the letter contains a series of variations on the title of one of Arp's first verse collections, *The Swallow's Testicle*.

13 Van Doesburg was already a pseudonym for Christian Emil Marie Küpper.

14 *Piet Mondrian 1872–1944*, exh. cat., The Hague/Washington/New York, Milan 1994, p.42.

15 *The First Russian Show: A Commemoration*, exh. cat., Annely Juda Fine Art, London 1983. See also Bruce Altshuler et al., 'The First Russian Art Exhibition', in *Salon to Biennial: Exhibitions That Made Art History*, London 2008, pp.203–16.

16 Fragments were used by Schwitters in some of his collages, for example 29/35 (1929). See Karin Orchard and Isabel Schulz (eds.), *Kurt Schwitters, Catalogue raisonné II: 1923–1936*, Stuttgart 2003, p.268, and *Kurt Schwitters*, exh. cat., Ubu Gallery, New York 2003, no.9.

17 Kurt Schwitters, *De Stijl*, final issue, January 1932, the special issue commemorating van Doesburg. Schwitters recalls in a letter to Hausmann in 1946 (written in his broken English): 'In Utrecht they came onto the scene, presented me with a bunch of dry flowers and Bloody bones and started to read in our place, but Doesburgh throw them into the into the basement where the music uses to sit and the whole public did dada. It was as if the dadaistic spirit was went over into hundreds of people who remarked suddenly that they were human beings. Nelly lighted a cigarette and cried to the public, that as the public had become quite dada, we would now be the public. We sat down and regarded our flowers and nice bones.' In Jasia Reichardt, *Kurt Schwitters and Raoul Hausmann: Pin and the story of Pin*, London 1962, p.13.

THEO VAN DOESBURG & THE DESTRUCTION OF ARCHITECTURAL THEORY

HENK ENGEL

> I must agree with the Dadaist who has said that all our words have been used and therefore cannot express anything essential. Our whole Euclidian time-space depiction of the world has indeed become a parody and for lack of language, which can bring contrary concepts to rational expression, we are compelled to apply words from an out-of-date belief to new concepts. This also applies to architecture.
>
> —THEO VAN DOESBURG, 'ARCHITECTUUR-DIAGNOSE', 1924[1]

Theo van Doesburg's best-known publication is without any doubt *Principles of Neo-Plastic Art*, originally published in 1919. The fact that van Doesburg chose this text for publication in the Bauhaus Book series ensured that the text became known internationally. The Bauhaus publication, somewhat updated, appeared in book form in 1925, and was reprinted in 1966 and published in an English edition in 1969.[2]

The most important difference between the original Dutch edition and the German Bauhaus edition is the addition of illustrations. They were specially selected for the German publication. Among those illustrations is the drawn representation of what van Doesburg regarded as the basic elements of each of the plastic arts: painting, sculpture and architecture. In particular, the illustrated representation of the basic expression of architecture later became *the* archetypal image of De Stijl architecture: a composition of floating planes in space.[3]

To illustrate the basic elements of architecture van Doesburg chose one of his *Counter-Constructions*, in this case of the 'Maison Particulière' from 1923. The 'Maison Particulière' is one of the legendary series of three architectonic models that van Doesburg designed in 1923 with the Dutch architect Cornelis van Eesteren, for the first exhibition of De Stijl architecture at the Galerie de l'Effort Moderne in Paris (15 October to 15 November 1923). Afterwards, van Doesburg published 'Towards a Plastic Architecture', a treatise in the form of sixteen propositions regarded by many as his last word on this form of art.[4]

The *Counter-Construction* image shows a clear similarity to the appearance of the Rietveld-Schröder House, completed in 1924. The Rietveld-Schröder House has generally been regarded

as the most perfect realisation of De Stijl's ambition to create a 'four-dimensional' architecture. Van Doesburg's representation of it is seen as a paradigm. Linking this image to the text of *Principles of Neo-Plastic Art*, originally written in 1919, gives the impression that in that year van Doesburg already had in mind the idea of a four-dimensional architecture assembled from floating planes in space. He even went on to declare in the introduction to the German edition that the original manuscript was in fact written in 1917 and the first drafts made in 1915.[5]

As regards these dates we can only establish that the first publication in which van Doesburg actually tried to define the differences between the arts was a text from 1916: *The New Movement in Painting*. In it he defined the distinguishing characteristics of music, the art of building, and painting: 'As silence is for the musician, for the art of building the primary condition for composition is space, the fundamental principle for the painter is: the plane. The architect breaks the space by *relationships of measurement* realised in stone; the musician breaks the silence by *relationships of sound*; the painter breaks the plane by *relationships of colour and form*.'[6]

Reasserting these views in *Principles of Neo-Plastic Art*, van Doesburg distinguished an active element, *mass*, and a passive element, *space*, for the art of building: 'The master builder must express his aesthetic (and practical) experiences through relationships of mass to space.'[7] In the German edition (1925) several changes were introduced in this passage.[8] They form the prelude to a total turnaround in the caption to the drawn representation of the basic element of architecture. Most significantly, van Doesburg speaks about 'The elementary means of expression of architecture' – the means being in the plural – in contrast to painting and sculpture. The means of expression are then divided into positive elements: *line, plane, volume, space, time*, and negative elements: *void, material.*

Three years earlier, in 1922, van Doesburg published a first version of the drawn representation of the basic elements of the plastic arts. This served as an illustration in the text 'Monumentalnoe iskusstvo' published in the journal *Veshch, Gegenstand, Objet*, edited by El Lissitzky and Ilja Ehrenburg.[9] The first illustration of the basic element of the art of building shows a totally different image from the spatial composition of floating planes, namely a composition of five 'volumes' standing on a base.

Among Theo van Doesburg's effects there are three drawings that probably served as the foundation for the publication in *Veshch*. It is assumed that van Doesburg also used these drawings as a teaching aid for the De Stijl course which he gave in Weimar from 8 March to 8 July 1922.[10] The German translation of the *Principles of Neo-Plastic Art* also came out of his association with the Bauhaus.[11] Van Doesburg gives a more detailed description of the first illustration of the basic element of architecture in the article 'The Influence of De Stijl in Germany' of 1923. The results of several studies from the De Stijl course are illustrated in it. These were entitled: 'Studies for pure architectonic plasticism, originating from the base.'[12]

Given that van Doesburg reproduced the first illustrations of the basic elements of the plastic arts in 1923 twice more, in the journals *G* and *Architectura*, we can safely assume that these formed the starting point for his work on the Paris models.[13] For painting, the illustration consists of three planes in red, yellow and blue against a white background. The illustration for sculpture is an arrangement of five 'volumes', drawn in oblique projection, floating in space. The illustration for the art of building in fact corresponds to that for sculpture. The arrangement of volumes has only been rotated a quarter turn, so that it appears to be standing on a base. There is, however, a more remarkable difference. The volumes of sculpture throw shadows. The represention of the basic element of architecture is a shadowless image.

The main question to be answered in this short essay is, how do the two different illustrations of the basic element of architecture – the earlier a group of volumes on a base, the later floating planes in space – fit into the development of van Doesburg's discourse on architecture?

Compositions on the basis of a motif

Van Doesburg's enquiries into the basic elements of the plastic arts were, certainly during the early years of De Stijl, intended to facilitate collaboration between the arts, with the aim of arriving at a new *Gesamtkunstwerk* or total work of art. In order to bring that to fruition and to guarantee the equality of the different disciplines, the arts would have to arrive at a pure definition of their own means of expression.[14]

Mondrian, van der Leck and van Doesburg were convinced that in these terms, painting had advanced the furthest. According to Mondrian and van der Leck, little was to be expected from collaboration for the time being. For van Doesburg, on the other hand, his work with the architects J.J.P. Oud and Jan Wils was rightly an important stimulus for theoretical reflection. But it was not so much the concrete experiences that he had undergone in collaboration with these architects that proved enlightening. In his eyes they were often disappointing. It was his observation on their individual works that led to an ever sharper insight into the complexity of the aesthetic experience of architecture.

The effort that it cost van Doesburg to get his teeth into architecture is evident in his inconsistent use of concepts to denote its 'basic element'. By investigating the differences in the structuring of aesthetic experiences in the plastic arts he attempted to define the principles of architecture from different points of view. From the beginning an analogy with music fulfilled a special role. Music allowed the most effective expression of the dimension of time. 'Going forward in time (after each other)' is characteristic of music, he wrote in 'Notes on New Music', and added in a footnote: 'Herein it shows a similarity with architecture, particularly street architecture, and Oud's notion that harmonic balance will be realised only in the *cityscape as a whole* is therefore very logical.'[15]

This casual comment draws attention to the fact that repeated forms – motifs succeeding each other – which play

Fig.20
**THEO VAN DOESBURG
Counter-Composition
from 'Grundbetriffe der neuen
gestaltenden Kunst', Munich** 1925

such an important part in van Doesburg's early decorative work, must be seen as a first attempt at depicting time as a spatial phenomenon. In connection with work on his first stained glass windows, van Doesburg wrote his earliest statement on collaboration between the arts.[16] Carel Blotkamp has argued persuasively that the manner of abstraction developed by van Doesburg for his stained glass window designs formed the basis for his part in the development of Neoplasticist painting.[17] Given van Doesburg's commentary on J.J.P. Oud's design for a 'Housing complex on a Strandboulevard' in the first number of *De Stijl*, this procedure also seems to be the starting point for the development of his thoughts about architecture.[18]

Van Doesburg explained the procedure of creating an abstract image by means of the transfiguration of a cow (*Composition VIII*, probably 1918). In *Principles of Neo-Plastic Art* he describes the process of aesthetic reconstruction, in which the 'object observed' is transformed into the 'accents that indeed depict the object'.[19] Among the illustrations in the German edition there are also two drawings of a nude, which show a similar process of abstraction.[20] Carel Blotkamp sees these drawings as preliminary studies for the basic motif of the stained glass window *Composition II* from 1917.[21] The window is built up from a motif that is repeated six times by reflection and rotation and so provides a configuration of a higher order. This method of composition, based on the complex repetition of a motif, is not only a characteristic of van Doesburg's early stained glass windows, but also of his designs for tiled floors and colour schemes for interior and exterior woodwork made for various architects in the early phase of De Stijl.[22]

The special point about Blotkamp's discovery is that he has shown that both processes – the derivation of a motif via abstraction from nature, and composition on the basis of complex patterns of repetition – were originally linked together in van Doesburg's work. It is immediately clear that the process of creating an abstract image, in which the individuality of the object observed is 'nullified' by 'breaking it up' into 'its visual accents', had the aim of letting the object, the 'thing', be absorbed in a greater whole.[23] In the aesthetic reconstruction, the 'naturalism' is breached. The object falls apart. The boundaries are abolished. A field of untied

relationships opens up: relationships between parts of the object and parts of the environment, as in the painting of the cow, but also with parts of other objects, as in the complex repetition of the nude motif in the stained glass window *Composition II*.

Van Doesburg recognised the same process in Oud's design for a housing complex.[24] According to him the design showed 'the possibility of a monumental composition of built masses on pure plastic principles'. 'Division of space' in architecture is primarily determined by practical considerations, and then the aesthetic principles are articulated in the mass. First of all, 'space' is conceived in the sense of its 'usefulness': 'As the architect always remains bound to practice, his task is this: *to utilise the space and to express it in aesthetic relationships from within to without*. The exterior expresses the interior and both form a complete unity: the building.'[25]

As before, van Doesburg called the building 'a materialised space diagram'. For architects it came down to this: 'to convert the physical suitability as completely as possible aesthetically, without the former suffering under it.'[26] The mediating factor between practical considerations and aesthetics is the 'space diagram'. From this viewpoint, van Doesburg saw Oud's design as 'an excellent example of style-conscious building'. He went on: 'As the artist in his design concentrated his attention on what *happens within* and he has understood the unity of function in all houses, he could repeat a specific motif, both internally and externally. Not monotonous, but full of lively expression in the tension between horizontal and vertical relationships, we see this motif govern the whole.'[27]

The same principle is under discussion in van Doesburg's notes on Robert van 't Hoff's design for a newel post. According to van Doesburg, in this object the 'disturbing difference between "in front", "behind" and "from the side" [is] cancelled out, so to speak. Only in this way will the observer, walking round the work, observe a logical development of spaces and volumes.'[28] In contrast to Oud's row of houses, which is experienced by going along in a linear movement, one must go round the newel post in order to see it fully. In contrast to painting, the aesthetic experience of architecture and sculpture comes about through a succession of images. The repetition of a motif provides the connection between

Fig.21
THEO VAN DOESBURG
Basic Elements of Painting
Sculpture and Architecture 1922

these images, so that they are experienced as one work. The four sides of the newel post show this through variations on a single basic motif. Van Doesburg himself used this principle in his design for a 'Monument' in Leeuwarden (1918).

Rietveld's 'mute eloquence'
The similarities of aesthetic experience in architecture and in sculpture which van Doesburg observed in Oud's row of houses and van 't Hoff's newel post made it difficult to make an unambiguous distinction between the principles of both forms of art. This became even more problematic when van Doesburg got to see *De Leunstoel*, the armchair made by Gerrit Rietveld in 1918, still without colour and with small, integral sideboards. In a first note from 1919 he placed the armchair in the category of sculpture: 'To the question, what place sculpture will take in the new interior, this piece of furniture, through its *new form*, gives an answer: our chairs, tables, cupboards and other items for use, those are the (abstract-real) images in our interior of the future.'[29]

Six months later, Rietveld's pieces of furniture appear to have provoked a drastic change in the categorising and characterising of the plastic arts. Van Doesburg then writes: 'The real in modern works is characterised by the unintentional. The painter, the architect, the sculptor, as well as the cabinetmaker each realise for themselves that they are concerned with only one essential plastic value: harmony through relationship. And each gives expression to this one essential and universal [principle] of plastic art with his particular means. Thus one and the same, always in a different way. The painter: through relationships of colour. The sculptor: through relationships of volume. The architect: through relationships of enclosed spaces. The cabinetmaker: through unenclosed (i.e. open) relationships of space.'[30]

In this statement, van Doesburg defines a separate form of art specially for Rietveld's furniture, but he also gives a clear separation between architecture and sculpture for the first time. Architecture creates 'relationships of enclosed spaces'; sculpture creates 'relationships of volume'. The similarity between architecture and sculpture then lies in the fact that in architecture 'the relationship of enclosed spaces' within the building shows ☛

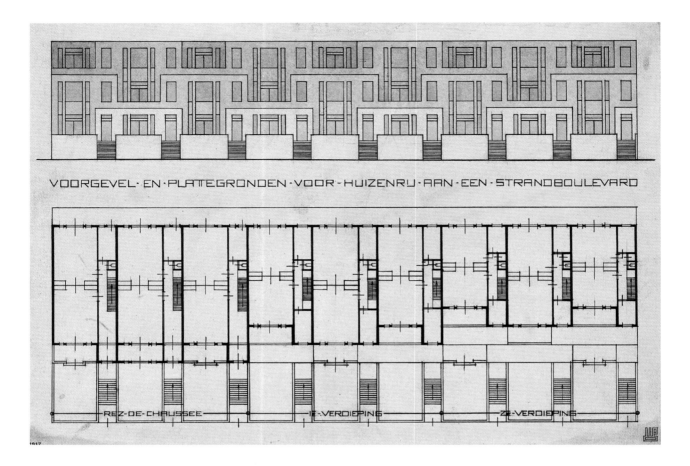

itself on the exterior in 'relationships of volume', that is, sculpture.

Rietveld's furniture does not simply take an intermediate position within this framework. The relationship of the exterior of architecture to the spaces that are found within can, in van Doesburg's terminology, be labelled symbolic. That is also precisely what H.P. Berlage did, when at about the same time he set out in *Beauty and Society* a whole compact principle of architecture.[31] This symbolism, which seems inherent to architecture, is not present in Rietveld's furniture simply because it is furniture. It creates 'unintentional', 'unenclosed (i.e. open) relationships of space'. This, according to van Doesburg, is not the lot of architecture.

Shortly afterwards, van Doesburg was to launch a frontal attack on Berlage's *Beauty and Society* and in a follow-up, in 'The Meaning of Mechanical Aesthetics for Architecture and the Other Disciplines', he spoke about 'a formless monumentality', an architecture that utterly excludes 'form and type'.[32] For the time being, however, van Doesburg was of the opinion that architecture was not in a position to bring into being a 'relationship of open space' purely by its own means. To achieve this, architecture needed painting.

Van Doesburg had already brought a painter's viewpoint to the work of architects such as Oud and Wils. He collaborated with Oud on the hall of the De Vonk House. Van Doesburg had written: 'Architecture gives constructional, that is, closed plastic expression... Painting gives open plastic expression by means of

Fig.22
J.J.P. OUD
'Huizen Complex Strandboulevard',
from 'De Stijl', vol.1, no.1, October 1917

Fig.23
THEO VAN DOESBURG
'Colour design for a room in Bart de Ligt's house in Katwijk aan Zee' 1919–20

flat colour.'[33] In this he followed van der Leck, who had stated in the first number of *De Stijl*: 'Modern painting is destruction of the naturalistic plastic expression as against the naturalistic plastic constructional character of architecture.'[34]

In this vision of the role of painting in architecture nothing had changed since van Doesburg's most recent work. His colour schemes for a room in the De Ligt House in Katwijk designed at the end of 1919, for which Rietveld provided the furniture, demonstrate the insight he had achieved into the 'basic element' of architecture, and as such can offer a key to his subsequent illustrations of his ideas.

Van Doesburg called the project for De Ligt 'a painting in three dimensions.[35] It involved painting the interior of an already existing room. In this case too van Doesburg was aware that all the walls and the ceiling could not be observed in one glance. He regarded the walls and ceiling as surface units that had to be brought into a harmonious unity by dividing them into colour accents. In this case, however, there is no clear linking motif to be found in the composition.[36]

For the design of the De Ligt room, van Doesburg made a drawing in which the walls are spread out from the ceiling towards different sides, so that the different surface units could be seen in their mutual relationship. He used a remarkable viewpoint. Rather than in interior view, he drew the room from outside, as if it were a glass box. The design had to be implemented as a mirror image.[37] In fact the procedure assumes that the given architecture has first been abstracted to an imaginary 'space diagram', a transparent geometric volume.

The shadowless image

The development of De Stijl and of van Doesburg's work as driving force and editor of the accompanying journal are generally divided into two periods: the early years (1917–22), and the later ones from 1922–32. Until, 1922 van Doesburg contributed applied or decorative art to architectural projects. From the time of the De Stijl course in Weimar, van Doesburg began to work as an architect himself. In Weimar he met the young Dutch architect Cornelis van Eesteren, with whom he was to collaborate closely during the following year in Paris on the models for exhibition in the Galerie de l'Effort Moderne.[38]

The Paris models were presented as a collaborative effort, and there has been much debate about van Doesburg's contribution. From a conceptual point of view, however, his part was certainly that of a painter. The application of colour in the models of 'Maison Particulière' and 'Maison d'Artiste' dominated the whole architectonic form.[39] (The model of 'Hôtel Particulière', which was made by Rietveld, was left without colour.)[40] At least as important, however, is the form of the drawings used by van Doesburg for the colour designs: the oblique forty-five-degree axonometric projection.

Van Doesburg called these drawings *Counter-Constructions*. Van Eesteren made the basic drawing for them, but van Doesburg is thought to have been influenced in this form ☛

Fig.24
ROBERT VAN 'T HOFF
Newel Post c. 1918
from 'De Stijl', vol.1, no.6, April 1918

of architectonic representation by El Lissitzky's *Prouns*. It is most likely that van Doesburg and El Lissitzky first met in January 1922 in Berlin, before the De Stijl course in Weimar.[41] It therefore goes without saying that the influence of Lissitzky's manner of spatial representation did not only apply in the *Counter-Constructions* of 1923. The oblique projections which van Doesburg used to illustrate the basic elements of sculpture and architecture in the beginning of 1922 demonstrate the first application of Lissitzky's manner of spatial representation.

The introduction of axonometric projection had for van Doesburg the allure of a radical upheaval in architecture. In contrast to central perspective, axonometric projection gives a spatial representation of the architectonic object without distorting its relationships of measurements. Yve-Alain Bois has made an extensive study of this subject.[42] From his analysis we can conclude that Lissitzky and van Doesburg have definitely given the axonometric projection an artistic dignity. Seen in the context of architectural theory, however, it cannot be regarded as a revolution. It is rather a rediscovery.

Leon Battista Alberti (1404–1472), who pioneered the development of architecture as an independent discipline, definitely rejected the use of perspective drawings in architecture. Alberti knew as no other did that, when the geometric principles of perspective were discovered, architecture had acquired a powerful instrument. He was even the first to put these principles in writing.[43] Yet in his treatise on architecture he rejected the use of the central perspective for the representation of architecture and also the reproduction of shadows. He regarded both as preeminently painting techniques to evoke an illusion of reality.[44] The architectural drawing, on the contrary, is a guide for the realisation of a depiction in reality.

The importance of the discovery of the geometric principle of perspective had, according to Alberti, quite different implications for architecture than for painting. The use of perspective in painting confirmed that, depending on place (chosen standpoint) and time (changing light and weather conditions), a building can provide innumerable images. Yet in every case it involves one and the same object.[45] In the architectonic design, the objective form must be determined, and set down in drawings.

In the first place an architectural drawing is a geometrical notation and an analytical instrument. It possesses a certain autonomy with respect to the form materialised. 'It is quite possible', according to Alberti, 'to project whole forms in the mind without any recourse to the material, by designating and determining a fixed orientation and conjunction for the various lines and angles.'[46] It is precisely this geometric representation of the architectonic object that van Doesburg finally regarded as the only principle of architecture. His first illustration of the basic element of architecture was exactly that: a shadowless image of transparent volumes.

It is in this connection that the axonometric representation proves its exceptional qualities. For Alberti, between the imaginative proposal and the illustrated notation of an architec-

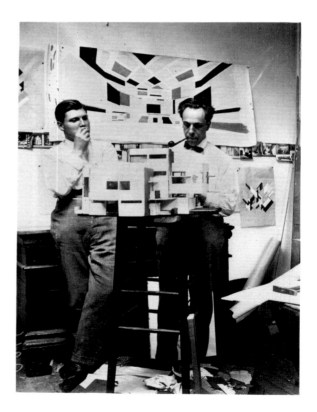

Fig.25
GERRIT RIETVELD
Armchair
from 'De Stijl', vol.2, no.11, September 1919

Fig.26
Cornelis van Eesteren and Theo van Doesburg work on the model of the 'Private House' in the Studio on Rue du Moulin Vert in Paris, 1923

Fig.27
**'Architects of the De Stijl Group'
exhibition at the Galerie de l'Effort
Moderne, Paris, 1923**

tonic object there gaped a deep chasm. According to him it was impossible to provide an adequate depiction of an architectonic representation in single drawing. That could only be assembled from several orthogonal projections, geometrically related to each other: plan, aspect and cross section. For a clear presentation of an architectonic design Alberti therefore had a preference for a tangible object, a scale model.[47] The axonometric drawing combines exactitude of relationships of measurement with spatial clarity, and furthermore has the advantage over the tangible scale model that the purely conceptual image of the architectonic representation emerges in plain terms.

Meanwhile van Doesburg's quest for the basic elements of the plastic arts had produced an almost comic result for the art of building. A pure definition of the principles was essential if the arts were to collaborate. But reducing the basic element of the art of building to a 'space diagram' had the result of removing all substance from its means of expression. For the art of building, traditionally mother of the arts, only a ghostly existence remains. From now on only sculpture, and above all painting, can provide architecture with a sensory reality. In the Paris models, this was all at stake.

In this context the choice of a *Counter-Construction* of 'Maison Particulière' to illustrate the means of expression of architecture in the Bauhaus edition of *Principles of Neo-Plastic Art* was logical. The *Counter-Construction* does not represent the basic element of the art of building. The floating planes in space show its destruction and at the same time its aesthetic reconstruction in sculptural accents, carriers of colour and non-colour.

After completion of the Paris models the 'unenclosed (i.e. open) spatial relationship' which van Doesburg had in 1920 reserved especially for Rietveld's furniture was declared to be the rule of 'architecture as the synthesis of neo-plasticism'.[48] With that he introduced a subtle difference in meaning between the concepts of 'the art of building' and 'architecture', which in current usage are synonymous. The final proposition of 'Towards a Plastic Architecture' states: 'In the new architecture the art of building is understood as *only one part*; by including all the arts, in their most elementary appearance, the new architecture manifests its very essence.'[49]

NOTES

1 Theo van Doesburg, 'Architectuur-Diagnose', in *Architectura*, no.15, 17 May 1924, pp.61–3. Reprinted in Theo van Doesburg, *Naar een beeldende architectuur*, Nijmegen 1983 (afterwards van Doesburg 1983(I)), pp.99–103.

2 Theo van Doesburg, 'Grondbegrippen van de nieuwe beeldende kunst', in *Tijdschrift voor Wijsbegeerte*, vol.13, no.1, 1919, pp.30–49, and no.2, pp.169–88. Reprinted in Theo van Doesburg, *Grondbegrippen van de nieuwe beeldende kunst*, Nijmegen 1983 (afterwards van Doesburg 1983(II)). German edition, no.6 in the Bauhaus Book series edited by Walter Gropius and László Moholy-Nagy: Theo van Doesburg, *Grundbegriffe der neuen gestaltenden Kunst*, Munich 1925. Reissued in the series *Neue Bauhausbücher*, Mainz 1966. English edition: Theo van Doesburg, *Principles of Neo-Plastic Art*, London 1969.

3 Theo van Doesburg, *Grundbegriffe der neuen gestaltenden Kunst*, Mainz 1966, fig.3. For an overview of the realisation of the German edition of 1925, see Cees Boekraad, 'Over de *Grondbegrippen*', in van Doesburg 1983(II), pp.85–99.

4 Theo van Doesburg, 'Tot een beeldende architectuur', in *De Stijl*, vol.6, nos.6/7, 1924, pp.78–83. Also appeared as 'De nieuwe architectuur', in *Bouwkundig weekblad*, no.20, 17 May 1924, pp.200–4. Reprinted in van Doesburg 1983(I), pp.91–8 (see note 1, above). After that van Doesburg wrote a great deal more about architecture. His contributions to the journal *Bouwbedrijf*, edited by the Delft Professor J.G. Wattjes, Jan Wils and P.W. Scharro are particularly noted. From 1924 until his death in 1931 van Doesburg provided the feature 'Architectuurvernieuwingen in het buitenland'. This series of articles offered the most extensive overview of the developments in modern architecture at the time. The articles have been published again with an introduction by Cees Boekraad: Theo van Doesburg, *De Stijl en de Europese architectuur*, Nijmegen 1986. English edition: Theo van Doesburg, *On European Architecture: Complete Essays from Het Bouwbedrijf 1924–1931*, Basel, Berlin and Boston 1990. The developments after 1924 lie outside the scope of this essay.

5 Van Doesburg 1966, p.4.

6 Theo van Doesburg, *De nieuwe beweging in de schilderkunst*, Delft 1917. Reprinted in Theo van Doesburg, *De nieuwe beweging in de schilderkunst (en andere opstellen)*, Amsterdam 1983, p.42. Van Doesburg dated this text 1916.

7 Van Doesburg 1983(II), p.22 (see note 2).

8 Ibid., p.78: Before 'massa', added 'Fläche'. Deleted: '(en practische). In place of 'from mass to space': 'von Flächen und Massen zu Innenräumen und zum Raum'. See also van Doesburg 1966, p.15.

9 Theo van Doesburg, 'Monumentalnoe iskusstvo', in *Veshch, Gegenstand, Objet*, nos.1/2, March–April 1922, pp.14–15. The text is the Russian translation of Theo van Doesburg, 'Aanteekeningen over monumentale kunst. Naar aanleiding van twee bouwfragmenten (Halle in vacantiehuis te Noordwijkerhout. Bijlage I)', in *De Stijl*, vol.2, no.1, 1918, pp.10–12. See Evert van Straaten, *Klare en lichte, gesloten ruimte geaccentueerd door diepe pure kleuren. Het werk van Theo van Doesburg in de architectuur*, dissertation, Amsterdam Vrije Universiteit 1992, p.86.

10 Els Hoek (ed.), *Theo van Doesburg: Oeuvre Catalogus*, Utrecht/Otterlo Centraal Museum/ Kröller-Müller Museum 2000, nos.674.I, 674. II, 674.III, pp.311–12.

11 Van Doesburg 1966, p.4.

12 Theo van Doesburg, 'De invloed van de Stijlbeweging in Duitsland', in *Bouwkundig Weekblad*, no.7, 17 February 1923, pp.80–3. Reprinted in Theo van Doesburg, *Naar een beeldende architectuur*, Nijmegen 1983, pp.73–80.

13 Theo van Doesburg, 'Zur Elementaren Gestaltung', in *G*, no.1, July 1923. Theo van Doesburg, 'Voorwaarden tot een nieuwe architectuur', in *Architectura*, no.27, 11 August 1923, pp.163–5. Reprinted in van Doesburg 1983(I), pp.86–90. In the different illustrations the position of the images varies. In *Architectura* one of the three pictures is also missing, namely the one for the principle of architecture.

14 P. Mondriaan, 'De Nieuwe Beelding in de Schilderkunst', in *De Stijl*, vol.1, no.1, 1917, p.5. Theo van Doesburg, *Drie voordrachten over de nieuwe beeldende kunst*, Amsterdam 1919. Reprinted in Theo van Doesburg, *De nieuwe beweging in de schilderkunst (en andere opstellen)*, Amsterdam 1983, p.110. See also van Doesburg 1918 (see note 9).

15 Theo van Doesburg, 'Aanteekeningen over de nieuwe muziek', in *De Stijl*, vol.3, no.1, 1919, pp.5–6. Van Doesburg refers to J.J.P. Oud, 'Architectonische beschouwing. A. Massabouw en straatarchitectuur', in *De Stijl*, vol.2, no.7, 1919, p.82.

16 Theo van Doesburg, 'Het esthetisch beginsel der moderne beeldende kunst', in *Drie voordrachten over de nieuwe beeldende kunst*, Amsterdam 1919. Reprinted in Theo van Doesburg, *De nieuwe beweging in de schilderkunst (en andere opstellen)*, Amsterdam 1983, p.77. Van Doesburg dated this text 1916.

17 Carel Blotkamp, 'Theo van Doesburg', in Carel Blotkamp (ed.), *De beginjaren van De Stijl 1917–1922*, Utrecht 1982, p.28.

18 Henk Engel, 'Van huis tot woning. Een typologische analyse van enkele woningbouwontwerpen van J.J.P. Oud', in *Plan*, 1981, no.9, pp.34–9. Henk Engel/Jan de Heer, 'Stadsbeeld en massawoningbouw', in *O. ontwerp, onderzoek, onderwijs*, no.7, Spring 1984,

pp.15–18. English translation: Henk Engel/ Jan de Heer, 'Cityscape and Mass Housing', in *Oase*, no.75, 2008, pp.44–55.

19 Van Doesburg 1983(II), pp.23–6 and figs.5–8 (see note 2, above).

20 Ibid., figs.14 and 15.

21 Blotkamp 1982, p.26.

22 Nancy Troy, *The De Stijl Environment*, Cambridge MA and London 1983, especially chapters 1 and 3. Allen Doig, *Theo van Doesburg: Painting into Architecture, Theory into Practice*, Cambridge 1986, especially chapter 2.

23 There has often been discussion of the relationship of Neoplasticism to the idealistic philosophy of Plato. In 'The architecture of De Stijl and the western philosophical tradition' (*Wonen/TABK*, nos.15–16, 1982, pp.45–56) Allen Doig has also included Kant to make it clear that De Stijl artists, by abstracting from the world of phenomena of the exterior appearances, wanted to provide direct access to the world of pure knowledge of ideas, the numinous world of the 'thing-in-itself'. So the armchair that Gerrit Rietveld designed in 1918, was to make visible the 'essence', the 'idea', the chair as 'thing-in-itself'. Doig immediately remarks that for both Plato as well as Kant this belongs to impossibilities, given that for these philosophers overstepping the boundary between the world of appearance and the world of ideas, between the phenomenal and the numinous, lies outside the reach of the sensory experience. However this may be, for Mondrian and van Doesburg the 'true reality' is not concealed in things but in their mutual relationships. Only if their 'thingness', their 'identity' is abstracted, do those reveal themselves in purity.

24 Ed Taverne, Cor Wagenaar, Martien de Vletter (eds.), *J.J.P. Oud 1890-1963: Compleet werk*, Rotterdam 2001, pp.145–8.

25 Theo van Doesburg, 'Bij de bijlagen. II. J.J.P. Oud. Ontwerp voor een complex huizen voor een boulevard', in *De Stijl*, vol.1, no.1, October 1917, p.11–12.

26 See note 16, p.77.

27 See note 25.

28 Theo van Doesburg, 'Bij bijlage XI. RuimtePlastische binnenarchitectuur', in *De Stijl*, vol.1, no.6, 1918, pp.71–2.

29 Theo van Doesburg, 'Aanteekeningen bij een leunstoel van Rietveld', in *De Stijl*, vol.2, no.11, 1919.

30 Theo van Doesburg, 'Aanteekeningen bij bijlagen VI en VII', in *De Stijl*, vol.3, no.5, 1920, p.46.

31 Dr H.P. Berlage, *Schoonheid en samenleving*, Rotterdam 1919, pp.10–11 and 39–41.

32 Theo van Doesburg, 'De taak van de nieuwe architectuur', in *Bouwkundig Weekblad*, no.50, 11 December 1920, pp.278–80, and no.51, 18 December 1920 pp.281–5, and no. 2, 8 January 1921, pp.8–10. Theo van Doesburg, 'De betekenis der mechanische

esthetiek voor de architectuur en de andere vakken', in *Bouwkundig Weekblad*, no.25, 18 June, pp.164–66, no.28, 9 July, pp.179–83 and no.33, 13 August, pp.219–21. Reprint of both series of articles in van Doesburg 1983(I). Jan de Heer, 'Stijl en woningtype. Berlage's woningbouw', in Sergio Polano (ed.), *Hendrik Petrus Berlage. Het complete werk*, Alphen aan den Rijn 1987, pp.70–1.

33 Theo van Doesburg, *De Stijl*, see note 9.

34 Bart van der Leck, 'De plaats van het moderne schilderen in de architectuur', in *De Stijl*, vol.1, no.1, 1917, pp.6–7.

35 Letter from van Doesburg to Oud, 23 December 1919, quoted in Evert van Straten, *Theo van Doesburg 1883–1931. Een documentatie op basis van materiaal uit de schenking Van Moorsel*, 's Gravenhage 1983, p.90. Theo van Doesburg, 'Proeve van kleurencompositie in intérieur (1919). Meubelen van G. Rietveld. Bijlage XIV', 'Aanteekening bij de bijlage', in *De Stijl*, vol.3, no.12, 1920, p.103.

36 Van Straaten 1992, pp.57–8 (see note 9). In a letter of 14 July 1917 to Antony Kok van Doesburg wrote: 'I still have a great gap in my work, that luckily I am aware of myself. When I have a motif in the handling I keep it too much the same. In music, especially in Bach, the motif is constantly being treated in a different way.' Quoted in Blotkamp 1982, p.27 (see note 17).

37 Hoek 2000, no.642a, p.262 (see note 10). Van Doesburg used this kind of drawing later too for the colour designs for Bloemenkamer, 1924–5, and for the Ciné-dancing at the Aubette building, 1926–8.

38 Manfred Bock/Vincent van Rossum/Kees Somer, *Bouwkunst, Stijl, Stedenbouw. Van Eesteren en de avantgarde*, Rotterdam/The Hague 2001, pp.71–80.

39 On the use of colour in the modern architecture of the 1920s and the position of De Stijl in it, see Henk Engel, 'Stijl en expressie', in Jan de Heer (ed.), *Kleur en Architectuur*, Rotterdam 1986, pp.63–74.

40 Much attention has been paid in the literature to the realisation of the Paris models and the van Doesburg and van Eesteren's respective input. For the most recent insights, see note 36, pp.153–95.

41 Van Straaten 1983, p.103 (see note 35). El Lissitzky arrived in Berlin around the turn of 1921–2. Together with Ilja Ehrenburg he took over the editorship of the journal *Veshch, Gegenstand, Objet*. As stated earlier, it published Theo van Doesburg's 'Monumentalnoe iskusstvo', with the first drawings of the basic elements of the plastic arts (see note 9). In June 1922 van Doesburg published 'Proun' by El Lissitzky in *De Stijl*, vol.5, no.6, June 1922, pp.81–5.

42 Yve-Alain Bois, 'Vormveranderingen van de axonometrie / Metamorphoses of axonometry', in C. Boekraad, F. Bool, H. Henkels, *Het Nieuwe Bouwen. De Stijl. De Nieuwe Beelding in de architectuur / Neo-Plasticism in architecture*, Delft/The Hague 1983, pp.146–61. See also Yve-Alain Bois, 'van - ∞ tot 0 tot +∞. Axonometrie, Lissitzky's mathematisch paradigma', in *1890–1941, El Lissitzky, architect, schilder, fotograaf, typograaf*, Catalogus Stedelijk van Abbemuseum, Eindhoven 1990, pp.27–34.

43 Leon Battista Alberti, *Della pittura libri tre*, geschreven in 1435–1436. Dutch translation: Leon Battista Alberti, *Over de schilderkunst*, Amsterdam 1996, introduction by C.A. van Eck en R. Zwijnenburg.

44 Leon Battista Alberti, *De re aedificatoria*, book II, chapter 1. English edition: Leon Battista Alberti, *On the Art of Building in Ten Books*. Translated by Josseph Rykwert, Neil Leach, Robert Tavernor, Cambridge MA and London 1994, p.35.

45 This conclusion is brought to the fore in the most penetrating way in William M. Ivins Jr., *On the Rationalization of Sight. With an Examination of Three Renaissance Texts on Perspective*, New York 1973 (1938), pp.9–10. 'Either the exterior relations of objects, such as their forms for visual awareness, change with their shifts in location, or else their interior relations do. If the latter were the case there could be neither homogeneity of space nor uniformity of nature, and science and technology as now conceived would necessarily cease to exist. Thus perspective, because of its logical recognition of internal invariants through all the transformations produced by changes in spatial location, may be regarded as the application to pictorial purposes of the two basic assumptions underlying the great scientific generalizations, or laws of nature. Alberti's perspective scheme of 1435–1436 marked the effectual beginning of the substitution of visual for tactile space awareness...'

46 See note 44, p.7.

47 Ibid., pp.33–4.

48 See note 4, pp.78–3. Proposition 9 and proposition 16.

49 Ibid., p.82.

A UNIVERSAL LANGUAGE FOR THE ARTS: INTERDISCIPLINARITY AS A PRACTICE, FILM AS A MODEL

GLADYS FABRE

Theo van Doesburg comes across not so much as an artist in the strict sense but as an instigator, or even a propagandist, with a self-appointed task of changing the world. The purpose of this essay is to define van Doesburg's originality and contribution in the context of the De Stijl movement and the European art scene over the period 1917 to 1931. Some have defended the idea that for avant-garde artists a work of art itself counts for less than its ability to promote new visions.[1] For them, art is inseparable from life and social issues. Indeed, the influence of van Doesburg derives as much from the theoretical impact of his philosophy on the international art scene and the expansion of his creative processes in order to transcend interdisciplinary divides as from his achievements in painting, architecture, design, poetry and typography.

His aesthetic principle, the motivating force of his vitality, can be summed up as the urge to create an international style: a collective, simple system of aesthetics based on a common denominator – the horizontal and vertical line, with, as a standard form, the square or the rectangle. On such a basis, this elementary language can be qualified as universal, that is to say, comprehensible to all and applicable to all disciplines. Mondrian, in his essay 'The New Plastic in Painting', defines this new style as 'the pure creation of the human spirit... expressed as pure aesthetic relationships manifested in abstract form'.[2] In addition, van Doesburg intended to connect this abstract universal language to new sciences and techniques. In this way, abstract (or pure) film became a modernist model of that new approach.

This passion for abstraction had various origins. Some were spiritual and philosophical, linked, for instance, with the concept of the fourth dimension, time. Others were of a formal, synthesised nature, relating to music as an art dependent upon elements of time – a prime example of abstraction. Still others had a social dimension, in the will to express the totality of the modernist spirit and to labour on behalf of the masses. This multiplicity of aims explains the involvement of the abstract in all disciplines in the shape of a deconstruction of the past and a synthetic reconstruction of the present. The Dadaists employed it as a weapon to undermine traditional bourgeois values, such as

the hierarchy of the arts and extra-pictorial significance – a good example being the work of Sophie Taeuber-Arp. Thus the collaboration between Dada and Constructivism was made possible by the galvanising shock of the abstract – destroy in order to build. 'The Call to Elementary Art', signed in Berlin in October 1921 by Raoul Hausmann, Hans Arp, Jean Pougny and Moholy-Nagy, confirms the collective nature of this vision.[3]

An interdisciplinary approach before 1920

One of the keynotes of van Doesburg's creativity was his ability to move effortlessly from one discipline to another; from stained glass or architecture to painting, poetry, music, typography or art criticism, as he strove to deconstruct the specifics of an art in order to broaden its outlook or, on the other hand, utilise those original specifics to enrich a different field. This was his method before 1920, when he designed stained glass using the equivalents of musical rhythm and composition: point, counterpoint, repetition, dissonance and harmony are the leitmotifs of *Composition IV* (no.20) and a 1917 glass mosaic for a chimney breast. In 1930 he summarised his methods as follows: 'In many of my 1916 and 1918 designs and in the windows installed in modern buildings, influenced by Bach's preludes and fugues, I followed the same method, making sure, however, that by using the motif freely, the unity of the whole was not interrupted by either the repetition or the leaded strips and iron supports. I included these in the motif or in the composition and as far as the proportion was concerned based this on the requisite subdivision of the windows.'[4] Avant-garde composers soon displaced Bach: particularly van Domselaer, who transposed the horizontal/vertical duality of Neoplasticism into music – but also Schönberg, Satie, Rieti, Hauer, Honegger, Poulenc, Milhaud and Antheil, not to mention less well known figures like Ribemont-Dessaignes and the undistinguished Herwarth Walden. Their work was played at a variety of concerts, Dadaist performances, musical soirées or private gatherings.

The use of standard elements like brick or tiles and the compositional methods of the decorative arts would transform van Doesburg's painting and his notions of architectural space. His design for the pavement of the De Vonk House (no.53) – using a black-and-white maze-like pattern contrasting with its ochre 'background' – was to recur pictorially in the form of a floating grill structuring *Composition XII in Black and White* and *Composition XIII* (1918). Moreover, the mock-chaotic dynamism of the pavement is exploited to thrust back the interior boundaries (of the walls) and 'neutralise gravity', in the artist's own words. This innovation is generally considered the first expression of an impulse to recreate the fourth dimension in architecture.

After introducing musical equivalences into pictorial composition and de-compartmentalising architecture, van Doesburg's next aims were to visualise sound in poetry and express words and letters in concrete form. Following Filippo Marinetti's 1912 publication of 'Zang Tumb Tumb' – a sound poem consisting of 'words-in-freedom' – van Doesburg adopted the Dadaist

pseudonym 'I.K. Bonset' and inaugurated a form of verse utilising capital letters and variations in font and texture in an attempt to give an optical expression to sonority and rhythm or fix the reader's attention on a key word. Eventually, in 1921, he ended up with a minimalist form of typography (*Letterklankbeelden* or 'letter sound images', fig.28) – a prophetic development, as it transformed abstraction into concrete art, a mutation later undergone by painting. Nonetheless, his poetical experiments differed from those of Futurism in his use of geometrical arrangements and his taste for non-sense, which he shared with the Dadaists.

A new synthesis: The scroll-pictures of Eggeling and Richter

The work of van Doesburg and others before 1920 represents an effort to free the arts from their traditional boundaries. The experiments of Viking Eggeling, a Swede, and the German Hans Richter were to alter the direction of Neoplasticism, just as van Doesburg was to influence their work and, through it, all the arts. The friends, who met within the Zurich Dadaist circle, decided in 1919 to collaborate at Richter's studio in Klein Koelzig. In Zurich, Eggeling strove to elaborate a syntax of basic forms which he named '*basso continuo* in painting', a study of their interrelationship that based its vocabulary – abstract and therefore universal – on the language of music. In 1920 their artistic intentions and social objectives were formulated in a text entitled *Universelle Sprache* (Universal Language). During 1919 and 1920 they decided to adopt the Japanese *makimono* format, painting on a scroll of material which, when unrolled, would reveal sequences of forms and colours. The results included Richter's *Preludium* (late 1919, fig.33 bottom), *Fugue* (1920), *Rhythmus 23* and *Orchestration der Farbe* (Orchestration of Colours, 1923) and Eggeling's *Horizontal-Vertical Mass* (late 1919, fig.33 top) and *Diagonal Symphony* (1920, fig.32). 'The next step was inevitable – film, the logical medium to extend this dynamic potential into actual kinetic movement.'[5] Having no experience of cinematic processes and faced with problems of funding, Eggeling and Richter set about seeking sponsors and sympathetic critics to whom they would send their so-called 'scores' on a scroll, together with a copy of *Universal Language*.

It was apparently at this stage that van Doesburg arrived in Klein Koelzig, as his account in *De Stijl* (June 21) does not mention films, only scrolls: 'When the artists Richter and Eggeling turned to *De Stijl* to realise this concept, I hastened to visit them in Klein Koelzig because I felt an artistic kinship there and I wanted to get to know their work and progress. Although they had not yet attained extreme purification of form, it seemed that they had found the general basis for dynamic plasticism and also had researched the possibilities for its technical realisation for more than a year with good results at UFA [Universal-Film A.G.] in Berlin. Drawings were needed for the mechanical realisation of the composition. Those consisted of long scrolls, or "scores", upon which the compositional development was shown in sequence and such a way that the various stages in between ▰

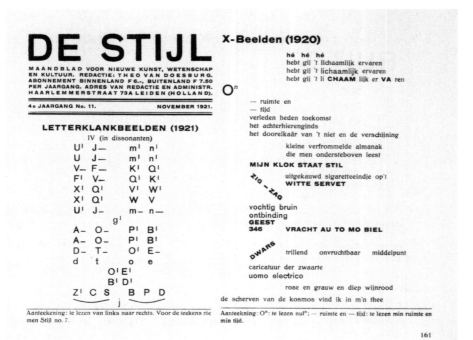

Fig.28
Typographic poems by I.K.Bonset (Theo van Doesburg) from 'De Stijl', vol.4, no.11, November 1921

were developed in a mechanical way. Still, these carefully worked out drawings in black, white and grey, proved to be insufficiently exact, in spite of their precision. The enormous enlargement by lens in a field of light, some 10 x 6 m, betrays each weakness of the human hand. And as it is not the hand any more but the spirit which makes art, and as the new spirit demands the greatest possible exactitude of expression, only the machine in its extreme perfection can realise the higher demands of creating spirit. This will not be difficult as they are assisted by the best talents in the technical and scientific field (for example, by Einstein).'[6]

The most striking features of this statement are van Doesburg's insistence on mechanical methods and the reference to Einstein, whose patronage the pair had solicited. This suggests that both van Doesburg and Richter, even at this stage, were already interested in science and the Theory of Relativity. But before examining this further and evaluating the influence of the 'scores', we need to emphasise two important facts. First, the technical problems encountered by the UFA engineer led Richter – but not Eggeling – to abandon the scroll as the framework for his films. As a result, *Rhythmus 21* (fig.28) has nothing in common with the earlier scores *Preludium* or *Fugue*. Richter composed his film directly on the screen just as he would a painting on canvas, using a formula of squares and rectangles and insisting on strictly orchestrated time sequences akin to those in music. In fact, *Rhythmus 21* conforms to the universe of forms adopted by van Doesburg: it employs an elementary vocabulary limited to the straight line, the square and the rectangle. The shapes grow larger or smaller, mimicking the zooming in and out of a lens; they draw together or apart, create contrasts of size or black against white, or overlap each other in a kind of grey

transparency producing a trompe-l'oeil illusion of depth. In short, the impression is of viewing an animated version of Malevich's *Black Square on a White Ground*,[7] or the decomposition and recomposition of a Neoplasticist painting. 'The square is the symbol of a new humanity. It is like the cross of the first Christians', van Doesburg had declared at Klein Koelzig.[8]

The second point of note is that these abstract films were rarely projected before late 1924. The first showing of Richter's *Rhythmus 21* was in Berlin in 1921 – briefly anticipated by Walter Ruttmann's *Opus 1*. The running time was between one and three minutes, and it was revised and extended in 1923 as *Rhythmus 23* and again in 1925 as *Rhythmus 25* (now lost). In Paris, it was shown during one of van Doesburg's lectures and during Tzara's infamous *Soirée du Coeur à Barbe* at the Théâtre Michel on 23 July 1923 along with Man Ray's *Return to Reason* (1923) and Charles Sheeler's *La Fumée de New York* (also known as *New York the Magnificent*). The musical accompaniment for the latter was by Jacob van Domselaer and Vittorio Rieti, performed on the piano by Nelly van Doesburg. Before 1923, therefore, very few members of the public had seen Richter's film – and no-one had seen Eggeling's. Eggeling, still persisting with his scrolls, had to wait until 1924, when Erna Niemeyer – the future wife of Soupault – dedicated herself to animating his film. As it happened, the first public projection of Eggeling's *Diagonal Symphony* (fig.30) took place in Berlin in 1925, a few days before his death.

Accordingly, the influence of the abstract film as the model of a basic and universal language and an expression of space-time was felt mostly in the texts and graphic 'scores' reproduced in journals. First and foremost among these was *De Stijl*.[9] Its presentation, which featured a page-by-page progres-

Fig.29
HANS RICHTER
Rhythmus 21 1921

Fig.30
VIKING EGGELING
Diagonal Symphony 1921

sion of forms imitating a time sequence, sparked an artistic revolution: now, a page of typography, a poem, a book, a publicity or propaganda poster could be designed or composed as a spatio-temporal entity – asymmetric, dynamic in its use of colour, precise in execution, clear, legible by all, and using geometry as a kind of visual Esperanto. This revolution was orchestrated by the International Fraktion der Konstruktivisten (International Faction of Constructivist Artists) led by Moholy-Nagy, El Lissitzky, van Doesburg, Richter, Karel Maes and Max Burchartz, active as early as May 1922 at the first International Congress of Progressive Artists in Düsseldorf. *De Stijl*'s promotion of abstract cinema had been immediately taken up by the Hungarian publication *MA* (August 1921), its Russian counterpart *Veshch, Gegenstand, Objet* (1922, fig.12) and in Germany by *G* (1923–6, fig.13). The European avant-garde press, including *Pasmo*, *Red* and *Die Form*, then followed suit.

Mechanical and Typographic Rhythms

Futurists, Dadaists, Constructivists and the entire international avant-garde made the machine their hobby-horse, vaunting its functionalism, its qualities of speed and precision, its rhythmical cadences and its capacity to destroy traditional art – all of which van Doesburg applauded in the January 1922 issue of his Dada-Constructivist review *Mécano* (no.68). Shortly after Enrico Prampolini published an article in *De Stijl* on the aesthetics of the machine, van Doesburg, in homage to Futurism, reproduced an image of an impressive machine with the caption 'Plastique Moderne de l'Esprit Italien' ('The new Italian spirit', a wry reference to Le Corbusier's l'Esprit Nouveau). Ivo Pannaggi and Vinicio Paladini issued their 'Manifesto dell' arte meccanica futurista' in *Lacerba* (October 1922), repeated in *Noi* (1923) with Prampolini's signature added.

The aesthetics of the machine, both in form and conception, therefore became a prime consideration for numerous artists, such as Moholy-Nagy with his *Telephonbilder* (*Telephone Pictures*, no.115),[10] Henryk Berlewi (the *Mechano-Fakturen*), Huszár (his monotypes, see no.114), Christian Schad, Nicolaas Werkmann, Karel Teige and Petro Saga (typo-compositions, see figs.10, 31). For van Doesburg, abstract film became the virtual model of an ultra-modern mechanical art. Richter foresaw the major role his and Eggeling's experiments would play. In the July 1921 issue of *De Stijl*, he proclaimed the aesthetic principles of an elementary language, indicating how these could be built up into a complete work of art, principles that would hold good for painting, music, speech, dance, architecture and drama. 'There can be little doubt that the cinema, as a new field of exploration for plastic artists, will soon be besieged by the productions of the fine arts. So it is all the more essential to point out that a simple succession of forms is, in itself, meaningless, and that art may not be the best means... of providing that meaning. With this new art, it is absolutely necessary to have univocal elements. Without them, we could easily give birth to a pleasant enough amusement, but never a language.'[11]

This simple succession of geometric forms al-

lied to what was termed mechanical execution – because it was smooth and precise, or involved mere stencilling – would be exploited by the Polish artist Henryk Berlewi. In 1923 he exhibited at the *Greater Berlin Art Exhibition* as a member of the November Group, as did Eggeling, El Lissitzky, van Doesburg, Moholy-Nagy, Richter and Hausmann. A subscriber to *De Stijl*, he was fascinated by the current experiments with film and optophonics. The commentary accompanying a reproduction of his *Mechano-Faktura. Contrasting Elements* 1924 (fig.34) reveals his multidisciplinary sources. 'The reading of this two part graphic invention should begin with the thin line at the bottom right. It increases in volume as it goes higher, grows stronger and swells in a crescendo into a thick bar. When the spectator (or listener) has reached the summit of this xylophone-like ascent, he descends by following the series of five squares. He then begins to move horizontally by advancing from the small black dot to the large one. From there the eye goes right, following the graduated vertical bars. The circles form the finale.'[12] Berlewi also emphasised the typographical or prefabricated repertoire of his forms and their kinetic, vibratory and acoustic properties which caused certain repetitions to echo 'like sub-machine gun fire'. All the borrowings from the painted scrolls, music and typography were condensed into these *Mechano-Fakturen*. From 1922, Francis Picabia used a succession of parallel lines of increasing thickness as a kinetic background in *Volucelle II* and *Conversation I* (no.113), while Victor Servranckx exploited the same graphic motif to represent the repetitive mechanical rhythms linked first to cinematography in *Ciné* or *Opus 11* 1921 (no.123), then to the machine in *Pure Plastic* 1922 (no.124).

In the context of the liaison between cinema and the machine, we may briefly mention the work of George Antheil, the only musician in the De Stijl fold. After his *Manifesto of Mechanical Music* (1922, published 1924) and an essay 'Abstraction and Time in Music' (October/November 1925), he produced a commentary on his score for Fernand Léger's film *Le Ballet mécanique* in *De Stijl* (December 1925). 'My Ballet mécanique', he begins, 'is the new FOURTH DIMENSION of music … It is the first time-form on Earth, neither tonal or atonal. In fact it is of no kind of tonality at all … In music there is nothing else, except TIME and SOUND, and the physical and psychic CONCEPT of these vibrating the human organism.' He concludes: 'My music is the FIRST PHYSICAL REALISATION OF THE FOURTH DIMENSION.'

In Berlin from 1921 to 1923 other artists were conducting their own experiments and formulating hypotheses for the creation of a new non-instrumental music, not in the vein of Russolo's *bruitisme*,[13] but rather generated in a scientific manner by optical means. Written in February and published in September 1921 in *De Stijl*, Hausmann's manifesto 'PREsentismus' shows how all his hopes were pinned on 'electric, scientific painting! Sound, light and electrical waves differ only from one another in their length and amplitude … It will be easy to employ sound waves by conveying them to giant transformers which will translate them into aerial spectacles of colour and music.' Hausmann accordingly began to investigate the optophone, which transmuted images

Fig.31
Pietro Saga
Typo-Plastic VII, from 'De Stijl' vol.6, no.12, 1924–5

Fig.32
RAOUL HAUSMANN
Optophonic Emanation: Abstract Picture Idea 1922

Fig.33
VIKING EGGELING AND HANS RICHTER
Studies, from 'De Stijl', vol.4, no.7, July 1921

Fig.34
HENRYK BERLEWI
Mechano-Faktura
Contrasting Elements 1924

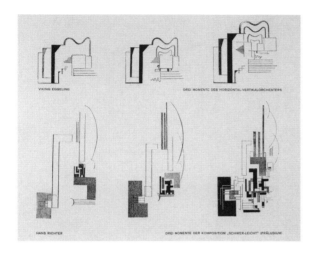

of luminous induction into sounds. From 1921 to 1922 he worked on his *Optophonic Emanations* (fig.32), while Moholy-Nagy researched a method of inscribing sounds on disc, and later on film soundtrack using photographic techniques.

The opposite approach – converting music into a visual format, as opposed to light into sound – remained the most popular, as can be gauged from the visual scores of Karl Peter Röhl or the attempts from 1922 to 1927 by Henri Nouveau (originally Neugeboren) to produce three-dimensional representations of a Bach fugue (no.138). Another variation was the *Reflected Light Compositions* of Ludwig Hirschfeld-Mack (no.141), presented at the Bauhaus (1923), where music, shapes, colours and optical effects were programmed by technicians from a special booth.[14]

The idea of a rapprochement between book and cinema was triggered by works such as Blaise Cendrars and Fernand Léger's *The End of the Word Filmed by the Angel of Notre Dame* (1919) and Yvan Goll's *Die Chapelinade*. The aesthetics of the machine were confirmed in the latter by the use of stencilled lettering and solid blocks of colour, Cubist fragmentation and the portrayal of the protagonist Charlie Chaplin as a sort of automaton. This same automaton recurs in Léger's 1924 film *Le Ballet mécanique*, but already existed as a symbol of modern times in the marionette shows of Vilmos Huszár (no.78) and Joost Schmidt at the Bauhaus (1920–3). El Lissitzky's 'Of 2 Squares' (no.126) was written in Vitebsk in 1920, but published in 1922 in Berlin and again in *De Stijl* in October/November of the same year. As its author remarks, it unwinds like a film, recalling the ☞

Eggeling and Richter scrolls. El Lissitzky's children's tale relates page by page the struggle of the red square and the black square with the red circle, the Earth, against Chaos. El Lissitzky also attempted the visualisation of sound in a 1923 study of poetry by Mayakovsky entitled *Dlia Golosa* (For the Voice): 'This book of poems... is meant to be read aloud... My pages stand in much the same relationship to poems as an accompanying piano to a violin. Just as the poet in his poem unites concept and sound, I have tried to create an equivalent unity using the poem and the typography' (no.125).[15] After 1923, there was a flood of works merging typographical, cinema and narrative techniques. Examples include *Cine-Poems* (Man Ray and Benjamin Fondane, 1927), Werkman's typographical 'divertissement' in *The Next Call* and children's books such as *Die Scheuche Märchen* (The Story of the Scarecrow, 1925) by Käte Steinitz (no.127), van Doesburg and Kurt Schwitters, or El Lissitzky's *Die vier Grundrechnungsarten* (The Four Arithmetical Operations, 1928) – both very similar in their use of printer's letters and figures to stylise the characters.

All Richter and Eggeling's graphical innovations to express musical time in visual terms thus became the basic vocabulary of a new typography whose pioneers were Moholy-Nagy, El Lissitzky, Schwitters and, to a lesser degree, van Doesburg. However, van Doesburg was the first, in 1919, to design a new alphabet (no.37) conforming to the tenets to Neoplasticism: each letter was framed in a standard square or rectangle. It fulfilled two main objectives: to harmonise all the disciplines in a single plastic language, and serve as a propaganda tool. The aims were therefore commercial – to gain publicity – as well as aesthetic. But there was also a social dimension, to inform (in all senses of the word) the culture of the masses. This style of typography somewhat resembled that employed by H.T. Wijdeveld in *Wendingen* (Turnings) but differed from it in its great sobriety and clarity, the regular width of the lettering and especially in its limitation to upper case. The typeface remained the principal modernist model until 1923. Egon Engelien used it at the Bauhaus in his poster for the Cologne Fair in 1922, and after van Doesburg left Weimar, it was occasionally adopted by Schwitters and some of the Bauhaus students – notably by Fritz Schleifer (fig.35) and Herbert Bayer for the entrance banner of the 1923 Annual Exhibition. It is even possible that Schlemmer's new Bauhaus logo was suggested by van Doesburg's study of a woman's profile for a stained glass window (1917, fig.36). This gouache could have been seen in Weimar by everybody and it was finally given to Sándor Bortnyik by van Doesburg. Apparently the Bauhaus logo was designed before van Doesburg's departure. The hypothesis rests principally, however, on the fact that the geometrical face in the logo, very closely resembling that in the stained glass, differs in form from the normally rounded Schlemmer profiles.

In 1924 Kiesler also employed van Doesburg's typography for the catalogue of the *International Exhibition of New Theatre Techniques* in Vienna (no.47). In 1927, van Doesburg returned to his alphabet, clarifying it for the signage in the Aubette building in Strasbourg, the interior of which he was redesigning with Hans

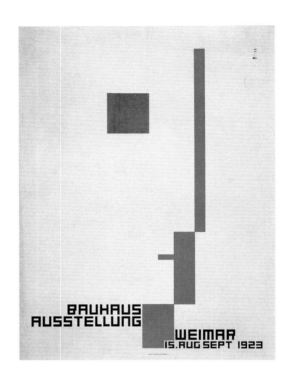

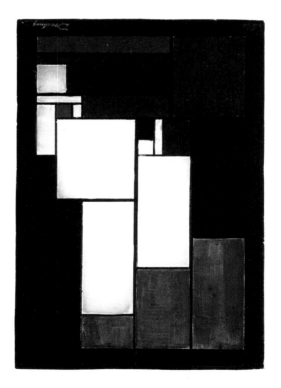

Fig.35
FRITZ SCHLEIFER
Poster for state Bauhaus exhibition 1923

Fig.36
THEO VAN DOESBURG
Composition (Design for Stained-Glass Composition: Female Head) 1917

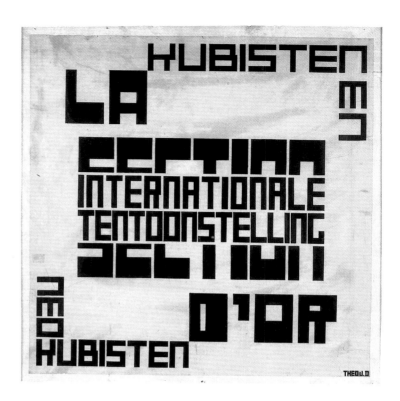

Fig.37
THEO VAN DOESBURG
Design for a poster for
the Section d'Or exhibition 1920

Arp and Sophie Taeuber-Arp (nos.157–8). He took his inspiration for the decoration of the ashtrays (no.45) from Röhl's typo logos. In Holland, Neoplasticist typography lingered on in several variants, particularly at the hands of Vilmos Huszár (nos.34, 36), Bart van der Leck and, initially, Piet Zwart and Paul Schuitema. The later adherents of De Stijl, however – among them César Domela and Friedrich Vordemberge-Gildewart – abandoned it. In fact, they turned more and more to typophotography and the principles of the new typography formulated by Moholy-Nagy in *New Typography* (published by the Bauhaus in 1923), by El Lissitzky in *Topography of Typography*, and by Schwitters in *Merz* (nos.14–15, 1923), the whole field being summarised by Jan Tschichold in *Elementary Typography* (1925) and *The New Typography* (1928). Van Doesburg's typographical system was thus rapidly dethroned because of its limitation to the use of the square and the orthogonal and because it was too static. In 1927 he took part in the *New Advertising* exhibition in Jena organised by Walter Dexel. In this same year an association formed around Schwitters – the Ring of New Advertising Designers – which included several of van Doesburg's former Weimar pupils (Dexel, Max Burchartz), members of De Stijl (Domela and Vordemberge-Gildewart), plus Willi Baumeister, Robert Michel, Georg Trump and Jan Tschichold. The group's aim was to promote advertising design by staging exhibitions. The principal event was *New Typography*, held in Berlin in April and May 1928. In addition to the founder-members and Zwart, invitations were extended to Bayer, Moholy-Nagy, Teige, Molzahn and van Doesburg.

Van Doesburg, who had been one of the instigators of the typographical revolution, did not follow up his astonishing results, even criticising other methods in *Die Form* (1929). As a poet, he considered that graphic artists should not impose a creative superfluity – or even mere extra tension – on a literary work that already enjoyed its own artistic content. 'Whether the book is well or badly printed does not affect the value of its contents.'[16] Further, he seems to have feared a loss of sobriety and the return to a form of mannerism reprehensible even if perpetrated by the avant-garde. His layouts remained austere and static, even if he did make the odd modest attempt to visualise time and a degree of dynamic movement. His poster for the *Section d'Or* exhibition (fig.37) or his cover for *The Theory of Syndicalism* (no.40) by Clara Wichmann (1920) use superimposed wording to induce simultaneous reading, while the cover of the text of van Doesburg's lecture *Classic, Baroque, Modern* (no.35) contravenes the Neoplasticist diktats of orthogonality and staticity by its diagonal alignment of the word 'Baroque'.

If the diagonal only appeared in van Doesburg's painting in 1924, it was already in use in other disciplines. We find it, for example, in the arrangement of van Doesburg's poems under his pseudonym I.K. Bonset, such as *X-Images*, where the words 'zigzag' and 'Dwars' (means diagonal or perverse) are diagonally opposite each other (*De Stijl*, June 1920). It appears again in the v-shaped figure formed by the colours chosen by van Doesburg for the front decoration of the apartment block in Rotterdam's Potgieterstraat (1921) and in his stained-glass composition *Pastoral* (1922, no.57) which exploits the oblique position of a skater's leg portrayed as a multiple image. Finally, van Doesburg's poster (no.45) for the Little Review Gallery, New York tilts the 1924 orthogonal cover design for his Bauhaus Book (no.44) at an ☞

angle of forty-five degrees. The diagonal, representing dynamism (anathema to Mondrian, who aspired to total stability and rejected the introduction of any form of tension) brings us now to film proper – in contrast to the experimental scroll – as a plastic expression of the fourth dimension.

Film Moments: Between Proun and Counter-Construction

The film as the 'seventh art' and as a modernist model of a new aesthetic was also defended by Ricciotto Canudo in France, at his club and in his *Gazette des 7 arts*, while in Belgium staunch supporters were the Bourgeois brothers, P. Flouquet, Karel Maes and G. Monier. The true champion of film, however, was Moholy-Nagy with his numerous articles – 'Produktion-Reproduktion' (*De Stijl*, 1922), 'Dynamik der Gross-Stadt' (no.117, 1924) in *MA* and *Pasmo* (1925) – and his book *Malerei, Fotografie, Film* (1925, no.116) published by the Bauhaus. Certain international exhibitions also played an important promotional role. The Viennese architect Friedrich Kiesler attracted the attention of the avant-garde by introducing a film projection into the electromechanical scenography that he created for the play *R.U.R. (Rossum's Universal Robots)* by Karel Capek (1923, fig.43). Invited to join De Stijl, Kiesler organised the *International Exhibition of New Theatre Techniques* in Vienna in 1924 (no.149) which, along with later manifestations such as *The Absolute Film* (Berlin, 1925) and *Film and Photo* (Stuttgart, 1929), played an important role in the promotion of experimental films.

The projection of Eggeling's *Diagonal Symphony* and Richter's *Rhythmus 21* and *Rhythmus 23* – and especially Richter's drawings and photos entitled *Film Moments* – appear to be at the origin of Bortnyik's pictorial experiments in *Geometric Forms in Space* (1923, no.96) and *Geometric Composition*. The former of these pictures is clearly inspired by film; the latter transposes onto canvas the shades of grey and the transparent effect of the potent superimposed forms of *Rhythmus 21* and *23*. Finally, *The New Adam* (1924, fig.38) is a humorous representation of the 'Total Man': a composite of Richter, El Lissitzky and van Doesburg, with the aid of some dandyish clothing and the fashionable fourth dimension aesthetic in addition. In this respect, the presence of El Lissitzky's *Proun 1 C* (see above) in the background of the picture and the illustration of Richter's *Film Moments* in the centre are very explicit, as we shall discover. Reproductions of *Film Moments* were first published in *MA* (March 1923), and then in *De Stijl* (figs.39, 40, 1923), where they accompanied two articles, 'Film', by Hans Richter, and 'Licht-en Tijdbeelding (Film)' by van Doesburg. In this number, Werner Graeff also presented a graphic score in brochure form with commentary (no.109). In his essay, van Doesburg offers a critical analysis of films shown at the Théâtre Michel, concluding that film could no longer be conceived of in two dimensions, as an image on a screen, but had to be considered in terms of its own elements: light, movement and space. (In 1929 he added the word 'shadow'.) Thus, the space-time of a projection would henceforth envelop the spectator like an architectural feature. Finally, he launches an appeal aimed, without mentioning his name, at

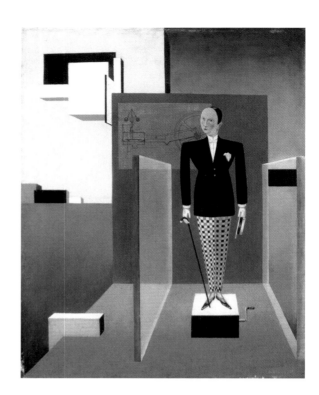

Fig.38
SÁNDOR BORTNYIK
The New Adam 1924

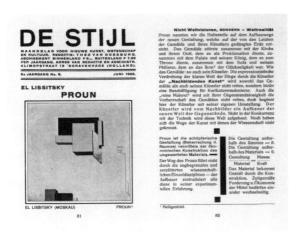

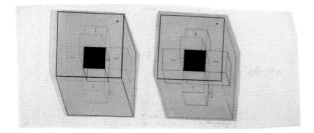

Fig.39
HANS RICHTER
Film Moment, from 'De Stijl'
vol.6, no.5 1923

Fig.40
EL LISSITZKY
Proun 1 C, from 'De Stijl'
vol.5, no.6, June 1922

Fig.41
THEO VAN DOESBURG
Tesseractic Studies 1924–5

Mondrian: 'Our consciousness does not allow us to deny the time element as an elementary means of expression on theosophical or other imaginary grounds.' This declaration is evidence, as early as the summer of 1923, of a break with Neoplasticism.

Furthermore, Richter's *Film Moments* themselves should be regarded as closely related to El Lissitzky's *Prouns*, which formed a halfway-house between two styles of painting and architecture. *Proun 1 C* was published as the cover illustration for the June 1922 issue of *De Stijl* (fig.40), with reference to the Russian artist's article 'Proun: Not World Vision, but World Reality'. This article begins: 'Proun is the name we gave to the stage on the road to Neoplasticism', and concludes: 'Proun goes beyond painting and the artist on the one hand and the machine and the engineer on the other, and advances to the construction of space, divides it by the elements of all the dimensions and creates a new, many-faceted unity as a formal representation of our nature.'[17] We can be sure there were close ties between Richter and El Lissitzky at the time as, together with Werner Graeff and Mies van der Rohe, they were publishing the review *G* (July 1923–March 1926) whose logo – a square – was a homage to van Doesburg.[18] Richter's *Film Moments* were influenced by Lissitzky's *Prouns*; they in turn left their mark on van Doesburg's *Architectural Analysis*, *Space-Time Construction IV* and *Counter-Constructions* (fig.42). From evidence derived from architectural axiometric studies made in association with Cornelis van Eesteren it is likely that these gouache sketches were created in late 1923 for the De Stijl exhibition in Paris (15 October–15 November 1923) at the Galerie de l'Effort Moderne.

In the absence of precise dates, we can estimate that van Doesburg's *Counter-Constructions* and the choice of an axonometric approach were inspired by the *Prouns* via the intermediary of the *Film Moments*. Ansje van Beusekom neatly sums up the situation: 'Architecture surpassed film, but film served van Doesburg's purpose to embed the time factor in his dynamic ideas on modern art.[19] This is further confirmed by van Doesburg's various studies of the tesseract (fig.41) or hypercube from 1924 to 1925. In May 1925 he wrote to Hannah Höch: 'Artistically I have been developing a schematic representation for the new space. I have now acknowledged the tesseractic space as the universal space in which to express form (including film). I am quite sure that mathematical and lucid knowledge is needed, and that all film, architecture, proun, etc., experiments, no matter how interesting, are based on aesthetic speculation.'[20] He returned to the tesseract to illustrate his article 'The Evolution of Modern Architecture in Holland' in *L'Architecture Vivante*, whilst in 1929, in his essay 'Film as a Pure Form' for *Die Form*, the artist adapts the geometry of the hypercube to film.[21] He always portrays the hypercube as a cube displacing itself in space and time in centrifugal/centripetal directions, right/left and up/down, but the face of the central cube is coloured black to represent a screen (see fig.41).

At this stage, it was no longer feasible to consider the screen as a mere canvas. In van Doesburg's words in 'Film as a Pure Form', 'Experiments of this kind [by Eggeling] go no

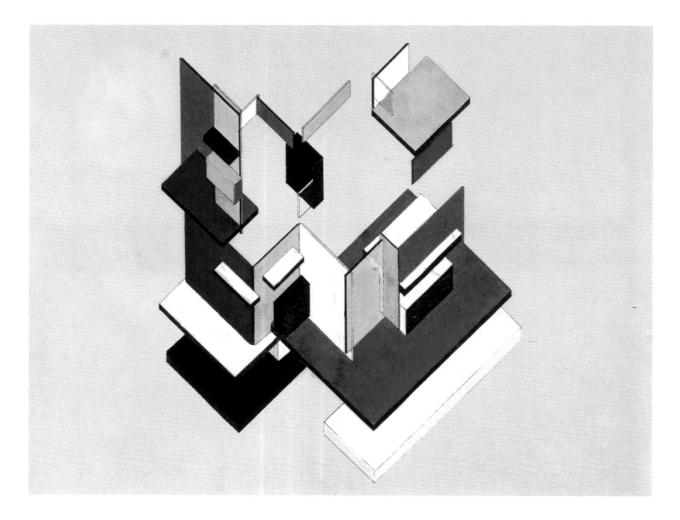

further than moving graphic design.' Nor was it sufficient sim-
ply to transpose the repetitive rhythms, the fragmentation and
simultaneous superimpositions from modern painting (Cubism,
Futurism, Neoplasticism) as in Léger's *Le Ballet mécanique*. The
film was now imagined as a form of architecture with light: 'This
kind of dynamic light form implies, in fact, a new type of art, and
art in which the "one thing after another" of music and the "one
thing next to another" of painting are brought together in one …
The spectator will no longer observe the film, like a theatrical pres-
entation, but will participate in it optically and acoustically.' The
music of Schönberg, Stravinsky and Antheil, Ludwig Hirschfeld-
Mack's *Coloured Light Plays*, the *Luminos* of Moholy-Nagy and
Baranoff Rossiné's optical piano appear to have enlarged van
Doesburg's imagination, leading him to envisage a total art form
of light, 3-D images and sound.[22] As ever with him, the transition
from one discipline to another involved the partial destruction of
his former aesthetic principles and the introduction of a series
of innovations whose effect would be felt especially in the world
of painting.

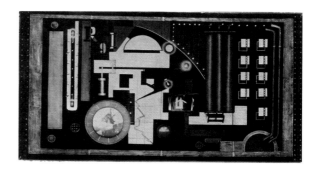

Fig.42
**THEO VAN DOESBURG
Counter-Construction, Axonometric
Private House** 1923

Fig.43
**FREDERICK KIESLER
Stage Design for Karel Capek's 'W.U.R.
[R.U.R.]', front view of stage, Theatre
in Kurfürstendamm, Berlin** 1923

NOTES

1 Ansje van Beusekom, 'Theo van Doesburg and Writings on Film in *De Stijl*', in Klaus Beekman and Jan de Vries (eds.), *Avant-garde and Criticism*, Amsterdam and New York 2007, p.58.

2 Piet Mondriaan, 'De Nieuwe Beelding in de Schilderkunst, *De Stijl*, vol.1, Oct. 1917, in Harry Holtzman and Martin S. James (eds.), *The New Art, The New Life: The Collected Writings of Piet Mondrian*, London 1987, p.28.

3 *De Stijl*, vol.4, no.10, 1921, p.124.

4 Theo van Doesburg, 'Het glas-in-lood in de oude en nieuwe archirectuur", *Het Bouwbedrijf*, vol.7, no.2, 1930 (17 January), pp.40–2. Translation in Els Hoek (ed.), *Théo van Doesburg: Oeuvre Catalogus*, Central Museum, Utrecht and Kröller-Müller Museum, Otterlo, 2000, p.198. For the links between *Composition IV* and music, see also Allan Doig, 'Les transformations géométriques et leur signification dans les premières œuvres néo-plastiques de Van Doesburg', in *Théo van Doesburg: Peinture, architecture, théorie*, Paris 1990, pp.136–8; and Nancy Troy, 'The Abstract Environment of De Stijl', in *De Stijl, 1917–31: Vision of Utopia*, exh. cat., Walker Art Centre, Minneapolis, New York 1982, p.169.

5 Stanley Lawder, *The Cubist Cinema*, New York 1975, p.46.

6 Translation in ibid., pp.48–9, note 5.

7 In 1927, Hans Richter was to work on a film project with Malevich.

8 Hans Richter, 'Chevalet-Rouleau-Film', extract from *Magazine of Art*, February 1952, reproduced in *Dada Cinema*, brochure accompanying DVD issued by the Centre Georges Pompidou, Paris 2005, p.9.

9 *De Stijl*, May, June, July and Oct. 1921; Feb. and May 1923. One of Eggeling's drawings had already been reproduced in *Dada*, no.4, 1919, but not in sequential form.

10 *Telephone Pictures* were so called because ordered from a factory by telephone, where they were custom made.

11 Hans Richter, 'Prinzipielles zur bewegungskunst', *De Stijl*, vol.4, no.7, 1921. Article signed by Eggeling in *MA*, no.8, August 1921. Text trans. into French in *Son et lumière: Une histoire du son dans l'art du XXe siècle*, exh. cat., Centre Georges Pompidou, Paris 2004, p.156.

12 Henryk Berlewi, 'Functional Design of the Twenties in Poland', special feature, *Neue Grafik*, no.9, Olten/Schweiz, 1961, pp.8–9, fig.16.

13 The 1921 performance in Paris is described by Mondrian in *De Stijl*, vol.4, no.9, 1921.

14 For all these processes involving the visualisation of sound, see the recent article by Karin von Maur, 'Bach et l'art de la fugue, modèle structurel musical pour la création d'un langage pictural abstrait'; also Marcella Lista, 'Empreintes sonores et métaphores tactiles, optophonétique, film et vidéo', in Paris 2004 (see note 11).

15 El Lissitzky, 'Typographical Facts', in Sophie Lissitzky-Küppers, *El Lissitzky*, London 1968, fig.108.

16 Theo van Doesburg, 'Film als reine Gestaltung', *Die Form*, vol.4, no.10, 1929, pp.241–8.

17 Translated in Lissitzky 1968, p.343.

18 Regarding the friendship between the three, van Doesburg was a witness at Richter's wedding.

19 Beusekom 2007, p.63 (see note 1).

20 Evert van Straaten, *Theo van Doesburg: Painter and Architect*, The Hague 1988, p.191.

21 See note 16.

22 Van Doesburg was very excited after witnessing a demonstration at Studio 28 in Paris.

TOWARDS A SPATIO-TEMPORALITY IN PAINTING

GLADYS FABRE

One of the two essential features differentiating the approach of van Doesburg from that of Mondrian was the former's preoccupation with building bridges between the disciplines. The second was without question his interest in movement in every sense of the word: regrouping, transposition, displacement in space and time, aesthetic evolution and change. In this respect Doris Wintgens shrewdly suggests that *Mouvement héroique* (no.5), the title of the artist's 1916 painting, would have made an excellent exhibition title, so apt a summary is it of van Doesburg's plastic techniques and all his involvements.

The implied references to Marinetti in *Mouvement héroique* afford a glimpse of the influence of Futurism, which revealed itself in van Doesburg's works through the choice of subjects in motion, such as *Rhythm of Russian Dance* 1918 (no.19) and *Rag Time* 1919. Very quickly, under the influence of Severini's articles in *De Stijl* (August 1918), Charles Howard Hinton's *A New Era of Thought* (1888) and *The Fourth Dimension* (1904), Poincaré's *La Mécanique nouvelle* (1909) and the work of Lorentz, van Doesburg moved on from the expression of movement to an expression of the fourth dimension, from his former esoteric conceptions to a scientific understanding — or what passed for it — of the world around him. In this essay, we shall therefore attempt to retrace how the artist succeeded in 'portraying' the continuous passage of time within a pictorial space.

Six months before leaving for Germany in 1920, van Doesburg would paint one of his most revolutionary works and one that illustrates his early desire to express a form of space-time already requiring the involvement of the spectator. No longer a passive onlooker, the viewer would become actively involved, in the sense of Marcel Duchamp's 'viewer who makes the picture', and would be physically enveloped in the space created by the work. Until then, the realisation of this idea had been limited in van Doesburg's work to the use of colour in architecture. *Composition XVIII in Three Parts* 1920 (fig.44) features three separate pictures forming, according to the artist, a single 'whole'. To achieve this effect, they must be hung in a pyramidal arrangement, the tops of the first and third pictures aligned with the base of the central one, so that the centre of the group is in fact the external space

between the three compositions. Delighted with his innovation, van Doesburg discussed it with Mondrian, who criticised his standpoint, arguing that it was essential not to externalise the centre, but to annihilate or neutralise it altogether. But since the viewer's perception of a work is obviously important, it is worth examining what he actually sees. In this three-in-one, what immediately stands out is not that the centre is externalised, but that the single stable element in the group, the small white cube, is displaced in both space and time from the first picture to the third, while the movement of this element is captured in time by the viewer's eyes from left to right. Van Doesburg appears to have been aware of the work's importance, as he exhibited it in Holland at the *Section d'Or* exhibition in 1920, in Berlin in 1923 and in 1924 in Weimar. He also used it as a model in his Bauhaus lectures. Its influence can be found in his pupils Karl Peter Röhl and Andreas Weininger. *Composition XXII*, his sole painting completed in Weimar, was the one and only logical follow-up; like many of his inventions it had no future, though the Arte Concreta movement in Switzerland and Italy would exploit these ideas at a later date.

From 1924 to 1927 van Doesburg's paintings adopted a fresh approach resulting from the theory of Elementarism, an offshoot of his *Counter-Constructions* (see fig.42) and his plans (June–October 1923) for the interior of the University Hall (never realised) in Amsterdam (fig.46), in collaboration with van Eesteren. The designs for the hall contained a diagonally orientated composition for the first time, and there is every reason to believe that the hexagonal ceiling was his chief reason for preferring this design to his alternative solution incorporating an orthogonal décor.[1] In parallel fashion, his lozenge-shaped orthogonal pictures, which appeared in 1924, would ensure the transition between Neoplasticism and Elementarism. We may imagine that if van Doesburg called these counter – that is, anti-static – compositions, it was because, even at this stage, he was mindful of the diagonal of the borders. Additionally, we know that once orientated to the square format, like *Counter-Composition V* (hung as a lozenge in August 1924, as a square in 1927), a work became an example of Elementarism. Finally, *Counter-Composition VI* 1925 (no.164) was, it seems, the first picture based on a diagonal grid. At first glance we might assume van Doesburg had returned to the initial, 1918 square format of Mondrian's *Composition with Grey Lines* (the diamond shape followed in 1919), picking out in black three diagonal rows of diamonds intersecting at right angles. What is more likely though is that he decided to leave the underlying structure (the grid) visible, thereby claiming the process of execution as his own concept. Geometric, functional, mathematical and conceptual, 'the grid has become an emblem of modernity, affirming the autonomy of an art that is anti-natural, anti-mimetic, anti-real.'[2]

Van Doesburg's first text on Elementarism – *From Composition to Counter-Composition* – was written in Rome in 1926, soon after Giacomo Balla sold him a picture entirely constructed of oblique lines and movements. Was this perhaps a case of van Doesburg drawing strength from another artist's work, a confir-mation of his need to claim as his own an idea that had been exercising him for many years? In any case, Elementarism, which in his eyes replaced Neoplasticism, made the diagonal the cornerstone of his reformed aesthetic. Elementarism proclaimed the end of the era of abstraction and the arrival of a 'real' art more concrete than illusionist painting, more representative of life's agitation than abstract composition. Mondrian adroitly termed it 'abstract-real'. Moreover, in an Elementarist 'counter-composition', in order to represent spatio-temporal tensions, balanced proportions were replaced by an instability injected by oblique elements. Again, the interdependence of planes of colour was replaced by the independence of colours as a form of energy. Van Doesburg's *Counter-Compositions XIV, XV* (no.165) and *XVI* 1925 (fig.58) are perfect examples of these new experiments. *Counter-Composition XVI*,[3] with its monumentality, variances and discords – two different shades of red, blue and yellow are juxtaposed – prefigures the work on the cinema-cum-dance hall (Cinébal) at the Aubette building in Strasbourg (1927–8). Here, in the Cinébal, we can see how the dynamism of the mural *Counter-Compositions* can be destructive of architecture and how the décor engenders an ambience of energy that, far from promoting structure and order, has a Dada-like effect.

Between 1925 and 1926, van Doesburg began to explore a means of introducing both a temporal continuity and an illusion of infinite space in his paintings. He employed a process of curtailment, cutting in a succession of forms to suggest an apparent extension of the work outside the picture frame. Neoplasticist artists – especially Mondrian, but occasionally van Doesburg – would interrupt a black line in a composition before it reached the edge of the picture, in the hope that this lack of a finite end-point would suggest the infinite. The effect is very subtle. With Elementarism and in *Counter-Compositions XIII* and *XVII* (fig.52), the succession of truncated triangular forms becomes an ambivalent statement of movement in time and space, which can be seen as a series of 'freeze-frames' imposed on continuous motion or, on the contrary, as an infinite extension of triangles.

During 1928 and 1929, van Doesburg started down a third path. In his painting he reverted to the idea of simultaneity – something he had already exploited in his typography – in two pictures entitled either *Simultaneous Composition* or *Simultaneous Counter-Composition*, depending on whether the superstructure or grid of black lines was imposed upon an orthogonal or diagonal composition. It is possible that this series derived from his recent experiments with stained glass, such as the designs for the *Abstract Cabinet* in Hanover Museum (1925, fig.47) and a house designed for the Horn family in Strasbourg (1928). Rosalind Krauss has compared the concept of the grid with Mallarmé's use of the window as a symbol. 'As a transparent vehicle, the window is that which admits light or *Spirit* ... and the bars of the windows – the grid – are what help us to see, to focus on.'[4] In Hanover, van Doesburg designed a Neoplasticist stained-glass window with grey and white panes, the whole structured vertically by a broad black upright flanked by two similar but

Fig.44
THEO VAN DOESBURG
Composition XVIII
in Three Parts 1920

Fig.45
THEO VAN DOESBURG
Arithmetic Composition 1929–30

Fig.46
THEO VAN DOESBURG
Colour design for University Hall 1923

thinner verticals and intersected horizontally by a bar a third of the way up. The thickness of the uprights contrasted with the transparency of the glass gives an impression of superimposition. *Composition in Half-Tones* 1928 (no.175) makes the transition between the stained-glass windows and the succeeding *Simultaneous Composition* and *Counter-Composition*. The rows of white panes tinted with a bluish grey imitate the gradations of colour produced by light passing through stained glass. Thus the superimposition of a linear grid on the *Composition* or *Counter-Composition*, indicating two simultaneous and overlapping states, appears to be borrowed from the techniques of stained glass. This argument is confirmed by his design for the rooflight in the library of his Meudon villa, which has much in common with *Composition in Half-Tones* (1928).[5] There are many similar examples which suggest that van Doesburg's interdisciplinary approach was not simply the expression of his demand for totality but a feature of his individual creativity.

The fourth stage of van Doesburg's career coincided with the era of Art Concret, bringing together much of the knowledge he had already acquired and inaugurating yet another re-evaluation of his aesthetic that was interrupted by his death in March 1931. *Arithmetic Composition* (1930, fig.45) fully exemplifies the radical nature of his manifesto *The Basis of Concrete Art* (p.187), prepared in December 1929 and issued in April 1930 in the form of a leaflet introducing the Art Concret group and the magazine of the same name (which lasted for only a single issue). Van Doesburg wrote on 23 January 1930 to his old friend Antony Kok: 'My latest canvas, on which I have worked for a long time, is in black, white and grey: a structure that can be controlled, a *definite* surface without chance elements or individual caprice. Lacking in fantasy? Yes. Lacking in feeling? Yes. But not lacking in spirit, not lacking the universal and not, I think, empty as there is *everything* which fits the internal rhythm: it is both the pyramid and the falling stone, both the stone skimming over the water and Echo; it is

both time and Space, the infinitely large and the infinitely small.'[6] *Arithmetic Composition* derives from a study entitled *Six Moments in the Development of Plane Space* (fig.54) which the artist reproduced with the date 1926 in his article on film in *Die Form* of February 1929 — but published on the occasion of the *Film and Photo* exhibition (18 May–7 July 1929).[7] Some historians believe that the artist antedated this preparatory drawing and that it belongs to 1929; what matters, however, is that this sketch was linked with film by van Doesburg himself, and that it recalls the succession of forms on Hans Richter's scrolls (no.108). We can deduce that at the moment van Doesburg was seeking to found a group he was still under the influence of the theories expressed in his article and that this was a subject of discussion among the members of Art Concret.

The Art Concret circle was formed somewhat hastily in December 1929 after the *Select Exhibition of Contemporary Art* in Amsterdam,[8] with a programme so constrictive that several of the invited artists were frightened off, including Pevsner, Neugeboren, Fernandez and probably others. The group included Marcel Wantz, who had practically never painted, being a typographer by profession. As for Jean Hélion, he had only just abandoned figurative painting during his summer in Pau; back in Paris, he shook off even more quickly his turgid attempts at abstraction, to plunge in late 1929 into a cold and mathematical version of integral geometric painting. A pupil and former assistant of Léger, Otto-Gustaf Carlsund also quit the abstract format in which he sought to portray a succession of musical tones using superimpositions, transparent forms and colour, as in *Sequence of Tones* 1929 (no.142). Finally, Léon Tutundjian, whom van Doesburg met at the Salon des Indépendants in January 1929, seems not to have fallen under the Dutch artist's influence to any extent. Nonetheless, his style hardened and he forsook all colour modulations indicating volume (fig.53), all perspective, and reduced his geometric reliefs (no.188) to a minimalist forms.

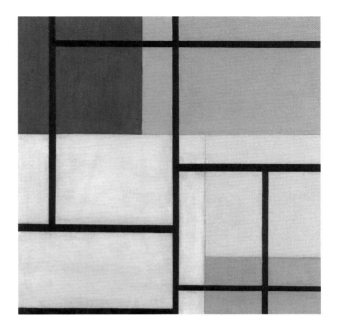

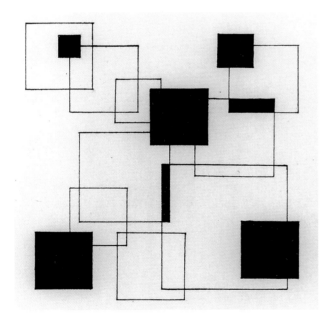

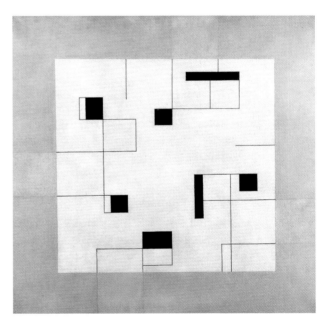

Fig.47
THEO VAN DOESBURG
Design for stained-glass window for
the Abstract Cabinet in Hanover 1925

Fig.49
WERNER GRAEFF
Z-Stijl 1 1921

Fig.48
THEO VAN DOESBURG
Simultaneous Composition 1929

Fig.50
JEAN HÉLION
Complex Tensions 1930

Tutundjian apart, it would appear that all these young recruits to Art Concret had not only a common theoretical programme but also used pictorial models related to some degree to early abstract films. Evidence for this may be found in Carlsund's interlacing patterns overlaid with circles (no.187), which recall a precise moment in Eggeling's film *Diagonal Symphony*; or Hélion's *Complex Tensions* (1930) with its rhythmical series of squares and rectangles inside a linear network, reminiscent of a study by Werner Graeff (1921, fig.49). Further, the description Hélion gives of his Art Concret period acknowledges the influence of van Doesburg and rhythmical composition in general: 'It was necessary to invent ceaselessly, to look to geometry to find a solid basis ... I ended up painting kinds of rectangular grids with flat blocks of colour in between. I strove to concentrate in these shapes all my optical and intellectual requirements ... Then I investigated the division of surfaces and spaces, notions of repetition, of progressions of elements, oppositions or successions of primary colours, the creation of greys among these colours.[9]

At that time, Walmar Shwab's 'nihilism' led him not to sign the Art Concret manifesto, but a drawing of his was reproduced in the leaflet (and he was also involved with cinema). Commenting in *Der Sturm* on his exhibition in November 1928, a critic stated: 'His outlook is mathematical, but he wanted to work in cinema in order to demonstrate the transformation of colours in movement through film and changing forms.' But faced with technical difficulties, Shwab tried at first to attain his objectives in painting (no.185). Finally, around 1930, he succeeded in presenting an abstract film at the Studio des Ursulines, Paris. The film caught fire at the end of the first showing.[10]

Let us return now to van Doesburg and the painting that epitomised the expression of space-time. *Arithmetic Composition* was not merely a mathematical arrangement on a grid displaying the progression and diminution of four diagonally aligned black squares (as many historians describe it). It is more complex than that. The work unites motif and background through the superimposition of two simultaneous progressions: that of the black squares in motion and that of the white background with its grey interventions. This neutral grey divides the picture's 'background' into four overlapping squares in the mathematical ratios of 3, 6, 12, 24. While the two progressions – of the background and the motif – are orientated in the same direction, their reading remains ambivalent; the first involves a combined movement of motif and background towards infinity, the second implies a returning, contrary motion. The movement of the black squares is from bottom right to top left; but on reaching the latter point, the eye is then turned back by the small grey square in the background toward the biggest square: the whole picture.

So if *Arithmetic Composition* is a successful synthesis of van Doesburg's earlier experiments with simultaneity and the expression of space-time, it also perfected the kind of anonymous, precise and slick style recommended in his Art Concret manifesto. 'The technique must be mechanical, that is to say, exact, anti-impressionist', or again, 'The best handiwork is that which

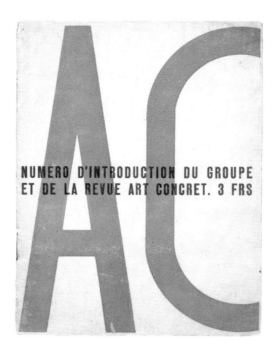

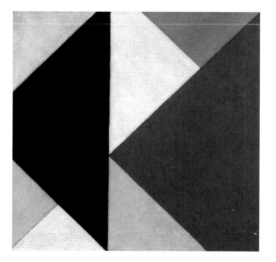

Fig.51
**THEO VAN DOESBURG, OTTO CARLSUND, JEAN HÉLION LÉON TUTUNDJIAN, MARCEL WANTZ (EDS.)
'Art Concret', no.1, April 1930**

Fig.52
**THEO VAN DOESBURG
Counter-Composition XIII** 1925–6

does not reveal the hand.'[11] To this end, as Evert van Straaten emphasises, van Doesburg sought to present the surface as a perfect plane and worked only with the contrasts between matt greys and whites and glossy blacks.[12] This new sobriety gave pride of place to white, as the colour of pure intellectuality, and to grey as neutral. Van Doesburg went on to state: 'Painting is a means of optically expressing thought: each canvas is a colour-thought.' A further step towards radicalism was taken with another piece also published in *Art Concret*, 'Towards White Painting'. In this, van Doesburg, not without exaltation, defends a kind of materialistic transcendence: 'White, that is the colour for the new times... [the colour] of perfection, purity and certitude.' He then adds, with a swipe at the rival field of Surrealism: 'Instead of dreams, the future will place art on a proper scientific and technical basis.' From early 1930, van Doesburg believed that with *Arithmetic Composition* he had found a mould from which to create a family of similar works.[13] Consequently, the Art Concret manifesto (p.187) reproduces one of his variations on this work, which resurrects the notion of progressions, now using three squares, superimposed on which are two further, transparent squares orientated in the reverse direction. With this van Doesburg went beyond depicting simultaneity and time sequences, experimenting in addition with the reduction of matter and colour from black to granular grey to transparency.

Yet as his friends and colleagues were keen to point out, van Doesburg functioned in a way contrary to Nature, to others and to himself, constantly questioning everything in order to alter or improve it. In this respect, his Dadaist self-portrait *I am Against Everything and Everyone* (see back cover) is strikingly lucid. Similarly, in August 1930, we find him soul-searching over his aesthetics. 'What is a picture?' he asks his diary.[14] 'A picture consists of fixed references; motion is foreign to the picture. With motion begins film, that is, variations in references. If painting has a *raison d'être*, it is thanks to its stability.' On 4 September he adds: 'Because people have failed to understand the true nature of the canvas on the wall, they imagine that a representation of movement would give the picture a new dimension. The experimentalists (El Lissitzky, Moholy-Nagy, Rodchenko, Eggeling) achieved the plastic ideal in film; but even if their experiments had a temporary value, they returned to the inferred movement of Ancient Greek paintings ... and to Delacroix. Thus motion was, so to speak, nothing other than a sterilisation of instanteity, of an action. The difference between the new painting and the former illusionism is that the dynamism of the past is replaced by a constant – a fixed set of relationships, a perfect equilibrium between action and rest.' Van Doesburg's entry for 15 September explains that 'this constant or fixed element is colour.' And so he rejected mathematical progressions of forms, white as a symbol of intellectuality and grey as the badge of technicity. With *Simultaneous Counter-Composition* (completed before October 1930, no.190) there emerges a new pictorial synthesis that could only be described as an artistic explosion. Colour is once more full of energy; the three squares – yellow, blue, red – escape towards the 🖝

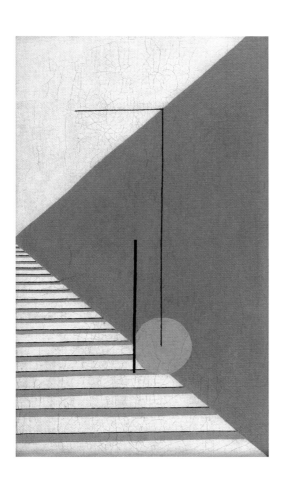

Fig.53
LÉON TUTUNDJIAN
Composition No.103 1929

exterior; the two black orthogonal lines are superimposed in an orientation contradicting that of the coloured squares. This overall instability is scarcely tempered by the black rectangle at the top right which itself appears as a square truncated by the edges of the picture.

This marked the end of Art Concret, the splinter group having lasted a mere six months. A few attempts were made – by Hans Arp with the exhibition *Produktion 1930* (Zurich) and *AC Art Post Cubiste* by Carlsund in Stockholm the same year – to constitute a larger and more homogenous group with a view to countering the influence of Surrealism and implanting non-figurative art in both France and beyond. Van Doesburg judged these efforts a failure, since they were a hotchpotch of every variety of the avant-garde. By way of reaction, he formed a new international group just before his death – Abstraction-Création – which operated from 1932 to 1936 and included only non-figurative artists.

In a rapid survey of his pictorial oeuvre, what strikes us most? What can we recall from among the huge artistic wealth of the avant-garde in the inter-war years? In the first place, it is notable how little van Doesburg actually painted, and that the majority of his key works were in a small format, generally around 50 x 50 cm. From this it can be deduced that his works were acts of research, optical expressions of innovative ideas. When he was active in other disciplines or in promoting his ideas, he temporarily stopped painting, as he did in Germany in 1921–3. Secondly, his paintings – of whatever size – are characterised by their monumentality. In other words, his compositions adopted a large scale which conflicts with the format. This monumentality is accompanied by what van Doesburg termed the atmosphere of colour, its 'variances' and dissonances. The latter ask more questions of the viewer – with sometimes disturbing effects – than the harmonious, stabilising arrangements of the three primary colours. The result is that the unexpected atmosphere combines with the expression of space-time to draw the spectator into the work. Van Doesburg's art is never an end in itself, but rather a constant process of creation.

A month before he died, van Doesburg wrote of both his hope in the future and his recent craving for rest: 'The next style will be first and foremost that of a free and peaceful life ... It will be monumental and heroic and I shall call it ... the "style of the whole man" – a style that holds in balance all the great contradictions.'[15]

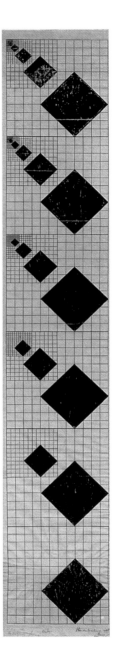

Fig.54
THEO VAN DOESBURG
Six Moments in the Development
of Plane to Space c.1926

NOTES

1 No.701, vol.1, in Els Hoek, *Theo van Doesburg: Oeuvre Catalogus*, Central Museum, Utrecht and Kröller-Müller Museum, Otterlo 2000, p.338.

2 Rosalind Krauss, 'Grids, You Say', in *Grid*, exh. cat., The Pace Gallery, New York 1979.

3 Some photos show the work hanging vertically in 1925, yet it appears horizontally in *L'Art d'Aujourd'hui*, November 1925, Paris.

4 Krauss 1979.

5 No.828, vol.3, Hoek 2000, p.515.

6 Letter from Van Doesburg to Antony Kok dated 23 January 1930, in Hoek 2000, p.533.

7 Theo van Doesburg, 'Film als reine Gestaltung', *Die Form*, no.10, vol.4, 15 May 1929, pp. 241–8.

8 *Expositions sélectes d'art contemporain*, Amsterdam, 2 October–late November 1929 and The Hague (Pulchri Studio), 10 December 1929–5 January 1930. Organised by Nelly van Doesburg, who showed three canvases under the name Cupera. The cover of the catalogue was designed by Tutundjian. Shwab and Tutundjian exhibited there, but not Hélion or Carlsund, confirming that they were recruited by Art Concret at a fairly late date.

9 *Hélion, cent tableaux, 1928–1970*, exh. cat., Galeries nationales d'exposition du Grand Palais, Paris 1970, p.8.

10 Interview by the author, 1975. Shwab met Moholy-Nagy in 1927; some of his compositions resemble those of the Bauhaus master. Shwab most likely arranged – through Georges Adamov – for the projection to be financed by the Conte de Beaumont. But no known trace remains of this event, which must date to the very early 1930s. In 1933, the artist gave up painting for at least twenty years.

11 Text published after the death of van Doesburg in *Abstraction-Création*, no.1, 1932, p.39.

12 Evert van Straaten, *Theo van Doesburg: Construction of the New Life*, exh. cat., Kröller-Müller Museum, Otterlo 1994, pp.101–2.

13 'I have done a sketch for the next [painting]. I can use this spatio-temporal basic form to make 1,000 paintings, for it is "universality" and inexhaustible! The new one will have the following planar proportions: 8, 16, 32, 64 and the colour will have to correspond with them.' Quoted in van Straaten 1994, p.101.

14 Theo van Doesburg Archives, Diary: 29 August 1930–1 January 1931, no.13, microfilm 11. Rijksdienst Beeldende Kunst/Netherlands Office for Fine Arts (Van Moorsel Donation); published Leyden, IDC, 1991.

15 Written February 1931, quoted in Evert van Straaten, *Theo van Doesburg: peintre et architecte*, Paris 1993, p.36.

THEO VAN DOESBURG: A COUNTER-LIFE

MICHAEL WHITE

When was 'Theo van Doesburg' born? It is customary to answer this question with the year 1883, though a persuasive case could be made for 1902, the first time the name appears as a signature. This also happens to be the date the artist who used the name began to keep a diary, beginning in earnest a process of urgent self-construction.[1] Or was van Doesburg born in 1908 when he had his first exhibition at the Hague Art Circle and was described in the catalogue as 'an artist sprung directly out of himself, someone en route from an obscure point of departure to an unknown place'?[2] The year 1912 could definitely be considered, the year of his first publication under the name.[3] It was also the year of the death of his stepfather, Theodorus Doesburg, the man from whom he had adopted it. Looking back shortly after, he reflected:

> Only in my most recent period (1908) did I manage – and then only for a moment – to pull aside the curtain that had kept hidden my spiritual being and to show the world what was hidden in me. I had chosen a battle name (Theo van Doesburg) for myself and armed with knowledge and discoveries – not to speak of passion – I shouldered my purpose.[4]

The combative metaphors deployed here were not accidental; these are lines written in November 1914 by Sergeant Christian Emil Marie Küpper (known as Emile), a man whose military career had begun in 1903, and who, after regular periods of service, was now stationed close to the Belgian border in earshot of the bombardment of Antwerp (fig.55). He described his purpose as showing the world 'that there was another world "somewhere", greater, nobler, holier', and he had devised a plan of campaign to take him through 'the whole of artistic and philosophical Europe.'[5] Such ambitions, he regretfully confessed, had been confounded by the outbreak of war. In some ways it was not until 1916 and Küpper's final demobilisation that the figure of Theo van Doesburg could fully emerge and take up the campaign.

Küpper's use of a *nom de guerre* was nothing unusual, but what we need to pay close attention to is the manner in which he

was to link the persona of van Doesburg to possibilities of radical change and historical destiny, to the potential to refashion the world and one's self within it. At the start he had a very significant source to work from. He had acquired a copy of Wassily Kandinsky's *Reminiscences* (Rückblicke), a text in which the Russian artist recounted his formative life experiences and their connections to his recent abstract painting. His fascination with this text is evident from the soiree he organised in 1915, while still in service in Tilburg, where he gave his first public readings as van Doesburg.

The evening began with a performance of Wagner's *Lohengrin*, the exact same music that Kandinsky had recalled as having produced the most intense synaesthetic reaction in him as a young man. In lectures and publications during 1915 and 1916 van Doesburg retold at length Kandinsky's story of how he had 'discovered' abstract art by unexpectedly encountering one of his paintings in his studio standing on its side, and realising how this had magically cancelled its representational content. As we shall see later, van Doesburg was to repeat the strategy of rotation as a way of marking an epiphanic entry to a new era.

As much as Kandinsky offered a potent model for linking the path to abstraction with moments of dramatic personal transformation, he had also used autobiography to convey the significance of past experience for the present. *Reminiscences* is certainly not all about leaving childhood behind but continually moves forwards and backwards in time in order to make connections. As a way of communicating the importance of these connections, Kandinsky used a very potent organic analogy:

> The new branch does not render the tree trunk superfluous: the trunk determines the possibility of the branch... And this replication, further growth, and complexity, which often appear confusing and disheartening, are the necessary stages that lead ultimately to the creation of the green tree.[6]

Here Kandinsky deploys one of the most enduring images for the process of evolution. Charles Darwin had first sketched his theory of natural selection as a tree diagram because it was the perfect way to convey the idea that life-forms that appeared different could have a genetic relationship. It was a powerful image later codified to its extreme in Ernst Haeckel's 'Tree of Life'.[7] Kandinsky deployed the image as suggestive both of the development of the personality, demonstrating the singularity of subjectivity despite the variety of forms it has been expressed in, and of art, positioning abstraction in painting as the culmination of the history of art in all its diversity.

Conceiving a developmental model of art was van Doesburg's abiding concern during the war years, and when he first encountered Mondrian's paintings in 1915, he began immediately to speak of them in such terms. He singled out *Composition 10 in Black and White* for effusive description and wrote that, although the feeling it conjured up was that of peace, it did so by

conveying a sense of transformation, 'for Art is not a being but a becoming.'[8] The following year van Doesburg broke dramatically with Expressionism by writing a damning 'psychoanalytic' study of the artist Janus de Winter, with whom he had previously been working closely and who had been similarly inspired by Kandinsky.[9] Van Doesburg diagnosed De Winter's paintings as evidence of a kind of psychic regression rather than progression, and then positioned Mondrian as representative of a higher stage of consciousness.[10] Mondrian's achievement, in van Doesburg's eyes, was to have produced works of art concerned with universal values of an 'impersonal' character. Having surpassed the limited individualism of Expressionism, abstraction in this form was truly ready to embody 'the working of the human spirit.'[11] In subsequent publications, van Doesburg positioned Mondrian beyond Kandinsky, whom he downgraded from being the ultimate representative of the new to a mere stepping stone.

Surprisingly, it was not until 1919 that van Doesburg presented his own practice and its development. Before that date, as art historian Joop Joosten has pointed out, he used the work of others as a means of self-analysis, or, looked at it another way, subsumed his artistic personality into that of others.[12] Van Doesburg illustrated two publications in 1919 with sequences of his works showing abstraction as a process. *The Style of the Future* showed in three stages how *Composition XIII* of 1918 had begun as a still-life painting (fig.56).[13] 'From "Nature" to "Composition"' was illustrated with a sequence of eight images, beginning with a photographic portrait and ending with *Composition in Dissonants* of 1919.[14] In the first case, the middle stage is explicitly labelled as 'expression'. The process illustrated in 'From "Nature" to "Composition"' is more complex and, although presented as totally clear and rational, the seemingly obvious transition from visible particularity to generalised abstraction conceals significant inconsistencies, revisions and contradictions, not least that the photograph positioned at the start of the sequence appears to be a curious restaging after the event.[15] As in the case of the still-life, the passage from 'nature' to 'abstraction' involves a destructive moment whose agent is the diagonal line. In the text accompanying the illustrations van Doesburg describes this moment at length as the 'tensing' of line, which cancels out representation of the motif and frees lines from their mimetic role. According to van Doesburg, this is the stage of abstraction when the dualities of front and behind, figure and ground, dualities he describes as the consequence of our perception in terms of space and time, are overcome. What follows the possibility of such an overcoming he compares to the 'fourth-dimensional vision' which had been described by the French mathematician Henri Poincaré, a moment when possibility for the new opens up and another dimension becomes perceptible.[16] As van Doesburg formulated it at this time, the destructive moment was followed by a reconstructive one represented by the arrangement of lines and planes in orthogonal relationship.

Van Doesburg's 1919 articles can be seen in many ways as in dialogue with Mondrian's major theoretical treatises of the time and his concept of *Nieuwe Beelding* or Neoplasticism,

the two elements of which term it is important to consider. The Dutch word *beelding* has no direct English equivalent; it is a gerund (a verbal noun) derived from the little used verb *beelden*, meaning to picture, which is more commonly prefixed to form verbs such as *afbeelden* (to depict), *uitbeelden* (to express) and *inbeelden* (to imagine). As literary historian Hubert van den Berg has commented, the best way to think about its meaning is what might be suggested by dropping the prefixes 'de' from 'depicting', 're' from 'representing' or 'ex' from 'expressing'.[17] *Beelding*, which retained its gerundial form when translated into German as *Gestaltung* (forming), indicated the making of art through primary means and not on the basis of mimesis. It was also, very importantly, described as 'new' and attached to a notion of historical change. That one might achieve 'plasticism' having passed through successive stages was the narrative behind Mondrian's major treatise 'Natural and Abstract Reality', published in instalments in *De Stijl* from June 1919 to July 1920, which took the form of a conversation between three characters journeying from the countryside to the city. The text provided a summary of Mondrian's personal transformation from landscape painter to abstract artist over the course of a decade, alongside an account of abstraction as the art of a new age, with the concept of evolution as fundamental to both. In van Doesburg's presentation of his own abstract paintings as the culmination of a process, we can see elements derived directly from Neoplasticism but also differences. For example, Mondrian had little interest in the notion that the destruction of the motif had opened a view into another dimension, as van Doesburg was attempting to describe.

Van Doesburg's burgeoning interest in questions of the fourth dimension, apparent in his correspondence during the years 1918 and 1919, was the first crack in his relationship with Mondrian.[18] He began to question the concept of Neoplasticism as the final step in the trajectory of abstraction. Having set out his theoretical agenda on the notion of 'becoming', he could not reconcile himself to an end point reached so quickly. And he could not accept the model of personality implied in it as well. He had been enjoying the potential that the new identity of van Doesburg had offered him but it was not the only identity he had. In a fascinating letter of 1917, written to his friend the poet Antony Kok, he proposed using his real name, Küpper, as a pseudonym.[19] In the same letter he revealed he was writing for another journal under the name Pipifox, which may itself have been a replacement for a previous pseudonym.[20] It was at this point that he launched the career of his best known alter-ego, the poet I.K. Bonset, whose poems began appearing in *De Stijl*. As has been pointed out before, Bonset became a vehicle for exploring concepts of dynamism and multi-dimensionality which perhaps he felt could not be expressed at this stage through the figure of van Doesburg.[21]

Indeed, the very first Bonset text to be published, in May 1920, describes the dissolution of the human subject into the environment; it begins with the line, 'I am penetrated by the room through which the tram glides', and ends with the statement, 'SPACE/AM I.'[22] In between, the fragmenting of the poet's

Fig.55
Christian Emil Marie Küpper, c.1915

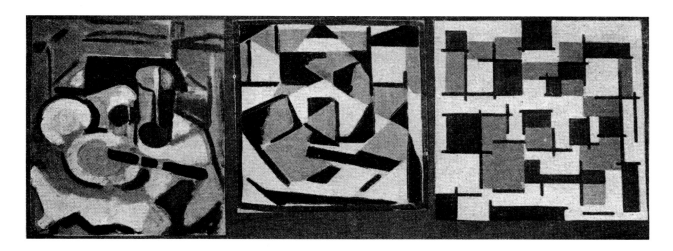

Fig.56
THEO VAN DOESBURG
Three Moments in the Formation of
a Composition, from 'Three Lectures
on the New Plastic Art' 1919

Fig.57
THEO VAN DOESBURG
Diagram from 'The Will to Style' 1922

subjectivity has interesting analogies to the process of abstraction van Doesburg had earlier attempted to describe theoretically:

> the rutsick vibrating treetop
> chops up the outsideofme
> into coloured material
> the blackwhite waterpoles
> 4 x HORIZONTAL
> incalculable vertical poles
> and also the high
> crooked blue

The dissolution of the human subject into qualities of colour and line, as figured here, has definite similarities to the destructive moment van Doesburg recounted in 'From "Nature" to "Composition"'. Writing shortly after publication to the architect and founder member of De Stijl, J.J.P. Oud, to reveal that he and Bonset were one and the same, van Doesburg explained that his 'plan of attack' would involve the 'splintering' of himself.[23] Only in this way would 'the old disappear.' From the start Bonset was not simply the other side to van Doesburg, an alternative irrational self to the rational one, but one of many potential identities.

The horizontals and verticals of Bonset's first poem, emphasised through its innovative typesetting, were challenged in a second, published shortly after, by diagonals. The notional topic was again the dissolution of a stable subjectivity, as registered in the first lines: 'have you exPERienced it phy SIC ally / 0^n / − space / − time / past present future / the behindhereandyonder / the interchangeability of nothing and appearance.'[24] The linear reading of the poem is then disrupted by two words at diagonals which cut into its structure. Quite appropriately they are ZIG-ZAG and DWARS, the latter meaning literally 'diagonal' but used frequently in colloquial terms to mean 'pig-headed,' 'contrary' or 'perverse'. Presenting Bonset that same summer to the Dada supremo, Tristan Tzara, van Doesburg wrote of his uncompromising character, that he was 'against everything and everyone.'[25]

Also assisting in making 'the old disappear' was ☞

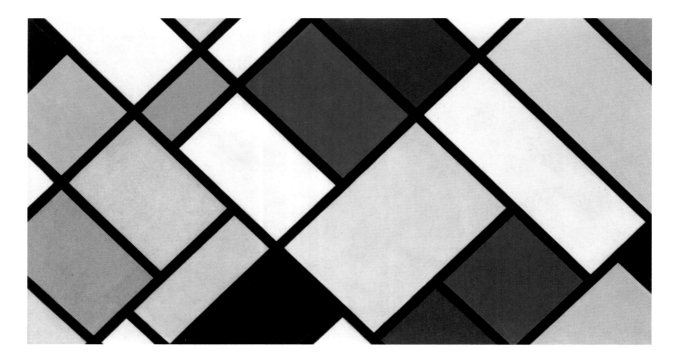

Fig.58
THEO VAN DOESBURG
Counter-Composition XVI 1925

yet another persona, that of Aldo Camini, an 'anti-philosopher' whose tracts began appearing in *De Stijl* a year later. Joost Baljeu, van Doesburg's first biographer, thought the name was derived from the Italian Futurist Giovanni Papini's 'Roman Discourse' of 1913 and its call for a new heroic man *che sa camminare da sè* (who knows how to walk unaided).[26] Van Doesburg was introduced to Papini's writings when taking Italian classes in 1916 and art historian Alied Ottevanger has proposed a slightly different reading of the pseudonym based on his teacher's interpretation of Papini's autobiography 'A Man Finished' as that of a man who does not stop *mezzo del cammin di nostra vita* (midway along the road of life).[27] Camini was to become the (anti) theoretical mouthpiece for the conception of the world Bonset was expressing poetically, cynically dismissive of traditional philosophies, totally engaged with relativity and fourth-dimensional theory and committed to showing their impact on questions of identity.[28] One text of Papini's we know for sure that van Doesburg read with great enthusiasm was the Dutch translation of his 1907 book *The Blind Pilot* which took the form of a series of fantastical stories dealing with problems of time, time travel and self-transformation. In his introduction to the translated edition, the Dutch poet Albert Verwey wrote about the transformatory experience of reading the book and posed the question, 'I-myself – am I the same as before? Is he who I have the consciousness of the same as who I am?... My world is in motion: it is a stream, a reflection, a never standing still semblance whereof the essence – yes where indeed, if anywhere – is to be sought, a phantasmagoria, a dream, dreamt by another.'[29] The first story of the book tells of the author's return to the town of his childhood and encounter with himself as a youth. He ends up drowning his former self in a pond out of disgust for his old life.

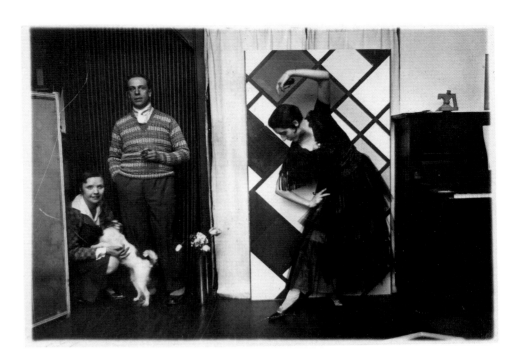

Fig.59
Nelly and Theo van Doesburg, the dog Dada and dancer Kamares in front of Counter-Composition XVI in 1925

Bonset and Camini's questioning of historical continuity and the teleological implications of the narrative of abstraction to be found in Neoplasticism started to break through into van Doesburg's writings. It became visible for the first time in the diagram he drew to illustrate his 1922 lecture 'The Will to Style' (fig.57). Here he still presented the end point of art history as Neoplasticism (represented in the diagram by the letters 'NG', *Neue Gestaltung*), and the key to the diagram explained how Neoplasticism had supposedly regained a balance lost since antiquity between the poles of 'nature' and 'spirit' represented by the horizontal lines at the top and bottom. However, the sharp diagonals which lead to this end point have no apparent diagrammatic value apart from emphasising direction and convergence. Their meaning has to be sought in the main text of the lecture, in which van Doesburg outlined his fundamental view of history as the replacement of cyclical notions of birth, flourishing and decay with 'continuous evolution'. As he went on, 'each new development contains the germ of decay and moreover ... all decay contains the possibility of a new beginning. Nowhere and never do we find an end. Everything is in a state of continuous development.'[30]

Why then do the diagonals converge? The diagram only makes sense if we imagine the diagonals in movement, in which case they mimic a famous diagram with which van Doesburg would have been familiar, the cone drawn by the French philosopher Henri Bergson to represent memory in his 1896 book *Matter and Memory*, a copy of which he owned. As Bergson described, the tip of this cone moves forward incessantly as the plane which it touches, which stands for the present, also moves forward. The orientation of the cone is significant; the present is not built up on the past but summons things from it as action requires.[31] Similarly, van Doesburg's diagram appears to invert and reverse expected polari-

ties. 'Nature' sits above 'spirit' and 'NG' could almost be read at first glance as less a point of arrival than one of emanation.

A year later, van Doesburg claimed Bergson to be a Dadaist and obviously saw the radical potential of his ideas.[32] We do not know if he was familiar with Bergson's most famous book, *Creative Evolution*, but the philosopher had used an analogy for evolution very different to the one of the tree we considered earlier. Life does not have a singular course, according to Bergson, but 'proceeds rather like a [bomb]shell, which suddenly bursts into fragments, which fragments, being themselves shells, burst in their turn into fragments destined to burst again, and so on for a time incommensurably long.'[33] Just like van Doesburg's 'splintering' of the self, for Bergson, personality was not predicted at birth: 'To mature is to go on creating oneself endlessly.'[34]

While writing 'The Will to Style', van Doesburg was revisiting another of his publications, in which he also used a notion of abstraction as sequence comparable to those discussed earlier. He was working on a German translation of his *Principles of Neo-Plastic Art*, which, when it appeared as a Bauhaus Book in 1925, would contain his now well-known montage of four images of a cow in stages from photograph to abstract painting.[35] The first section of this text not only discusses concepts of evolution, it relates them directly to individual human development. Van Doesburg invoked in this regard the Enlightenment philosopher Jean-Jacques Rousseau's 1762 study of childhood development, *Emile*, a striking, if covert, reference to his own previous identity. In terms of biology, van Doesburg connected his comments to Darwin and the work of the German scientist Jakob von Uexküll. He was an enthusiastic reader of Von Uexküll's *Foundations of a Biological Worldview* which argued strongly against a mechanistic application of the theory of evolution and particularly against what Von

DE STIJL

MAANDBLAD VOOR NIEUWE KUNST, WETENSCHAP
EN KULTUUR
Prix de ce numéro frs 10.-- S'adresser à Mme Pétro van Doesburg
41 Rue Charles Infroit, Meudon (S. et O.) France

DERNIER NUMÉRO JANVIER 1932

FÜR THEO VAN DOESBURG

den kopf nach unten
die beine nach oben
stürzt er in das bodenlose
dorthin von wo er hergekommen ist

er hat keine ehre mehr im leibe
beisst keinen biss mehr in einen imbiss
erwiedert keinen gruss
und hält nicht an selbst wenn man ihn anbetet

den kopf nach unten
die beine nach oben
stürzt er in das bodenlose
dorthin von wo er hergekommen ist

wie eine behaarte schüssel
wie ein vierbeiniger säugestuhl
wie ein tauber echostamm
halb voll halb leer

den kopf nach unten
die beine nach oben
stürzt er in das bodenlose
dorthin von wo er hergekommen ist

hans arp (meudon, märz 1931.)

1

THEO VAN DOESBURG
30 8 1883–7 3 1931

2

Fig.60
The last issue of De Stijl, January 1932, showing Hans Arp's poem 'For Theo van Doesburg' and a photograph of van Doesburg

Uexküll termed 'Darwinism', a view of evolution as strict continuity summed up in the phrase *natura non facit saltus* (nature makes no leap).[36] Proposing the complete opposite, Von Uexküll concentrated on surprise mutations in organisms and species.

By the mid-1920s, then, van Doesburg was primed to take a new direction and was to relate it both to concepts of autobiography and evolutionary theory, as explained in his article 'Painting: From Composition to Counter-Composition', which specifically invoked in its title his earlier 'From "Nature" to "Composition"'. The article began with a short autobiographical statement, recapitulating van Doesburg's key points of origin such as his first published articles, the outbreak of war, his demobilisation and the start of an assault on European culture. The main topic under discussion though was van Doesburg's recent *Counter-Composition* or Elementarist paintings. But in linking the artist's personal development to the 'general development of art', on this occasion he detailed not a process of advancement but a number of end points: the end of 'abstracting' from naturalistic form, the end of 'plastic' composition and the end of the combination of both of these in what he termed 'classical-abstract composition', a thinly veiled reference to Mondrian's Neoplasticism.[37] Entry into the 'new' was now fundamentally conditional on the rejection of both a previous means and a previous identity.

The most notable (and now infamous) feature of the *Counter-Compositions*, which the article aimed to justify, was their diagonal lines. As has been shown before, the 'process' van Doesburg went through to reach this 'new' stage was no longer successive or developmental but a simple act of rotation, turning his perpendiculars into diagonals.[38] Van Doesburg's awareness of the status of the issue of rotation in the history of abstract art is evidenced by a photograph taken at the time in his studio showing *Counter-Composition XVI* standing on its side behind the figure of a dancer (fig.59). As if in reversal of Kandinsky's story, it had been

made once more representational. Furthermore, he would tip over the evolutionary tree and he drew a diagram of it in the article to show the process not as branching but as divergence, or what he called 'the disturbance of the existing equilibrium.'[39] The only relationship between the vectors expressed in the diagram is that of obliqueness. Their ends are left unresolved and unproductive.

There came no new persona to accompany the *Counter-Compositions*. Instead the multiple identities of van Doesburg were gathered together under the sign of the diagonal line, whose meaning as 'contrary' has been discussed earlier in connection with his presentation of I.K. Bonset. We see this first in the rotation of the design of the book cover of *Principles of Neo-Plastic Art* to become a poster for a retrospective exhibition at the Little Review Gallery in New York (no.45). In the poster, 'Theo van Doesburg' rises towards the top right-hand corner, like a signature. It was a motif repeated to less dramatic effect in 1928/9 on a jacket design for van Doesburg's unpublished book *Modern Architecture in Holland* (Architecture nouvelle en Hollande). Finally, the association with the diagonal was fully confirmed on his death when the cover of the memorial edition of *De Stijl*, dedicated to him, was emblazoned with VAN DOESBURG diagonally across it, again on an upward trajectory. The letters' ascent into the ether was qualified, though, on the very first page of the issue in Hans Arp's dedicatory poem 'For Theo van Doesburg' (fig.60), the repeated refrain of which goes: 'Head below / legs above / he plunges into the bottomless / there from where he came.'[40] The Icarus metaphor is clear for all to read, but also the reminder that, for all the talk of 'progress' and 'development' surrounding abstract art, van Doesburg had begun and ended as 'someone en route from an obscure point of departure to an unknown place'.

NOTES

1 Although there are paintings from 1900 signed Theo Doesburg and from 1901 with abbreviations such as TvD, 1902 would appear to be the point from which he consistently used the name Theo van Doesburg.

2 Agnita Feis, 'Inleiding' in Haagsche Kunstkring, *Tentoonstelling van teekeninigen en schetsen van Theo van Doesburg*, The Hague 1908, n.p.

3 Theo van Doesburg, 'Proeve tot nieuwe kunstkritiek. I. Over schilder- en beeldhouwkunst, naar aanleiding van de Internationale tentoonstelling van schilderijen en beeldhouwen in het Sted. Museum te Amsterdam', *Eenheid*, no.111, 20 July 1912.

4 Emile Küpper, 'Brieven aan Bertha. Derde brief', manuscript dated 18 November 1914 Van Doesburg Archive, The Hague, no.522–4, n.p.

5 Ibid.

6 Wassily Kandinsky, 'Reminiscences/Three Pictures', in Kenneth Lindsay and Peter Vergo (eds.) *Complete Writings on Art*, Boston 1982, p.378.

7 Ernst Haeckel, *Generelle Morphologie der Organismen: Allgemeine Grundzüge der organischen Formen-Wissenschaft*, Berlin 1866.

8 Theo van Doesburg, 'Kunst-kritiek. Moderne kunst. Stedelijk Museum Amsterdam. Expositie Mondriaan, Leo Gestel, Sluijters, Schelfhout, Le Fauconnier', *Eenheid*, no.203, 6 November 1915.

9 Theo van Doesburg, *De Winter en zijn werk: Psychoanalytische studie*, Haarlem 1916.

10 Ibid., p.7.

11 Ibid.

12 Joop Joosten, 'Painting and Sculpture in the Context of De Stijl', in Mildred Friedman (ed.), *De Stijl: 1917–1931. Visions of Utopia*, Oxford 1983, p.52.

13 Theo van Doesburg, 'De stijl der toekomst', in *Drie voordrachten over de nieuwe beeldende kunst*, Amsterdam 1919, pp.49–64.

14 Theo van Doesburg, 'Van "natuur" tot "kompositie"', in *De Hollandsche Revue*, vol.24, no.8, August 1919, pp.470–6.

15 I have discussed this issue in my essay 'Abstraction, Sublation and the Avant-Garde' in Dietrich Scheunemann (ed.), *Avant-Garde and Neo-Avant-Garde*, Amsterdam 2005, pp.77–90.

16 For a discussion of van Doesburg and Poincaré see Linda Dalrymple Henderson, *The Fourth Dimension and Non-Euclidean Geometry in Modern Art*, Princeton 1983, pp.321–34.

17 Hubert van den Berg, *The Import of Nothing: How Dada Came, Saw and Vanished in the Low Countries (1915–1922)*, New Haven and London 2002, p.132.

18 See Carel Blotkamp, 'Theo van Doesburg' in *De Stijl: The Formative Years 1917–1922*, Cambridge MA and London 1986, p.30.

19 Theo van Doesburg, letter to Antony Kok, 22 May 1917, Van Doesburg Archive, The Hague, no.2202.

20 See Alied Ottevanger, 'De brieven en de schrijvers: Theo van Doesburg en Antony Kok', in *'De Stijl overall absolute leiding': De briefwisseling tussen Theo van Doesburg en Antony Kok*, Bussum 2008, p.46.

21 Blotkamp 1986, p.30.

22 I.K. Bonset, 'X-Beelden', *De Stijl*, vol.3, no.7, May 1920, p.57.

23 Letter from Theo van Doesburg to J.J.P. Oud, 12 July 1920, Fondation Custodia, Paris.

24 I.K. Bonset, 'X-Beelden', *De Stijl*, vol.3, no.9, July 1920, p.77.

25 Letter from Theo van Doesburg to Tristan Tzara, 27 June 1920, Bibliothèque Littéraire Jacques Doucet, Paris.

26 Joost Baljeu, *Theo van Doesburg*, London 1974, p.47.

27 Alied Ottevanger, 'De brieven en de schrijvers: Theo van Doesburg en Antony Kok', p.46.

28 See, for example, chapter 5 of Camini's so-called 'Caminoscopie': 'Het identiteitsprinciep', in *De Stijl*, vol.4, no.6, June 1921, pp.84–7.

29 Albert Verwey, 'Inleiding', in Giovanni Papini, *De blinde loods*, Amsterdam 1908, p.xi.

30 Theo van Doesburg, 'Der Wille zum Stil', *De Stijl*, vol.5, no.2, February 1922, p.25.

31 Henri Bergson, *Matter and Memory*, trans. N.M. Paul and W.S. Palmer, New York 1988, p.152. Van Doesburg may also have had in mind the 'movement of the triangle' described in Wassily Kandinsky's book *Concerning the Spiritual in Art* (Über das Geistige in der Kunst) of 1912, a copy of which he owned. He was also in contact with Wyndham Lewis by 1919 and could well have been familiar with his image of the Vortex.

32 Theo van Doesburg, *Wat is Dada???*, The Hague 1923, p.9.

33 Henri Bergson, *Creative Evolution*, trans. Arthur Mitchell, London 1919, p.103.

34 Ibid., p.8.

35 Theo van Doesburg, 'Grondbegrippen der nieuwe beeldende kunst', *Tijdschrift voor Wijsbegeerte*, vol.13, 1919, no.1, pp.30–49 and no.2, pp.169–88. *Grundbegriffe der neuen gestaltenden Kunst*, Bauhaus Book no.6, Munich 1925.

36 Jakob von Uexküll, *Bausteine zu einer biologischen Weltanschauung*, Munich 1913, p.17.

37 Theo van Doesburg, 'Schilderkunst. Van kompositie tot contra-kompositie', *De Stijl*, vol.7, no.73/74, 1926/7, pp.17–28.

38 Carel Blotkamp, *Mondrian: The Art of Destruction*, London 1994, p.193.

39 Van Doesburg 1926/7, p.26.

40 Hans Arp, 'Für Theo van Doesburg', *De Stijl*, January 1932 (last issue), p.1.

1.
INTRODUCTION & DE STIJL

'BY WAY OF INTRODUCTION' DE STIJL, VOL.1, NO.1, OCTOBER 1917, PP.1-2

'This journal will make a contribution to the development of a new consciousness of beauty. It will make the modern person receptive to the new in Fine Art. In opposition to archaic confusion – the "modern baroque" – it will establish the logical principles of a maturing style in pure relationship to the spirit of the time and means of expression. It will unite in itself the latest conceptions concerning the new plasticism, which, however alike they are in essence, have developed independently of each other. [...]

In so doing it will prepare the possibility for a deepened artistic culture, founded on communal embodiment of the new plastic artistic consciousness. As soon as artists in the different visual fields acknowledge that they are in principle alike, that they share a common language, they will no longer cling anxiously to their individuality. They will serve a common principle beyond a restricted individuality. The serving of such a common principle must of itself produce an organic style. Not a social but a spiritual community is necessary for the dissemination of the beautiful. A spiritual community can not actually come into being without the sacrifice of an ambitious individuality.' [...]

'NOTES ON MONUMENTAL ART: OCCASIONED BY TWO BUILDING FRAGMENTS (HALL IN THE HOLIDAY HOUSE IN NOORDWIJKERHOUT)' DE STIJL, VOL.2, NO.1, NOVEMBER 1918, PP.11–12

[...] 'Architecture produces a constructive, thus closed plasticity. It is for that reason neutral in contrast to painting which produces open plasticity by means of flat colour formation. For that reason painting is neutral in contrast to architecture. Architecture joins together, it binds. Painting frees and disintegrates. Because they have in essence different functions to perform, a harmonious combination is possible. Harmonious combination comes about not through characteristic equality but really through characteristic oppositionality. This oppositionality, in the complementary relationship of architecture and painting, of plastic form and flat colour, provides the basis for pure monumental art. Not only does painting place the free and open against the constructive and closed, expansion against restriction, it also it stirs the organically closed plasticity out of its constriction, placing movement against stability. This movement is obviously not an optical-material one but an aesthetic one and because it is aesthetic, this movement, which according to the practice of painting is formed through colour relationship, must be brought to rest by a counter-movement. The neutral character of architectural plasticity assists in this regard.' [...]

'THE DEVELOPMENT OF MODERN PAINTING', DRIE VOORDRACHTEN OVER NIEUWE BEELDENDE KUNST (AMSTERDAM: MAATSCHAPPIJ VOOR GOEDE EN GOEDKOOPE LECTUUR, 1919), P.5

'Life is in continual motion.

We perceive life externally and internally. Art expresses our perception of life, not only the *external* perception but above all the *internal*. The more this perception fixes itself on the *external* the more superficial art is. The more this perception directs itself to the *internal*, the deeper, more spiritual and more abstract art will be.

Thus art all through the ages in its many forms has manifested the relationship which different peoples had to life; everything that these peoples discovered in life, they expressed in their art. Hence art has concerned itself with the highest truth of the relation between peoples and life. Because the subject of art is eternally changing life, its means of expression is necessarily constantly changing. This continual change is the *movement* or evolution of art. Art is continually in movement because life commands it to be so and whenever it happens to us, such as now, that we do not understand the art of this time, it is not because art stands still, but because *we* do not move together with art.

We stood still and art went past us: that's what so many of us experience at the moment. I intend in this lecture to bring you closer to the art of today, that is painting, in order to make you see the way in which, before our very eyes, art has seized its independent existence.' [...]

'MANIFEST I OF "DE STYLE"', DE STIJL, VOL.2, NO.1, NOVEMBER 1918, P.4

1. There is an old and a new consciousness of time.
The old is connected with the individual.
The new is connected with the universal.
The struggle of the individual against the universal is revealing itself in the world-war as well as in the art of the present day.
2. The war is destroying the old world with its content: individual domination in evey state.
3. The new art has brought forward what the new consciousness of time contains: a balance between the universal and the individual.
4. The new consciousness is prepared to realise the internal as well as the external life.
5. Traditions, dogmas and the domination of the individual are opposed to this realisation.
6. The founders of the new plastic art therefore call upon all, who believe in the reformation of art and culture, to annihilate these obstacles of development, as they have annihilated in the new plastic art (by abolishing natural form) that, which prevents the clear expression of art, the utmost consequence of all art notion.
7. The artists of to-day have been driven the whole world over by the same consciousness, and therefore have taken part from an intellectual point of view in this war against the domination of individual despotism. They therefore sympathize with all, who work for the formation of an international unity in Life, Art, Culture, either intellectually or materially.
8. The monthly editions of "The Style", founded for that purpose, try to attain the new wisdom of life in an exact manner.
9. Co-operation is possible by:
I. Sending, with entire approval, name, address and profession to the editor of "The Style".
II. Sending critical, philosophical, architectural, scientific, literary, musical articles or reproductions.
III. Translating articles in different languages or distributing thoughts published in "The Style".

Signatures of present collaborators:
THEO VAN DOESBURG, Painter
ROBT. VAN 'T HOFF, Architect
VILMOS HUSZÁR, Painter

ANTONY KOK, Poet
PIET MONDRIAAN, Painter
G. VANTONGERLOO, Sculptor
JAN WILS, Architect

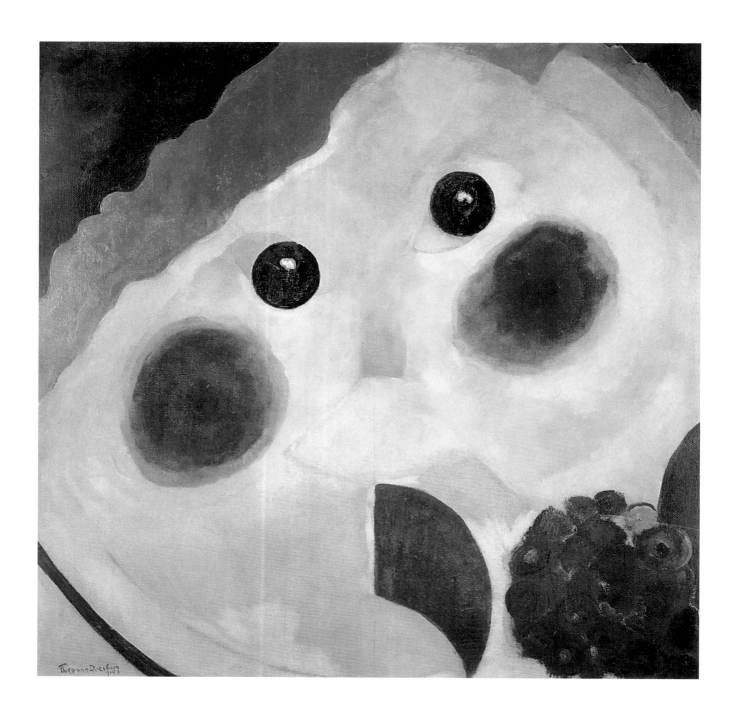

1
THEO VAN DOESBURG
Girl with Buttercups 1914

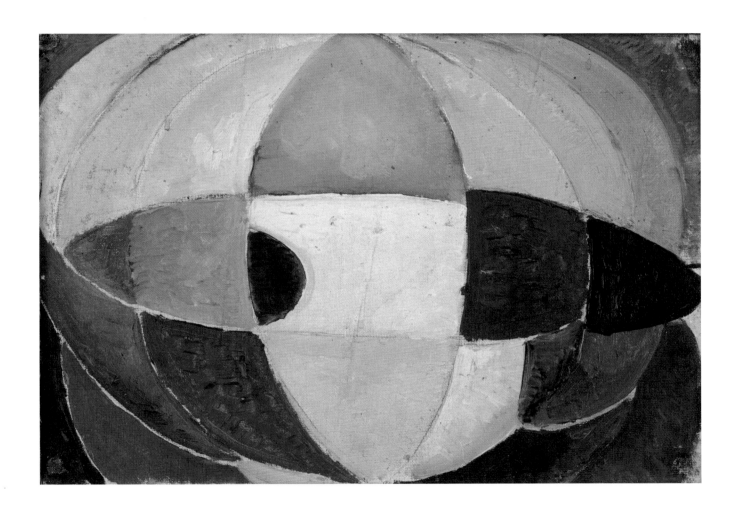

2
THEO VAN DOESBURG
Sphere 1916

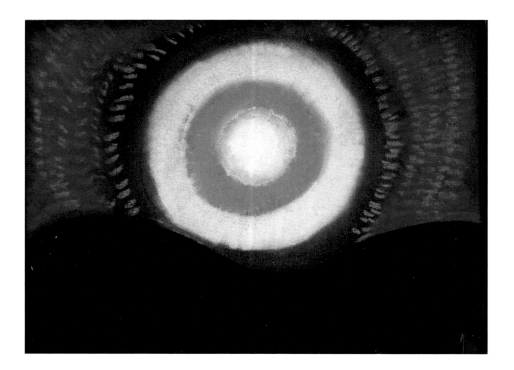

3
THEO VAN DOESBURG
Cosmic Sun 1915

4
THEO VAN DOESBURG
Composition 1915

5
THEO VAN DOESBURG
Mouvement héroïque 1916

6
THEO VAN DOESBURG
Composition III (Still Life) 1916

7
THEO VAN DOESBURG
Composition I (Still Life) 1916

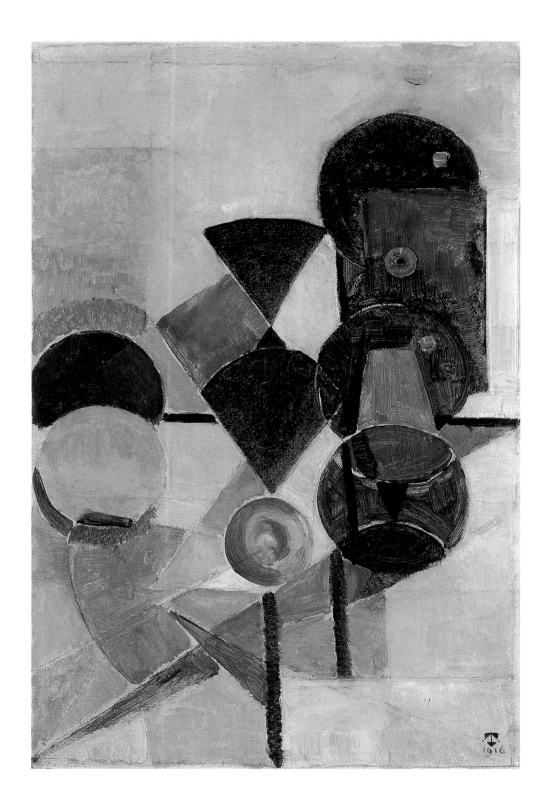

8
THEO VAN DOESBURG
Composition II (Still Life) 1916

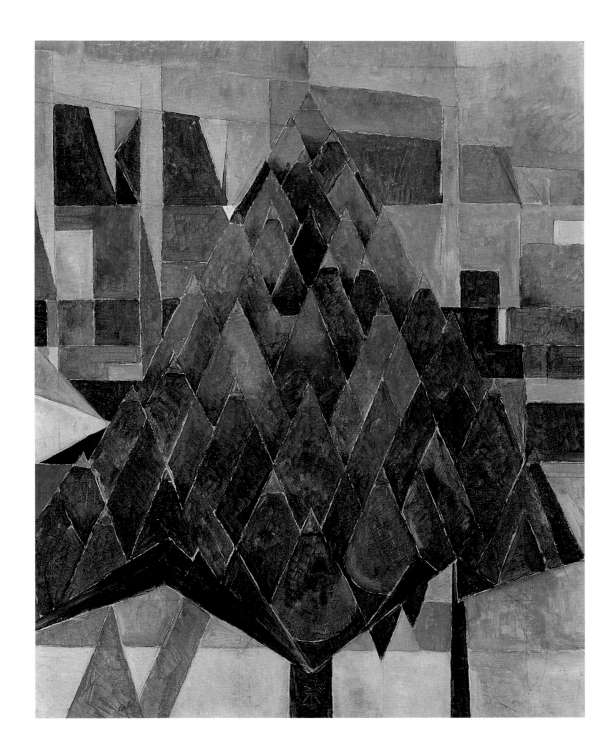

9
THEO VAN DOESBURG
Tree 1916

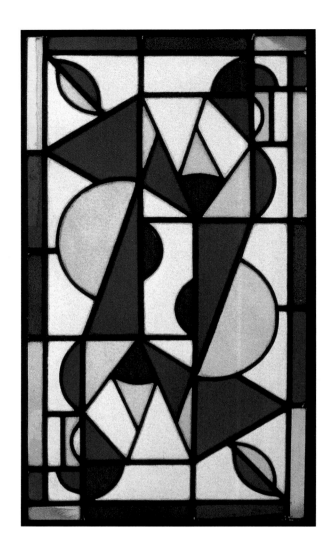

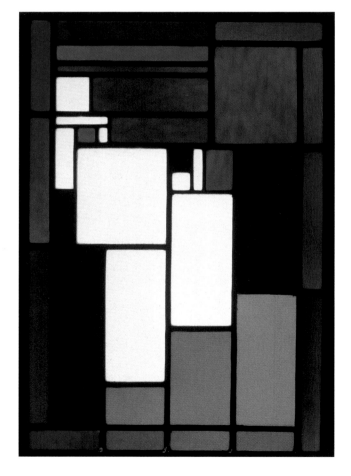

10
THEO VAN DOESBURG
Dance I 1917

11
THEO VAN DOESBURG
Stained-Glass Composition
Female Head 1917

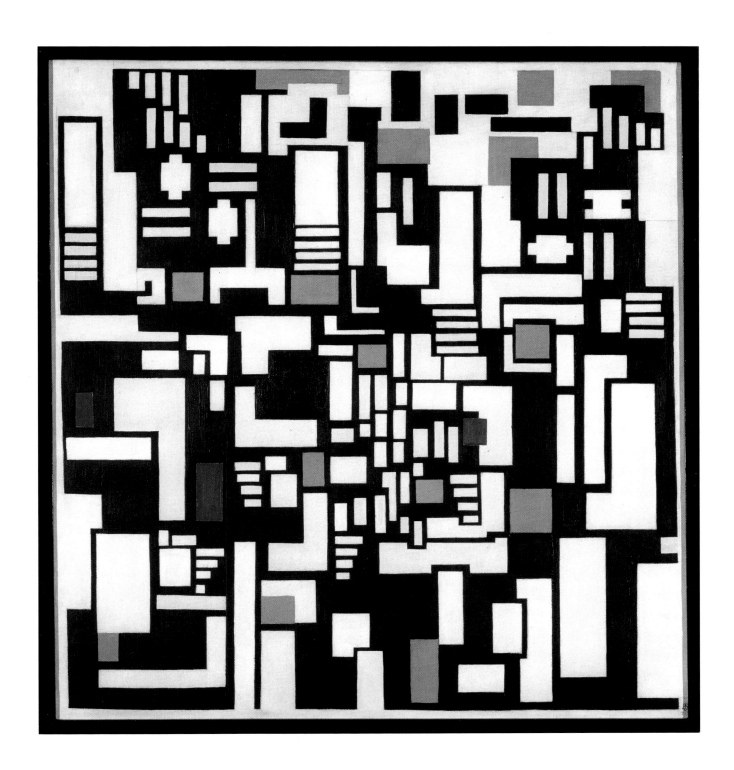

12
THEO VAN DOESBURG
Composition IX, Opus 18
'Decomposition' of The Card Players 1917

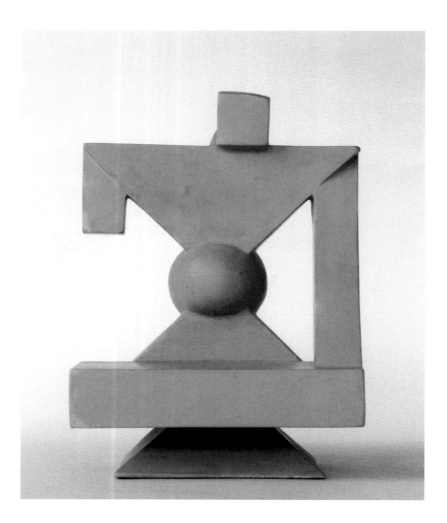

13
GEORGES VANTONGERLOO
Construction in a Sphere 1918

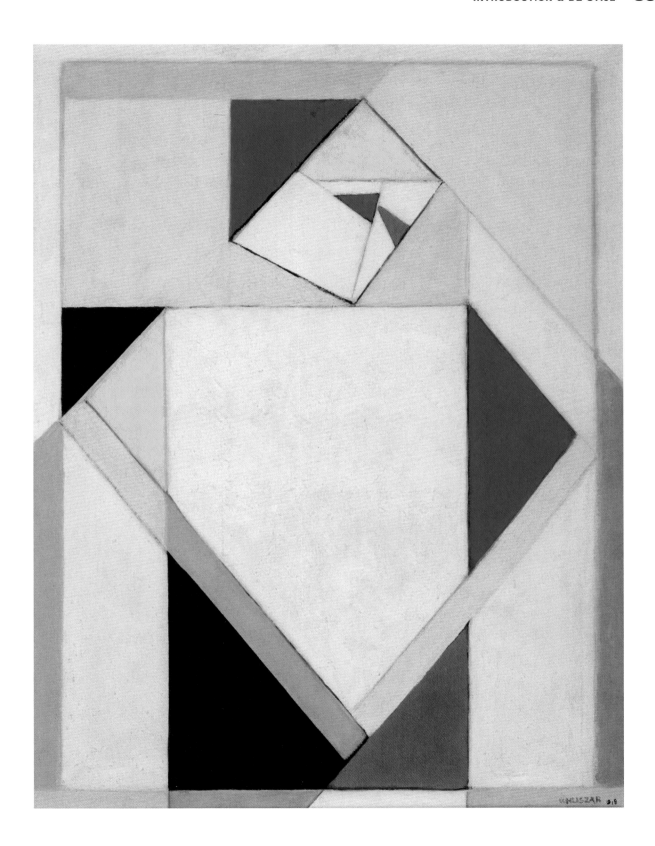

14
VILMOS HUSZÁR
Composition with Female Figure 1918

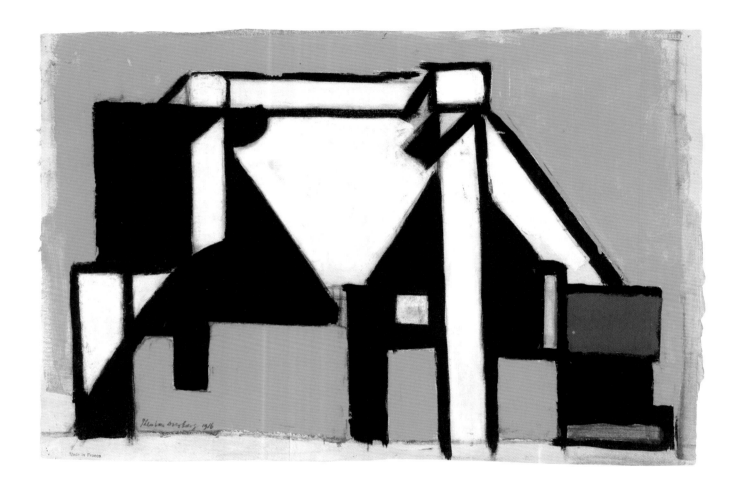

15
THEO VAN DOESBURG
Composition (The Cow) c.1917

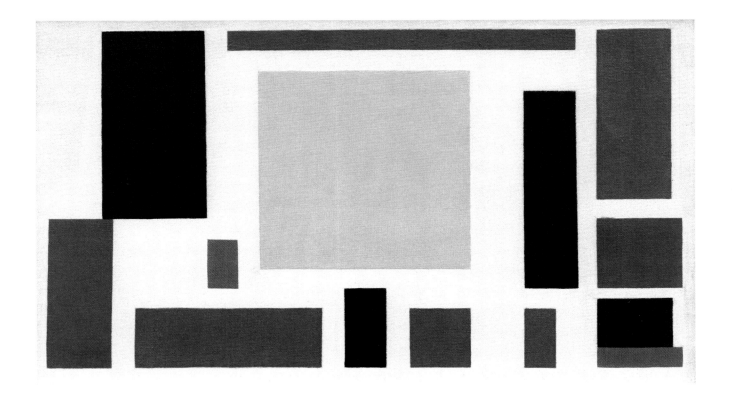

16
THEO VAN DOESBURG
Composition VIII (The Cow) c.1918

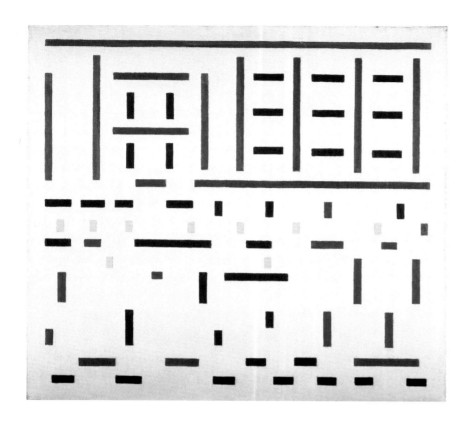

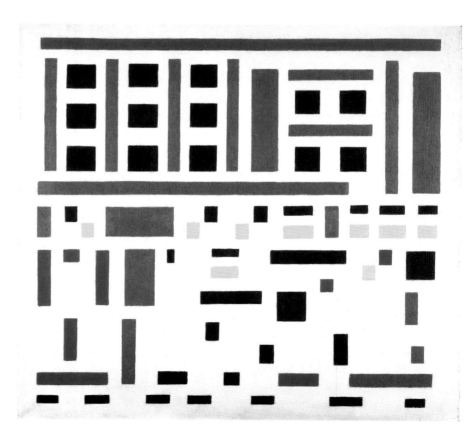

17
BART VAN DER LECK
Composition 1917 no.3
(Leaving the Factory) 1917

18
BART VAN DER LECK
Composition 1917 no.4
(Leaving the Factory) 1917

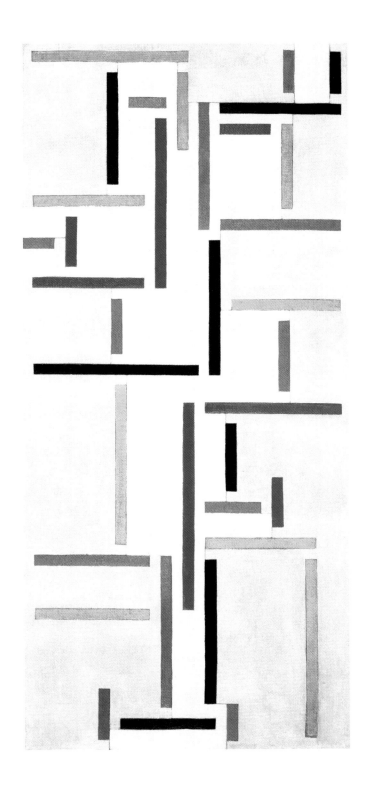

19
THEO VAN DOESBURG
Rhythm of a Russian Dance 1918

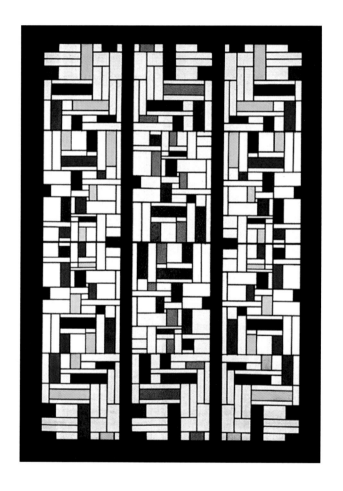

20
THEO VAN DOESBURG
Stained-Glass Composition IV
for the De Lange House, Alkmaar 1917

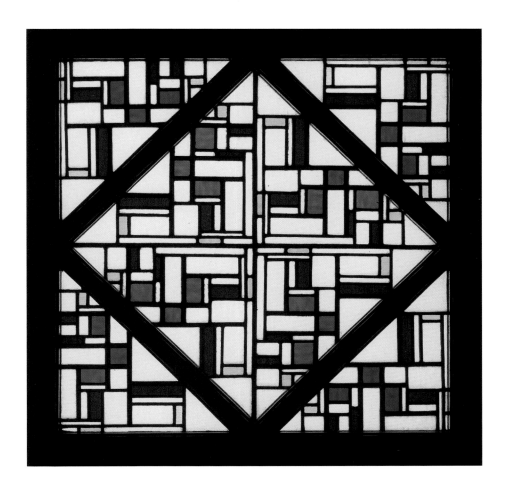

21
THEO VAN DOESBURG
Stained-Glass Composition III
Teacher's house in Sint Anthoniepolder 1917

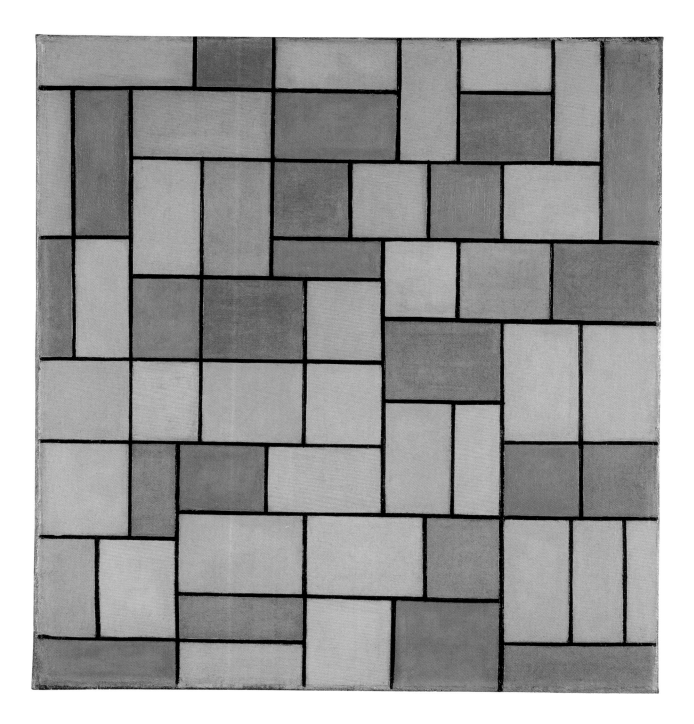

22
THEO VAN DOESBURG
Composition in Dissonances 1919

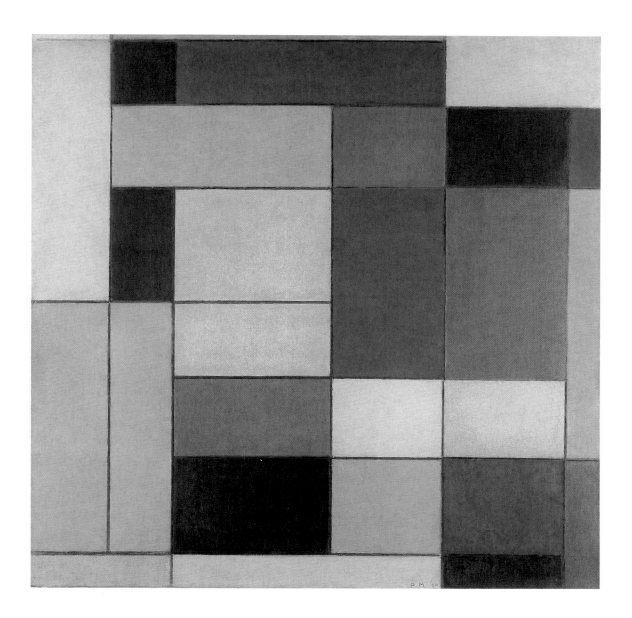

23
PIET MONDRIAN
No.VI/Composition No.II, 1920 1920

24
THEO VAN DOESBURG
Composition XI 1918

25
THEO VAN DOESBURG
**Stained-Glass Composition IX: stained glass for housing
blocks I and V in the Spangen district, Rotterdam** 1918–19

26
PIET MONDRIAN
Composition with Grid 9
Checkerboard Composition with Light Colours, 1919 1919

27
PIET MONDRIAN
Composition with Grid 8
Checkerboard with Dark Colours, 1919 1919

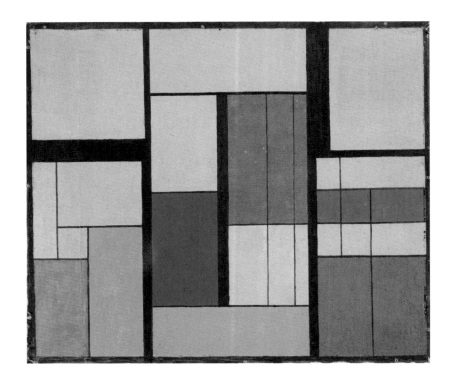

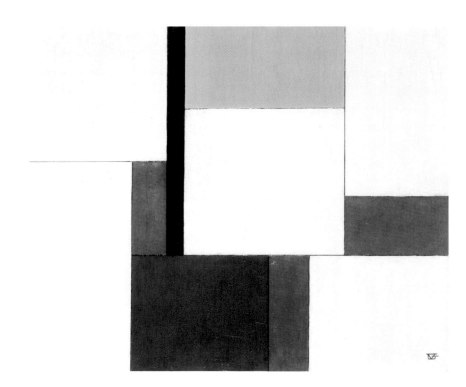

28
GEORGES VANTONGERLOO
Composition II, Indigo Violet
Derived from Equilateral Triangle 1921

29
GEORGES VANTONGERLOO
Composition of Three Parallel Lines 1921

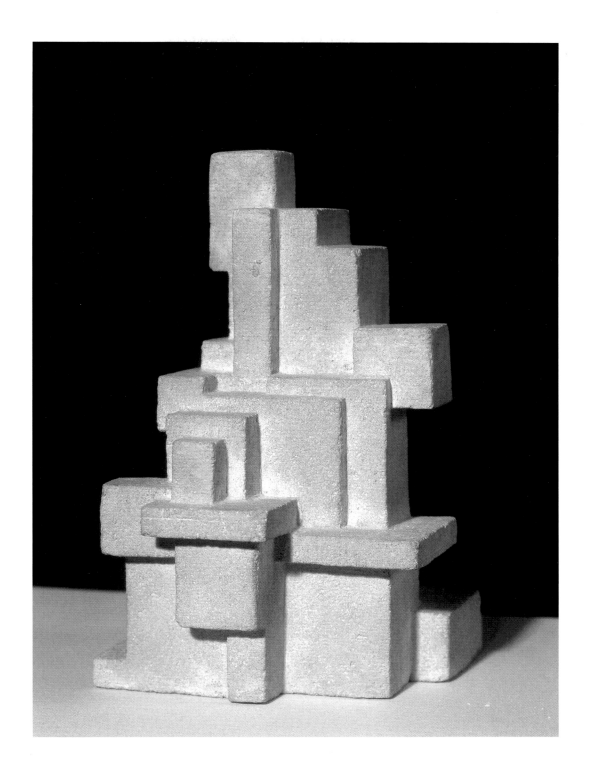

30
GEORGES VANTONGERLOO
Interrelation of Volumes 1919

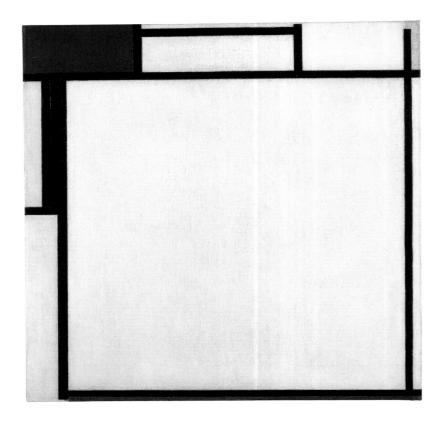

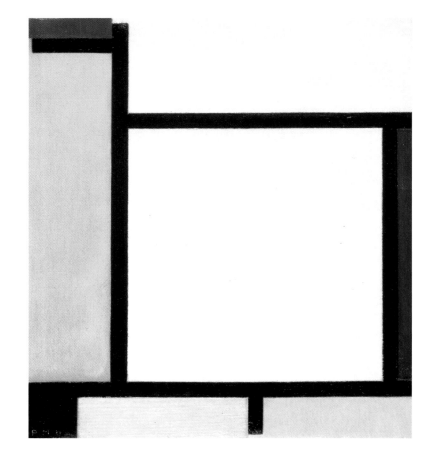

31
PIET MONDRIAN
Composition with Blue, Yellow
Black and Red, 1922 1922

32
PIET MONDRIAN
Composition with Red, Blue
Black, Yellow and Gray, 1921 1921

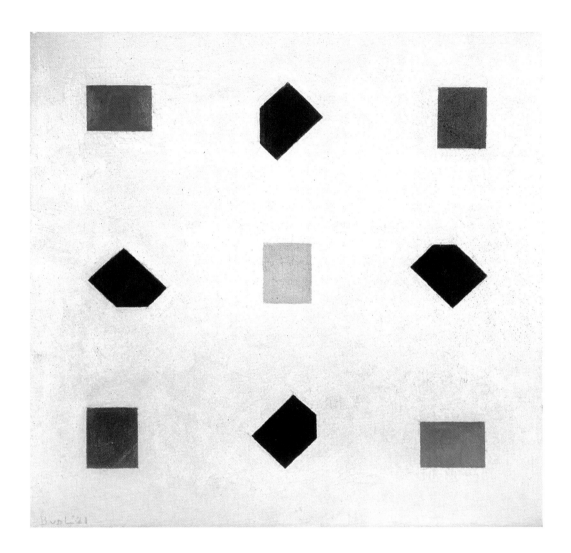

33
BART VAN DER LECK
Composition 1921

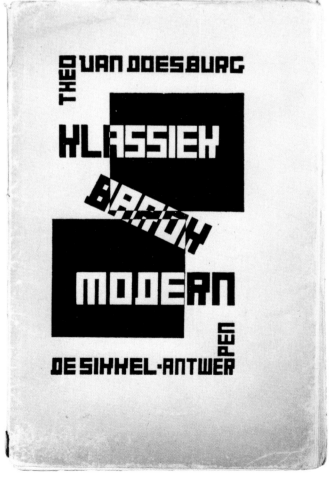

34
VILMOS HUSZÁR
Public Housing Poster
Hague Art Circle 1919

35
THEO VAN DOESBURG
Classic Baroque Modern 1920

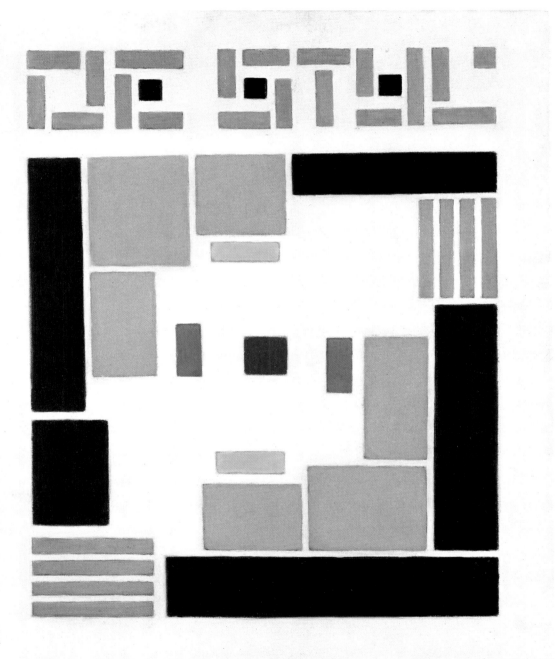

COMP. 1916 V. HUSZÁR

36
VILMOS HUSZÁR
Composition 'De Stijl' Designed 1916, executed 1950–5

37
THEO VAN DOESBURG
Printed matter for Hagemeyer & Co Exporters 1919

38
NELLY VAN DOESBURG (ED.)
De Stijl, 1917–31, last issue, January 1932

39
THEO VAN DOESBURG
Letter paper. Typography for De Stijl 1921

40
THEO VAN DOESBURG
Cover design for 'The Theory of
Syndicalism' by Clara Wichmann 1920

41
THEO VAN DOESBURG
Monogram Design for Antony Kok 1919

42
THEO VAN DOESBURG
Design for a cheese label 1919

43
THEO VAN DOESBURG
Ashtray for Café Aubette 1927

44
THEO VAN DOESBURG
Design for cover of Principles of Neo-plastic Art 1924

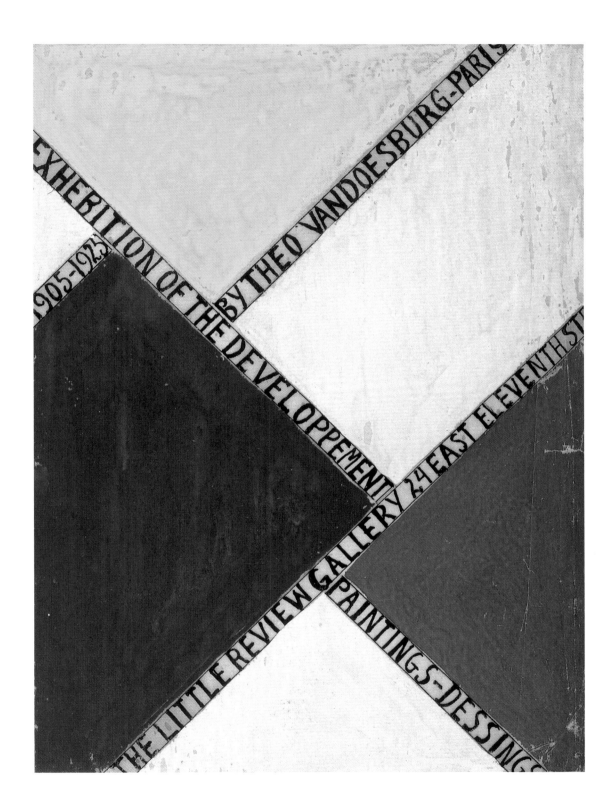

45
THEO VAN DOESBURG
Design for poster for The Little Review 1925

46
PIET ZWART
Publicity card for Vickers House
rubber flooring c.1922

47
FREDERICK KIESLER
Layout and design for International
Exhibition of New Theatre Techniques
catalogue 1924

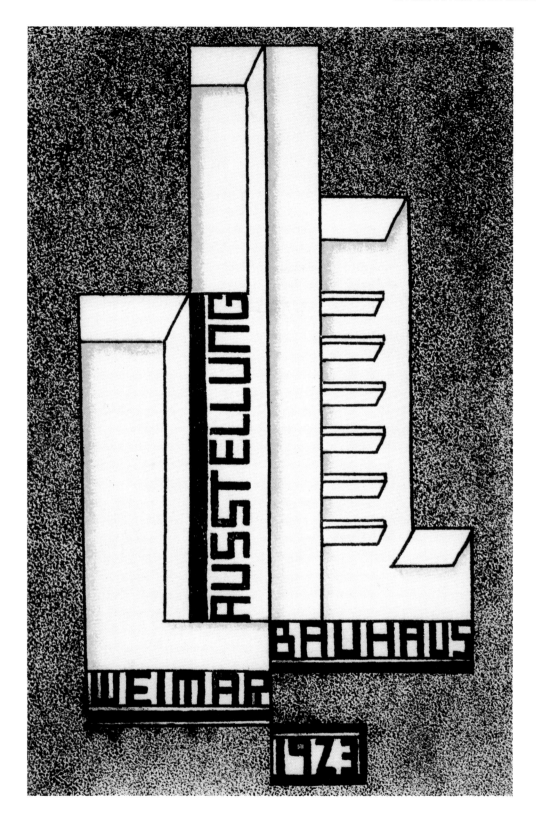

48
FARKAS MOLNÁR
Postcard for the State Bauhaus Exhibition
Weimar July–September 1923

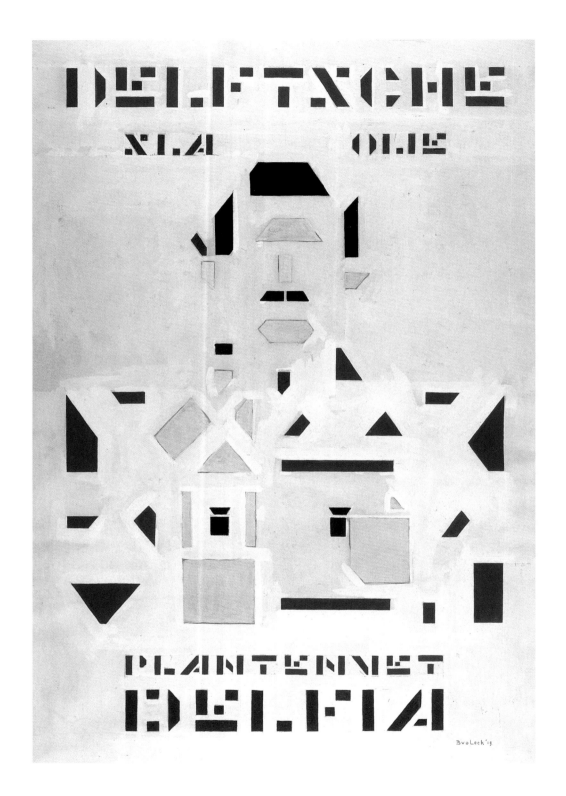

49
BART VAN DER LECK
Delft Salad Oil, definitive
version for poster (state 10) 1919

50
VILMOS HUSZÁR
Poster for Miss Blanche
Virginia Cigarettes 1926

51
J.J.P. OUD
THEO VAN DOESBURG
Brick mosaic for De Vonk holiday home, Noordwijkerhout
NOT EXHIBITED

52
J.J.P. OUD
THEO VAN DOESBURG
Tiled floor in De Vonk holiday home
NOT EXHIBITED

53
THEO VAN DOESBURG
Design for a tiled floor, De Vonk
holiday home, Noordwijkerhout c.1917–18

54
THEO VAN DOESBURG
Colour scheme for front wall, Potgieterstraat (block VIII)
Drawing A and A', colour designs for the housing blocks
VIII and IX in the Spangen district, Rotterdam 1921

VOLTOOIDE GEVEL AAN DE POTGIETERSTRAAT.

DIT HOEKPAND BEHOORT NIET TOT DIT BOUWBLOK.

55
THEO VAN DOESBURG
Colour design for back wall, Pieter Langendijkstraat (block VIII), colour designs
for the housing blocks VIII and IX in the Spangen district, Rotterdam 1921

56
THEO VAN DOESBURG
Colour design for front wall, Potgieterstraat (block VIII), Drawing B
colour designs for the housing blocks VIII and IX in the Spangen district, Rotterdam 1921

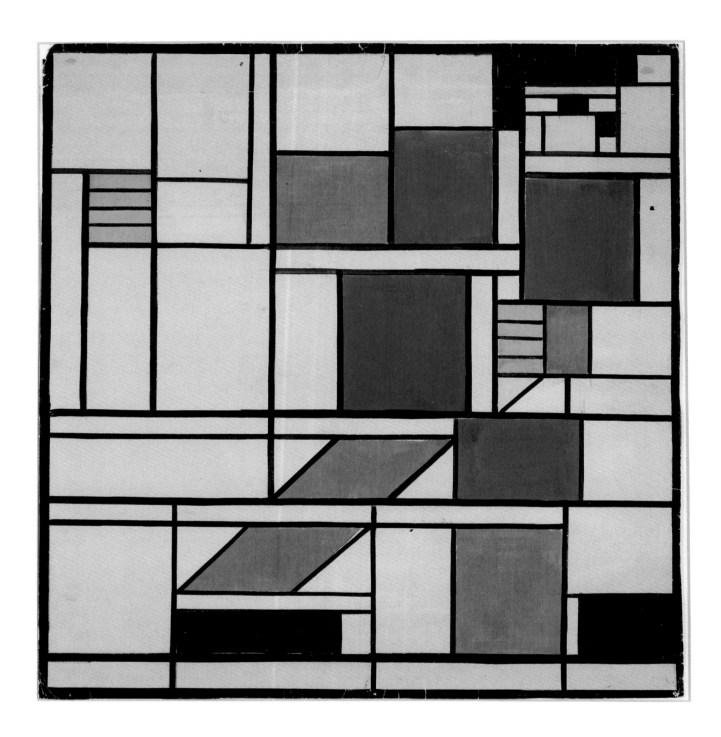

57
THEO VAN DOESBURG
Definitive design for the Sower, stained-glass windows
Large Pastorale and Small Pastorale, Agricultural
Winter School, Drachten 1922

58
GERRIT RIETVELD
Hanging Lamp 1922

59
GERRIT RIETVELD
Sideboard Design 1919, reconstruction 1996

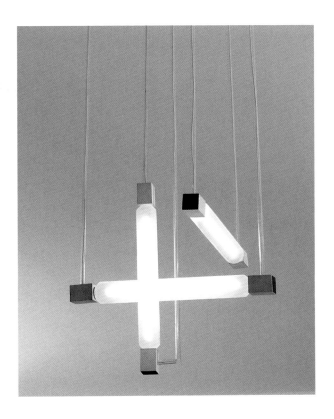

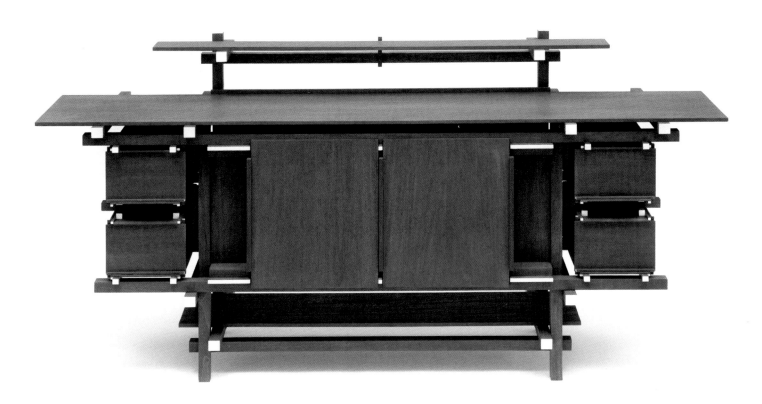

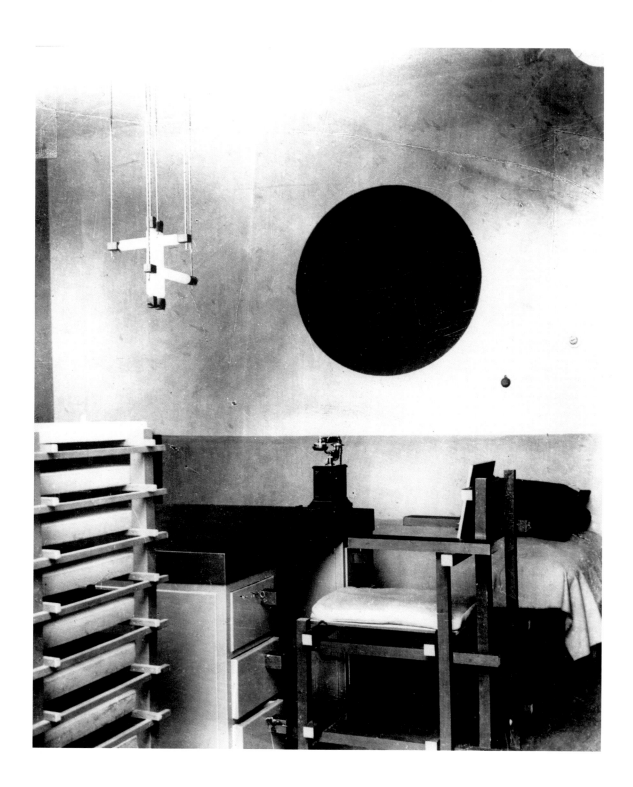

60
Associated with GERRIT RIETVELD
Study for the office of
Dr A.M. Hartog, Maarssen 1922

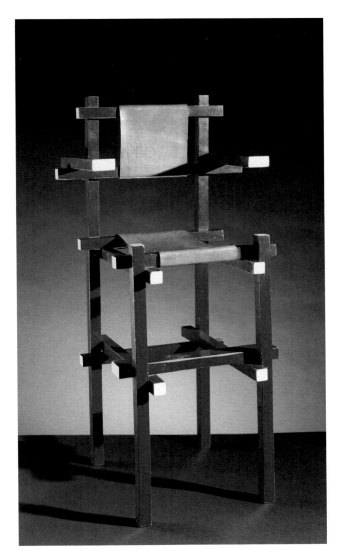

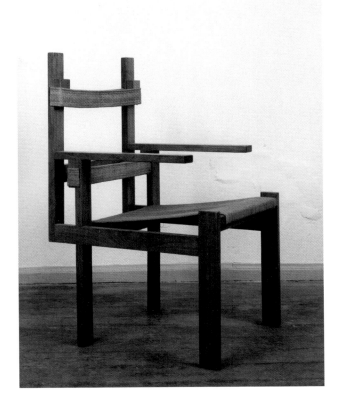

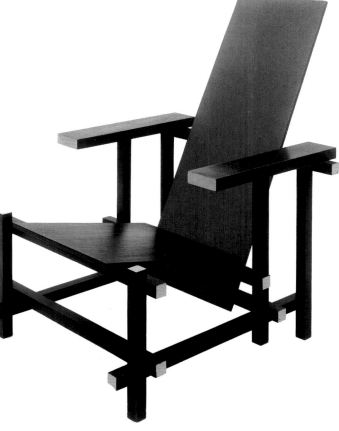

61
GERRIT RIETVELD
Associated with GROENEKAN
Child's Highchair c.1921, reconstruction 1965

62
MARCEL BREUER
Armchair 1922

63
GERRIT RIETVELD
Red-blue chair 1923

2.

INTERNATIONAL CONTACTS 1920-1923

'MANIFESTO III: TOWARDS A NEW WORLD PLASTICISM', DE STIJL, VOL.4, NO.8, AUGUST 1921, P.126

[...] There is no longer any help for Europe. Concentration and possession, spiritual and material individualism were the foundations of the old Europe. It imprisoned itself in them. It can no longer escape from them. It is going to ruin. We look on calmly. Even if we were able to do so, we should not wish to help. We do not wish to prolong this old prostitute's life.

Already a new Europe has begun in us. The ludicrous socialist 1-2-3 Internationals were only external; they consisted only of words. The international of the spirit is **internal**, unexpressed. It does not consist of words, but of creative deeds and internal force. Spiritual force. With this a new world order is being formed. [...]

'WHAT IS DADA???', THE HAGUE, 1923, P.10–11

Dada rejects evolution. Every movement engenders a counter-movement of equal strength which cancel each other out. Nothing really changes. The world remains ever as it was. Dada has completely abolished the generally accepted duality of matter and spirit, man and woman, and hereby created the 'point of indifference', a point above all human comprehension of time and space. By this means, Dada possesses the ability to make mobile the fixed view and the vanishing point, which kept us imprisoned in our (three-dimensional delusions). In this way it became possible to see the entire prism of the world in one go rather than one facet. With respect to this, Dada is one of the strongest manifestations of the fourth dimension, transposed on to the subject. For every 'yes' Dada simultaneously sees the 'no'. Dada is a yes-no: a bird with four legs, a ladder without rungs, a square with no corners. Dada possesses positive and negative in equal measure. To hold the opinion that Dada is only destructive is to misunderstand life, of which Dada is the expression. To fight Dada is to fight oneself. Dada wants to have done with the division between transcendental and everyday reality. Dada is the need for uniform world reality made up of dissonant and contrasting relationships. Dada sees nature not as the attractive phenomenon we so readily imagine it to be, but as the stinking corpse which spoils our spiritual pleasures and immediately transforms everything into a state of decay: everyone from cleaner to artist (in essence one and the same thing) battles against the decomposition of nature.

DECLARATION OF THE INTERNATIONAL FACTION OF CONSTRUCTIVISTS AT THE FIRST INTERNATIONAL CONGRESS OF PROGRESSIVE ARTISTS, DE STIJL, VOL.5, NO.4, APRIL 1922, PP.61–4

We came to Dusseldorf with the definite will to form an International. The following turned out to be the case.

Union

I. The founding call of the Union emphasised the 'warm, lively interrelation of international spirits' as the basis of the organisation.

II. There is total lack of clarity concerning the actual purpose of the Union, whether its job is that of a trade union working on behalf of economic interests or whether it should form an economical apparatus as the means to carry out particular cultural interests.

III. There is no definition of the concept 'progressive artist'. Questions of this kind were **excluded** from the agenda on grounds that the manner in which people approach the problem of art is a totally personal matter.

IV. As it appears from the founding manifesto, the Union has provided for a series of enterprises aimed primarily at an international business in picture exhibitions. The Union has, in this regard, a plan to pursue a commercial colonial politics.

Us

I. Good will is not a programme and therefore cannot serve as the basis of an organisation, especially not when at this time good will is failing, and it is not put into action within the Congress as regards to the opposition.

II. It is clear to us that first a definitive statement on the problem of art must be produced and only in connection to that can questions of economics come into consideration.

III. We define the progressive artist as one who rejects and fights the tyranny of the subjective in art and constructs his work not from lyrical capriciousness but rather from the principle of the new forms, through the systematic organisation of the medium into a universally comprehensible expression.

IV. We reject the present exhibition, set out like a warehouse, where trade is pursued in things with no relationship put next to each other. We stand today between a society which does not need us and one which does not yet exist; for us the only exhibitions to be considered are those serving as demonstration of what we want to achieve (designs, plans, models) or what we have already realised.

For the reasons mentioned, it is clear that an International of progressive artists can only come about on the following basis:

a) Art, just like science and technology, is a method for organising life generally.

b) We demand that art stop being a dream and direct itself instead to the reality of the world, stop being a means of revealing cosmic secrets. Art is a universal and real expression of creative energy, which organises the progress of humanity, that is to say, it is the tool of universal working processes.

c) To bring this change about in reality, a struggle is necessary and we should be organised for this struggle. This is the only way that the collective energy can be released. This is the way to unite principles and economics.

The actions of the Congress have proved that the tyranny of individuals prevents the formation of an international and progressive solidarity founded on the elements of this Congress.

Düsseldorf, 30 May 1922

Theo van Doesburg
El Lissitzky
Hans Richter

64
THORVALD HELLESEN
Painting 1920

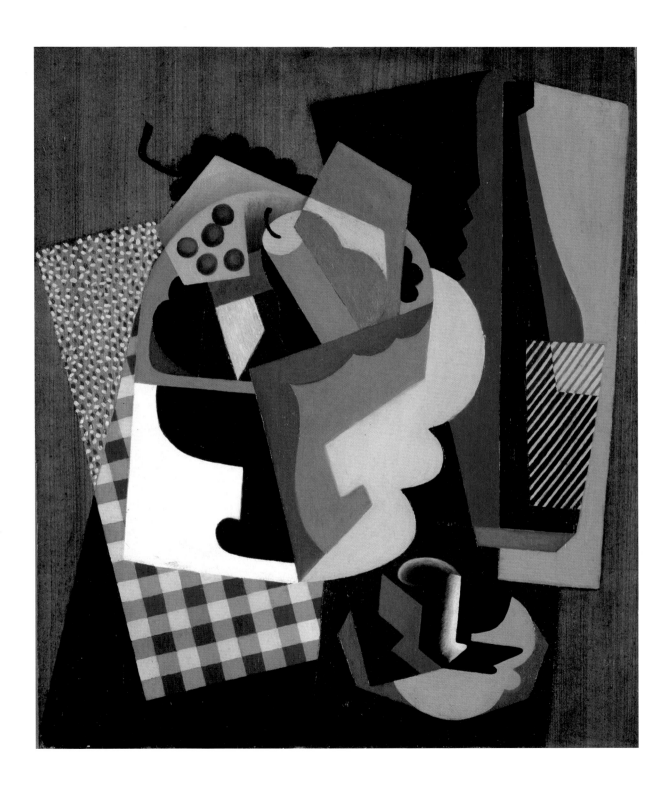

65
GINO SEVERINI
Still Life with Blue Grapes 1916

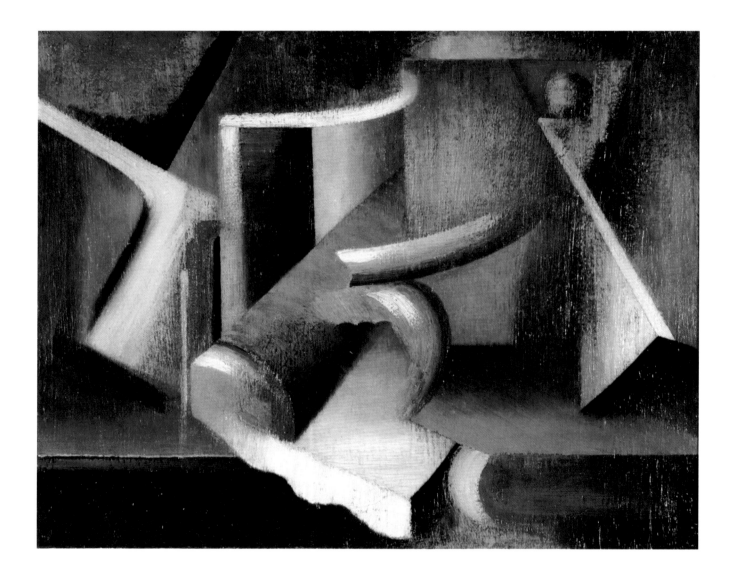

66
MARTHE (TOUR) DONAS
Still Life 1920

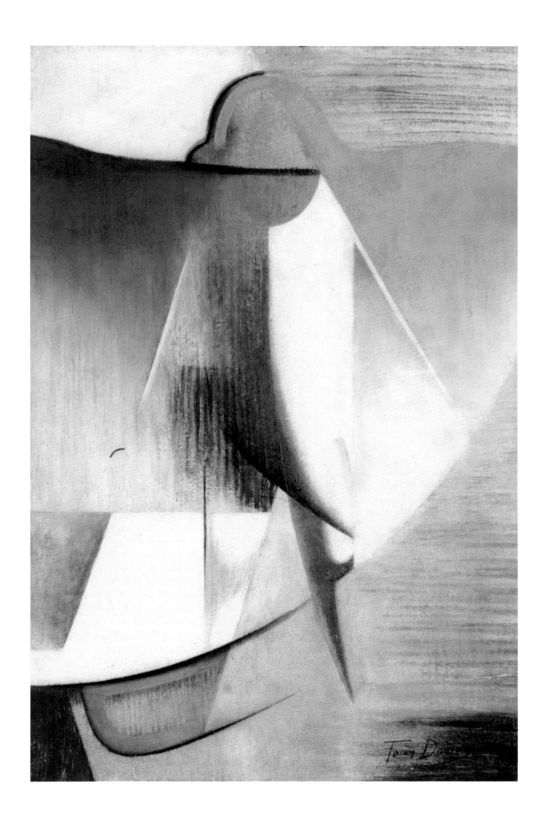

67
MARTHE (TOUR) DONAS
Child with Boat c.1917–18

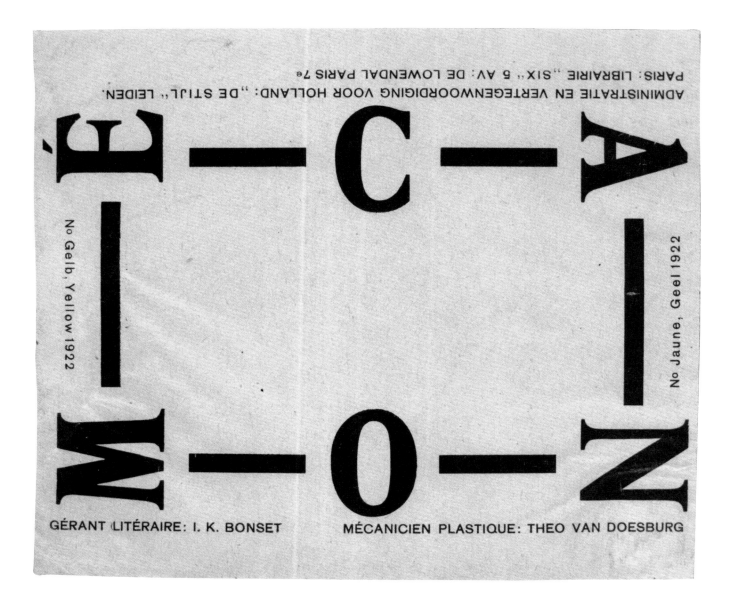

I.K.BONSET (THEO VAN DOESBURG) (ED.)
Mécano no.Jaune, Geel, Gelb Yellow, February 1922

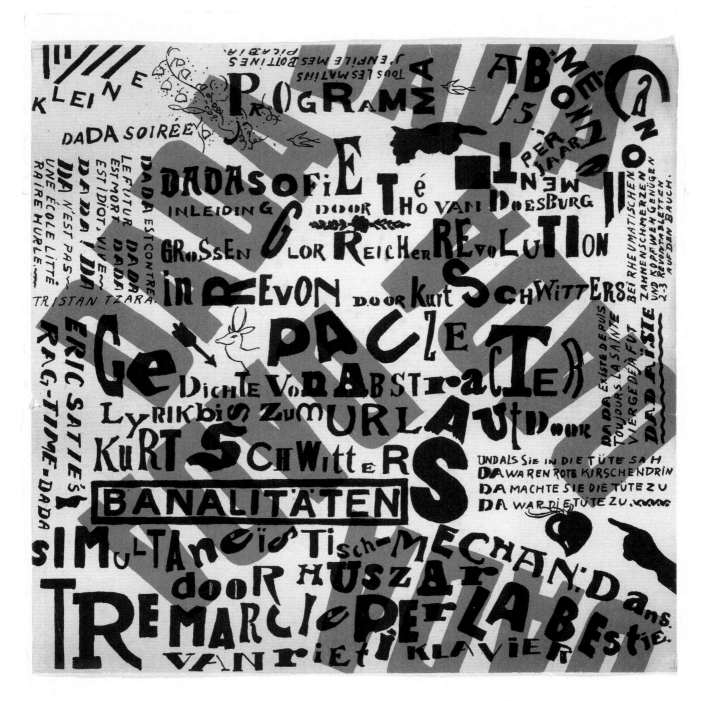

69
THEO VAN DOESBURG
**Poster for Small Dada Soirée, Dada tour of
the Netherlands, 10 January–14 February 1923** 1922

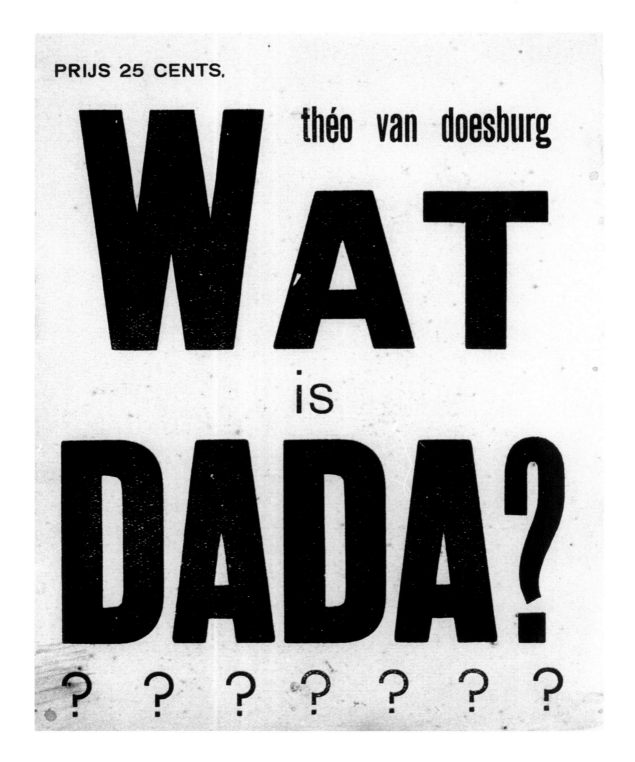

70
THEO VAN DOESBURG
What is Dada? 1923

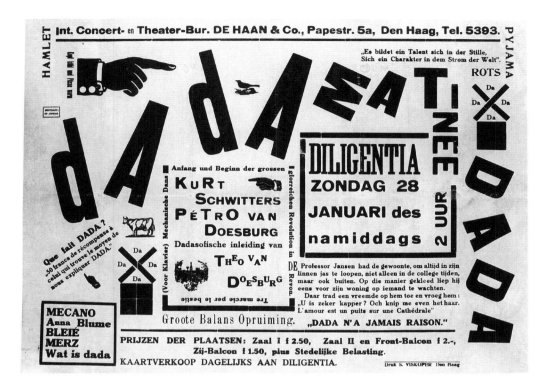

71
THEO VAN DOESBURG
Poster for Dada Matinée on
28 January 1923 in the Diligentia
Theatre, The Hague 1923

72
RAOUL HAUSMANN
Postcard to I.K. Bonset showing
the portrait of Herwarth Walden 1921

73
FRANCIS PICABIA
Mechanomorphic Drawing
(J-K-E-F-B-D-L-H) 1918–20

74
THEO VAN DOESBURG
Mechanical Child 1918

75
SERGE CHARCHOUNE
Bibi c.1921

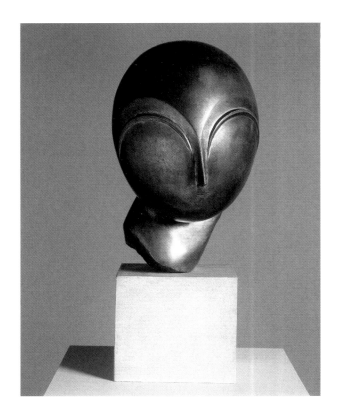

76
CONSTANTIN BRANCUSI
Danaïde c.1918

77
ALEXANDER ARCHIPENKO
Woman Combing her Hair 1915

78
VILMOS HUSZÁR
Mechanical Dancing Figure 1920, reconstruction 1984–5

79
GEORGES RIBEMONT-DESSAIGNES
Silence c.1915

80
JEAN CROTTI
Motor and Laboratory of Ideas 1921

81
JEAN ARP
The Eggboard c.1922

82
FRANCIS PICABIA
Radio Concerts 1921–2

83
MAX ERNST
JOHANNES THEODOR BAARGELD
Typescript Manifesto
We 5 (Weststupiden) 1920

84
I.K. BONSET (THEO VAN DOESBURG)
Composition c.1921–5

85
I.K. BONSET (THEO VAN DOESBURG)
Reconstruction c.1921–5

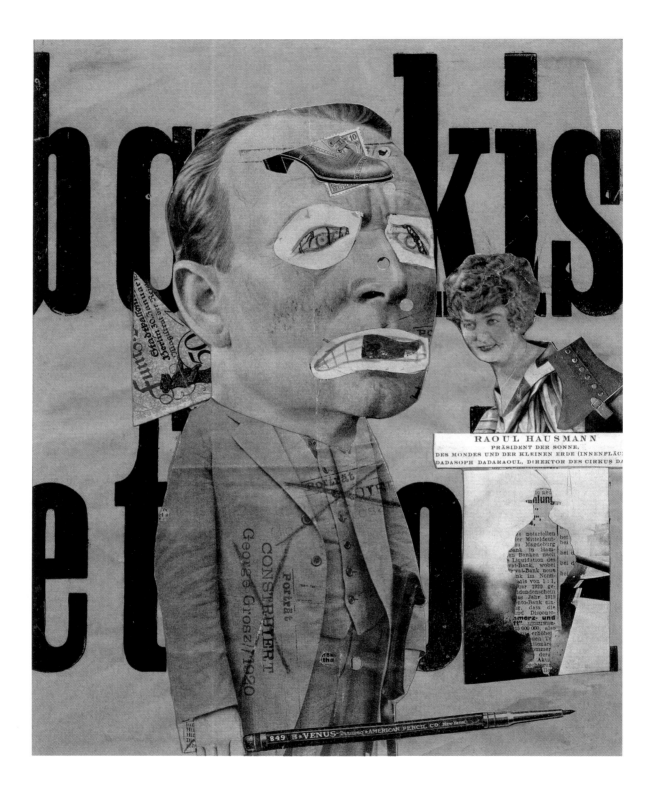

86
RAOUL HAUSMANN
The Art Critic 1919–20

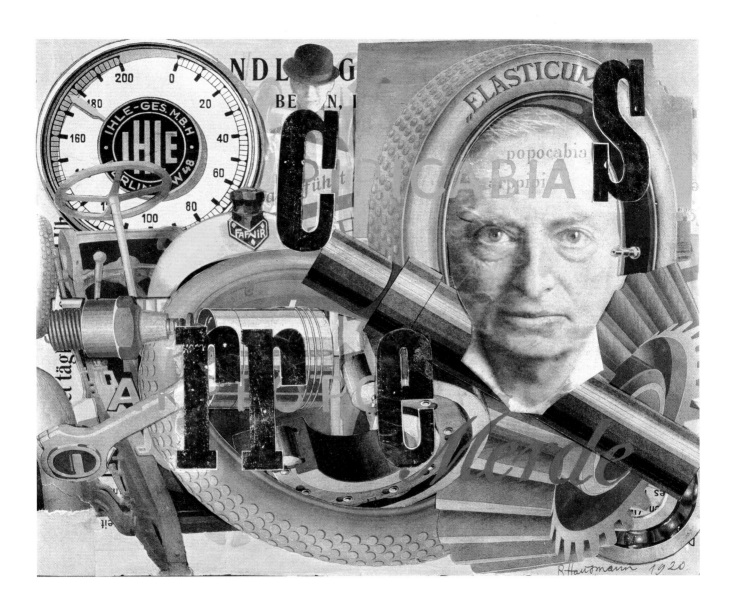

87
RAOUL HAUSMANN
Elasticum 1920
GALERIE BERINSON, BERLIN

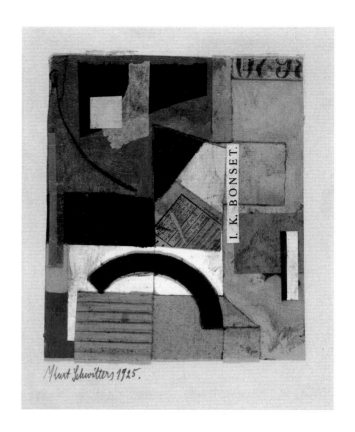

88
PAUL JOOSTENS
Dada Object 1920

89
KURT SCHWITTERS
Untitled (I.K. Bonset) 1925

90
THIJS RINSEMA
Olympia 1920–30

91
HANNAH HÖCH
2 x 5 1919

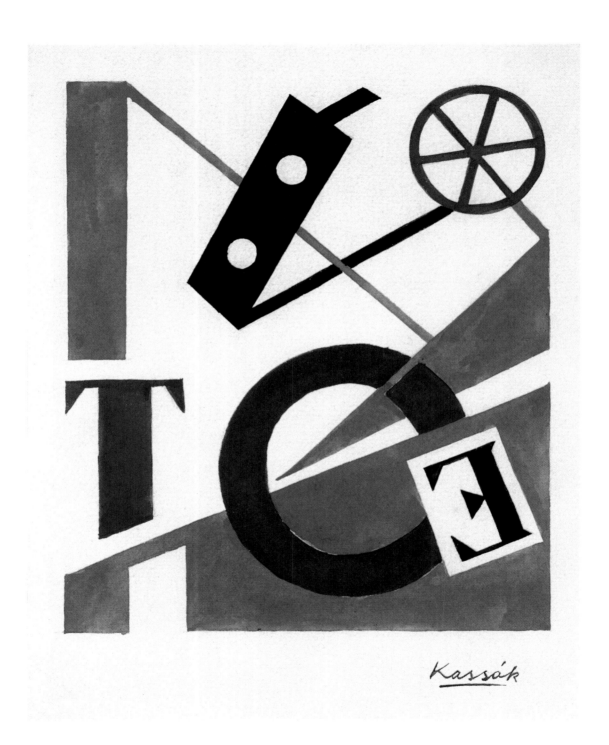

92
LAJOS KASSÁK
ST 1921

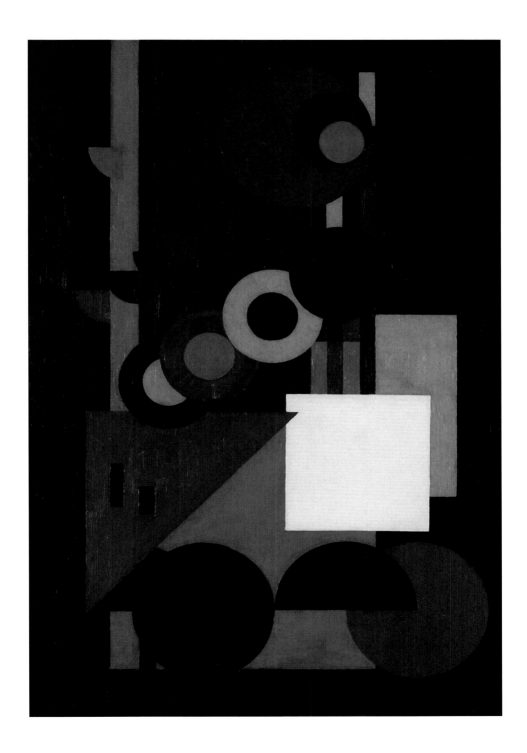

93
KAREL MAES
Composition no.17 1922

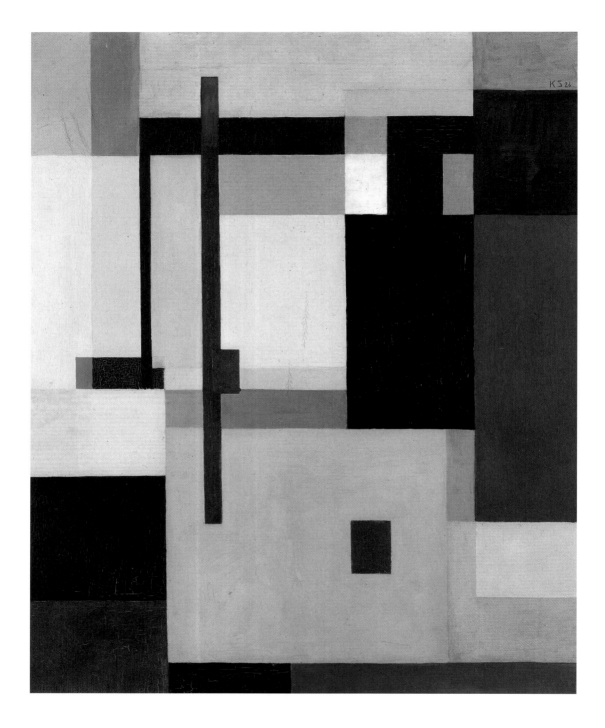

94
KURT SCHWITTERS
(Merz 1926, 8/Picture 1926 8 Shifted Planes) 1926

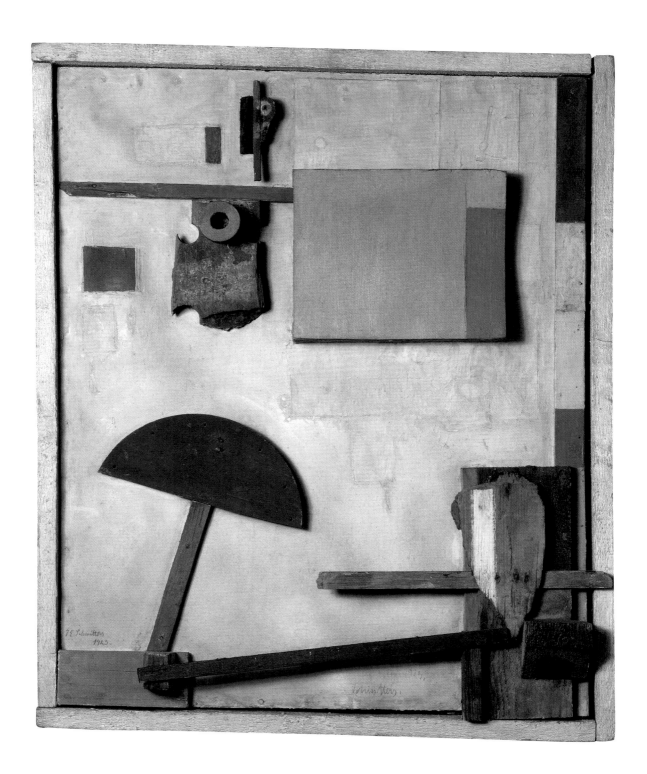

95
KURT SCHWITTERS
Merz Picture Kijkduin 1923
NOT EXHIBITED

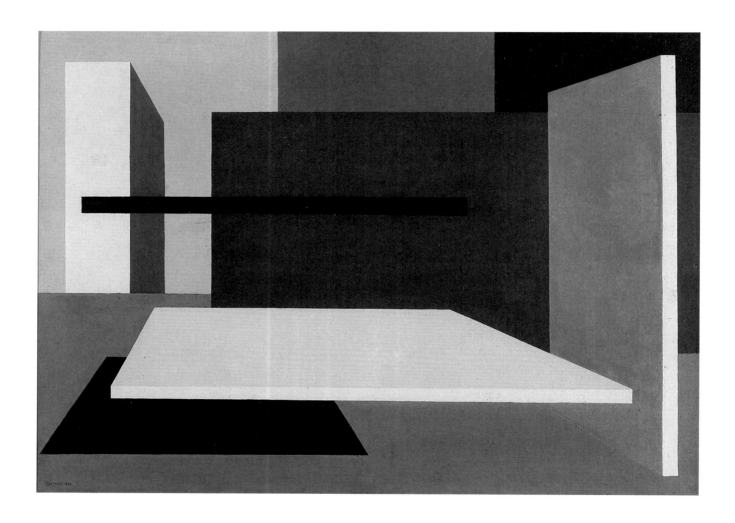

96
SÁNDOR BORTNYIK
Geometric Forms in Space 1924

97
EL LISSITZKY
Proun 1 C 1919

98
KARL PETER RÖHL
De Stijl Composition 1922
GALERIE BERINSON, BERLIN

99
WALTER DEXEL
Composition 1924

100
KARL PETER RÖHL
NB Styl No.XV 1923

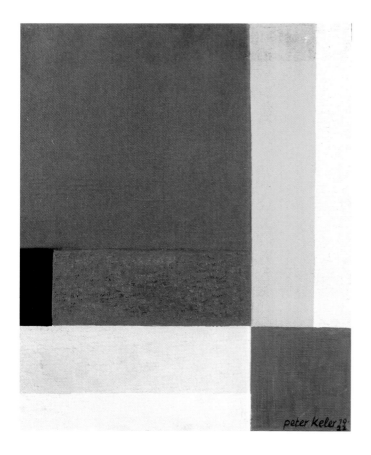

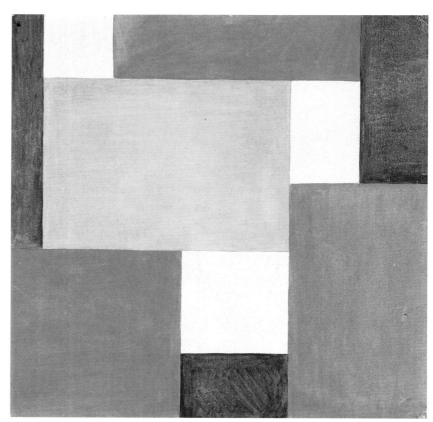

101
PETER KELER
De Stijl 1, Flat Composition 1922

102
ANDOR WEININGER
CURI I 1922

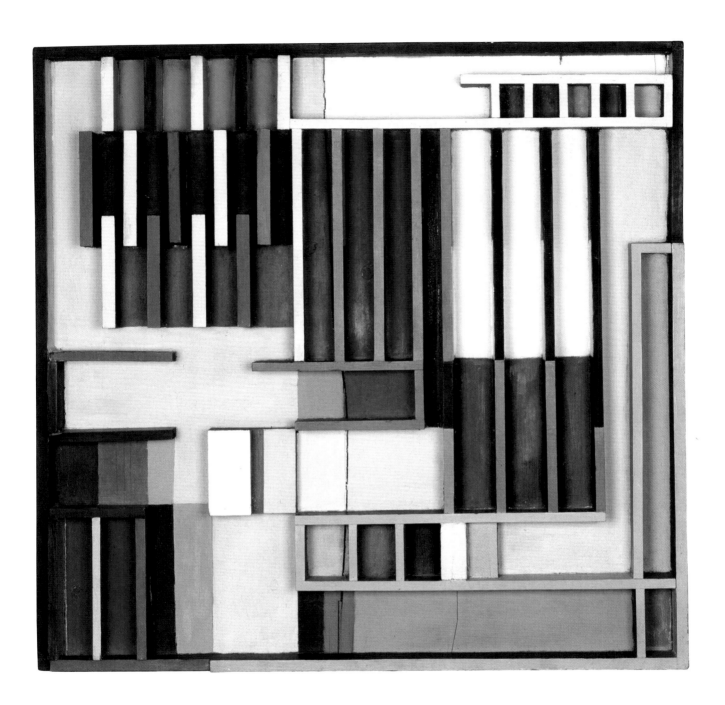

103
KURT SCHMIDT
Wood Relief Construction 1923
NOT EXHIBITED

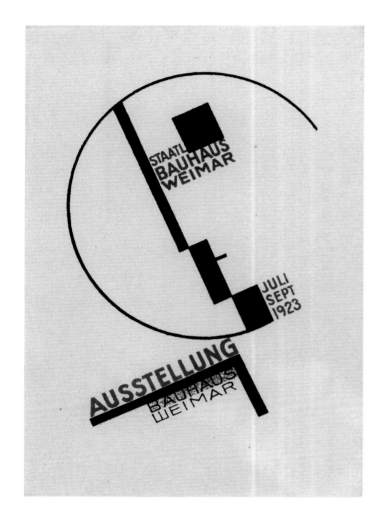

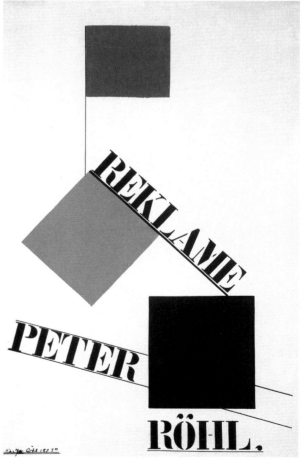

104
DÖRTE HELM-HEISE
Design for Bauhaus invitation card 1923

105
KARL PETER RÖHL
Design for 'Reklame Peter Röhl' 1923

106
MAX BUCHARTZ
Geometric Composition 1923

107
HERBERT BAYER
Design for multimedia booth 1924
reproduced in OFFSET, III, no.7 1926

3.

INTERDISCIPLINARITY

'ABSTRACT FILM-FORMING', DE STIJL, VOL.4, NO.5, JUNE 1921, P.71

The abstract film-forming of the painters Hans Richter and Viking Eggeling was not totally unexpected. The idea of surpassing the static character of painting with the dynamism of film technology already existed among artists wanting to bring about a solution to the modern problems in fine art with the assistance of advanced film technology, in order thereby to amalgamate the dynamic and static aesthetic. A satisfactory result was not achieved, as little as was the attempt to bring out the dramatic content of a thoroughly corroded ideology by the so-called expressionist film (condensed tragedy), or a solution which could meet the expectations of the new time. I could mention here many compromises but the abstract film-forming to usher in a new era of dynamic expressive possibilities has little to do with them. It is generally known that the futurists also sought a dynamic effect in painting, which, despite the static character of their products, nevertheless remained always more or less suggestive. More technically dynamic was the idea of our De Stijl contibutor, Mr V. Huszar, who in 1918 transferred abstract colour formation onto film technology and hereby created the possibility of 'performing' continually changing compositions. I draw attention to this in connection to the already far advanced experiments of Richter-Eggeling. I know that some danger lies in likening this abstract film-forming with music as this continually leads to misunderstanding but it might be enlightening to compare this abstract film-forming with visible music because somewhat in the same way as music, the whole composition develops in the open light-field. The spectator sees the composition (established beforehand by the artist in a 'score') grow in the light-field, achieve definiteness and disappear again, after which yet another composition of totally different grouping, relationship and structure is constructed in the light-field. [...]

This film-forming not only makes possible a collaboration of all the arts in a new general-basis but also lifts the new plastic artist away from the old and primitive way of handcraft-painting with oils. When film technology is completely set up for the dynamo-plastic, fine artists will 'write' their compositions for film, the colour or formal relationships will be indicated by precise numbers whereupon their designs will be expressed in the most exact, most perfect way by mechanical means and through electric current.

'LIGHT AND TIME-FORMING (FILM)', DE STIJL, VOL.6, NO.5, 1923, PP.60-1

[...] I had the opportunity to see these three different film experiments shown one after each other in the Théatre Michel, the first by Hans Richter from Berlin, the second by Sheeler (New York) and the third by Man Ray from Paris.

Out of the comparison one could state that what one neglected the other emphasised. None of the three named artists really managed to produce a satisfactory solution to the problem of film. Despite the fact that no positive result was achieved, the problem of film is nevertheless in an important developmental stage. One cannot expect that such a complex problem is solved during a time when one is first starting to research the means and possibilities of expression. [...]

It is self evident that in the attempt to produce film as art it must first be established what the primary and elementary means of film-forming are. To date all means of expression (in the widest sense) were applied reproductively. Film has been imitative of theatre or photography in time. This reproductive method, which all arts have gone through, film and the gramophone are also going through now. Yet these mechanical means of expression are truly of more consequence to the modern creative consciousness than the handcraft culture in modern painting and sculpture. The advantage the latter have over the mechanical technologies of expression such as film, mechanical theatre, the gramophone and wireless telegraphy lies principally in the realm of the purely artistic. That which cubism already showed could be used as a technique for expression, processes using denaturalised material (newspaper, glass, metal etc.), will also in the future nullify the handcraft techniques of painting completely.

In order to apply film technology artistically, we need first of all to understand its elementary means. It was a mistake to think that the film-field is identical with the flat surface and that consequentially that the forming thereof should be one of two dimensionality. The film-field has nothing to do with the architectonic surface from which light actually distinguishes it. It is light and not the surface which is its means of expression. The light-field of film is peripheral, x-dimensional and truly chaotic, from the point of view of its latent means of expression, and substantial, from a technical standpoint. [...]

Movement and light are the elements of the new film forming. The light-field is unbounded on all sides. The artistic possibilities of expression lie as much in time as in space – just as in the new architecture – and can make visible a new dimension to the extent which temporal and spatial moments are expressed equivalently and in balance. [...]

I.K.BONSET, 'PLASTIC POETRY AND ITS RELATIONSHIP TO THE OTHER ARTS', DE STIJL, VOL.5, NO.6, (JUNE 1922), PP.90-1

[...] Comprehension (the contour of the word) closes the word (as material) off and in. The introduction of a-logical word use (by the dadaists Hans Arp, Picabia, Tzara, Péret, Huelsenbeck, Kurt Schwitters, amongst others) has nullified the old poetic construction. The word is open and free. It has become material. The syllable has been given direct power of expression while a new element (of which Mallarmé was the forerunner) has become to belong to poetry, that of plastic form provided by typographic specification and arrangement. Very clever in this regard is Pappaseit's 'Ondes Herzianes' which emphasizes its perpendicularity. The whole thing stands before you in an immutable way.

Typographical word composition gives the word its perfection as expressive material and contributes to it, shifting the accent of time to that of space, such as, in another area, music has already done. Thus, another (spatial) dimension is placed vertically on the (sequential) dimension of time.

You must understand that to achieve a real and firm unity of temporal and spatial accents, the stabilisation of time in all the arts must be closely bound up with the general necessities of life .

Every work of art, and that includes poetry, becomes an object built from the unity of material energy and thus has not the positive but the relative value of a vital interest, progressing towards the mathematically controlable development of life as a whole.

108
HANS RICHTER
Rhythmus 23 1923

109
WERNER GRAEFF
Film Score. Composition II/22 1922

110
WALTER RUTTMANN
Light-Play, Opus III 1922

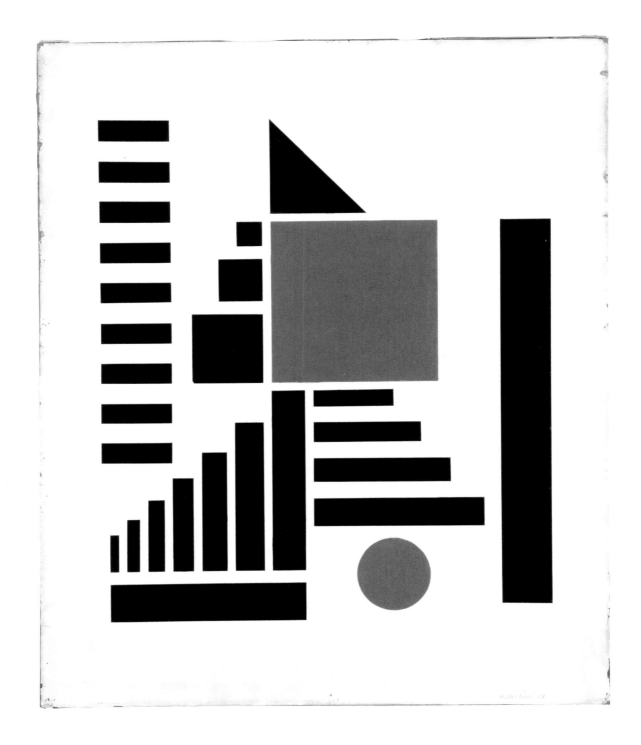

111
HENRYK BERLEWI
Mechano-Faktura 1924–c.1960

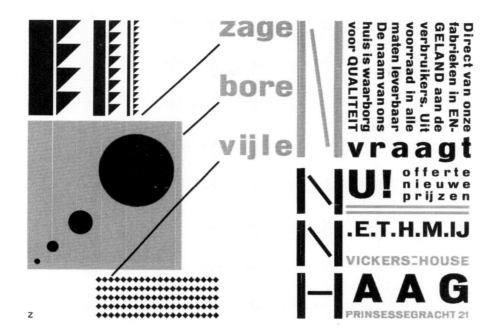

112
PIET ZWART
Publicity card for Vickers
House, N.E.T.M.IJ. 1923

113
FRANCIS PICABIA
Conversation I 1922

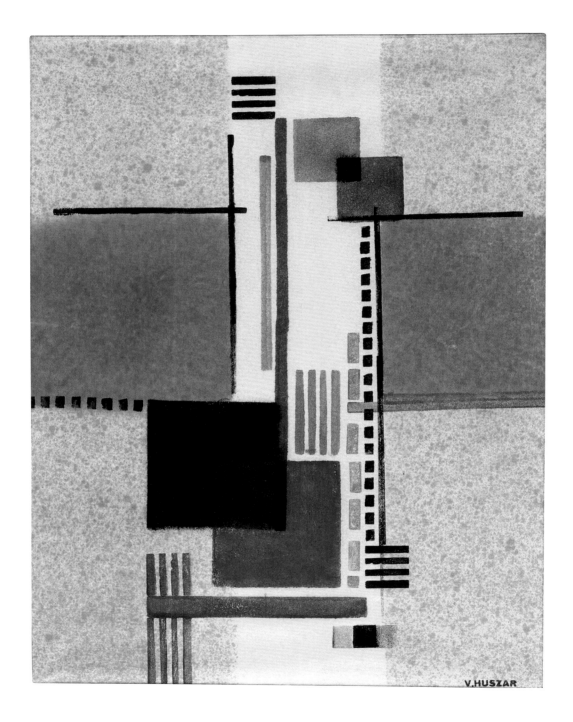

114
VILMOS HUSZÁR
Composition 1924

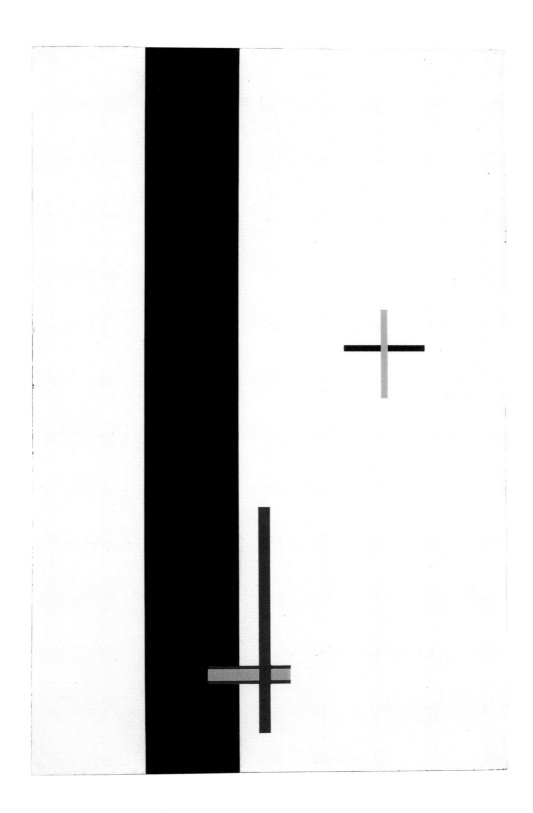

115
LÁSZLÓ MOHOLY-NAGY
Telephone Picture EM1 1922
NOT EXHIBITED

116
LÁSZLÓ MOHOLY-NAGY
Cover of Painting, Photography, Film 1925

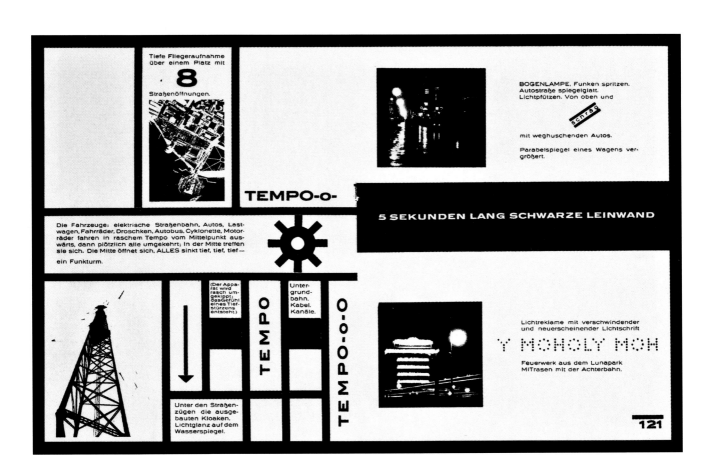

117
LÁSZLÓ MOHOLY-NAGY
Pages from Painting, Photography, Film 1925

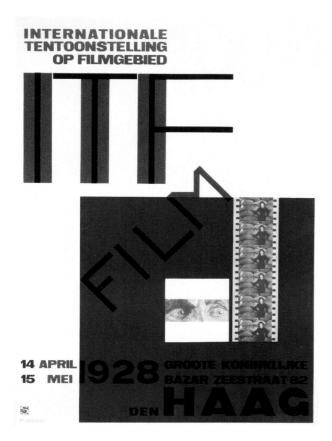

118
PIET ZWART
Poster for the International Film
Exhibition, The Hague 1928

119
CÉSAR DOMELA
Advertisement for 400 Anlagen date unknown

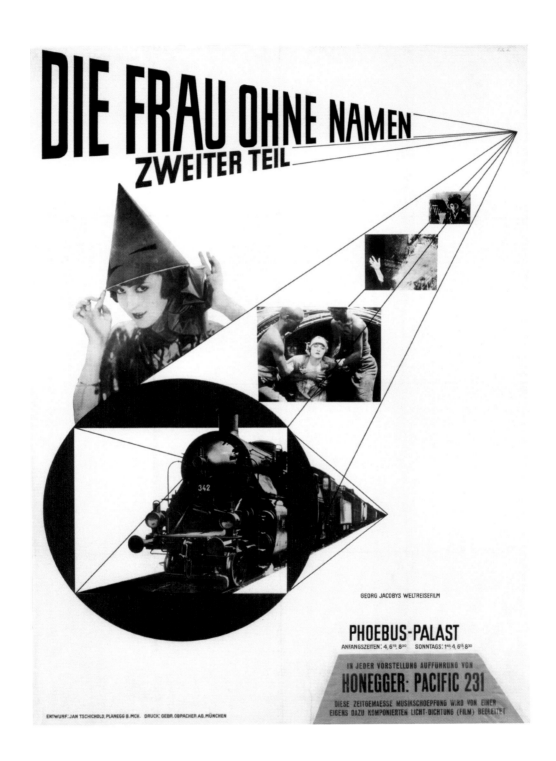

120
JAN TSCHICHOLD
Poster for The Woman
Without a Name, Part Two 1928

121
MAN RAY
Rayogram 1923

122
LÁSZLÓ MOHOLY-NAGY
Photogram c.1923

123
VICTOR SERVRANCKX
Ciné (Opus 11) 1921

124
VICTOR SERVRANCKX
Pure Plastic 1922

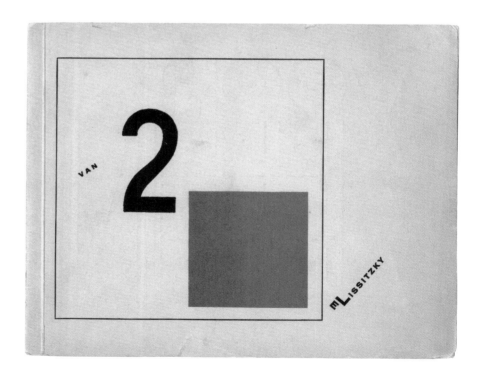

125
EL LISSITZKY
Dlia golosa (For the Voice) 1923

126
EL LISSITZKY
Of 2 Squares. Suprematist Story of
Two Squares in 6 Construction 1922

127
THEO VAN DOESBURG
KURT SCHWITTERS
KÄTE STEINITZ
The Scarecrow 1925

128
PIET ZWART
Untitled (Free Typographic
Composition) 1925

130
CÉSAR DOMELA
Cover design for
Revista Alemana 1931

131
CÉSAR DOMELA
Cover for i10, no.4 1927

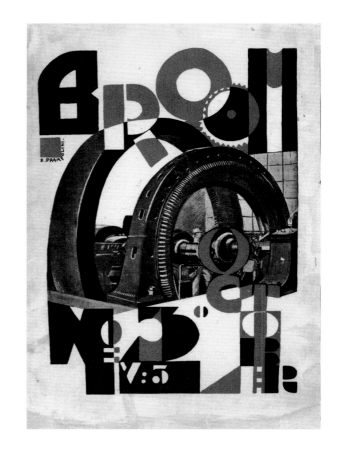

132
LAJOS KASSÁK (ED.)
MA, vol.9, no.15, 15 April 1924

133
KURT SCHWITTERS
The New Design in Typography 1930

134
ENRICO PRAMPOLINI
Cover for Broom, vol.3, no.3 1922

135
EL LISSITZKY
HANS ARP (EDS.)
The Isms of Art 1925

136
KURT SCHWITTERS (ED.)
Merz, no.11 1924

137
THEO VAN DOESBURG
Portrait of Pétro (Nelly van Doesburg) c.1922

138
HENRI NOUVEAU
Model for a Monument to J.S. Bach 1927, reconstruction c.1950

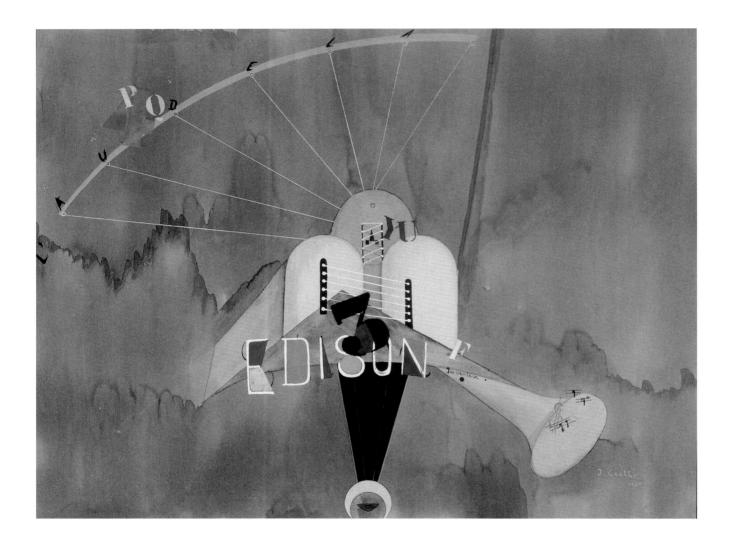

139
JEAN CROTTI
Portrait of Edison 1920

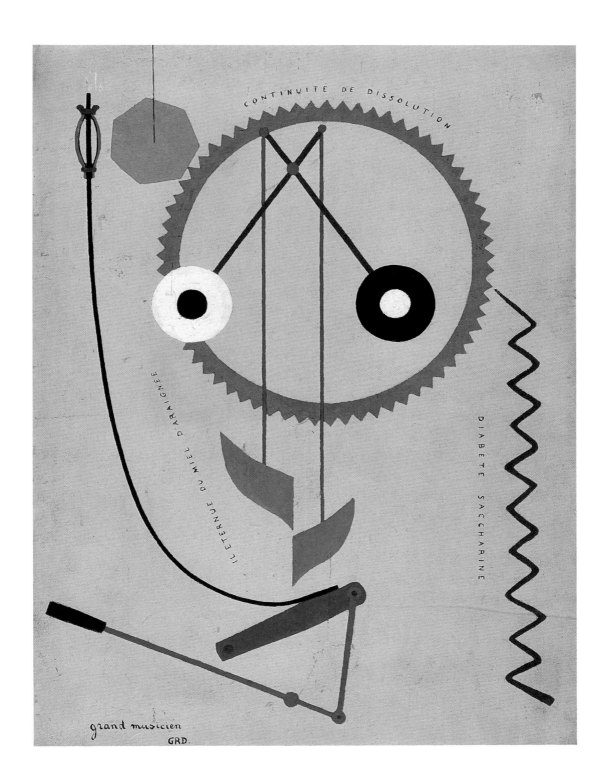

140
GEORGES RIBEMONT-DESSAIGNES
Great Musician 1920

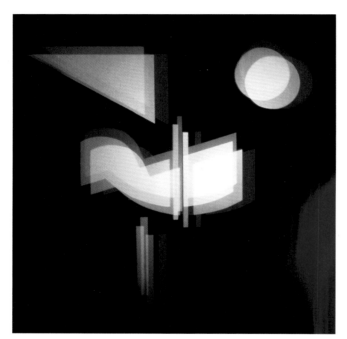 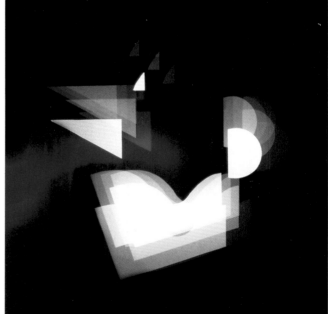

141
LUDWIG HIRSCHFELD-MACK
Colour Light-Play: Sonatine II (Red) c.1923–4, reconstruction 2000

142
OTTO CARLSUND
Sequence of Tones 1929

4.
DE STIJL AND ART CONCRET 1923–1931

'NOTES ON THE AUBETTE IN STRASBOURG', DE STIJL, VOL.8, NO.87/89, PP.4-5

In September 1926 I came into direct contact with the Aubette for the first time, through Mr Arp's mediation. Mr Paul and André Horn got me to come to Strasbourg and there I had the opportunity to realise my ideas in the field of interior design on a grand scale, and to transform the most beautiful rooms in a modern manner. Mr Paul Horn, in whom I found a real advocate of my ideas, got me an office on the place Kléber. The first task was to create new plans which, according to the nature of things, ought to match the use of the different rooms. The Horns and Mr Heitz agreed my plans with no significant changes.

These first plans, in which the function of the entire building was established, bore the impression of a project of considerable stature, such as one might find in major cities. I conceived it as a sort of 'building of passage', in which the uses of the different rooms would not be very strict. On the first floor, I wanted to connect the large dance hall to the cinema-dance hall by means of a foyer bar. Thus, members of the public could watch the film in the cinema-dance hall without having to be in the hall itself. Such fluctuation, as I conceived it, had already been established in the passage on the ground floor which links the place Kléber to the rue de la Haute Montée. I fixed a direction board to the left of the entrance whose text and signs visitors could use to orientate themselves very easily. The same sign was placed in the different rooms as well.

'ELEMENTARISM AND ITS ORIGINS', DE STIJL, VOL.8, NO.87/89, PP.23-4

[...] This oblique dimension not only nullifies ancient modes of orthogonal expression (in music, architecture, painting, sculpture, dance and so forth) but simultaneously creates a new system of optics and phonetics. These elementary renovations find their equivalent in the theory of relativity, in the new research on the nature of matter and in a fresh attitude towards the unlimited intelligence and creative initiative of human beings. Unlike defenders of religious dogmatism and absolutism, the Elementarist experiences life as a perpetual transformation and spiritual activity as a phenomenon of contrast. The Elementarist seeks to unify in a new method of expression the two main factors in creative activity, which is to say, rest and movement or space and time. The Elementarist acknowledges times as an important value in the plastic work of art; in this manner he has presented film, music, drama, sculpture and architecture with new possibilities. This provides a universal method both for art and for industrial production. Elementarism is opposed to compromise, to decadence, to contemporary aesthetic confusion (Neo-Classicism, Surrealism and so forth) and to narrow-minded dogmatism.

It reduces all spiritual and technical activity to its most elementary form. It stems from functional thought, acknowledges the latent energy of matter (in colour, glass, iron, concrete, sound and word) and discovers for architecture a construction method which synthesizes all functions of human life. Elementarism was born in 1924 in The Netherlands (from the De Stijl group) and has since won adherents in many countries.

Georges Antheil in music, Cesar Domela, Vordemberghe-Gildewart [sic] and the author of the present article (founder of the movement) in painting, Constantin Brancusi in sculpture, Mies van der Rohe, Van Eesteren, Rietveld and the author in architecture, I.K. Bonset in literature and Fr. Kiesler in the renovation of the theatre are all Elementarists.

'THE BASIS OF CONCRETE PAINTING', ART CONCRET, APRIL 1930, P.1

We state:
1. Art is universal.
2. The work of art should be fully conceived and spiritually formed before it is produced. It should not contain any natural form, sensuality or sentimentality. We wish to exclude lyricism, dramaticism, symbolism and so forth.
3. The painting should be constructed completely with pure plastic elements, that is to say, with planes and colours. A pictorial element has no other meaning than what it represents; consequently the painting possesses no other meaning than what it is by itself.
4. The construction of a painting and its elements should be simple and direct in its visualization.
5. The technique should be mechanical, that is to say, precise rather than impressionistic.
6. Absolute clarity should be sought.
Carslund, Doesburg, Hélion, Tutundjian, Wantz

'ELEMENTARISM (THE ELEMENTS OF THE NEW PAINTING)', ABSTRACTION-CRÉATION: ART NON FIGURATIF, NO.1, 1932, P.39

[...] One must not hesitate then to surrender our personality. The universal transcends it. Spontaneity has never created a work of lasting cultural value. The approach to universal form is based on calculation of measure and number. The Pyramid of Cheops is based on the same approach. Personality had some reason as far as the period of composition was concerned, but now in the period of 'construction', personality becomes an obstacle and something to be ridiculed. Composition entails individual variations of form, colour and balanced relationships. Construction entails the stabilisation and synthesis of form, colour and relationships. Its tendency is towards the supra-individual. To have a preference for a certain colour (yellow, for example) or a certain direction (vertical, for example) is just the same as having a preference for a certain dish. Art descends to the level of cuisine. To change direction (such as by the oblique) is to change and renew the spectator's vision. The spontaneous approach never created 'the marvellous' because this approach is based on fantasy. Fantasy is in the spirit of the music hall. Only that which is worked profoundly, which is mortified, is of importance.

The best handicraft is the one which displays no human touch. Such perfection is dependent upon an environment of absolute cleanliness, constant light, a clear atmosphere and so forth. These characteristics of our environment become qualities found in our work. The artist's studio will be like a glass-bell or a hollow crystal. The painter must be white, which is to say, without tragedy or blemish. The palette must be glass, the brush square and hard, without a trace of dust and as immaculate as a surgical instrument.

Doubtless, there is much to learn from a medical laboratory. Do not artists' studios usually smell like the cages of sick monkeys? The studio of the modern painter must have the atmosphere of mountains 3,000 metres high and with snow lying eternally on the summit. The cold kills the microbes.

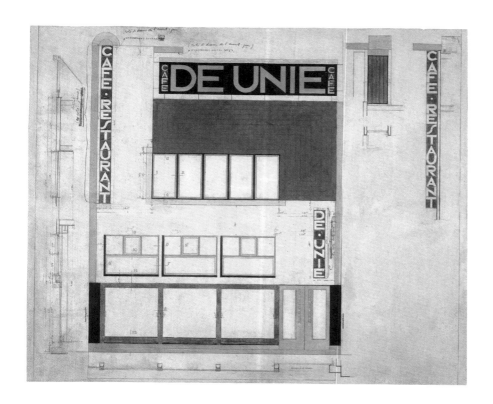

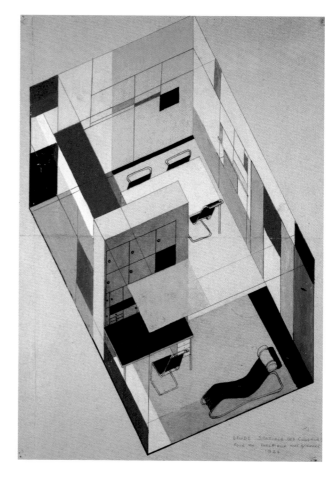

143
J.J.P. OUD
Design for façade of
Café De Unie, Rotterdam 1925

144
JEAN GORIN
Spatial study of colours for
an interior, Nort-sur-Erdre.
Neoplastic design for a living
room no.1, axonometric view 1927

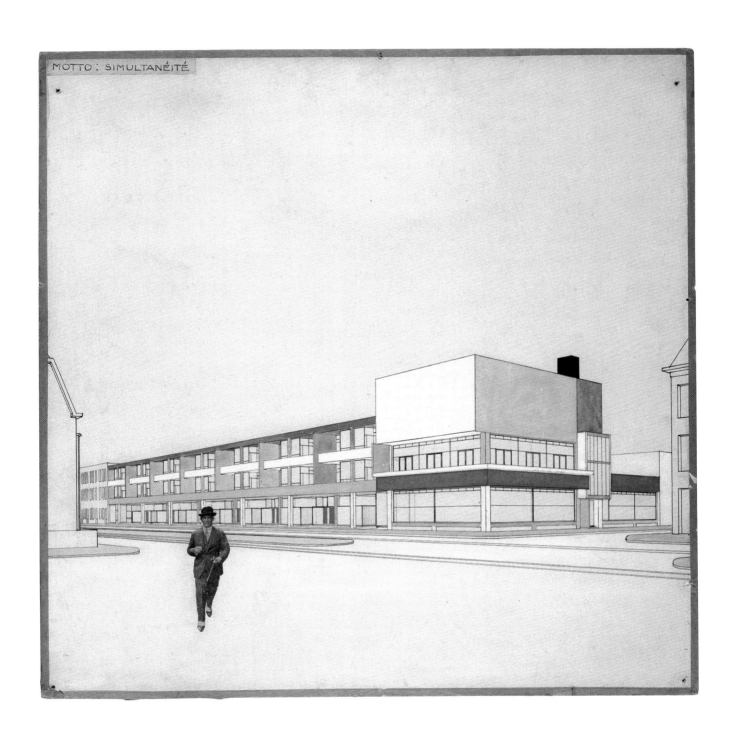

MOTTO: SIMULTANÉITÉ

145
THEO VAN DOESBURG
CORNELIS VAN EESTEREN
Perspective with final colour design, shopping arcade
with bar restaurant, Laan van Meerdervoort, The Hague 1924

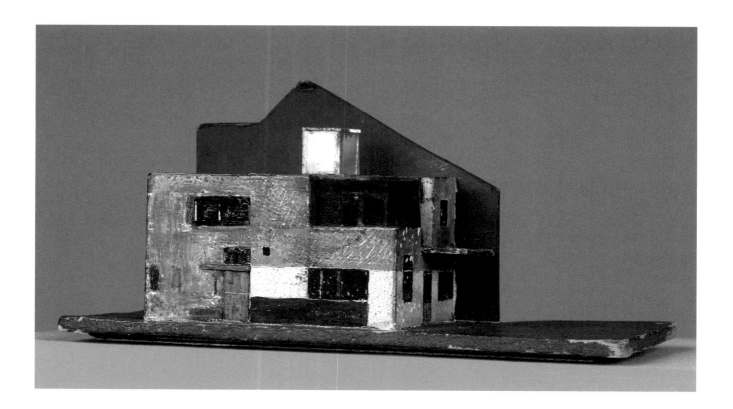

146
GERRIT RIETVELD
Model for the Rietveld-Schröder House 1924, reconstruction 1987

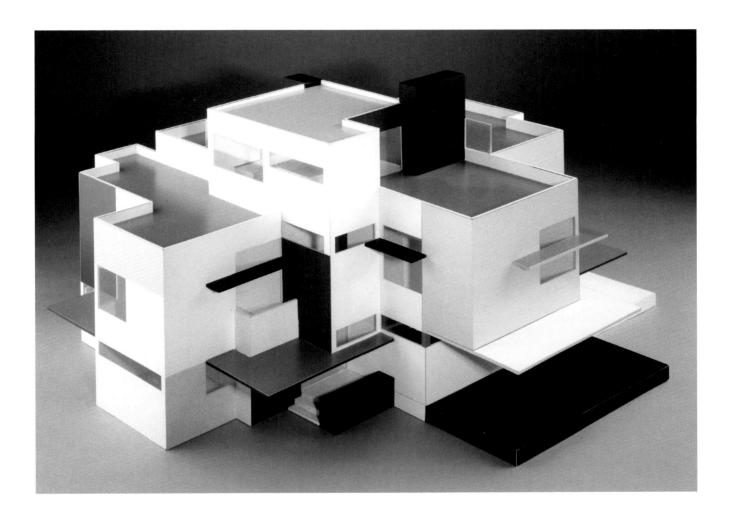

147
THEO VAN DOESBURG
CORNELIS VAN EESTEREN
Private House 1923, reconstruction 1983

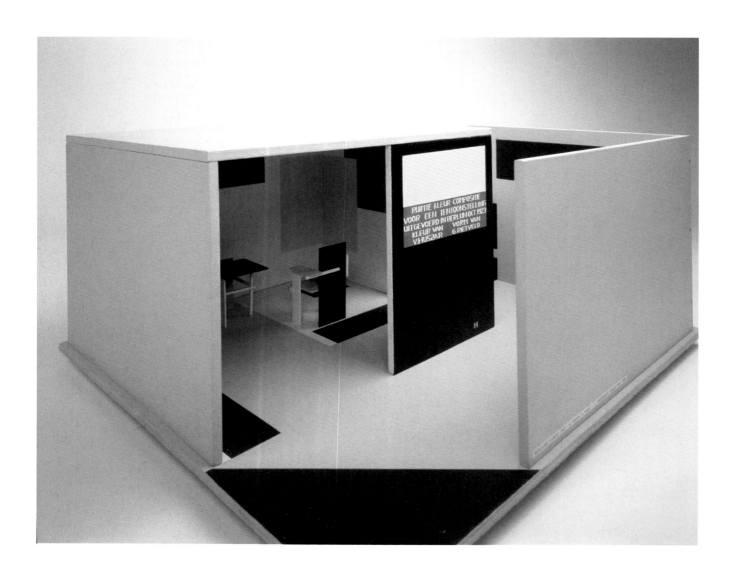

148
VILMOS HUSZÁR
GERRIT RIETVELD
**Model of the Space-Colour-Composition for
the Nonjuried Exhibition in Berlin** 1923, reconstruction 1983

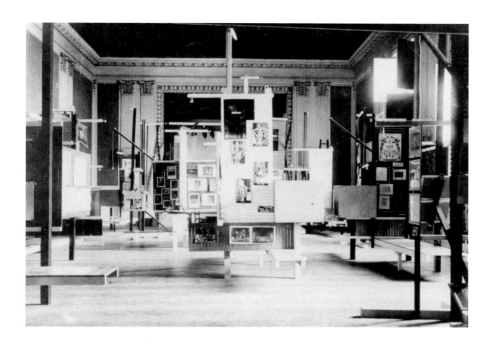

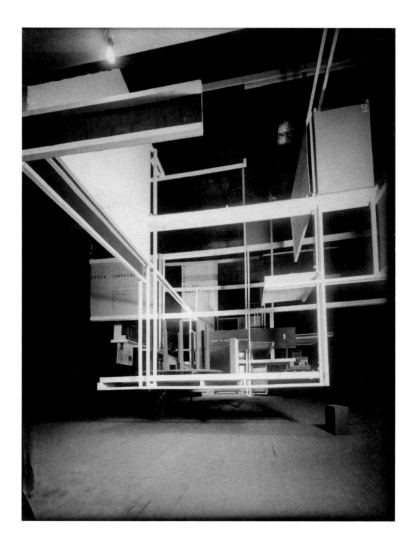

149
FREDERICK KIESLER
International Exhibition of New
Theatre Techniques, Vienna 1924
NOT EXHIBITED

150
FREDERICK KIESLER
Installation view of the City
in Space, Paris 1925

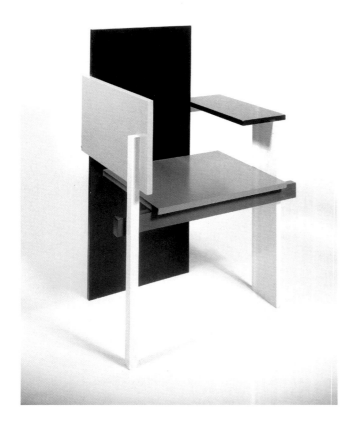

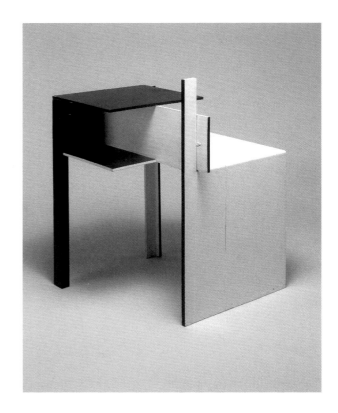

151
GERRIT RIETVELD
Berlin chair 1923

152
EILEEN GRAY
Table c.1924, reconstruction 2009

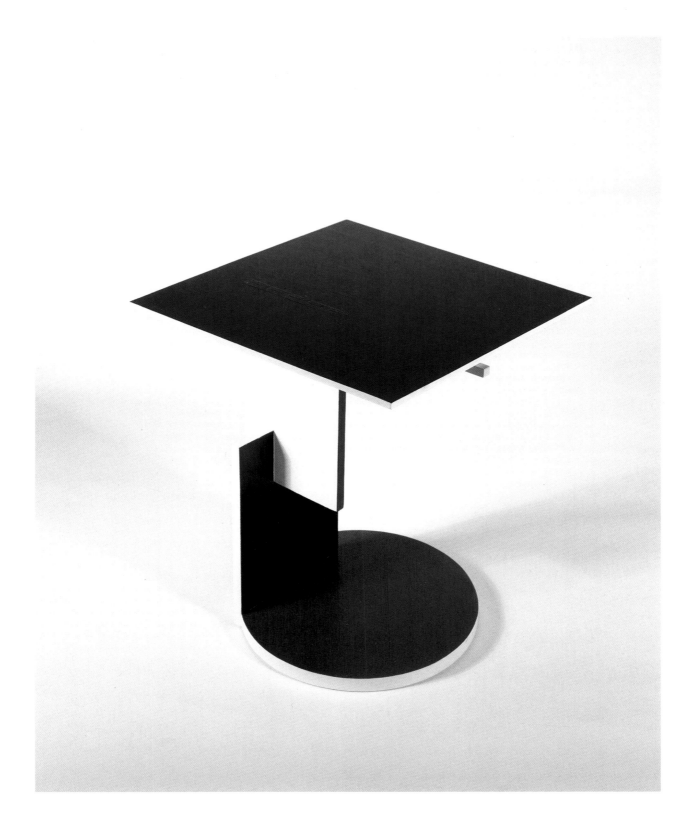

153
GERRIT RIETVELD
End Table 1923

154
THEO VAN DOESBURG
Final colour design for wall with gallery, Cinema-Dance Hall
conversion of the Café Aubette interior, Strasbourg 1927

155
THEO VAN DOESBURG
Final colour design for ceiling, Cinema-Dance Hall
conversion of the Café Aubette interior, Strasbourg 1927
NOT EXHIBITED

156
THEO VAN DOESBURG
Colour design for ceiling and three walls
Small Ballroom, conversion of the Café
Aubette interior, Strasbourg 1926–7

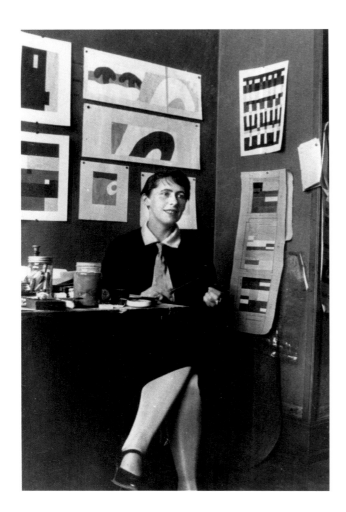

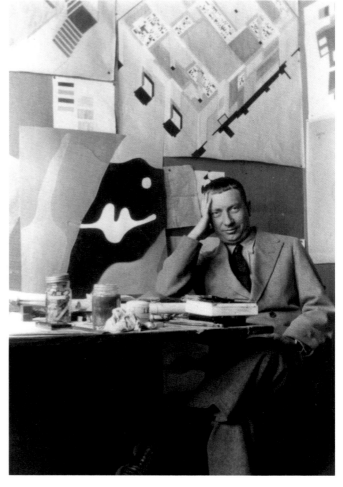

157
Sophie Taeuber-Arp in the studio of the Aubette building, Strasbourg 1928

158
Hans Arp in the studio of the Aubette building, Strasbourg 1928

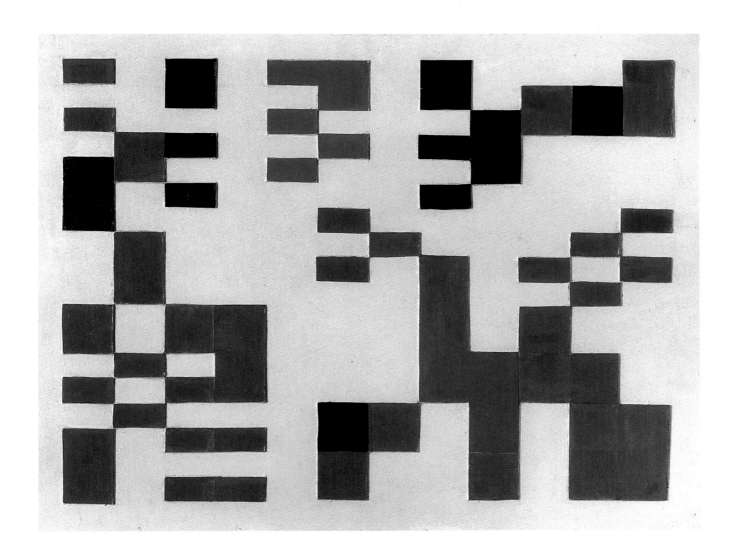

159
HANS ARP
SOPHIE TAEUBER-ARP
Composition l'Aubette (Recreation on cardboard
by Jean Arp from a drawing by Sophie Taeuber-Arp) c.1927–8

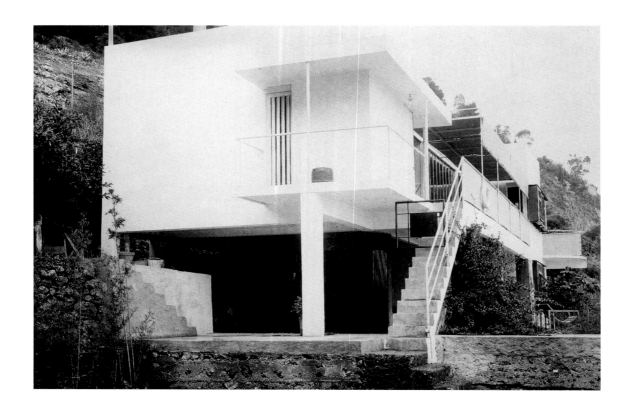

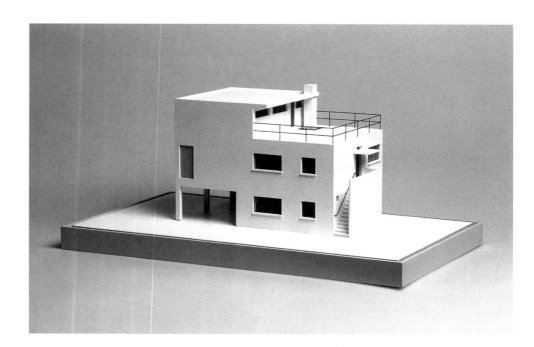

160
EILEEN GRAY
JEAN BADOVICI
E.1027 reproduced in
'L'Architecture Vivante', Winter 1929

161
THEO VAN DOESBURG
ABRAHAM ELZAS
Model of the studio house
of Theo van Doesburg in
Meudon 1927–30, reconstruction 1988

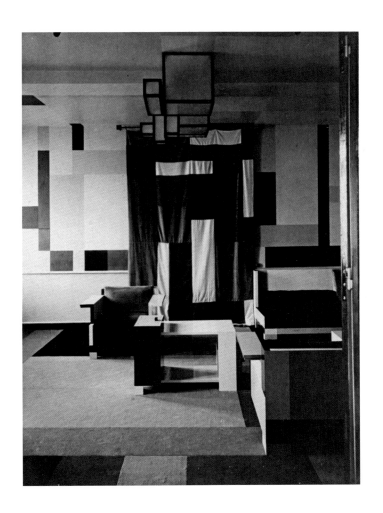

162
FELIX DEL MARLE
Interior 1926

163
THEO VAN DOESBURG
Armchair 1930

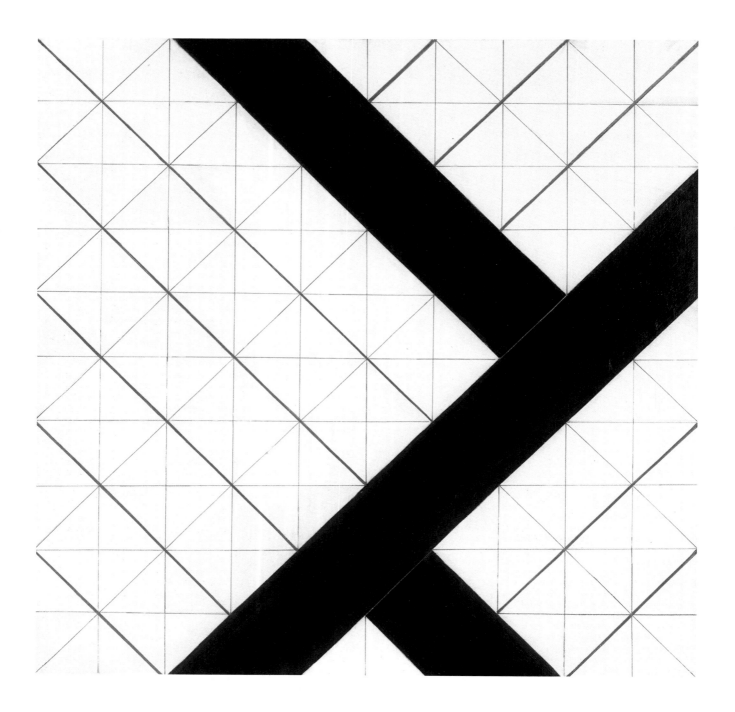

164
THEO VAN DOESBURG
Counter-Composition VI 1925

165
THEO VAN DOESBURG
Counter-Composition XV 1925

166
CUPERA (NELLY VAN DOESBURG)
Little White Jar 1929

167
THEO VAN DOESBURG
Counter-Composition XX c.1928

168
FRIEDRICH VORDEMBERGE-GILDEWART
Composition No.15 1925

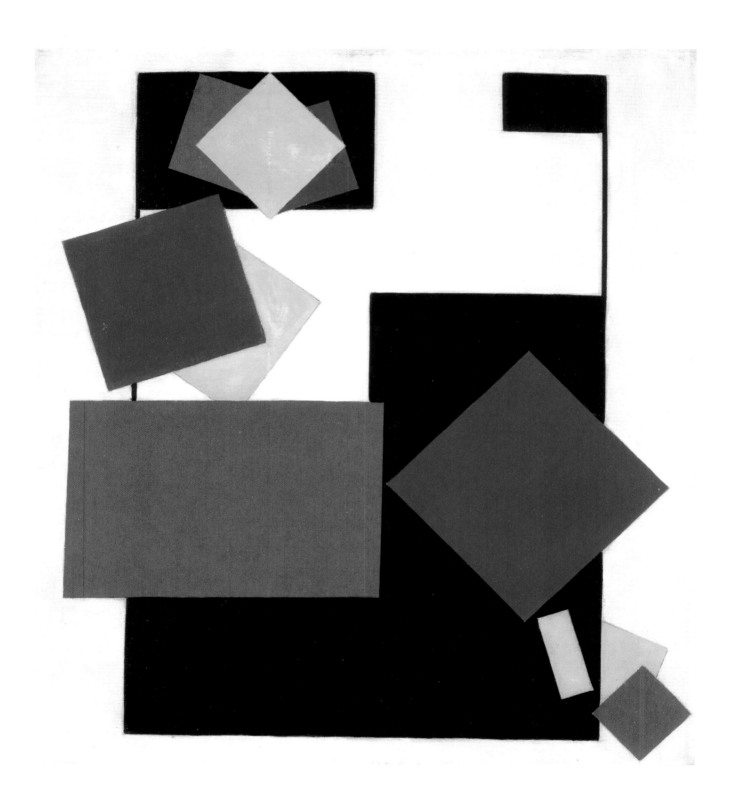

169
VILMOS HUSZÁR
Composition: The Human Form 1926

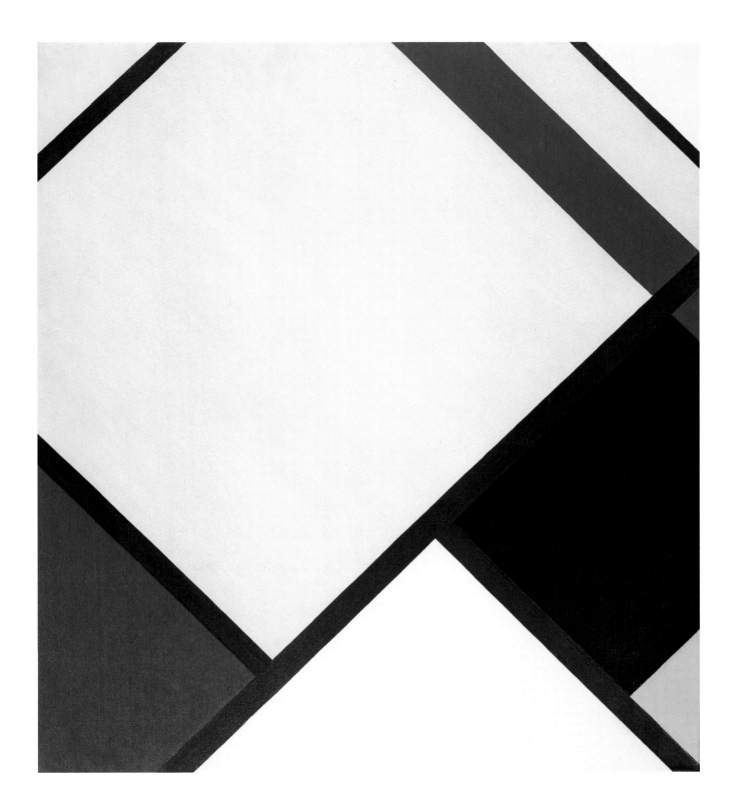

170
CÉSAR DOMELA
Composition no.5N 1927

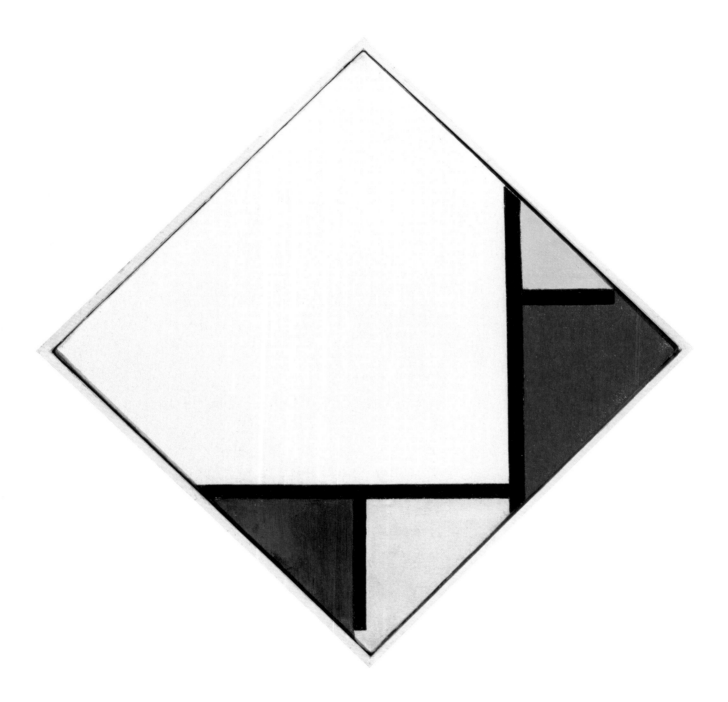

171
THEO VAN DOESBURG
Composition 1929

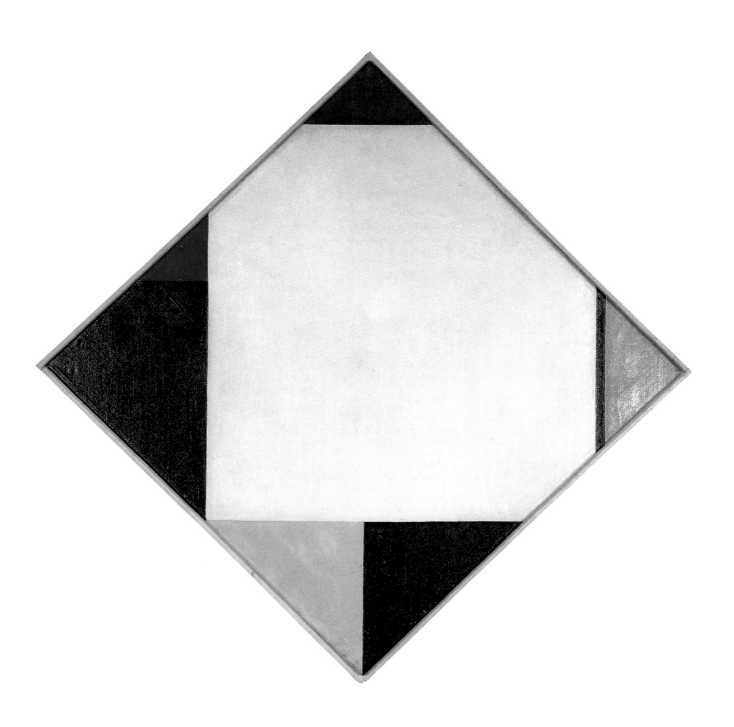

172
CÉSAR DOMELA
Neoplastic Composition 1925

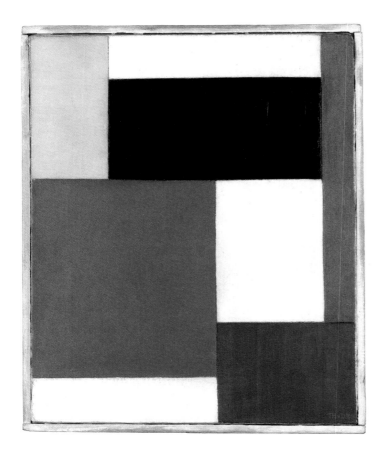

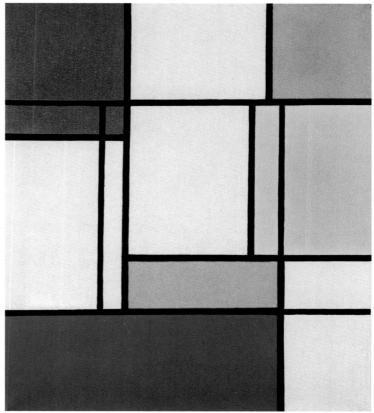

173
THEO VAN DOESBURG
Composition 1924

174
JEAN GORIN
Composition no.3 (emanating
from the equilateral triangle) 1927

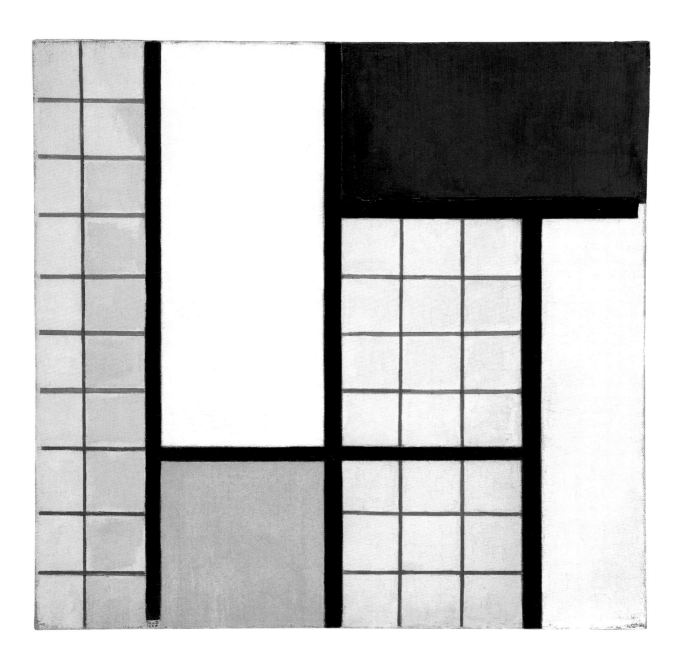

175
THEO VAN DOESBURG
Composition in Half-Tones 1928

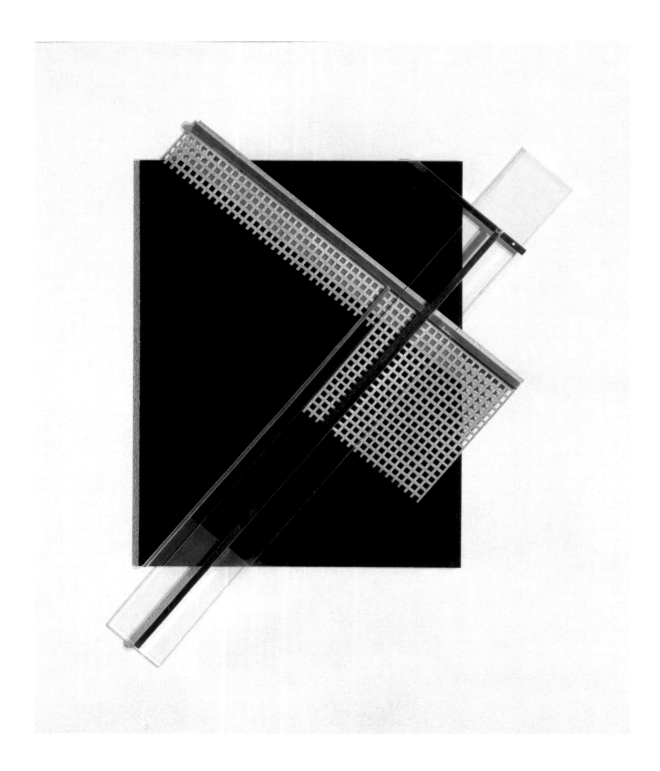

176
CÉSAR DOMELA
Composition no.11 1932
NOT EXHIBITED

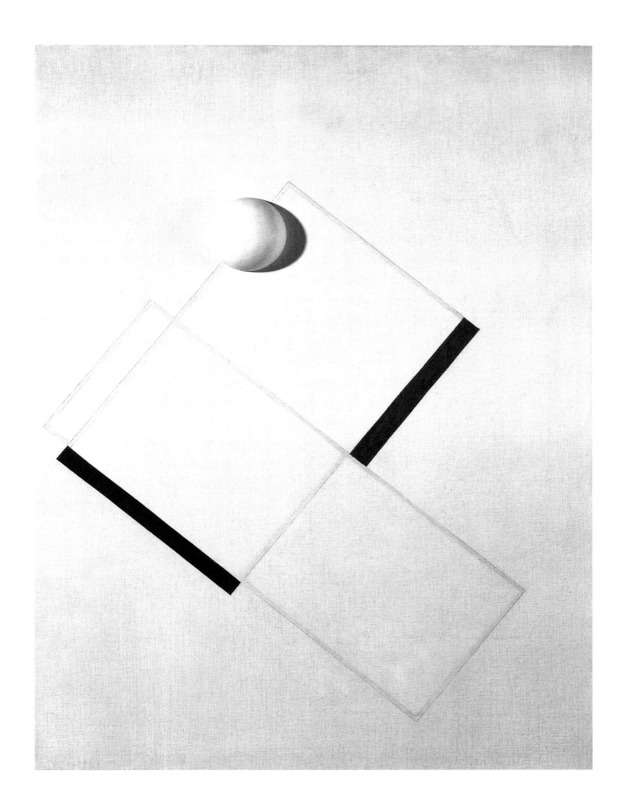

177
FRIEDRICH VORDEMBERGE-GILDEWART
Composition No.26, 'Sphere' 1926

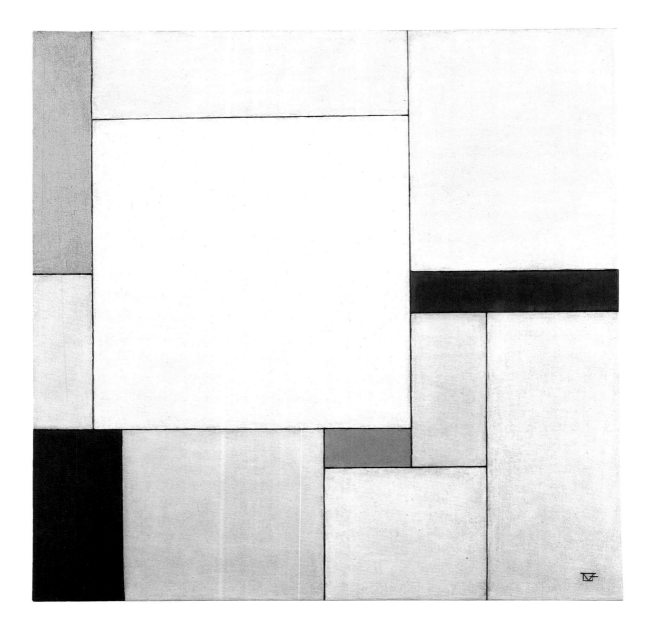

178
GEORGES VANTONGERLOO
Composition in a Square with the Colours
Yellow, Green, Blue, Indigo, Orange 1930

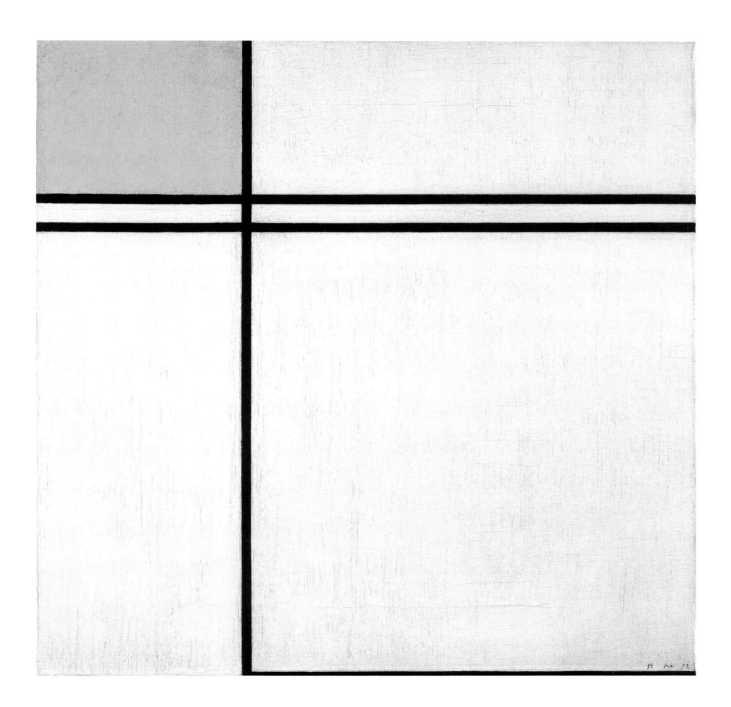

179
PIET MONDRIAN
Composition with Double Line
and Yellow, 1932 1932

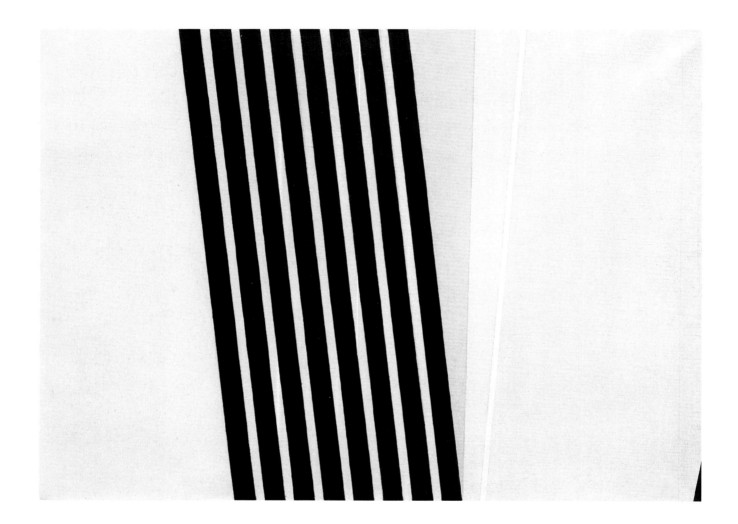

180
FRIEDRICH VORDEMBERGE-GILDEWART
Composition No.56 1930

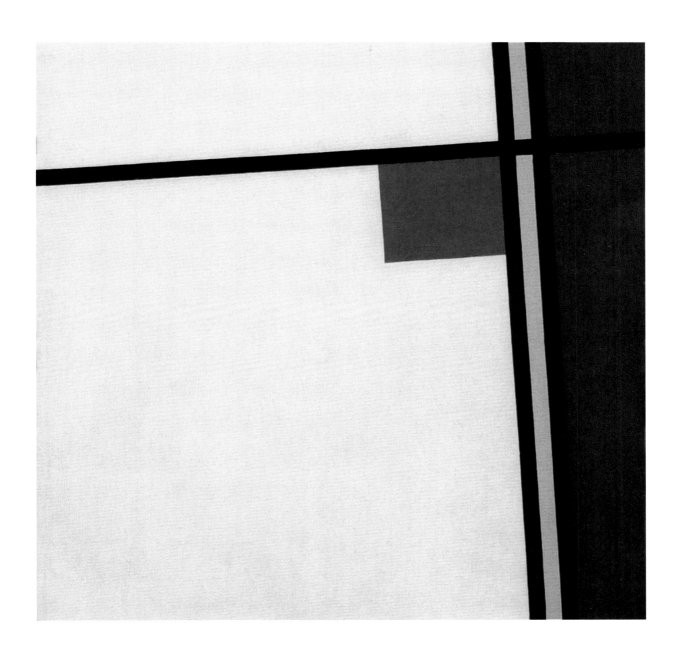

181
OTTO CARLSUND
Second Programme Picture
Six Announcements for Art Concret 1930

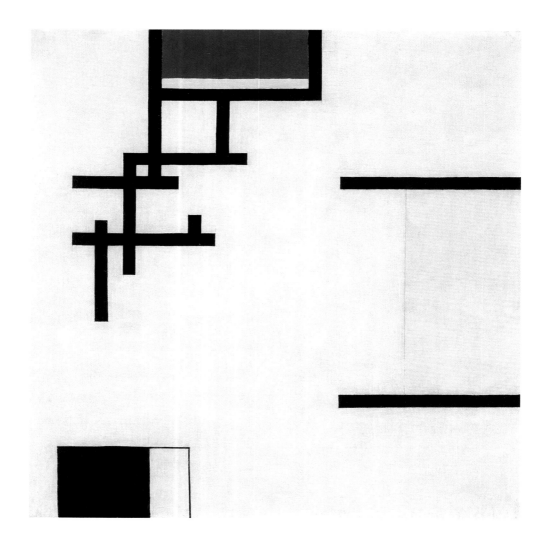

182
JEAN HÉLION
Composition 1930

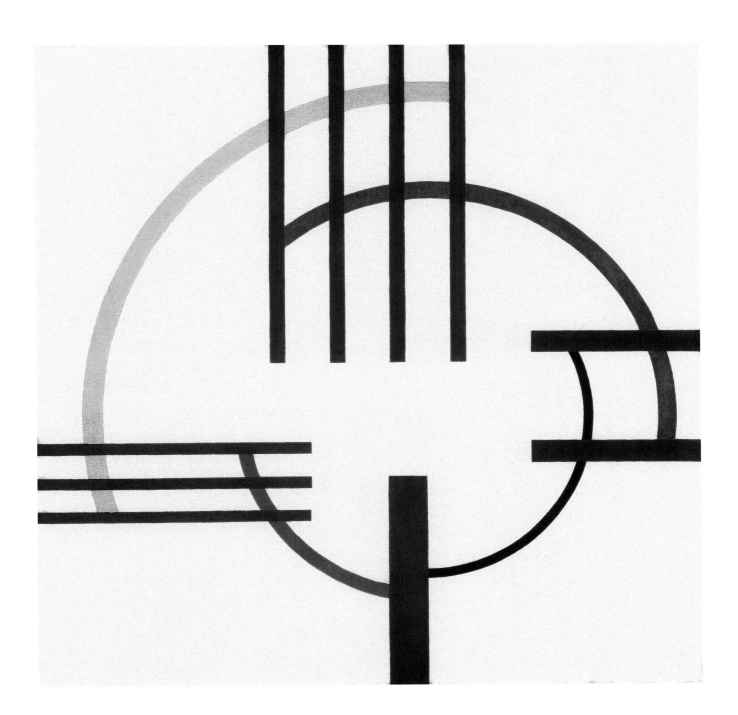

183
JEAN HÉLION
Circular Tensions 1931–2

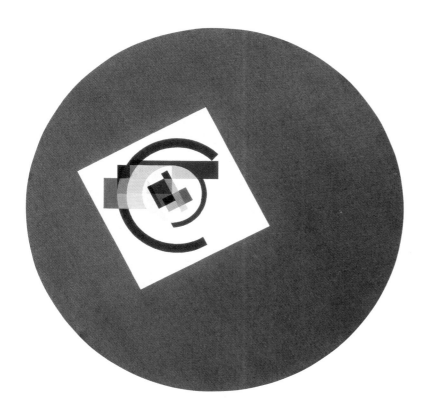

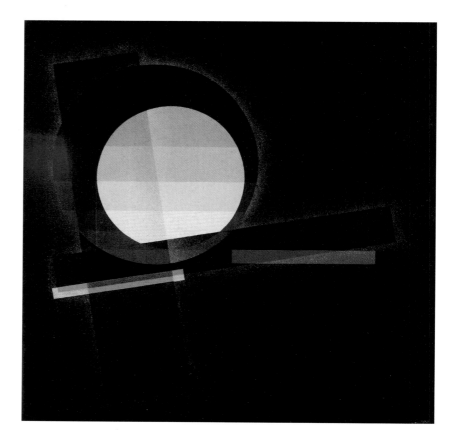

184
WALMAR SHWAB
Untitled c.1929

185
WALMAR SHWAB
Integral Painting 1929/1930

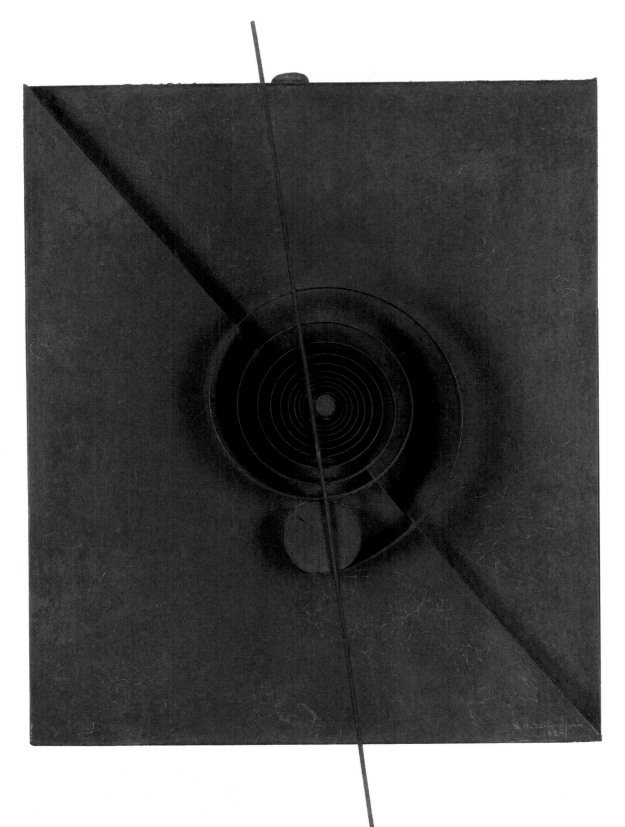

186
LÉON TUTUNDJIAN
Relief 1929

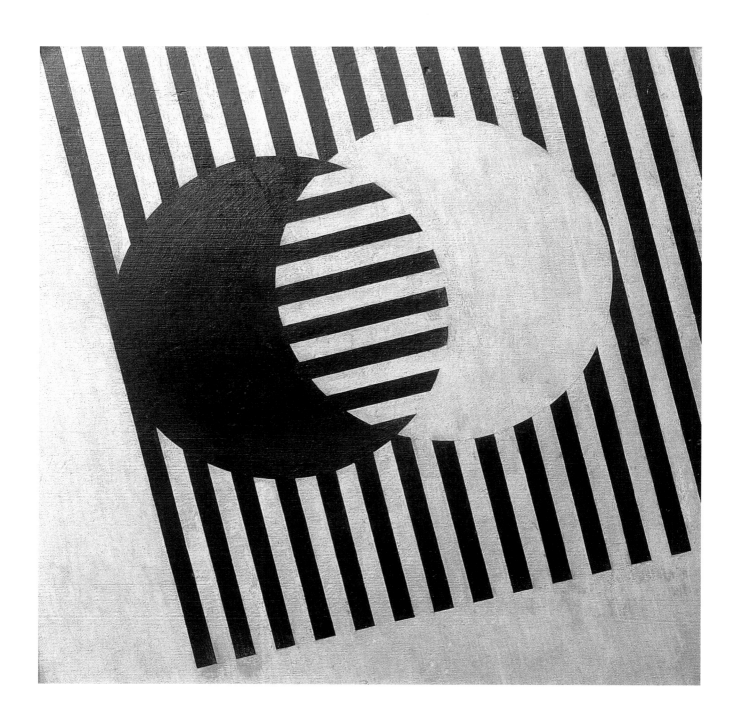

187
OTTO CARLSUND
Fourth Programme Picture
Six Announcements for Art Concret 1930

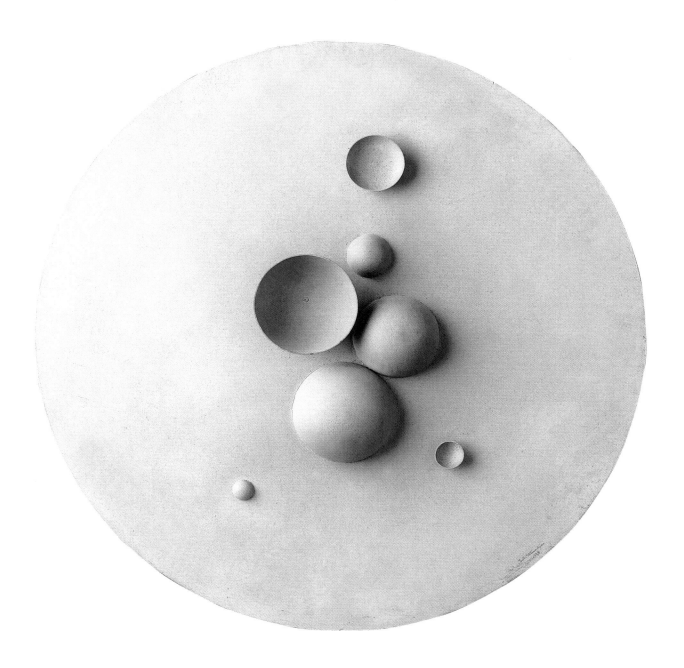

188
LÉON TUTUNDJIAN
Relief 1929

189
THEO VAN DOESBURG
Simultaneous Counter-Composition 1929

190
THEO VAN DOESBURG
Simultaneous Counter-Composition 1930

Joost Baljeu, *Theo van Doesburg*, London, 1974

Stephen Bann (ed.), *The Tradition of Constructivism*, New York, 1974

Jane Beckett, 'Dada, Van Doesburg and De Stijl,' *Journal of European Studies*, vol.9, no.33-4, 1979, pp.1–25

Jane Beckett, '"De Vonk", Noordwijk: An Example of Early De Stijl Co-operation,' *Art History*, vol.3, no.2, 1980, pp.202–217

Hubert van den Berg, *The Import of Nothing: How Dada Came, Saw and Vanished in the Low Countries* (1915–1929), Crisis and the Arts, vol.7, New Haven and London, 2002

Carel Blotkamp (et. al.), *De Stijl: The Formative Years, 1917–1922*, Cambridge MA and London, 1986

Carel Blotkamp (ed.), *De vervolgjaren van De Stijl 1922–1932*, Amsterdam, 1996

Cees Boekraad, Flip Bool and Herbert Henkels (eds.), *Het Nieuwe Bouwen. De Nieuwe Beelding in de architectuur. Neo-Plasticism in Architecture. De Stijl*, Delft and The Hague, 1983

Yve-Alain Bois, 'The De Stijl Idea' in *Painting as Model*, Cambridge MA and London, pp.101–22

Jo-Anne Birnie Danzker (ed.*) Theo van Doesburg: Maler-Architect*, exh. cat., Munich, London, New York, 2000

De Stijl, exh.cat., Stedelijk Museum, Amsterdam, 1951

Theo van Doesburg, *On European Architecture: Complete Essays from Het Bouwbedrijf 1924–1931*, trans. Charlotte and Arthur Loeb, Basle, Berlin, Boston, 1990

Theo van Doesburg, *Principles of Neo-Plastic Art*, trans. Janet Seligman, London, 1969

Theo van Doesburg, *What is Dada??? And other Dada writings*, trans. Michael White, London, 2006

Allan Doig, *Theo van Doesburg: Painting into Architecture, Theory into Practice*, Cambridge, 1986

Craig Eliason, 'De conferenties van 1922: Tristan Tzara als Van Doesburgs saboteur', Jong Holland, vol.16, no.2, 2000, pp. 31–7

Marco Entrop, ' "Je suis contre tout et tous": I.K.Bonset en Tristan Tzara's Dadaglobe', *Jong Holland*, vol.4, no.3, pp.23–32

Marco Entrop, 'Holland Dada in Italië', *Het Oog in 't Zeil*, no.2, 1991–2, pp.17–20

Sjarel Ex, *Theo van Doesburg en het Bauhaus. De invloed van De Stijl in Duitsland en Midden-Europa*, exh. cat., Centraal Museum, Utrecht, 2000

Gladys Fabre, *Paris 1930, Arte abstracto, Arte concreto, Cercle et Carré*, exh. cat., Ivam Centre Julio González, Valencia, 1990

Bernd Finkeldey, Kai-Uwe Hemken, Maria Müller and Rainer Stommer (eds.), *Konstruktivistische Internationale Schöpferische Arbeitsgemeinschaft. 1922–1927. Utopien für eine europäische Kultur*, exh.cat., Kunstsammlung Nordrhein-Westfalen, Dusseldorf, 1992

Mildred Friedman (ed.), *De Stijl: 1917-1931. Visions of Utopia*, exh.cat., Walker Art Center, Minneapolis, 1982

Emmanuel Guigon, Hans van der Werf and Mariet Willinge (eds.), *De Aubette of de kleur in de architectuur. Een ontwerp van Hans Arp, Sophie Taeuber-Arp en Theo van Doesburg*, Rotterdam, 2006

Hannah Hedrik, *Theo van Doesburg: Propagandist and Practitioner of the Avant-Garde*, Ann Arbor, 1980

Els Hoek (ed.), *Theo van Doesburg: Oeuvre catalogus*, Utrecht and Otterlo, 2000

H.L.C. Jaffé, *De Stijl, 1917–1931: The Dutch Contribution to Modern Art*, Amsterdam, 1956

H.L.C. Jaffé, *De Stijl*, London, 1970

H.L.C. Jaffé, *Theo van Doesburg*, Amsterdam, 1983

Serge Lemoine (ed.), *Theo van Doesburg. Peinture, architecture, theorie*, Paris, 1990

Donald McNamee, 'Van Doesburg's Elementarism: New Translations of his Essays and Manifesto Originally Published in De Stijl' *The Structurist*, no.9, 1969, pp.22–9

Steven A. Mansbach, *Visions of Totality. Laszlo Moholy-Nagy, Theo van Doesburg and El Lissitzky*, Ann Arbor, 1980

Wies van Moorsel, *De doorsnee is mij niet genoeg. Nelly van Doesburg 1899–1975*, Nijmegen, 2000

Alied Ottevanger, *De Stijl in Tilburg: Over de vriendschap tussen Theo van Doesburg en Antony Kok*, Amsterdam, 2007

Alied Ottevanger (ed.), *De Stijl overal absolute leiding: De briefwisseling tussen Theo van Doesburg en Antony Kok*, Bussum, 2008

Paul Overy, *De Stijl*, London, 1991

K.Schippers, *Holland Dada*, Amsterdam, 1974

Evert van Straaten, *Theo van Doesburg 1883–1931 Een documentatie op basis van materiaal uit de schenking Van Moorsel*, The Hague, 1983

Evert van Straaten, '"Ze hebben Tzara bijna doodgeslagen". Theo van Doesburg als ooggetuige van de Soirée du Coeur à Barbe', *Jong Holland*, vol.3, no.4, 1987, pp.24–31

Evert van Straaten, *Theo van Doesburg: Painter and Architect*, The Hague, 1988

Evert van Straaten. *Theo van Doesburg: Constructor of the New Life*, Otterlo, 1994

The Antagonistic Link: Joaquín Torres-Garcia, Theo van Doesburg, exh. cat., ICA, Amsterdam, 1991

Theo van Doesburg 1883–1931, exh. cat. Stedelijk Van Abbemuseum, Eindhoven, 1968

Nancy Troy, 'Theo van Doesburg. From Music into Space', *Arts Magazine*, vol.56, no.6, February 1982, pp.92–101

Nancy Troy, *The De Stijl Environment*, Cambridge MA and London, 1983

Marguerite Tuijn, *Mon cher ami…Lieber Does. Theo van Doesburg en de praktijk van de internationale avant-garde*, Amsterdam 2003

Jan de Vries, 'Theo van Doesburg. Terug naar de natuur.' *Jong Holland*, vol.9, no.3 (1993), pp. 39–44

Robert Welsh, 'Theo van Doesburg and Geometric Abstraction' in Francis Bulhof (ed.), *Nijhoff, Van Ostaijen, "De Stijl." Modernism in the Netherlands and Belgium in the First Quarter of the 20th Century*, The Hague, 1976, pp.76–94

Michael White, *De Stijl and Dutch modernism*, Manchester, 2003

Michael White, 'Spiritual Hygienists: Van Doesburg, Teige and the Concept of Progress,' *Umeni*, vol.43, no.1–2, 1995, pp.63–5

Doris Wintgens Hötte and Ankie de Jongh-Vermeulen (eds.) *Dageraad van de Moderne Kunst. Leiden en omgeving 1890–1940*, exh. cat., Stedelijk Museum De Lakenhal, Leiden, 1999

Doris Wintgens Hötte, 'Vijf glas-in-loodramen. Theo van Doesburg', *Bulletin van de Vereniging Rembrandt*, vol.13, no.2, 2003, pp.21–4

Doris Wintgens Hötte, 'De stillevenarchitect en de geometricus. De relatie tussen Emil Filla en Theo van Doesburg', *Jong Holland*, vol.22, no.2, 2006, pp.37–45

Texts by
Juliet Bingham
Iria Candela
Cliff Lauson
Rosie O'Donovan
Wenny Teo
Doris Wintgens Hötte

ALEXANDER ARCHIPENKO

1887 Kiev, Ukraine – 1964 New York, United States

1902 Studies painting and sculpture at the School of Art in Kiev. **1905** Forced to leave after criticising the academicism of tutors. Goes to Moscow. **1908** Establishes himself in Paris. Rejects contemporary sculptural styles. Studies for two weeks at the Ecole des Beaux-Arts before leaving to teach himself sculpture. **1910** Exhibits with Cubists at the Salon des Indépendants. Exhibits at Section d'Or, at the Galerie de la Boetie, Paris. Shows with the Modern Art Circle, Amsterdam. **1911–13** Work shown at the Salon d'Automne. **1912** Opens an art school in Paris. Championed by critic Guillaume Apollinaire. **1913** Joins Der Sturm group and has first solo show at their gallery in Berlin. Is represented in the New York Armory Show. **1914–18** Resident in Cimiez, near Nice. **1917–21** Contributes to De Stijl. **1918–21** Travels extensively in Europe. **1919** Exhibits in large group show at Galerie d'Art des Editions Georges Crès & Cie. Solo shows in Geneva and Zurich. **1920** Meets van Doesburg and participates in the Section d'Or exhibition in Paris, The Hague, Rotterdam and Amsterdam organised by van Doesburg. Solo show at the Société Anonyme Inc. in New York. **1921** Moves to Berlin to open an art school. **1923** Settles in USA. Establishes an art school in New York. **1927** Is granted a patent for his invention Archipentura 1924, a machine for the production of images in sequence which shows his continued interest in Futurism. **1928** Becomes an American citizen. **1930s–1940s** Turns to classical naturalism and traditional sculptural materials. Lectures and teaches art at universities and colleges across the USA and Canada. **1964** Dies in New York.

HANS ARP (JEAN ARP)

1886 Strassburg, Germany (now Strasbourg, France)
– 1966 Basel, Switzerland

1913 Contact with Der Sturm Gallery in Berlin. **1915** Moves to Zurich. Exhibits at the Galerie Tanner, where he meets Sophie Taeuber. Her use of abstraction has a strong impact on his work and the two begin to collaborate on collages. **1916** Co-founds Zurich Dada at the Cabaret Voltaire. **1919** Co-founds Dada in Cologne with Max Ernst and Baargeld, calling themselves Gruppe D. **1920** Travels to Berlin and meets Hausmann and Höch. **1922** Marries Taeuber. Disrupts the Constructivist Congress in Weimar with Tzara, turning it into a Dadaist-Constructivist congress. Embarks on Dada tour to Jena, Dresden and Hanover with van Doesburg. **1922–3** Contributes to various magazines including Merz, Der Sturm, Mécano and G. **1925** Takes part in the first Surrealist exhibition at the Galerie Pierre. Participates in the November Group show in Berlin. **1926–8** Along with van Doesburg and Sophie Tauber, he embarks on the commission to design and decorate the interior of the Café Aubette in Strasbourg. The Arps move to the house and studio in Clamart. **1929** Participates in the Select Exhibition of Contemporary Art at the Stedelijk Museum in Amsterdam. **1930** Joins Circle et Carré, and exhibits in the group show at Galerie 23. **1931** Founding member of Abstraction-Création until 1934. **1936** Exhibits in the MOMA, New York show Fantastic Art, Dada and Surrealism. **1938** Exhibits in Abstract Art at the Stedelijk Museum in Amsterdam. **1940** The Arps move to Grasse in the south of France with Sonia Delaunay. **1945** Contributes introductory text and work to the Art Concret exhibition at the Galerie René Drouin. **1946** Returns to Meudon. Exhibits in the Salon des Réalités Nouvelles, Paris. **1954** Awarded the International Prize for Sculpture at the Venice Biennial. **1958** Major retrospective at MOMA, New York. **1959–62** Exhibitions of his work tour major museums in Europe. **1966** Dies of a heart attack in Basel.

JOHANNES THEODOR BAARGELD (ALFRED EMANUEL FERDINAND GRUENWALD)

1892 Stettin, Germany (now Szczecin, Poland)
– 1927 Chamonix, France

1892 Born in Stettin. **1917** Starts writing lyrical and political texts for Franz Pfemfert's pacifist journal Die Aktion. **1918** Joins the radical left-wing Independent Socialist Party of Germany, adopting the pseudonym Johannes Theodor Baargeld (bargeld means 'cash' in German). Publishes the anti-authoritarian Der Ventilator. **1919** Discovers the works of Giorgio de Chirico. Co-founds Dada in Cologne with Max Ernst and Hans Arp. They mount a Dada exhibition alongside the autumn exhibition of the Holner Gesellschaft der Kunste and begin calling themselves Gruppe D. He publishes the Cologne Dadaist journal Bulletin D in November under the name 'Zentrodada'. Begins, under the influence of Arp, to write Dadaist collage poetry. **1920** In April, along with Ernst and Arp, he organises the exhibition Dada-Early Spring, which includes the works of Francis Picabia. He co-publishes Die Schammade with Ernst. The two continue to produce drawings, assemblages and writings collaboratively. In June he participates in the Internationale Dada Fair in Berlin. **1921** Participates in the Salon Dada at the Galerie Montaigne, Paris. **1923** Completes his doctorate in philosophy and economic theory in Cologne. **1927** Dies in a mountain climbing accident.

JEAN BADOVICI

1893 Romania – 1956 Vézelay, France

Studies architecture in Paris after the First World War. **1923–5** Founding editor, with the support of the publisher Albert Morancé, of the French journal L'Architecture Vivante, devoted to promoting avant-garde architecture and design. **1924** Renovates the Vézelay House for his own residential use. An influential critic and mentor of international modern architecture, Badovici also writes articles in the Dutch journal Wendingen, and in Cahiers d'Art, edited by his friend Christian Zervos. Befriends Paul Eluard and Le Corbusier. Undertakes trips through Europe with Eileen Gray to study examples of modern architecture. Presents the portfolios for Sue et Mare, French interiors, and Frank Lloyd Wright. **1925** L'Architecture Vivante dedicates an issue to De Stijl. **1926–9** Builds, with Eileen Gray, the famous architectural work E-1027, a house on the cliffs at Roquebrune-Cap-Martin, near Monaco. As an example of a classic modern building, L'Architecture Vivante features E-1027 in its autumn

issue of 1929. Le Corbusier is impressed by the house and in 1939 paints colourful wall murals in it, which Gray disapproves of. **1930** Exhibits with Gray the plans for E-1027 at the first exhibition of the Union of Modern Artists. **1934** Builds another residential house for himself near the Pont de Sèvres, Paris. **1938** Writes the first seven volumes for the complete works by Le Corbusier. **1945** After the Second World War, gets involved in the reconstruction of the architectural heritage of France, as assistant to chief architect Robert Edouard Camelot.

WLADIMIR BARANOFF-ROSSINÉ
1888 Kherson, Ukraine – 1944 (disappeared during the Second World War)

1903 Studies in Odessa. **1904-7** Attends the Imperial Academy of Fine Arts in St Petersburg. Exhibits at the first historic exhibitions of the Russian avant-garde. **1907-8** With the Stephanos group in Moscow. **1908** With the Zvienogroup in Kiev. **1909** With both groups in St Petersburg. **1910** Moves to Paris where he is influenced by Futurism and Cubism. Has numerous artistic contacts and is particularly friendly with Robert and Sonia Delaunay. He also attends the Paris soirees given by Baronne d'Oettingen and Serge Ferat, who welcome the Russian and French avant-garde. **1910-14** Exhibits at the Salon des Indépendants in Paris. **1914** Travels from Paris to his parents in Moscow and then to Scandinavia where he lives in Oslo and Stockholm. **1915** Exhibits with Archipenko, Kandinsky, Chagall and Zadkine on the exhibition of *The Independents* in Amsterdam. Here van Doesburg is very much impressed by his painted sculptures. Van Doesburg considers Archipenko and Baranoff-Rossiné to be artists who first introduced rhythmic sculpture. **1917** After the Russian Revolution returns to Russia where he is part of the Artistic Revolution. **1922** Takes part in the *First Russian Art Exhibition* in the Van Diemen Gallery in Berlin. **1923** The same show is on view in the Stedelijk Museum in Amsterdam. **1924** Achieves his dream of combining sound, colour and shape in building the 'Optophonic' piano, an instrument that was capable of creating sounds and coloured lights, patterns and textures simultaneously. **1925** Emigrates to France. **1931** In his letter of condolence to Nelly van Doesburg he writes that van Doesburg really was one of his best friends.

HERBERT BAYER
1900 Haag, Austria –1985 Santa Barbara, United States

1919-20 After serving in the army during the First World War, apprenticeship with designer G. Schmidthammer in Linz. **1921** Moves to Weimar in October. **1921-3** Student at Bauhaus. Creates the Universal Type alphabet. Presents murals for the large Bauhaus exhibition in 1923. **1923-4** Travels through Italy and earns living as a house painter. **1924-5** Training at the mural-painting workshop, led by Oskar Schlemmer and Wassily Kandinsky. **1925** Marries art student Irene Hecht, from whom he separates in 1928. **1925-8** Instructor at the Bauhaus in Dessau. Takes charge of the new printing and advertising workshop. Designs

printed matter for the school. Introduces photography as an advertising technique. **1928** Leaves the Bauhaus following Walter Gropius's resignation as director. **1929** Invited to exhibit with the Circle of New Advertising Designers in Magdeburg. **1928-38** Settles in Berlin as director of the Dorland advertising agency. Art director of *Vogue*. Works as exhibition designer and also devotes time to painting and photography. **1938** Emigrates to USA. Designer of the exhibition *Bauhaus 1910–1928* at the Museum of Modern Art, and co-editor of its catalogue with Gropius. **1938-46** Lives and works in New York as a graphic designer, developing exhibition design techniques and commercial art in America. **1946** Settles in Aspen, Colorado as consultant for the cultural centre. Works in painting, graphic design, architecture and landscape design. **1946-56** Artistic consultant for the Container Corporation of America. Designs a world atlas, unique in its class. **1968** Designs touring exhibition *50 Years of Bauhaus* in Stuttgart, London, Chicago, etc. **1975** Moves to Montecito, California.

HENRYK BERLEWI
1894 Warsaw – 1967 Paris

1913-15 Studies at the School of Drawing in Warsaw, comes into contact with Cubism and Futurism. **1921** Attends Lissitzky's lecture in Warsaw, which has a considerable impact on him. **1922-3** Moves to Berlin. Joins the November Group, meets van Doesburg, Eggeling, Moholy-Nagy, Richter and Herwarth Walden. Advocates 'Mechano-Faktura' (Mechano-texture), a theory of mechanistic Constructivism. **1922** Participates in the Dusseldorf Congress. **1923** Returns to Warsaw, joins the Blok group. **1924** Contributes to the journal *Blok*, which also publishes submissions by van Doesburg, Lissitzky and Arp, amongst others. Publishes his Mechano-Faktura manifesto and starts an advertising company called Reklama-Mechano. Produces paintings of geometric shapes and flatly applied colour and expressive typographic works. Becomes interested in stage design and architecture. **1927** Abrupt shift to figurative painting in keeping with the spirit of New Classicism. **1928** Moves to Paris. **1950s** After the war, he returns to abstraction and his Mechano-Faktura aesthetic. **1960** Organises Archives de l'Art Abstrait de l'Avant-garde Internationale in Paris. Participates in exhibitions throughout Europe and the US, also working as an art critic. **1967** Dies in Paris.

SÁNDOR BORTNYIK
1893 Marosvásárhely, Hungary (now Tîrgu Mures, Romania) – 1976 Budapest

1915 Achieves success as poster designer. Becomes a leading figure of the MA group. Joins the Hungarian Activists. **1918-19** Produces linocuts for the title pages of *MA*, marked by an increasingly abstract and rhythmic use of colour. Exhibits radical cubo-futurist works in the MA group show. **1920** Moves to Vienna with Kassák. **1921** He and Kassák's collaborative 'picture-architecture' work is considered the inaugural work of Hungarian Constructivism. **1922** Falls out with Kassák, moves to Weimar at the invitation of

Farkas Molnár. Attends Bauhaus programs but is not matriculated there. Influenced by the De Stijl lectures of van Doesburg and Dutch Constructivism. Exhibits at Der Sturm Gallery in Berlin. **1924** Begins depicting architectural elements and human forms in an increasingly mechanistic aesthetic. **1925** Moves back to Budapest. Establishes the avant-garde Zöld Szamár (Green Donkey) Theatre. Works as an advertisement designer and publisher of reviews. **1927** Founds the magazine *Új Föld*. **1928** Opens a Bauhaus-type school called Mühely (Workshop). **1930s** Moves towards realism and painting, and after the war, designs political posters. **1948-9** Made professor at the Academy of Design and the Director of the Academy of Fine Arts in Budapest until 1956. **1960s** Recreates his early Constructivist works and abstract paintings for several German exhibitions. **1976** Dies in Budapest.

CONSTANTIN BRANCUSI
1876 Hobitza, Romania – 1957 Paris

1904 Arrives in Paris. **1905** Enters Antonin Mercié's Studio at Ecole des Beaux Arts. **1907** Experiments with the simplification of forms and abstract expression. Presents works at the Salon of the Société National des Beaux Arts. **1908** Works at La Ruche, an artists' residence in Montparnasse. **1909** Befriends Archipenko. **1910** Co-founds L'Association Amicable des Roumains de Paris. Exhibits for the first time at the Salon des Indépendants. Frequents soirees with Guillaume Apollinaire, Modigliani, Léger and Picasso. **1912** Visits Paris Air Show with Duchamp and Léger. **1913** Exhibits in the *Armory Show*, New York. **1914** First solo show in New York at the Photo-Secession Gallery. Shows work in Prague alongside Archipenko. **1916** Rents studio in artists' colony on Impasse Ronsin. Makes *Princess X*. **1918** First version of *Endless Column*. **1920** *Princess X* is withdrawn from the Salon des Indépendants by the police. A petition is signed by Picasso, Léger and Archipenko amongst others. Shows in first exhibition by the Société Anonyme. Exhibits at the *Section d'Or* at Galerie Boétie. **1920-2** Attends various Dada events with Tzara and Janco but does not commit himself to the movement. **1925** Participates in *The Art of Today* with van Doesburg. **1925-7** Becomes member of *De Stijl* and contributes to publications. **1926** Shows works in the *Modern Art Exhibition* at the Salon d'Art Contemporain in Antwerp. **1927** *Bird in Space* is seized by US customs authorities. Brancusi v. United States court case ensues. His *Aphorisms* appear in the anniversary issue of *De Stijl* which is published in early 1928. **1934** Contributes to the third edition of *Abstraction-Création*. **1935** Receives commission to make monument at Tirgu-Jiu in Romania to commemorate local heroes of First World War. **1935-57** Exhibits internationally. **1951** Peggy Guggenheim and Nelly van Doesburg visit his studio. **1957** Dies in Paris.

MARCEL BREUER
1902 Pécs, Hungary – 1981 New York

1920 Moves to Vienna to study painting and sculpture. Disappointed with the Art Academy. **1920-4** Student at the Bauhaus in Weimar. Training in the cabinet-making workshop. **1921** Meets van Doesburg in Germany. As early as 1921, attracts attention with his unconventional designs for chairs and tables, partly influenced by the De Stijl group, and in particular by Gerrit Rietveld. **1924** Short stay in Paris. **1925-8** Instructor at the Bauhaus in Dessau, leading the furniture workshop. Creates numerous landmark furniture designs, such as the tubular steel club armchair (1925). Interior designs for the Bauhaus buildings in Dessau and for Erwin Picator's home in Berlin. **1928** Sets up office as independent designer in Berlin, focusing on furniture design as well as interior and exhibition design. **1932** Builds the Harnischmacher House, his first architectural project. **1935-7** Works as an architect in London. Collaborates with F.R.S. Yorke. **1937** Appointed Professor Chair of Architecture at Harvard University. **1938-41** Partner at Walter Gropius's firm in New York. **1946** Opens his own architecture studio in New York. **1947** Builds his house in New Canaan, Connecticut, and later builds numerous residential, apartment, office, church and cultural buildings in North and South America and Europe, including the Whitney Museum in New York, and participates in the design of the UNESCO building in Paris. **1956** Founds the firm Marcel Breuer and Associates. **1981** Dies in New York.

ERICH BUCHHOLZ
1891 Bromberg, Germany (now Bydgoszcz, Poland) – 1972 Berlin

1911-15 Works as a teacher in a primary school in Berlin and paints in his free time. **1915** Moves to Berlin. **1917** Works as dramatist in the Bamberg Theatre. **1918** Starts working on abstract paintings and designs abstract stage sets for the Albert Theatre in Dresden. **1921** First exhibition at Der Sturm Gallery in Berlin. Makes *Reliefbilder*, shallow wooden reliefs with weakened, primary colours using gold instead of yellow. **1922** Concentrates on architectural constructions and on typographic design. Remodels his studio flat into the first 'environment', an abstractly designed three-dimensional space. His studio was a meeting place for artists of the avant-garde, including Schwitters, Höch, Hausmann, Richter and Eggeling. Together with Péri, Moholy-Nagy, El Lissitzky and Eggeling he designs a dynamic form of Constructivism. **1923** Participates in the *Greater Berlin Art Exhibition* in the Glaspalast in Berlin together with van Doesburg, Burchartz, Dexel, Engelien, Graeff, Röhl, Berlewi, Moholy-Nagy, Péri, Iwan Puni, Domela and Richter. **1933** The Nazis label his work 'degenerate'.

MAX BURCHARTZ
1887 Elberfeld, Germany – 1961 Essen, Germany

1906-8 Studies at the Art Academy in Dusseldorf. **1914-18** Army service in the First World War. **1919** Meets Kurt Schwitters and El Lissitzky. Aesthetic shift towards realism. **1921** Meets van Doesburg in Germany. Takes part in the Weimar De Stijl group. **1922** Enrols in the Bauhaus school. Attends van Doesburg's independent course *Stijl-Kurs I* in Weimar. Departs from his previous style and enters into the new abstract trend of Constructivism. Participates in the Congress of Constructivists and Dadaists in Weimar. Attends Dada soirees in Jena and Hanover. Translates van

Doesburg's *Principles of Neo-Plastic Art* into German for the Bauhaus Books collection. **1924** Settles in the Ruhr province and opens the Werbebau advertising agency with J. Canis. Works on typography and architectural colour design. Experiments with technical juxtapositions of typography, photography and photo collage. **1926** Furthers his interest in furniture design. **1927-33** Teaches typography at the Folkwang School in Essen. Member of the Circle of New Advertising Designers. Joins architect Alfred Fischer, who built the Hans Sachs House in Gelsenkirchen, and develops a colour coding system for its interior. **1933** Joins the Nazi party. **1933-9** Works for the company Forkardt. During this period also devotes himself to photography and printing of industrial subject matter. **1939-45** Joins the German army and fights in the Second World War. **1949** Back to teaching at the Folkwang School in Essen. **1953** His book on art theory, *Allegory of Harmony*, comes out. **1961** Dies in Essen.

OTTO GUSTAF CARLSUND
1897 St Petersburg, Russia – 1948 Stockholm

1921-3 Studies in Dresden and Oslo. **1924** Studies in Paris with Fernand Léger and Amédée Ozenfant. Assists Legér with his film *Le Ballet mécanique*. Shows in group exhibition at Maison Watteau. **1925** Takes part in *The Art of Today* in Paris alongside van Doesburg. **1926** Exhibits at the *International Exhibition of Modern Art* curated by Katherine Dreier in New York. **1927** Solo show at the Galerie Mots et Images in Paris. **1928** Exhibits at the Salon des Surindépendants, Paris with van Doesburg and Léon Tutundjian. **1929** Style moves towards the non-representational. Meeting at Café Zeyer in Paris with van Doesburg, Hélion, Tutundjian and Wantz. **1930** Co-founds group Art Concret with van Doesburg which publishes only one edition of its journal *L'Art Concret*. Curates *Art Post-Cubism* exhibition in Stockholm and arranges Art Concret section in the restaurant. Exhibits in *Produktion-Paris 1930* in Zurich. **1931** Invited to join Abstraction-Création. His style turns towards Surrealism. Devotes more time to art criticism. **1941-5** Publishes his own magazine *Konstvärlden*. **1944** Returns to non-figurative painting after death of Mondrian. **1945** *Art Concret* exhibition at the Galerie Drouin in Paris. **1948** Dies in Stockholm.

SERGE CHARCHOUNE
1888 Bougourouslan, Russia – 1975 Villeneuve-Saint Georges, France

1909 Travels to Moscow to attend different art academies. **1912** Avoids army service and leaves for Paris. Attends classes at the Académie La Palette in the company of Cubists with Metzinger, Segonzac and Le Fauconnier as teachers. **1913** Shows at the Salon des Indépendants. **1914-16** Lives in Barcelona with the sculptor Hélène Grunöff. There meets Picabia, Gleizes and Laurencin and has exhibition in the Dalmau Gallery. **1917** In Paris, becomes involved with the Dada movement **1921** Participates in the Salon Dada at the Galerie Montaigne. **1922** In Berlin, publishes the Dada review *Perevos* and writes for the magazines *391*, *Manomètre*, *Merz*, *Mécano*. Exhibits at Der Sturm Gallery with Pougny and Lissitzky. **1923** Settles in Paris. **1925** Becomes interested in anthroposophy. **1926** Shows at the Galerie Jeanne Bucher and Percier Gallery. **1927** Introduced to Amédée Ozenfant by Nadia Léger and becomes interested in Purism. **1930-46** Shows in the Salon des Surindépendants. **1944** Paints first works inspired by music. **1948** Becomes interested in abstract landscapes. **1971** First major retrospective at le Musée National d'Art Moderne, Paris.

JEAN CROTTI
1878 Bulle, Switzerland – 1958 Paris

1915 Arrives in New York. Frequents the gatherings of Walter and Louise Arensberg. Becomes active in the New York avant-garde scene, resulting in a drastic change in his work. Meets Picabia and shares a studio with Duchamp. **1916** Exhibits three constructions at the Montross Gallery in New York with the Puteaux group. Moves to Paris in September. **1919** Marries Suzanne Duchamp. **1920** He and Suzanne, along with Ribemont-Dessaignes, submit their work to the first post-war Salon des Indépendants using this cultural event to inject Dada into Paris. He is featured in *De Stijl*, and he and Suzanne are listed amongst the 'presidents' of Dada in *Dada* (no.6). **1921** In February he has a mystical experience he calls 'Tabu' that changes his artistic direction. He and Suzanne jointly exhibit their Dada works at the Galerie Montaigne. **1922** Submits an article on Tabu to *The Little Review*, and to the Yellow (first) issue of *Mécano*. **1926** Participates in Société Anonyme exhibitions in New York. **1937** Gives a performance at the Palais de l'Electricité et de la Lumière using abstract light and colour, a mechanical/electrical projection using a kaleidoscope device. **1938** Takes out a patent for his coloured-glass constructions he calls *Les Gemmaux*. **1945** First major exhibition of *Les Gemmaux* in Galerie Gerard, Paris. **1947** Exhibits at the Centre d'Etudes Supérieures, New York. **1950** Made a Knight of the Legion of Honour. **1954** Begins 'cosmic' paintings reminiscent of earlier Tabu works. **1958** Dies in Paris.

WALTER DEXEL
1890 Munich, Germany – 1973 Braunschweig, Germany

1910-14 Studies art history at the University of Munich, with Heinrich Wölfflin and Fritz Burger. **1912-13** First paintings influenced by Cubism and Expressionism. Trip to Italy. **1914** Short stay as student in Paris. **1916** Graduated from Jena University. Becomes exhibition organiser at Kunstverein, Jena. **1916-29** Lives as an independent artist and graphic designer. **1917-18** His paintings abandon reality in an abstract search for absolute forms. **1919-25** Close ties with the Bauhaus professors. **1920** Exhibits with Oskar Schlemmer and Willi Baumeister at Der Sturm Gallery. **1921** Meets van Doesburg. Member of the Weimar De Stijl group. Develops a new style in painting, towards a Constructivist figuration inspired by De Stijl. **1922** Van Doesburg gives his lecture 'The Will to Style' at Kunstverein in Jena. Definitive transition to absolute construction in painting. Attends Dada soirees in Jena and Hanover. **1923** Together; with art historian Adolf Behne, organises a Constructivist exhibition in Jena. **1923-7** Member of the November Group, which exhibits regularly in the *Greater Berlin Art Exhibition*. **1925** Participates in the group exhibition *The Art of Today* in Paris. **1928-9** Stage design in Jena for theatre pieces by Brecht, Gide and Shakespeare. **1929** Participates in the group exhibition of the Circle of New Advertising Designers in Magdeburg. **1933** Gives up painting. **1935** Discredited as a 'degenerate' artist by the Nazi regime. **1936-42** Professor of the Form course at the School of Art Education in Berlin. **1942-55** Founder and director of the historical Form Collection in Braunschweig. **1973** Dies in Braunschweig

NELLY VAN DOESBURG
(PETRONELLA VAN MOORSEL)
PSEUDONYM: CUPERA
1899 The Hague, The Netherlands – 1975 Meudon, France

1914–17 Studies piano at the School of Music in The Hague. **1918** Studies piano at the School of Music in Rotterdam. **1918–20** Gives piano lessons and concerts. **1920** Meets Theo van Doesburg at the opening of the *Section d'Or* exhibition at The Hague Art Circle on 10 July. Falls in love with van Doesburg, who is fifteen years older and still married to Lena Milius. **1921** In January, breaks with her family and moves to Leiden where van Doesburg lives. **1921** Travels with van Doesburg through Europe and on 29 April they settle in Weimar. In Antwerp, Ghent and Brussels Nelly plays piano compositions by Ruyneman and van Domselaer at van Doesburg's lectures. **1921** In December, stays in Vienna and meets Lajos Kassák, editor of the magazine *MA*. **1921–3** Performs modern piano pieces at Dada evenings and at van Doesburg's lectures in Germany. Plays piano at the International Congress of Progressive Artists in Dusseldorf and at the Congress of Constructivists and Dadaists in Weimar. **1923** In January and February, participates with van Doesburg, Schwitters and Huszár on the Dada tour in several Dutch cities and plays piano compositions by Satie and Rieti, amongst others. **1923** In April moves with van Doesburg to Paris. In contact with Arthur Honegger and George Antheil. Under the name Sonia Pétrowska, is engaged as a dancer in an operetta company. **1924** Death of Nelly's father. **1928** Marries van Doesburg. Occupies herself more and more with curating exhibitions. **1929** Acquires a plot for a house in Meudon with her father's inheritance. Organises the *Select Exhibition of Contemporary Art* in the Stedelijk Museum, Amsterdam and in the Pulchri Studio, The Hague. Participates in the exhibition under the name Cupera. **1930** In December, moves with van Doesburg to their newly built house in Meudon. **1931** Van Doesburg dies. Devotes herself to the promotion of van Doesburg's work. **1938** Meets and makes a firm friendship with Peggy Guggenheim. **1939–46** Close friendship with Sourou Migan Apithy, later president of Dahomey, Africa (now the Republic of Benin). **1947–9** Stays in the USA and organises several exhibitions of van Doesburg's work there. Relationship with Mies van der Rohe. **1949** Spends several months in Italy. **1952, 1955, 1958** Travels to the USA and promotes the work of van Doesburg and De Stijl. Continues to place De Stijl and van Doesburg in the public eye in Europe and the USA. **1975** Dies in Meudon.

THEO VAN DOESBURG
(CHRISTIAN EMIL MARIE KÜPPER)
PSEUDONYMS: ALDO CAMINI,
I.K. BONSET
1883 Utrecht, The Netherlands – 1931, Davos, Switzerland

1908 First exhibition at The Hague Artists' Circle. From **1912** Publishes articles as art critic. **1914** Mobilised with Dutch army on the Belgian border. Draws, writes and lectures on modern art. **1916** Works with architect J.J.P. Oud on stained glass designs for the Broek-in-Waterland building. Works with architect Jan Wils. **1917** Founds and is editor-in-chief of *De Stijl* journal. Collaborative work with Oud at the De Vonk House (The Spark), Noordwijkerhout. **1919** Joins the League of Revolutionary Socialist Intellectuals. Visits Mondrian in Paris and attends Dada soirees. **1920** Adopts pseudonym I.K. Bonset under which he contributes Dada poems and collages to *De Stijl*. Begins working in Drachten for architect Cornelius de Boer. Focuses largely on architecture and the role of colour. First trip to Germany. Visits the Bauhaus. **1921** Leaves second wife Lena Milius and travels via Belgium, France and Italy to Weimar with Nelly van Moorsel, later his third wife. Lives on

and off in Germany for almost two years. Adopts Dada/Futurist pseudonym Aldo Camini. **1921–31** Travels extensively, in France, Germany, Austria, Belgium, Italy, Spain and Czechoslovakia, meeting artists and architects and promoting his own work and the ideas of De Stijl. **1922** Founds Dada magazine *Mécano* (1922–3, 4 issues). Gives controversial De Stijl course to Bauhaus students in Weimar. Meets young Dutch architect Cornelis van Eesteren and collaborates on designs and colour schemes. Organises the International Congress of Constructivists and Dadaists in Weimar. **1923** Embarks on Dada tour of Holland with Schwitters. Moves to Paris. Contributes to Mies van der Rohe's *G* magazine. Produces drawings and models for three 'ideal' architectural projects with van Eesteren, reviving the dynamic projection technique of axonometry. Designs focus on problems of form, colour and space. Exhibits designs and models at Léonce Rosenberg's Galerie de l'Effort Moderne, Paris. **1924** Estrangement from Mondrian. Strikes Mondrian from the list of De Stijl collaborators. **1925** First exhibits diagonal *Counter-Compositions* at the *Art of Today* exhibition. **1926** Publishes major article 'Painting: From "Composition" to "Counter-composition"' in *De Stijl*, in which he opposes the horizontal-vertical orientation of the natural world and architecture in contrast to the diagonals of his paintings. **1927–31** Lives in Meudon. Redesigns interior of the Café Aubette in Strasbourg with Arp and Sophie Taeuber-Arp. **1928** Tenth Anniversary issue of *De Stijl* published. **1930** Publishes the review *L'Art Concret*, a charter of a new group of abstract artists, calling for a type of abstract art entirely free of any basis in observed reality, and with no symbolic implications. **1931** Establishes a new association, SIDANF, which becomes Abstraction-Création, with Arp, Giacometti, Hélion, Herbin, and Vantongerloo. Dies of heart attack in March.

CÉSAR DOMELA
1900 Amsterdam – 1992 Paris

1920–2 Begins painting in a synthetic Cubist style. **1923** Travels to Berlin, meets Arthur Segal, Hausmann, Eggeling, and Archipenko. Exhibits with the November Group and moves to Paris. **1924** Meets Mondrian and van Doesburg. Joins De Stijl and paints his first Neoplastic works. **1925–6** Introduces the diagonal line into his compositions in a radical rupture from Mondrian's style. Returns to Amsterdam. Contributes photographs to *De Stijl*. Has works included in an exhibition at the Société Anonyme in New York, and at the *Art of Today* exhibition in Paris. **1927** Founding member of Die Abstrakten group in Hanover with Schwitters and Vordemberge-Gildewart. Becomes involved with typography and photomontage. Contributes to *De Stijl*. **1928** Joins The Circle of New Advertising Designers. Contributes work to the STUCA group exhibition in Lille organised by Del Marle. **1930** Joins Circle et Carré. **1931** Organises and participates in the exhibition *Fotomontage* at the Staatliche Kunstbibliothek in Berlin. **1932** Introduces the curve to his compositions. **1934** Settles in Paris and has a solo exhibition at the Galerie Pierre. Submits a photograph to the third issue of *Abstraction-Création*. **1936** Represented in the exhibition *Cubism and Abstract Art* at MOMA, New York. **1937** Included in the *Constructivism* exhibition at the Kunsthalle, Basel. Launches the Constructivist review *Plastique* with Hans Arp and Sophie Taeuber-Arp. **1938** Exhibits in *Abstract Art* at the Stedelijk Museum in Amsterdam. **1945** Takes part in the *Art Concret* exhibition at the Galerie Drouin in Paris. **1946** Founding member of Réalités Nouvelles. **1951** Represented in the *De Stijl* exhibition at the Stedelijk Museum in Amsterdam. **1955** Retrospective at the Stedelijk Museum. **1960s–80s** Has a number of retrospective exhibitions internationally. **1992** Dies in Paris.

MARTHE (TOUR) DONAS
1885 Antwerp, Belgium – 1967 Audregnies, Belgium

1916 Arrives in Paris. Introduced to Cubism when working at the studio of André Lhote. **1917** Moves to Nice, begins working at the studio of Archipenko. **1918** Returns to Paris and joins La Section d'Or. **1919** Van Doesburg publishes reproductions of her work in *De Stijl*. First solo exhibition in the Librairie Kundig, Geneva, using the pseudonym Tour Donas, in case her female identity discouraged prospective buyers. Van Doesburg persuades her to change her name to Tour d'Onasky. Participates in a number of group exhibitions throughout Europe alongside Gleizes, Kupka, Braque, Léger and Archipenko. **1920** Solo exhibition at Der Sturm Gallery in Berlin. Her drawing is featured on the title page of *Der Sturm* magazine. Katherine Dreier of the Société Anonyme in New York purchases five pieces from the exhibition. **1923** Van Doesburg includes one of her illustrations in the White (4/5) issue of *Mécano*. **1949** Starts painting again after a hiatus of nearly twenty years. Exhibits figurative but schematic paintings at the Gallery Apollo in Brussels. **1958** Returns to abstraction. Exhibits at the Hessenhius in Antwerp. **1960** Major retrospective at the Palais de Beaux-Arts in Brussels. **1961** Included in *Der Sturm: Herwarth Walden and the European Avant-Garde* at the National Gallery in Berlin. **1967** Dies in Audregnies.

CORNELIS VAN EESTEREN
1897 Kinderdijk, The Netherlands – 1988 Amsterdam

1915 Draughtsman at Willem Kromhout's studio in Rotterdam. **1917** Graduates from the Academy of Fine Arts and Technical Sciences in Rotterdam. **1919–20** Works in architects' studios in The Hague and Amsterdam. **1921** Wins 'Prix de Rome' with a design for a Royal Academy of Sciences. **1922** Meets van Doesburg in Weimar while on a bursary and begins friendship. Participates in Congress of Constructivists and Dadaists in Weimar. **1923** Joins De Stijl. Begins intensive collaboration with van Doesburg in Paris, producing drawings and models for three 'ideal' architectural projects: the 'Hôtel Particulière' (a villa and gallery for Léonce Rosenberg), a 'Maison Particulière' and a 'Maison d'Artiste'. With van Doesburg, revives the dynamic projection technique of axonometry in these designs, focusing on problems of form, colour and space. Exhibits designs and models at Rosenberg's Galerie de l'Effort Moderne, Paris. **1924** Assists Jan Wils on the design of Olympic Stadium, Amsterdam (until 1927). Publishes manifesto 'Towards Collective Construction' with van Doesburg. **1924–5** Collaborates with van Doesburg on urban planning projects including a shopping arcade in The Hague. Proposes plan for reorganisation of the Rokin, Amsterdam's central canal, based on principles of Elementarism. **1925** Member of the Rotterdam group Opbouw. Designs for Unter den Linden. **1926** Designs for the commercial district in Paris. **1927–9** Contributes to *i10* magazine. **1929** Member of Amsterdam group D8. Architect, town planner and head (until 1929) of the Amsterdam Urban Development Department. Co-author of the influential General Expansion Plan for west Amsterdam (1934). The plan becomes a model for urban planning globally. **1930** President of the International Congress of Modern Architecture until 1947. **1947** Professor at Delft Polytechnic. Dies February **1988**.

VIKING EGGELING
1880 Lund, Sweden – 1925 Berlin

1897 Emigrates to Germany. **1900-7** Works as a book-keeper in Switzerland and Milan. **1907** Studies at the Art Academy in Milan. **1911** Moves to Paris, meets Arp and Modigliani. **1911-15** Paintings influenced by Cubism. Moves to artists' colony in Ascona, Switzerland. **1916** Member of Zurich Dada. Takes part in Dada exhibition at the Cabaret Voltaire. **1918** Tristan Tzara introduces Eggeling to Hans Richter and they begin a lengthy collaboration. **1919** Gives lecture on abstract art at the eighth Dada soiree in Zurich. His abstract lithographs are published in *Dada*. Produces drawings on long scrolls of paper, *Horizontal-Vertical Orchestra* and *Diagonal Symphony*, which he later recreates as film works. Co-founds the group Des Artistes Radicaux with Arp and Richter. Moves with Richter to Berlin where they join the November Group. **1920** Along with Richter, meets van Doesburg in Klein Kölzig and shows him his abstract scrolls for later films. Co-authors *Universelle Sprache* (Universal Language) with Richter, which is published in *De Stijl*. **1921** Has article published in *MA*. **1922** Takes part in Congress of Progressive Artists in Dusseldorf with van Doesburg. Acquires own studio in Berlin. **1924** Finishes filming *Diagonal Symphony* with the help of Erna Niemeyer-Soupault. Films exemplify his distancing from Dada. **1925** *Diagonal Symphony* is shown at a screening by the November Group, *Der Absolute Film*, in Berlin, alongside work by Richter, Ruttmann and Hirschfeld-Mack. Dies of a heart attack in Berlin.

EGON ENGELIEN
1896 Stettin (now Szczecin), Poland
– 1967 Kulmbach, Germany

1914-17 Educated at the School of Arts and Crafts, Stettin. **1917-18** Study period at the Art Academy of Munich. **1919-20** Student at the Bauhaus. Training in the wall-painting workshop and, simultaneously, apprenticeship as glass painter. **1920** Works independently in Weimar. **1922** Attends Theo van Doesburg's independent course *Stijl-Kurs I* in Weimar. Marries Inka Kroenberg. Designs the poster for the Cologne Fair. Publishes the article 'Constructivism' in *De Stijl*. **1923** Participates in the *Greater Berlin Art Exhibition*, where his works are shown in the same room as works by van Doesburg, Domela, Burchartz, Dexel, Graeff, and Röhl. Lives and works in Szczecin, Posen and Riga. After the **1933** exclusion from the Reich Culture Chamber, his paintings are shown in the *Degenerate Art* exhibition. During the **1930s** lives in Vienna and after the Second World War is active in Frankenwald and Kulmbach, Germany.

MAX ERNST
1891 Brühl, Germany – 1976 Paris

1914 Meets Arp at a Werkbund show in Cologne. **1916** Joint exhibition with George Muche at Der Sturm Gallery in Berlin. **1919** Co-founds Dada Cologne with Arp and Baargeld. They mount an exhibition and begin calling themselves Gruppe D. Discovers the works of Georgio de Chirico, which have a profound influence on his painting. First correspondence with Tzara, establishing link between the Cologne and Paris Dada groups. **1920** He and Baargeld publish *Die Schammade* and collaborate on drawings and assemblages. Along with Baargeld, Arp and Picabia, he organises the exhibition Dada-Early Spring. **1921** First solo exhibition in Paris at the Galerie Au Sans Pareil. Begins collaborating with Surrealist poet Paul Eluard. **1922** Moves to Paris and joins Dadaist

activities there. Contributes to the Yellow (first) issue of *Mécano*. **1925** Invents the frottage technique. **1926** Collaborates with Miró on theatrical designs and stage sets. Invents 'decalcomania', another automatist technique. **1929-36** Heavily influenced by Surrealist concepts, becomes a leading figure of the movement. Produces a series of collages and returns to illusionistic style. **1937** Special issue of *Cahiers d'Art* devoted to his work. **1941** After brief internment as an enemy alien in France, flees to New York with the help of Peggy Guggenheim, whom he marries. Becomes a leading figure among the émigré art community. **1946-52** Lives in Arizona with Dorothea Tanning. **1953** Returns to Europe. **1954** Awarded a Grand Prix at the Venice Biennale. **1961** Major exhibitions held in New York, then in 1962 in Cologne and 1969 in Stockholm. **1975** Retrospectives in New York and Paris. **1976** Dies in Paris.

EMIL FILLA
1882 Chropyne, Moravia (now Czech Republic) – 1952 Prague

1903-6 Studies at the Academy of Fine Arts in Prague. **1907** Co-founder of the artists' group Osma. **1911** Member of the Skupina group. **1912** Influenced by the Cubist French art of Braque, Gris and Picasso in the collection of Vincenc Kramár in Prague. Exhibits at the *International Art Exhibition* in the Sonderbund building in Cologne together with Mondrian and Peter Alma. **1912-13** Travels to Paris. **1913** Exhibits in Berlin with Mondrian, Otto van Rees and Jacoba van Heemskerck at the First German Autumn Salon. Exhibits in Herwarth Walden's Der Sturm Gallery in Berlin together with the Skupina group. **1914** Stays in Paris with Otto Gutfreund. On the outbreak of the First World War he is forced to flee Paris: as a citizen of the Austrian-Hungarian Empire he is considered a national enemy. Arrives in the Netherlands. **1915** Participates in the exhibition of the Modern Art Circle in Amsterdam. **1916** Participates in the exhibition *Der Sturm: Expressionists and Cubists* in the Gallery d'Audretsch in The Hague. Van Doesburg describes this show in an article in the magazine *Eenheid* as a very important exhibition of contemporary art and is particularly enthusiastic about Filla's work. The analysed, organised structure of little planes in Filla's work helps van Doesburg to overcome the intuitive influence of De Winter and Kandinsky and to concentrate on a balanced, analytical structure in painting. Filla's painting *Plat avec un raisin* inspires van Doesburg directly to make his painting *Composition IV*. Filla participates (with van Doesburg) in the exhibition of independent artists in the Stedelijk Museum, Amsterdam. **1917** Participates in the first international exhibition of the De Sphinx group in Leiden, founded by van Doesburg and J.J.P. Oud. Van Doesburg invites Filla in several letters to participate in *De Stijl* magazine. This never happens. **1921** Moves to Prague. **1925** Plans to organise an evening by Theo and Nelly van Doesburg with the artists' group Manès in Prague, but this never takes place.

JEAN GORIN
1899 Saint-Emilion-de-Blain, France – 1981 Niort, France

1923-4 Travels to Paris and encounters Cubism in the galleries of the Rue la Boétie. **1926** First sees the works of Mondrian, van Doesburg and Huszár in Del Marle's review *Vouloir*. Begins correspondence with Vantongerloo and Del Marle. Meets Mondrian in his studio and is strongly influenced by the De Stijl aesthetic. **1926-7** Meets Michel Seuphor through Mondrian. Begins to apply Neoplastic ideas to furniture and interior design. **1928** Exhibits for the first time with the STUCA group (Science, Technique, Urban, Comfort,

Art) in Lille organised by Del Marle. Becomes increasingly interested in architecture. **1930** Exhibits at Galerie 23 with Cercle et Carré, where he meets the Arps, Kandinsky, Torres-Garcia and Vantongerloo. Publishes a volumetric construction in *Cercle et Carré* (no.2). **1931** Becomes a member of the 1940 group, exhibits in their first show. After the death of van Doesburg (whom he never met but admired), he travels to Meudon to see his home. **1934** Joins the management committee of Abstraction-Création. **1937** Featured in the *Constructivism* exhibition at the Kunsthalle, Basel. **1938** Included in *Abstract Art* at the Stedelijk Museum in Amsterdam. **1942** Freed from a POW camp. **1945** participates in the *Art Concret* exhibition at the Galerie René Drouin. **1946** Made secretary of the Salon des Réalités Nouvelles. **1954** Exhibits a project for a cultural centre at the *Architecture, Colour, Form* show presented by Groupe Espace in Biot. **1957** Participates in Michel Seuphor's exhibition *Fifty Years of Abstract Art* at the Galerie Creuze. **1963** First project for *Spatial House*. **1965** Retrospective at the Musée des Beaux-Arts in Nantes. **1967** Awarded Chevalier de l'Ordre des arts et letters. Retrospective at the Stedelijk Museum in Amsterdam. **1981** Dies in Niort.

WERNER GRAEFF
1901 Wuppertal-Elberfeld, Germany – 1978 Blacksburg, Virginia, United States

1921 Joins the Bauhaus, Weimar and studies industrial design and is greatly influenced by van Doesburg. **1922** Takes part in the Congress of Constructivists and Dadaists, Weimar. **1922-30** Associated with De Stijl. Continues studies at the Technical University of Berlin-Charlottenburg. Co-founds *G* with Mies van der Rohe and Richter. Invents international road sign language, composes musical scores for abstract films, some with Richter, and designs bodies for cars and motorcycles. **1925** Member of German Factories Association. **1926-7** Chief of Press for the *Dwelling* exhibition, Stuttgart; publishes books *Bau und Wohnung* and *Innenräume*. **1927** Joins the Circle of New Advertising Designers along with Vordemberge-Gildewart, Domela and Richter. **1929** Exhibits in *Film and Photo*, Stuttgart. **1931-3** Lecturer at the Reimann School, Berlin. **1934** Leaves Germany for Spain, then Switzerland. **1951** Returns to Germany and becomes Professor at the Folkwang School, Essen, working on abstract murals.

EILEEN GRAY
1878 County Wexford, Ireland – 1976 Paris

1902 Settles in Paris. **1907** Begins learning lacquer techniques. **1913** Exhibits in the Salon des Artistes Décorateurs. **1919** Designs first complete interior. **1922** Opens a gallery (Galerie Jean Désert) at 217 rue du Faubourg Saint Honoré. Exhibits at the Salon d'Automne. A number of her designs are shown in an exhibition of French art in Amsterdam. Her works catch the attention of the De Stijl group. She begins correspondence with Oud and Wils. **1923** 'Room-boudoir' for Monte Carlo exhibited at the *Exhibition of Decorative Artists*. **1924** The June issue of the Dutch art journal *Wendigen* is devoted to her work. Attracts the attention of Walter Gropius and Kiesler. Befriends Le Corbusier, Badovici and Robert Mallet-Stevens. Under their advice, begins her architectural studies. With the help of Badovici, begins designing E-1027. **1926** Begins work on E-1027 at Roquebrune, completed in 1929. Badovici, editor of the influential *L'Architecture Vivante*, dedicates an issue to E-1027. **1929** Founding member of the Union of Modern Artists. **1930-1** Apartment for Badovici, rue Chateaubriand, Paris. **1932-4** Builds second home for herself at

Castellar. **1937** Exhibits in Le Corbusier's Pavillon des Temps Nouveaux at the Paris International Exhibition. **1946–9** Project for Cultural and Social Centre. **1954–8** Holiday home, Saint-Tropez. **1972** Retrospective at London's Heinz Gallery. **1976** Dies in Paris.

RAOUL HAUSMANN
1886 Vienna – 1971 Limoges, France

1905 Meets Johannes Baader in Berlin. **1909–14** Begins first typographical designs **1913** Meets Ludwig Meidner and is influenced by artists exhibiting at Der Sturm Gallery. **1915** Contributes numerous articles to *Der Sturm*, *Die Aktion* and other magazines. Begins a personal and collaborative relationship with Hannah Höch. **1917** Founding member of Club Dada in Berlin. **1918** Writes the Dada manifesto with Huelsenbeck. **1919–20** Meets Arp and Schwitters. Edits the journal *Der Dada*, and co-organises the First International Dada Fair, as well as numerous other Dada events and soirees. Meets van Doesburg and Eggeling in the home of the art critic Adolf Behne. **1921** Participates in the November Group exhibition. Along with Höch and Schwitters, embarks on the *Anti-Dada-Merz-Trip* lecture tour of Prague. **1922** Begins contributing writing and works to *Mécano*. Attends the International Congress of Progressive Artists in Dusseldorf. Attends the Congress of Dadaists and Constructivists in Weimar. Embarks on Dada tour to Jena, Dresden and Hanover with van Doesburg, Arp, Schwitters, Tzara and Nelly van Doesburg. Ends relationship with Hannah Höch. **1927** Begins experimenting with photography. Tries to patent the 'Optophone', a device intended to convert light into sound. **1931** Participates in the exhibition *Fotomontage* organised by Domela at the Staatliche Kunstbibliothek in Berlin. **1933** Flees to Ibiza during the war. Writes ethnographic studies of architecture accompanied by photography. Sends work to *Architecture d'aujourd'hui* (1935–6) and *Oeuvres* (1935). **1934–5** Briefly returns to Paris and contributes to Man Ray's book *Nus*. **1944** Moves to Limoges. **1946–7** Resumes contact with Schwitters and the two plan the monograph *PIN*. **1947–59** Exhibits his photographic work widely in France, Germany and the US. Publishes books and essays on Dada. **1971** Dies in Limoges.

JEAN HÉLION
1904 Couterne, France – 1987 Paris

1926 Shares a studio in Paris with Torres-García. **1927** Founds the review *L'Acte*. Work is banned by the Salon d'Automne. **1928** He organises a protest exhibition in response, *Five Painters Refused by the Jury of the Salon d'Automne* at Galarie Marck. **1929** Moves towards abstraction. Meeting at Café Zeyer in Paris with van Doesburg, Carlsund, Tutundjian and Wantz. **1930** Co-founds Art Concret group, which publishes only one edition of the journal *L'Art Concret* including the manifesto 'The Basis of Concrete Art' signed van Doesburg, Tutundjian and Carlsund. **1931** Co-founds Abstraction-Création group, along with van Doesburg, Arp and Giacometti. Group publishes writings by van Doesburg after his death and exhibits his work in their gallery. **1931–4** Contributes to first three issues of *Abstraction-Création*. **1931** First solo show, at the Galerie Pierre Loeb, Paris. **1931–2** First trip to USA. *Abstraction-Création* exhibition in Paris with Arp, Tutundjian, Taeuber-Arp and van Doesburg. **1934** Writes *The Evolution of Abstract Art* for an exhibition at New York University. **1936** Shows at the gallery Pierre, Paris with Arp and Taeuber-Arp. Shows in *Abstract and Concrete* exhibition in London. Settles in the USA. Solo shows in Hollywood and New York at the Valentine Gallery. **1937** Participates in

Constructivism exhibition in Basel alongside van Doesburg, Mondrian and Arp. **1939** Produces last abstract work, returns definitively to figurative painting. **1940** Returns to France. Is drafted into the army and taken prisoner. **1942** Escapes and publishes his story *They Shall Not Have Me* which becomes a bestseller. **1946** Returns to France. Exhibits widely in Europe with retrospectives at the Grand Palais (1971), at the Stadtische Galerie in Lenbachhaus, Munich (1984) and the Pompidou Centre (2004). **1987** Dies in Paris.

THORVALD HELLESEN
1888 Kra, Norway – 1937 Copenhagen

1910 Enrols at the Academy of Art in Oslo. **1914** Receives scholarship to study painting in Paris. **1914–15** Meets and is influenced by Braque, Picasso, Picabia and Léger. **1919** Solo exhibition at the Tivoli Hall in Kristiania, Norway. Marries the French artist Hélène Perdriat and they live next to Brancusi in Paris. Befriends Henri-Pierre Roché who supports his work. **1920** Exhibits at Salon des Indépendants and *Section d'Or* in Paris, later in Holland. Van Doesburg champions the work of Hellesen and Léger in *De Stijl* as playing an important role in the evolution of Cubism. Befriends Léonce Rosenberg, director of Galerie de l'Effort Moderne, who includes him in his exhibition touring Holland. Influence moves away from Léger towards Gleizes. **1921–5** Exhibits at the Salon des Indépendants. **1923** Participates to the Franco-Scandinavian exhibition at Maison Watteau. **1925** Takes part in *The Art of Today* show in Paris alongside van Doesburg. **1930** Acts in the films *Les Rondes des heures* and *Cendrillon de Paris*. **1936** Dedicates himself to designing posters, illustrations and murals in Copenhagen, where he dies in **1937**. **1939** Retrospective exhibition in Oslo.

DÖRTE HELM-HEISE
1898 Berlin – 1941 Hamburg, Germany

1898 Born in Berlin. **1913–15** Trains at school of arts and crafts in Rostock. **1915–18** Studies at Academy of Arts, Kassel. **1918–19** Studies at the Academy of Arts in Weimar with Walter Klemm. **1919/20** Enrolls at the Bauhaus. Takes basic course with Itten, and further classes with Feininger. **1920–2** Mural-painting workshop with Itten, Schlemmer and Kandinsky. Typography and graphics with Dora Wibiral. **1921** Collaborates on interior decoration of Sommerfeld House. **1921–2** Typography course with Schreyer. **1922** Sits for journeyman's exam at a painter and varnisher guild. Participates in the painting of Walter Gropius's Otte House in Berlin-Zehlendorf. **1922–3** Works in the weaving workshop. Becomes a member of the exhibitions committee. Illustrates children's books. **1924** Journeyman at Bauhaus. Comissioned to design the interior of public institutions in Rostock. Begins writing. **1930** Marries the journalist Heinrich Heise. **1932** Relocates to Hamburg. **1933** Occupational ban as Hitler comes to power. **1941** Dies in Hamburg.

LUDWIG HIRSCHFELD-MACK
1893 Frankfurt am Main – 1965 Sydney, Australia

1912–14 Studies painting and crafts at the Debschitz School, Munich. Also attends lectures in art history by Heinrich Wölfflin and Fritz Burger at the University of Munich. **1914–18** Army service during First World War. **1917** Marries Elenor Wirth. **1919** Enrols at the Bauhaus in Weimar. Studies under Johannes Itten, Paul Klee and Wassily Kandinsky. Apprenticeship in the print workshop, led by Lyonel Feininger. **1922** With an special interest in colour theory and pure abstraction,

and following the work of Kurt Schwerdtfeger, produces his famous colour-light compositions: builds and operates an apparatus which combines moving projections of coloured light, mechanical templates and music. **1923** Publishes the booklet *Farben Licht-Spiele*, and performs his colour-light compositions in Berlin, Vienna, Weimar and Leipzig. **1925** After Bauhaus relocates to Dessau, remains in Weimar teaching art. **1930** With Gertrud Grunow, participates in the Second Congress for Colour-Tone Research, Hamburg. **1934** Moves to Berlin. **1936** Flees Nazi Germany. Settles in Britain, where he teaches art and works in large-scale, projected-light advertising projects. **1940** Is deported to Australia as an enemy alien in the famous ship Dunera. **1942** Is released from detention through the sponsorship of James Darling, headmaster of Geelong Grammar School, where he is appointed its art master. As an inspirational influence to his students, he keeps propounding the Bauhaus principles of self-knowledge, economy of form and material and reform of society through art. **1946** Exhibits at the University of Melbourne. **1953** Exhibits at the Peter Bray Gallery, Melbourne. **1955** Marries Olive Harrison Russell. **1957** Retires to Ferny Creek. **1963** Publishes *The Bauhaus: An Introductory Survey*. **1964** Visits Europe and is invited by the Bauhaus Archive in Darmstadt to reconstruct his colour-light apparatus and perform his colour-light compositions. **1965** Dies in Sydney.

HANNAH HÖCH
1889 Gotha, Germany – 1978 Berlin

1915 Begins a personal and collaborative relationship with Hausmann in Berlin. **1917** Begins abstract collages while working in the handicrafts department of the Ullstein Verlag, designing labels, patterns, typesettings. **1918–19** Collaborates on photomontages with Hausmann. Together they meet Schwitters and become involved with Dada. **1920** Presents her photomontages and handcrafted Dada dolls at the First International Dada Fair in Berlin. Joins the November Group and participates in many of their annual exhibitions until 1931. Meets van Doesburg. **1921** Embarks on a lecture tour of Prague with Schwitters and Hausmann. **1922** Ends relationship with Hausmann. Contributes a 'grotto' to Schwitters's Merzbau, an architectural-scale assemblage containing grottoes dedicated to friends. **1924** First stay in Paris with Taeuber-Arp and Dadaists, meets Mondrian in van Doesburg's studio. **1925** Contributes second grotto to Schwitter's Merzbau. Holidays in Brittany with the van Doesburgs. **1926–8** Moves to The Hague with the Dutch poet Til Brugman. Maintains contact with the De Stijl group. **1929** First solo exhibition in The Hague. **1931** Participates in the exhibition *Fotomontage* organised by Domela at the Staatliche Kunstbibliothek in Berlin. **1932–3** Participates in the first and second *International Exhibition of Photography and Film* in Brussels. **1939** Moves back to Berlin. **1946** Exhibits at the Gallery Rosen, Berlin. **1958** Dada exhibition in Dusseldorf. **1961** Retrospective of work from 1918 to 1961 at the Galerie Nierendorf, Berlin. Participates in *The Art of Assemblage*, MOMA, New York. **1978** Dies in Berlin.

ROBERT VAN 'T HOFF
1887 Rotterdam, The Netherlands – 1979 New Milton, England

1906–14 Studies at the School of Art, Birmingham, and the London Architectural Association. Meets avant-garde British artists. **1913–14** Travels to America where he meets Frank Lloyd Wright. **1914–16** Returns to Holland. Designs and builds houses at Huis ter Heide, including Villa Verloop, which are influenced by Wright. **1916–19** Meets van Doesburg and Oud. Designs and builds the modernist Villa Henny

in Huis ter Heide, also know as the Concrete Villa. Holds extreme socialist, and later anarchist views. Briefly a member of the Dutch Communist Party. **1917** Founding member of De Stijl group. **1918** Co-signs the first De Stijl manifesto published in November. Publishes five articles in *De Stijl* between 1918 and 1919 and provides financial support for the magazine. Builds his own houseboat, called 'De Stijl', with De Stijl interior. Designs a studio for Bart van der Leck. Obtains a commission for van Doesburg for a colour scheme for the interior of Bart de Ligt's house in Lage Vuursche. Designs middle-class and council housing estates with architect P.J.C. Klaarhamer. Sends photographs of works by De Stijl artists and architects to Russia. **1919** Falls out with van Doesburg and withdraws from the group. **1920** Sells his houseboat and builds two simple 'workers' houses' in Laren, one for his parents and one for himself. **1922** Returns to England and eventually gives up architecture, seeking to achieve true communism on a small scale, without property and overproduction. **1979** Dies in England.

VILMOS HUSZÁR
1884 Budapest – 1960 Hierden, The Netherlands

1901-4 Studies mural painting and decoration at the School of Applied Arts, Hungary, then leaves for the art academy in Munich. **1906** Emigrates to Holland; settles in Voorburg. **1907-8** Associates with art critic H.P. Bremmer and paints in both a naturalistic and stylised manner. Sojourn in Paris and London. **1912-14** Inspired by van Gogh and Gauguin. Exhibits regularly in the Netherlands. Begins experimenting with colour. **1915-16** Graphic works suggest the influence of Mondrian, Cubism and Futurism. **1916** Joins De Anderen, an artists' association founded by van Doesburg, and exhibits geometrical drawings and paintings. Joins The Hague Artists' Circle. Produces designs for stained glass, which greatly influence van Doesburg. **1917** Co-founder of De Stijl and associated with De Stijl until 1923. Designs cover image for *De Stijl* journal (issues 1917–20) and regularly contributes articles. **1918** Co-signs first De Stijl manifesto in Leiden, though opposes Vantongerloo's involvement. Begins to integrate stained-glass windows into specially designed interiors, which he calls 'Space-colour compositions'. Adopts grid structure in paintings. Recommends van der Leck to design the colour scheme for the interior of van 't Hoff's De Stijl houseboat, causing clash with van Doesburg. **1919-21** Designs colour applications for bedroom of Bruynzeel house, Voorburg. P.J.C. Klaarhamer designs the furniture. Draft designs for interiors, some with Wils (Bersenbrugge photographic studio in The Hague) and Zwart (Bruynzeel's living room and a residential home for single mothers in The Hague). Collaborates with Zwart on furniture designs. **1920** Shows spatial colour compositions in exhibition *La Section d'Or*. **1922** Visits van Doesburg at the Bauhaus in Weimar and takes part in the Congress of Constructivists and Dadaists. Meets El Lissitzky. **1923** Participates with Nelly van Doesburg, Theo van Doesburg and Schwitters in the Dada Tour of Holland. Leaves De Stijl, although remains loyal to the principles during 1920s. Collaborates with Rietveld on exhibition interior for the *Non-juried Art Exhibition*. Participates in Merz. Represented in the De Stijl architecture exhibition at Léonce Rosenberg's Galerie de l'Effort Moderne, in Paris. **1923-5** Develops so-called 'monotypes'. Joins MA group. Exhibits in *The Art of Today*, Paris. **1925** Pursues work in graphic design including a draft for the Miss Blanche cigarette campaign and continues to paint. **1930** Shows with Cercle et Carré, Paris. Active as an interior designer until late 1940s. **1960** Dies in the Netherlands.

PAUL JOOSTENS
1889 Antwerp, Belgium – 1960 Antwerp, Belgium

1916 Works primarily in a Cubo-Futuristic style, makes first abstract collages. **1917** Exhibits his 'pasted-paper paintings' at the Galerie Giroux in Brussels. Begins making three-dimensional constructive objects. **1919** After a visit to Rotterdam and Paris, becomes influenced by Dada. **1920-2** Very productive period. Makes collages, assemblages, photomontages and creates abstract, geometric sculptures that have a resonance with Vantongerloo's De Stijl constructions. Contributes to the magazines *Lumiere*, *Ruimte*, *Sélection*, *Het Overzicht*, *Oesophage* and *Ça Ira* (which also publishes an article by van Doesburg in 1921). **1922** Produces a mechano-dadaist erotic and satirical series of *Salopes*. **1923** Exhibits alongside Feininger, Lissitzky, Moholy-Nagy and Magritte in a *Ça Ira* exhibition at the Cercle Royal Artistique in Antwerp. **1925** Returns to objective painting. **1930s** Begins the *Poezeloesfiguren* series, ambivalent paintings of female Hollywood icons recast as gothic madonnas. **1931** Works included in the *International Collection of New Art* group show at the Sztuki Musuem in Łódź, Poland. **1950s** Begins a productive period of new assemblages and photomontages. **1960** Dies in Antwerp.

LAJOS KASSÁK
1887 Érsekújvár, Hungary (now Nové Zámky, Slovakia) – 1967 Budapest

1915-16 Publishes the avant-garde review *A Tett*. **1916-19** Edits the journal *MA*, promoting Hungarian activism. Organises events and exhibitions in collaboration with Bortnyik, Huszár, Moholy-Nagy and Péri amongst others. **1920** When *MA* is banned, he moves with Bortnyik, Péri and Moholy-Nagy to Vienna, where he resumes publication of the journal until 1926. **1921-3** Establishes contact with many European avant-garde groups. Contributes to *De Stijl* between 1921 and 1922. Van Doesburg contributes to three issues of *MA* between 1921 and 1923. Collaborates with Bortnyik on an album of 'picture-architecture', which references El Lissitzky's *Proun* projects and Schwitter's Merz compositions. **1922** With Moholy-Nagy, publishes the *Buch neuer Künstler* (Book of New Artists), which includes Constructivist, Futurist and Purist illustrations. **1924** Exhibits at Der Sturm Gallery in Berlin. **1926** Returns to Budapest. Continues his activities as a writer. **1928-39** Publishes the review *Munka*, around which a circle of avant-garde painters, photographers and writers gather. **1949-56** Lives in compulsory retirement in a suburb of Budapest and starts painting again. Returns to his earlier Constructivist style. **1967** Dies in Budapest.

PETER KELER
1898 Kiel, Germany – 1982 Weimar, Germany

1917-19 Army service in the First World War. **1919-21** Studies at the School for Applied Arts in Kiel. **1921-5** Student at the Bauhaus. Training in the mural-painting workshop with Kandinsky and Schlemmer. Carries out the colour design for the office rooms of the Fagus factory designed by Walter Gropius, and for the room of the Bauhaus Director. **1922** Enrolled in van Doesburg's independent course *Stijl-Kurs I* in Weimar. Co-founder of the KURI group with Molnár, Weininger, Schmidt and other Bauhaus students, whose aesthetic position is close to that of De Stijl and contributes to the turn towards Constructivism at the Bauhaus. Designs his famous *Cradle*, following the Bauhaus theory of basic colours applied to elementary forms. **1923**

Designs furniture for the large Bauhaus exhibition. **1925** Sets up independent studio in Weimar for painting, interior design and advertising. Designs furniture, like the famous armchair D 1/3 for a house by Molnár. **1927-36** Settled in Dresden, works for the textile and mechanic industries as an advertising designer. **1937-45** Works as architect and exhibition designer in Berlin. **1942-3** The Nazi regime prohibits him from exhibiting his works. **1943** His studio is bombed during the war. **1945** Appointed professor at the newly founded Superior School for Figurative Art and Architecture in Weimar. Teaches freehand drawing and colour in architecture, later exhibition design, lighting and architecture. During this period also works on the refurbishment of cultural buildings in Weimar, Jena and Greifswald. **1964** Retires from professorship. Continues to paint and to exhibit his work. **1982** Dies in Weimar.

STEFANIE KIESLER PSEUDONYM: PIETRO DE SAGA
1897 Teschen, Austro-Hungary (now Skoczów, Poland) – 1963 New York, United States

1920 Marries Frederick J. Kiesler. **1925** Moves to Paris. Works closely with van Doesburg and the De Stijl group on her 'Typo-plastic' designs. These are featured in *De Stijl* (no.12, 1924–5; no.75–6, 1926–7; and no.77, 1926–7). **1926** The Kieslers move to New York. **1927** Starts working at the New York Public Library. Begins writing numerous film, theatre and literary reviews. **1930** Typo-plastic design included in Frederick Kiesler's *Contemporary Art Applied to the Store and its Display* (p.93). Keeps a shared diary-calendar with her husband as a document of their artistic and personal development. **1930s-40s** Works on the *Dream Book*, an anthology of dreams in literature, psychoanalysis, anthropology and science. **1959** Retires from her position at the Public Library. Works as a film, theatre and literature critic for the publishing house and magazine Aufbau in New York. **1963** Dies in New York.

FREDERICK KIESLER
1890 Czernowitz, Austro-Hungarian Empire (now Ukraine) – 1965 New York, United States

1908 Studies at the Technical University and Academy of Fine Arts, Vienna. **1923** Designs sets for Karel Capek's play *RUR* and meets van Doesburg, Richter, Lissitzky and Moholy-Nagy. Becomes affiliated with De Stijl. Designs first 'endless' house, conceived as a space theatre. **1924** Architect and director for Music and Theatre Festival, Vienna. Designs exhibition printed materials and 'Leger and Träger' display system. **1925** Designs and builds model of *City in Space* for the theatre section of the Austrian Pavilion at the *Exhibition of Decorative Art*, Paris. Publishes in *De Stijl*. **1926** Emigrates to New York. Appointed Director of the *International Theatre Exhibition*, New York. **1928** Designs Saks Fifth avenue window displays. **1929** Builds the Film Guild Cinema. **1930** Obtains New York architects license and establishes Planners Institute Inc. **1933** Designs *Space House*, a single-family dwelling using biomorphic forms. **1937** Director of the Laboratory for Design Correlation at the School of Architecture, Columbia University. Focuses on theory of Correalism, an anti-functionalist philosophy. **1942** Designs Peggy Guggenheim's Art of This Century gallery, New York. **1947** Designs installation for the *International Surrealism Exhibition*, Gallery Maeght, Paris. Writes the 'Manifesto of Correalism'. **1957** Forms architectural firm Kiesler and Bartos. **1963** Begins environmental sculpture *Us-You-Me*.

BART VAN DER LECK
1876 Utrecht, The Netherlands – 1958 Blaricum,
The Netherlands

1900-4 Studies painting at State School of Arts and Crafts, Amsterdam, having previously worked for eight years in stained glass studios. **1905** Co-illustrates publication with P.J.C. Klaarhamer. Contact with H.P. Berlage. **1907** Plans to work in Paris, but returns to Holland after only a few weeks. **1912** Paints subjects from working-class life in a stylised figurative manner, using flat planes of colour. From **1914** Executes design commissions for the Müller company and then for Mrs Kröller-Müller personally. Travels to Southern Spain and Algeria. **1915-17** Associated with The Hague Artists' Circle, where he meets Huszár and Chris Beekman. **1916** Moves from The Hague to Laren. Paints using unmixed primary colours, flatly applied. Collaborates with Berlage on interior colour schemes for Villa Kröller-Müller, Wassenaar. Meets Dr M.H.J. Schoenmaekers and Mondrian. Paints seemingly abstract *Mine Triptych*. **1917** Co-founder of *De Stijl* magazine. Contributes his essay 'The Place of Modern Painting in Architecture' to the first issue. Creates seemingly abstract paintings containing rectangular elements which are 'decomposed' from figurative drawings. **1918** Refuses to sign the first De Stijl manifesto and dissociates himself from De Stijl group. Introduces 'lozenge' forms and diagonal elements that become increasingly important in his paintings. Designs colour schemes for interior of his own house in Blaricum, where he lives from May 1916 onwards. **1921** Returns to figurative painting, although highly formalised and geometrised. From **1928** Works with Rietveld on model interiors for Metz & Co., Amsterdam. **1930s-40s** Designs colours schemes for interiors of Piet Elling's International Style Villas. **1949** Retrospective exhibition at Stedelijk Museum, Amsterdam. **1950s** Briefly paints abstract works shortly before his death in 1958.

FERNAND LÉGER
1881 Argentan, France – 1955 Gif-sur-Yvette, France

1903 Admitted as a pupil to the Ecole des Arts Décoratifs in Paris but turned down by the Ecole des Beaux-Arts. **1908-9** Makes the acquaintance of Delaunay and Henri Rousseau. **1910** Dealer Daniel Henry Kahnweiler exhibits his works. **1911** Exhibits at the Salon des Indépendants. **1913** First contract with Kahnweiler. Exhibits at the Salon d'Automne. **1914** Conscripted. **1919** Exhibition in the Galerie Léonce Rosenberg. Van Doesburg admires Léger's preoccupation with movement in *De Stijl* (no.2, 1919, p.144). Meets Le Corbusier, builds contacts with *L'Esprit Nouveau*. **1921** Designs the sets of *Skating Rink* for the Swedish Ballets. **1924** Makes the film *Le Ballet mécanique* with music by Antheil (who later becomes a member of De Stijl). **1925** First wall-paintings in Le Corbusier's Pavillon de l'Esprit Nouveau. Makes his so-called *Peinture Murale* paintings and gouaches in an style very similar to that of De Stijl. **1928** Exhibition at the Galerie Flechtheim in Berlin with 150 paintings. **1929** Member of Cercle et Carré. **1931** Member of Abstraction-Création. **1931, 1935, 1938** Trips to the United States. **1932** Travels to Sweden and Norway on the occasion of the International Congress of Modern Architecture. **1935** Exhibition in the Museum of Modern Art, New York. **1940-5** Lives in the United States. **1945** Returns to France.

EL LISSITZKY
1890 Pochinok, Russia – 1941 Moscow

1909-14 Studies architectural engineering at the Darmstadt Technical College, Germany. **1912** First exhibits with the St Petersburg Artists Union. **1919** Becomes Professor of Graphic Design, Printing and Architecture at the Vitebsk Art Labour Cooperative. Encounters Malevich and Suprematism. Creates first *Proun*. **1921** Becomes head of the Faculty of Architecture at the Vkutemas School of Art, Moscow. First Constructivist exhibition *Obmokhu*. **1922** Travels to Berlin as an ambassador of Soviet arts and culture and meets van Doesburg. Participates in the International Congress of Progressive Artists, Dusseldorf and later co-signs with van Doesburg, Richter and Burchartz the 'Declaration of the International Group of Constructivists' in *De Stijl*. Publishes the magazine *Veshch, Gegenstand, Objet*. Attends the Congress of Constructivists and Dadaists, Weimar. Assists in the Dada soirees in Jena and Hanover. **1923** Creates the *Prounenraum* with the November Group at the *Greater Berlin Art Exhibition*. Founds *G* magazine with Richter, Eggeling and Graeff. Lectures on Russian art in the Netherlands and establishes contact with Huszár and Oud. **1923-5** Moves to Switzerland and focuses on typography and architecture. **1925** Co-editor with Arp of *Die Kunstismen*. **1926** Designs room for Constructivist art for the *International Art Exhibition*, Dresden. **1927** Typographical exhibition in Moscow. Designs layout for the abstract art room at the Landesmuseum, Hanover. **1928** Receives commission for the Soviet pavilion at the *International Press Exhibition*, Cologne. **1930-41** Continues to produce exhibitions abroad under the auspices of *Vnesh-torga* (Foreign Trade). **1932** Works as creative designer for the propaganda magazine *SSR na stroike* and other Soviet publications.

KAREL MAES
1900 Mol, Belgium – 1974 Koersel, Belgium

1910 Moves to Brussels. **1913** Enrols for one year at the Academy of Brussels with Servranckx. **1919** Experiments with Neo-expressionism, Futurism and Cubism. Works in woodcuts and linocuts. **1920** Works with Magritte and Servranckx at the Centre d'Art where he attends van Doesburg's lecture on De Stijl. **1920** Takes part in the *International Exhibition of Modern Art* in Geneva alongside van Doesburg. **1921** Van Doesburg attempts to persuade Maes to accept Léonce Rosenburg's offer of a contract with Galerie de l'Effort Moderne. Maes refuses. **1922** Co-founds and illustrates *7 Arts* journal until 1929. Works exclusively with neo-geometric abstraction. Exhibits at the First Congress of Modern Art in Antwerp where Vilmos Huszár lectures. Exhibits at the Second Congress of Modern Art in Antwerp. Signs the manifesto of the International Union of Neoplasticist Constructivists in Weimar along with van Doesburg, Lissitzky and Richter. Manifesto is published in the September issue of *De Stijl*. Lectures at the Third Congress of Modern Art in Bruges. **1923** Exhibits at the Salon de la Jeune Peinture at Gallery Giroux in Brussels and in *Les Arts Belges d'Esprit Nouveau* exhibition in Brussels. **1924** Starts designing furniture with his brother, Jef Maes. **1925** Joins L'Assaut group. Exhibits furniture and paintings at the *International Exhibition of Modern Decorative and Industrial Art* in Paris. **1926** Designs furniture and tapestry in a geometric style. **1927** Exhibits with L'Assaut at Fauconnier Gallery in Brussels. Has a family home built to his design. **1929** Establishes himself as an independent furniture maker in Brussels. **1930** Moves towards Expressionism and Surrealism. **1944** Imprisoned for political collaboration with Germany. **1950** Moves to Belgian colony of Congo. **1974** Dies in Koersel, Belgium.

FELIX DEL MARLE
1889 Pont sur Sambre, France
– 1952 Becon-les-Bruyères, France

1906 Studies painting at L'Ecole des Beaux Arts in Lille and Valenciennes. **1911** Moves to Paris. Holds ardent social and political convictions. **1913** Shares a studio with Severini. His painting before the war is characterised by modernity of subject and a cubo-futurist style. Publishes 'Futurist Manifesto against Montmatre' in the *Paris Journal* (13 July) and later in *Lacerba* (15 August) with Marinetti's signature. Exhibits at the Galerie Clovis Sagot in Paris. **1914** Exhibits *The Port*, his major work (now lost, 300 x 190 cm) in the Salon des Indépendants and Galerie Giroux in Brussels. Mobilised by the army, is wounded in the war. **1917** Founder of an anti-militarist newspaper *Tac-à-Tac-Teuf-Teuf*. **1923** Exhibits at the Galerie de l'Effort Moderne. **1924** Meets Kukpa and is influenced by his style. Member of the group and magazine *Vouloir*, co-founded by Emile Donce-Brinsy and Charles Rochat. **1925** Gives a lecture on Kukpa in Lille on 30 April. Impressed by De Stijl works at the exhibition *The Art of Today* in December 1925. Makes contact with Mondrian and van Doesburg. As a consequence, Del Marle abandons Kupka's style in favour of Neoplasticism. **1926** In January becomes co-director of *Vouloir* and in March publishes important articles by Mondrian ('Art. Purity and Abstraction') and van Doesburg ('Towards an Elementarist Art'). Becomes friends with Domela, Oud, Huszár, Rietveld and Vantongerloo and publishes their works. He designs Neoplasticist decoration (painted walls, lamps, furniture) in his home in Pont sur Sambrer and Neoplasticist furniture for Didier Demarcq in the same town. Designs a Neoplasticist facade for a shop, Armande, in Dinard. **1927** Exhibits with Vouloir group in Lille and the Der Sturm Gallery in Berlin. Visits the Bauhaus and creates tubular chairs just after. **1928** Last issue of *Vouloir*. Creates a design workshop called STUCA (Science, Technique, Urbanism, Comfort, Art), which runs for one year. **1929** Becomes more involved in Catholicism and returns to figuration. **1932** Associates with Valensi's Salon des Artistes Musicalistes. **1946** Co-founder and general secretary of the Salon des Réalités Nouvelles. **1949** Retrospective in the Galerie Colette Allendy, Paris.

LÁSZLÓ MOHOLY-NAGY
1895 Bacsbarod, Hungary – 1946 Chicago, United States

1917 Meets Lajos Kassák and joins the group of artists around the review *MA*. **1919-20** Moves to Vienna and then Berlin. Makes contact with Dada artists including Schwitters, Höch and Hausmann. **1921** At the end of the year, meets El Lissitzky, who has a great influence on his work. Co-authors 'The Call to Elementary Art' which is published in *De Stijl*. **1922** First exhibition at Der Sturm Gallery, Berlin. Takes part in the Congress of Constructivists and Dadaists, Weimar. Creates *Telephone Paintings* and experiments with photograms. Co-authors 'Constructive System of Forces' which is published in *Der Sturm*. Publishes 'Production-Reproduction' in *De Stijl* and *MA* runs a special issue on van Doesburg. **1923-8** At the Bauhaus, directs the Preliminary Course and is Master of Form in the metal workshop. With Gropius, publishes a series of fourteen Bauhaus Books. **1928** Moves to Berlin and experiments with film, stage and costume design. **1930** With Gropius and Bayer, organises the German section of *20e Salon des Artistes Décorateurs Français*, Paris and exhibits *Prop for an Electric Stage*. **1932-4** Associated with the Abstraction-Création group, founded by van Doesburg. **1934** Travels to Amsterdam and runs a commercial design studio. **1935** Lives in London where he meets Moore, Hepworth and Nicholson. Makes

documentary films and *Space Modulators*. **1937** Travels to Chicago to direct the short-lived New Bauhaus American School of Design. **1938** Founds and is director of the Institute of Design in Chicago.

FARKAS MOLNÁR
1897 Pécs, Hungary – 1945 Budapest

Studies at the Technical University and at the Art School in Budapest. **1920** Emigrates to Germany after the fall of the Soviet Republic of Hungary. **1921** Student at the Bauhaus in Weimar. Attends the foundation course by Johannes Itten. Later joins the architecture workshop, with Georg Muche, Marcel Breuer and others. Works with Walter Gropius's professional studio. **1922** Enrols in van Doesburg's independent course *Stijl-Kurs I* in Weimar. With Henrik Stéfan and Weininger organises the student group KURI. Designs the *Red Cube* house for the Am Horn colony in Weimar. **1923** Exhibits the *Red Cube* design in the large Bauhaus exhibition, attracting much attention. **1925** Publishes *Theatre in the Bauhaus* with Schlemmer and Moholy-Nagy, the fourth in the Bauhaus Books collection. Returns to Budapest, where for political reasons does not receive public commissions and builds only private villas. Works with Ligeti, and later with Fischer. His works are examples of Constructivist and functionalist architecture in Hungary. Exhibits his architectural projects at the Mentor Library. **1929** Invited by Walter Gropius to the International Congress of Modern Architecture in Frankfurt (ICMA). Leads the Hungarian ICMA group till 1938, contributing to the propagation of modern architecture. **1931-2** Participation in the International Committee for the Realisation of the Problems of Modern Architecture exhibitions. **1944** Dies at home during the bombing of Budapest in the Second World War.

PIET MONDRIAN
1872 Amersfoort, The Netherlands – 1944, New York, United States

1900s Following academic training as an artist in 1890s, paints in naturalistic style. **1909** Joins Theosophical Society of Amsterdam and makes work of Symbolist character. **1912-14** Lives in Paris, is influenced by Cubism. Returns to Holland. **1915-16** Moves to Laren and meets modernist composer Jacob van Domselaer and writer M.H.J. Schoenmaekers. Meets van der Leck and is influenced by his technique and use of colour. **1917** Evolves simplified abstract style which he calls Neoplasticism, restricted to the three primary colours and to a grid of black vertical and horizontal lines on a white ground. Co-founds De Stijl group. Publishes theoretical essay 'The New Plastic in Painting' in *De Stijl* in twelve instalments from November 1917 to December 1918. **1918** Co-signs first De Stijl manifesto. First 'diamond'-shaped paintings. **1919** Contributes second major essay to *De Stijl*, titled 'Natural Reality and Abstract Reality: A Trialogue'. Relocates to Paris in June. Moves into new studio at 5 rue de Coulmiers and begins to create Neoplastic interiors. **1920** Hosts van Doesburg and attends Dada soirees with him. Co-signs manifesto on literature for April issue of *De Stijl*. Sends paintings to Holland for *La Section d'Or* exhibition organised by van Doesburg. Develops close relationship with Oud who visits in August. Returns to 26 rue du Départ studio where he remains until 1936. **1921** Refines style to rectangles of primary colours set on white grounds divided by black lines. **1922** Second solo show at the *Hollandsche Kunstenaarskring* exhibition at the Stedelijk Museum. **1923** Exhibits works with other regular contributors to *De Stijl* at the *Greater Berlin Art Exhibition*. *Merz* publishes his short

essay 'Neo-Plasticism'. Nelly and Theo van Doesburg stay with him at the time of the exhibition *Architects of the De Stijl Group* at Rosenberg's Galerie de L'Effort Moderne. **1924** Meets Hannah Höch and César Domela. Relationship with van Doesburg deteriorates. Ceases to contribute to *De Stijl* (except for 1932 memorial issue). **1925** Breaks with van Doesburg over personal differences, spurring van Doesburg's promotion of diagonals into painting (Elementarism) and his rebuttal of Mondrian's Neoplasticism. Contributes his major writings to Moholy-Nagy's Bauhaus Book series. Exhibits in *The Art of Today*. **1926** Takes part in Société Anonyme exhibition at the Brooklyn Museum, New York. **1927** Contributes articles to *i10* magazine. **1929** Renews friendship with van Doesburg. Shows works in the *Select Exhibition of Contemporary Art*, Stedelijk Museum, Amsterdam, organised by Nelly van Doesburg. **1930** Exhibits with Cercle et Carré. Includes works in the *Art Post-Cubism* exhibition in Stockholm organised by Carlsund. **1931** Joins new association Abstraction-Création. **1938** Leaves Paris for London. **1940** Moves to New York. **1944** Dies of pneumonia on 1 February.

MARLOW MOSS
(MARJORIE JEWELL)
1890 London – 1958 Penzance, United Kingdom

1916-17 St John's Wood School of Art. **1919** Slade School of Fine Art. **1919-23** Lives in Cornwall. **1923** Moves to London. Adopts the name Marlow Moss. **1927** After a short visit to Paris she decides to live there. Studies at the Académie Moderne under Léger and Ozenfant. Deeply impressed by the paintings of Mondrian. **1929** Meets the Dutchwoman Netty Nijhoff, who becomes her partner. Through her she meets Mondrian, whom she frequently visits from now on. **1930** Introduces the double line in her work. **1932** Member of Abstraction-Création. **1939** In Holland at the outbreak of the Second World War. Her house in France is seized by the French airforce and she is unable to return. **1940** Germany invades The Netherlands. Moss flees to England where she lives in Cornwall until her death. **1944** Her work up to 1940 is destroyed in a bombardment of her house in Gauciel near Evreux, France.

HENRI NOUVEAU
(HENRIK NEUGEBOREN)
1901 Kronstadt, Transylvania – 1959 Paris

1921-5 Studies at the Berlin Academy of Music. Attends musical performances and exhibition openings held at Der Sturm Gallery, becomes acquainted with various painters. Begins his first abstract drawings in pastels. **1925** Begins creating collages and developed his technique of using pigment on paper. **1928** Visits the Bauhaus in Weimar, where he meets Kandinsky, Paul Klee and Schlemmer. Inspired by synaesthetic ideas and Constructivist form, he creates planimetric and sculptural renderings of the fugues of Johann Sebastian Bach. **1930** Adopts the name Henri Nouveau. Exhibits paintings for the first time in Paris under the advice of van Doesburg, but does not exhibit again for another sixteen years. **1946** Picabia persuades him to take part in the Salon des Realites Nouvelles, of which he becomes a member. Continues to exhibit in Berlin, Stockholm, Zurich and other parts of Europe. **1951** Exhibits at the Galerie Arnaud in Paris. **1959** Dies in Paris. A retrospective is held at the Galerie de France in the same year.

HARM KAMERLINGH ONNES
1893 Zoeterwoude, The Netherlands – 1985 Leiden

1912 Gets his training as an artist in Leiden at the studio of his father Menso Kamerlingh Onnes and his uncle Floris Verster. **1913** Meets the architect J.J.P. Oud. **1916** Facilitates the meeting between Oud and van Doesburg. Member of the De Sphinx art circle in Leiden founded in 1916 by van Doesburg. Designs a modern typography for the poster for the first international exhibition of De Sphinx in Leiden in which van Doesburg, Oud and Filla participate. Works with van Doesburg and Oud on the renovation of the Villa Allegonda in Katwijk. **1917** Solo exhibition at the Rotterdam Art Circle. **1917-18** Works with Oud and van Doesburg on the De Vonk house in Noordwijkerhout for which he designs large stained-glass windows in the hall. **1922** Designs a stained-glass window in the laboratory of his uncle, Professor Dr Heike Kamerlingh Onnes. **1929** Designs a stained-glass window for the Handelsbladgebouw in Amsterdam (now in the Stedelijk Museum De Lakenhal, Leiden).

J.J.P. OUD
(JACOBUS JOHANNES PIETER OUD)
1890 Purmerend, The Netherlands – 1963 The Hague The Netherlands

1904-7 Studies at the School of Decorative Art in Amsterdam. **1907-8** Works at Cuijpers & Stuijt's architectural studio in Amsterdam. **1909-12** Studies at Amsterdam State School of Drawing and the Technical University in Delft. **1912** Introduced to the work of Frank Lloyd Wright by H.P. Berlage. **1913** Moves to Leiden and works with W.M. Dudok. Until 1916 his architectural works are strongly influenced by H.P. Berlage. Works in Germany before war. **1916-17** Collaborates with van Doesburg on the design of two houses: De Vonk in Noordwijkerhout, and Villa Allegonda in Katwijk. Designs Strandboulevard Apartments (unrealised). Co-founds De Stijl. **1917** His short article 'The Monumental Image of the City' published in the first issue of *De Stijl* (November 1917) defines the architectural outlook of the journal. Oud describes architecture as 'the art of the definition of space'. **1918** Appointed as architect for the Rotterdam Housing Authority (until 1933). Begins designing Spangen housing projects (Blocks I, V, VIII and IX) based on repetition, standardisation and a concern for monumentality. Commissions van Doesburg to design colour schemes for housing blocks, representing the first attempt to realise abstract painting in an urban architectural environment. Refuses to sign the De Stijl manifesto in November 1918 due to concern that its extreme rhetoric might harm his career. **1921** Falls out with van Doesburg over the latter's 'destructuring' colour designs for the facade of the Spangen buildings. Officially withdraws from De Stijl, although stays in contact with many of the other members. **1922** Develops contacts with the Bauhaus, Weimar. His influential essay 'On Future Architecture and its Architectonic Possibilities' is translated into German. **1923** Gives a lecture on modern Dutch architecture at 'Bauhaus Week' in Weimar. Meets Lissitzky in Holland. Work included in the De Stijl architecture exhibition held at Léonce Rosenberg's Galerie de l'Effort Moderne, Paris. **1921-4** Designs apartment blocks at Tusschendijken. **1924** Designs small terraces at Oud-Mathenesse estate (White Village) and, most famously, the village-like housing at Kiefhoek (designed 1925, completed 1930). **1925** Designs facade of the Café de Unie, Rotterdam. **1927** Submits plans for a row of standardised workers' houses for the Weissenhofsiedlung housing project exhibition, Stuttgart. Kiefhoek and Weissenhof are his last housing projects to be built. Architecture editor for *i10* magazine, much to van Doesburg's displeas-

ure. **1931** Produces designs for Blijdorp estate north of Rotterdam (unrealised). **1932** Museum of Modern Art, New York names him as one of 'the four leaders of modern architecture' with Mies van der Rohe, Le Corbusier and Gropius. **1963** Dies in The Hague.

JOZEF PEETERS
1895 Antwerp, Belgium – 1960 Antwerp, Belgium

1909-13 Studies at the Royal Academy of Fine Arts in Antwerp. **1918** Co-founder of the Modern Art Circle in Antwerp. **1919** First contact by letter with Marinetti and van Doesburg. In the ensuing correspondence van Doesburg gives him information and addresses of avant-garde artists. Peeters uses this information to broaden his network. **1920** On the invitation of Jozef Peeters, van Doesburg gives the lecture *Classic, Baroque, Modern* in Antwerp. Peeters designs the poster for it. Peeters organises the First Congress of Modern Art in Antwerp together with Huib Hoste. **1921** Visits Paris. Meets Mondrian, Léger, Gleizes, Archipenko and Tour (Marthe) Donas. Member of the Société des Artistes Indépendants in Paris. Correspondence with Behne, Walden, Marinetti, Oud, Mondrian, Kupka and Ensor. On 1 December 1921 meets van Doesburg on the occasion of his lecture 'Tot Stijl' in Antwerp. Van Doesburg's lecture was accompanied by Nelly van Moorsel's piano music. **1922** In January, organises the Second Congress of Modern Art in Antwerp and gives two lectures. Participates in the *First International Art Exhibition* in Dusseldorf. Organises the Third Congress of Modern Art in Bruges and gives a lecture. Visits Berlin with Seuphor and there meets Walden, Marinetti, Behne, Moholy-Nagy, El Lissitzky and Kandinsky. **1923** Participates in an exhibition organised by the magazine *Ça ira!*, together with Joostens, Servranckx, Magritte, Bortnyik, Burchartz, Dexel, El Lissitzky, Moholy-Nagy, Rodchenko, Kassák and Röhl. **1924** In contact with Werkman and Alkema in the Netherlands. Organises a lecture by Oud in Antwerp. **1927** Stops his public artistic activities because of his wife's illness and takes care of his family.

LÁSZLÓ PÉRI
1899 Budapest – 1967 London

1919 Introduced to the *MA* circle through Moholy-Nagy and Bortnyik. **1920** Travels to Vienna and Paris, eventually settling in Berlin. **1921** Produces first Constructivist works. Associates with Lissitzky, Moholy-Nagy, Richter and Hausmann. **1922** First exhibits his *Space Constructions* in a joint show at Der Sturm Gallery with Moholy-Nagy. Attends the International Congress of Progressive Artists in Dusseldorf. Meets van Doesburg, who reproduces one of his concrete abstractions in the second volume of *De Stijl*. Became closely involved with *Der Sturm* magazine in Berlin, in which a large number of his drawings were reproduced between 1922 and 1928. **1924-8** Works in the municipal architecture office of Berlin. Is influenced by Bauhaus ideas. Joins Die Abstrakten and the Red Group. Participates in the exhibitions of the November Group. **1929** Turns away from abstract constructions and returns to realist sculpture, as his leftist political views deepen. **1933** Flees to England during the war. Helps establish the Artists International Association along with other anti-fascist artists. **1938** Exhibits his concrete reliefs and architectural plastics in Camden, London. **1939** Perfects his 'Pericrete' technique, a mixture of concrete, polyester resin and metallic powder. Begins to work on public commissioned sculpture. **1967** Dies in London.

FRANCIS PICABIA
1879 Paris – 1953 Paris

1905 The Galerie Haussmann, Paris, mounts his first solo exhibition. **1912** Joins the Puteaux group through Marcel Duchamp and participates in the *Section d'Or* exhibition at the Galerie Boétie. **1913** Visits New York and participates in the *Armory Show*. Becomes part of the 291 circle through Alfred Stieglitz, who organises a solo exhibition of his works. Publishes in Stieglitz's journals *291* and *Camera Work*. Starts to produce his first 'machinist' works. **1916** Returns to New York and exhibits at the Modern Gallery before moving to Spain. **1917** Inspired by Stieglitz, he publishes the journal *391* in Barcelona, which becomes a popular avant-garde platform. **1919** Frequent contact with Tristan Tzara. Together they produce issue 4/5 of *Dada* in Zurich. Co-founds Dada Paris with Georges Ribemont-Dessaignes. **1920** Meets André Breton. Tristan Tzara arrives in Paris. The group organises Dadaist activities, publications and exhibitions. **1922** Takes part in the Dada Paris Congress. Contributes a text and drawing to the Yellow (first) issue of *Mécano*. **1924** Collaborates with René Clair and Erik Satie on the film *Entr'acte*. Participates in the Salons des Indépendants. Ceases publication of *391*. **1925** Distances himself from the Parisian avant-garde and is critical of both Dada and Surrealism. Moves to Cannes. **1930** Galerie Léonce Rosenberg in Paris mounts a retrospective of his works. **1933** Awarded Knight of the Legion of Honour. **1936** Included in the *Dada and Surrealism* exhibition at MOMA, New York. **1940s** After the war, he exhibits in a number of galleries in Paris, including the Salons des Réalités Nouvelles. **1947** A major retrospective of his work *Cinquante ans de plaisir* is held at the Galerie René Drouin, Paris. **1953** Dies in Paris.

ENRICO PRAMPOLINI
1894 Modena, Italy – 1956 Rome

1912 Joins the studio of Giacomo Balla. **1914** Exhibits with the Futurists at the Galleria Sprovieri in Rome. **1916** Meets Tristan Tzara in Rome and later takes part in the International Dadaist Exhibition in Zurich. **1917** Together with the writer Bino Sanminiatelli, begins running the magazine *Noi: rivista d'arte futurista* (1917–20, 1923–5). **1920** Makes several trips abroad. Meets Archipenko, Gleizes, Arp and Kandinsky, amongst others. Establishes contact with a number of European artistic groups, including Der Sturm, La Section d'Or, the November Group and members of the Bauhaus. Exhibits in Paris, Vienna, Berlin and New York. **1921-2** Contributes articles to *De Stijl*. **1922** With Ivo Pannaggi and Vincio Paladini, publishes 'Il Manifesto dell'Arte Meccanica'. **1925** Moves to Paris. Associates with the Surrealists. **1926** Exhibits at the Venice Biennial with the Die Abstrakten group. **1927** Meets van Doesburg in Rome, along with Balla and Marinetti. **1929** Signs the 'Manifesto dell'aeropittura'. **1930** Joins Cercle et Carré. Establishes Gruppo 40. **1931** Joins Abstraction-Création. **1934** Creates the magazine *Stile Futurista*. Works on decorative and architectural designs for pavilions and museums in Turin and Milan. **1944** Futurism officially ends with the death of Marinetti and the end of the war. Moves into cinematographic work and once again plays a prominent role in Italian avant-garde circles. **1956** Dies in Rome.

MAN RAY
(EMMANUEL RADNITSKY)
1890 Philadelphia, United States – 1976 Paris

1911 Begins frequenting the 291 gallery owned by Alfred Stieglitz. **1913** Visits the *Armory Show* and is strongly influenced by the European artists shown there. **1915** First solo exhibition at the Daniel Gallery, New York, after which mechanist imagery becomes more prominent in his paintings. Walter Arensberg, a patron of modern art, introduces him to Duchamp. **1920** Becomes a founding member of Société Anonyme and exhibits in their first show. Picabia reproduces his work in an issue of *391*. **1921** He and Duchamp publish the only issue of *New York Dada*. His photographs are exhibited at the Salon Dada International at the Galerie Montaigne, Paris. Moves to Paris later that year and has his first solo exhibition. Becomes a prominent photographic contributor to avant-garde as well as commercial magazines. **1922** Works featured in the Yellow (first) and Blue (third) issue of *Mécano*. **1923** For the final Dada soiree, he shows his first 'cine-rayographs', or camera-less photographic images on film. **1929** Discovers the 'solarisation' technique. **1930s** Continues to contribute to Surrealist films and becomes a prominent figure in the movement. **1936** Participates in *Fantastic Art, Dada and Surrealism* at MOMA, New York. **1940** Returns to the US and teaches photography in Los Angeles. **1951** Moves back to Paris. **1961** Wins the gold medal the Venice Photography biennial. **1974** A major exhibition of his work is held at the Cultural Centre, New York, which travels to London and Rome. **1976** Awarded the Order of Artistic Merit by the French government in August, shortly before he dies in Paris.

GEORGES RIBEMONT-DESSAIGNES
1884 Montpellier, France – 1974 Saint-Jeannet, France

1910 Associates with the Puteaux group. Meets Duchamp and Picabia. **1912** Participates in the *Section d'Or* exhibition in the Galerie de la Boétie. **1915** Mobilised for war duty in Paris, begins poetic writing. **1919** Addresses his first letter to Tristan Tzara and contributes to the journal *Dada* and Picabia's *391*. Under Picabia's influence, begins producing mechano-morphic paintings. He and Picabia travel to Zurich to visit Tzara. **1920** His play *Le Serin muet* is performed in a Dada soiree. He is made official polemicist of the Dada group, contributing texts to *Dadaphone*, *Cannibale* and *Littérature*. Contributes to various issues of *De Stijl* until 1924. Shows his paintings at the Salon des Indépendants in Paris, the Galerie Néri in Geneva, and at the Société Anonyme in New York. **1922** Takes part in the Dada Paris Congress. Contributes 'Manifeste a l'hulle' to the Yellow (first) issue of *Mécano*. **1923** Serves as one of the editors of *Mécano* with Tzara and Schwitters. Submits poetry to Schwitter's magazine *Merz*. Begins to focus on writing novels and essays. **1928** Starts *Le Grand Jeu*, a short-lived Surrealist periodical. **1929-31** Edits *Bifur*. **1941** After the war, starts writing for the revues *Fountaine*, *Poésie* and *Les Cahirs du Sud*. Publishes further novels and introductions to literary and artistic texts. **1974** Dies in Saint-Jeannet.

HANS RICHTER
1888 Berlin – 1976 Locarno, Switzerland

1916 Arrives in Zurich. Becomes closely involved with Dada activities and shows his paintings with the Dadaists at the Galerie Corray. **1918** Tzara introduces him to Eggeling. The two move to Germany together, to Klein Koelzig, the house of Richter's father, to collaborate on films. **1920** Along with

Eggeling, he meets van Doesburg, who champions their efforts in *De Stijl*. Begins contributing regular articles and illustrations to *De Stijl*, and introduces van Doesburg to Schwitters. **1921** Makes his first abstract film, *Rhythmus 21*. **1922** Attends the International Congress of Progressive Artists in Dusseldorf with van Doesburg, etc. Attends the Congress of Dadaists and Constructivists in Weimar. **1923** Begins publishing the magazine *G*, co-edited with El Lissitzky and Werner Graeff, promoting Dada, De Stijl and international Constructivism. The first issue contains van Doesburg's 'On Elementary Formation'. Shows his film *Rhythmus* at the final Dada soiree in July in Paris. **1925** Stops painting to concentrate on film-making. **1926** *G* is discontinued. He founds the Society for New Film in Berlin. **1929** Joins the Circle of New Advertising Designers. **1933** Emigrates to France. Travels to Meudon, where he stays with Nelly van Doesburg, Arp and Taeuber-Arp. **1941** Moves to New York, where he collaborates with Fernand Léger, Ernst, Duchamp and Man Ray on the full-length feature film *Dreams Money Can Buy*, financed by Peggy Guggenehim. **1947** Becomes US citizen, promoted to position of professor at New York City College. **1953** Takes part in the De Stijl exhibition at the Stedelijk Museum in Amsterdam. Produces last film, *Dadascope*, a film collage composed of Dada poems by Duchamp, Man Ray, Arp, Tzara, Schwitters and van Doesburg. **1961** Moves back to Switzerland. **1969** Awarded German Order of Merit. **1976** Dies at the age of 87.

GERRIT RIETVELD
1888 Utrecht, The Netherlands – 1964 Utrecht, The Netherlands

1917 Sets up a furniture workshop. **1918** Designs the Red/Blue chair, which is not painted till about 1923. Becomes a member of Voor de Kunst. **1919** First contact with van Doesburg and Oud. Collaborates on *De Stijl*. Designs sideboard based on Neoplastic principles and other furnishings. **1920** Designs furnishings for an interior (with colours designed by van Doesburg) for a housing block in Spangen, Rotterdam, built by Oud. Contributes furniture to a room (painted by van Doesburg) in Bart de Ligt's home in Katwijk. **1921** Receives first architectural commission from Truus Schröder-Schräder. **1923** Meets Schwitters on the latter's Dada tour, and Lissitzky. His design for the facade of the Gold and Silversmith's Company is included in the *De Stijl* exhibition at Galerie de l'Effort Moderne in Paris. In Berlin, exhibits a model for an interior in collaboration with Huszár which is featured in an issue of *L'Architecture Vivante*. **1924** Registered as an architect. **1925** Completes Schröder-Schräder house, which has become regarded as the epitome of De Stijl architecture. **1926** Interior of a flat on the Weteringschans, Amsterdam. **1927** Begins experimenting with prefabricated concrete slabs. Designs the Lommer House in Wassenaar (destroyed) in a manner similar to the Schröder-Schräder House. **1928** Breaks with De Stijl, moves towards a functionalist style. Takes part in preliminary meeting for the International Congress of Modern Architecture in La Sarraz, Switzerland. **1930s** Designs mass housing in Utrecht and Vienna. Takes private commissions. Shop renovations for Metz & Co, the Dutch company that produces his furniture, including the 'Zig-zag' chair, until 1955. **1944–55** Teaches architectural design at the Academy of Architecture in Amsterdam. **1951–2** Helps design the *De Stijl* exhibition at the Stedelijk Museum, Amsterdam and MOMA, New York. **1954** Designs Dutch Pavilion at the Venice Biennial. **1960s** Receives large international commissions. **1963** Sketches design for the Vincent van Gogh Museum in Amsterdam. **1964** Dies in the Schröder-Schräder House, Utrecht.

THIJS RINSEMA
1877 Drachten, The Netherlands – 1947 Drachten The Netherlands

Works as a cobbler in the family business throughout his life. Teaches himself painting. **1917** Meets van Doesburg through his brother, Evert, who had met him during the mobilisation of Dutch troops in 1914. Van Doesburg often visits the Rinsema family in Drachten where he encourages Rinsema to paint more frequently. **1920** Designs and makes several pieces of furniture with van Doesburg. Meets Cees de Boer, the town's architect who later seeks advice from van Doesburg about colour schemes for the local college. **1922** Purchases van Doesburg's painting *Composition XXII*. Corresponds with van Doesburg until his death in 1931. **1923** Organises a Dada Matinee in Drachten with van Doesburg. There he meets Schwitters, with whom he maintains extensive correspondence. **1925** Work influenced by De Stijl. Starts to exhibit his paintings in the window of his shop. **1931** Continues to paint after Schwitters's return to Norway and the death of van Doesburg, albeit in a more traditional style. **1947** Dies in Drachten. **1972** Exhibition of work at the Nijmegen Museum, Holland. **1974** Works shown in the *Dada in Drachten* exhibition in Franeker and The Hague.

KARL PETER RÖHL
1890 Kiel, Germany – 1975 Kiel, Germany

1909–11 Art student at the Berlin Royal Applied Art Academy. Friendship with Viking Eggeling and Hans Richter. **1912–14** Studies at the Grand Ducal Art School in Weimar. **1914–18** Army service in the First World War. **1919–21** Enrolled at the Bauhaus school. Contact with Itten, Schlemmer, Klee, Kandinsky and close association with Feininger and Gropius. Creates paintings and sculptures with expressionistic style. Designer of the first official Bauhaus seal and active member of the school. Together with Werner Lange and Peter Drömmer organises an exhibition of new art in the Kunsthalle, Kiel. **1921** Meets Theo and Nelly van Doesburg through architect Alfred Meyer and develops close friendship with them. Organises the Weimar De Stijl group. Turns to Geometric-Constructive paintings. **1922** Offers his studio to van Doesburg for his De Stijl course, where he sits as an advanced student and assistant teacher. Exhibits his De Stijl paintings at the *Nonjuried Art Exhibition* in Berlin, together with El Lissitzky. Takes part in the Congress of Constructivists and Dadaists in Weimar, Jena and Hanover. During those years (1921–6) as an independent artist, makes contributions to the magazines *De Stijl*, *Mécano*, *MA* and *G*. **1926–42** Professor at the Städel School in Frankfurt, where he works with Meyer. **1943–6** Army service in the Second World War and ultimate imprisonment in France. **1946** Settles in Kiel as an independent artist. **1952–5** Teacher at the Goethe School in Kiel. **1975** Dies in Kiel.

WALTER RUTTMANN
1887 Frankfurt am Main – 1941 Berlin

1906 Goes to Zurich to study architecture, but soon gives up his training. **1909** Studies painting at the Academy of Fine Art in Munich. Meets Paul Klee and Feininger. **1914–18** Serves as a lieutenant in the German army. Continues painting and drawing but becomes increasingly frustrated with the static nature of painting. **1918** Exhibits in Frankfurt. Becomes seriously ill with flu and stops painting. **1919/20** Starts the study of cinematography. **1921** Makes first abstract film *Opus I* with score written by Max Butt-

ing, which premieres in Berlin. The film is well received and very influential for other avant-garde film-makers, especially Oskar Fischinger. **1921–4** Makes *Opus II, III and IV*. **1925** Shows work at Berlin screening by the November Group, *Der Absolute Film*, alongside Eggeling, Richter and Ludwig Hirschfeld-Mack. **1927** Films *Berlin: Symphony of a Great City*, influenced by Serge Eisenstein and inspired by techniques used by Dziga Vertov. **1928** Makes sound piece for Berlin Radio. **1929** Early abstract films shown at the Baden-Baden Festival to international acclaim. Works with Erwin Piscator on experimental film *Melodie der Welt*. **1935** Works as assistant to director Leni Riefenstahl on *Triumph of the Will*. **1936** Edits Nazi film of the Berlin Olympics with Riefenstahl. **1941** Injured whilst making a newsreel on the Eastern Front. Dies shortly afterwards in Berlin.

JOOST SCHMIDT
1893 Wunstorf, Germany – 1948 Nuremberg, Germany

1910 Begins studying painting at the Fine Art School in Weimar with Max Thedy. **1914–18** Army service during the First World War. **1919–25** Student at the Bauhaus. Training with Itten and Schlemmer in the wood sculpture workshop. In Weimar, concentrates primarily on sculpture. **1921–2** Designs and executes the interior wood decoration for Gropius's Sommerfeld House in Berlin. **1923** Also involved in the development of new typographical vocabulary. With Bayer and Moholy-Nagy promotes the commercial application of the new Bauhaus typography. Participates in the large Bauhaus exhibtion, where he creates four relief walls for the lobby of the main building. **1925** Marries Bauhaus student Helene Nonne. **1925–32** Professor at the Bauhaus in Dessau, in charge of the sculpture workshop until its dissolution in 1930. **1928** Takes charge of the typography and advertising design when Bayer leaves the school. **1933** Moves from Dessau to Berlin. **1934** Along with Gropius, designs the metal-without-iron display at the exhibition *German People, German Work*. **1935** Professor at architect Hugo Haring's Reimann School. The Nazi regime prohibits him from teaching. From then on makes his living from temporary work. Investigates colour and writes. **1943** His studio in Charlottenburg, Berlin, is destroyed during the Second World War. **1944–5** Called up for military service. **1945** Max Taut invites him to teach architecture in the Fine Arts School in Berlin. **1946** Organises the exhibition *Berlin Projects* with other former Bauhaus students. **1947–8** Gets an offer from the American Exhibition Centre to design exhibitions. **1948** Dies in Nuremberg.

KURT SCHWITTERS
1887 Hanover, Germany – 1948 Kendal, England

1918–19 In contact with Herwarth Walden of Der Sturm Gallery in Berlin. Makes his first collages. Befriends Hausmann, Arp and Höch. Begins his first Merz pictures and publishes writing and reproductions of pictures in *Der Sturm* magazine. Publishes the Merz poem *Anna Blume*. **1920** First inclusion at the Société Anonyme exhibitions in New York, followed by a solo exhibition at Der Sturm Gallery. Richter introduces him to van Doesburg. Begins work on the Merzbau. **1921** *Anti-Dada-Merz-Trip* lectures with Hausmann and Höch in Prague. Contributes to the fourth and seventh issue of *De Stijl*. **1922** Attends the Dadaist-Constructivist Conference in Weimar. **1922–3** Embarks on Dada tour with the van Doesburgs, Arp, Hausmann and Tzara to Jena, Dresden and Hanover. Contributes to the third and fourth issues of *Mécano*. **1923** Launches the magazine *Merz*. The first issue recounts his first joint performance with the van Doesburgs in Holland. Con-

structs the Merzbau in Hanover. Submits works and articles to the magazines *G*, *i-10*, *Pasmo*, *Fronta*, *Der Sturm* and *Blok* amongst others. **1925** Collaborates with van Doesburg on *Die Scheuche*, a children's book published as a special issue of *Merz*. Becomes subscription agent in Germany for *De Stijl*. **1927** Founding member of group Die Abstrakten, Hanover. **1928** Initiates the Circle of New Advertising Designers along with Domela, Burchartz, Lissitzky, Moholy-Nagy, etc. **1930** Shows in the Salons des Surindépendants, Paris. Takes part in the *Cercle et Carré* group show. Elected Honorary President of the Société Anonyme. **1932** Ceases publication of *Merz*. Joins the Abstraction-Création group and publishes his work in its magazine. **1936** Travels to Meudon to visit the Arps. Meets Mondrian. His works are included in the *Cubism and Abstract Art* and *Dada and Surrealism* exhibitions at the Museum of Modern Art in New York. **1937** Relocates to Norway where he creates his second Merzbau. **1940** Flees to England. **1944** Represented in the *Art Concret* exhibition at the Kunsthalle, Basel. **1947** Begins his third Merzbau, plans the monograph *PIN* with Hausmann. **1948** Dies in Kendal.

PAUL SCHUITEMA
1897 Groningen, The Netherlands – 1973 Amsterdam

1897 Begins his drawing and painting studies at the Academy of Fine Arts, Rotterdam. Works as a graphic designer and photographer and subsequently as a furniture designer and filmmaker. From **1924** P. van Berkel, the Rotterdam meat exporter and manufacturer of slicing machines and weighing scales, gives Schuitema the opportunity to put his innovative ideas in the field of typography and advertising into practise. **1925** Member of Opbouw, the progressive circle of architects in Rotterdam, with Oud and van Eesteren. **1927–34** Secretary of Opbouw. Familiar with the innovations in architecture and design occurring in Russia, Poland, Germany and Czechoslovakia. **From 1926** Works with photomontage, becoming a pioneer of this technique in the field of industrial design. **1928** Participates in the exhibition Film and Photo in Stuttgart together with his Dutch colleagues Zwart and Gerard Kiljan. Publishes an article entitled 'Advertising' in the avantgarde magazine i10, which has the tone of a manifesto and clearly marks his break with tradition. **1930** He and Gerard Kiljan become the first teachers of design and photography at the Academy of Visual Arts in The Hague. Teaches new generations of designers and photographers until 1959. **1931** Designs the poster for the Amsterdam exhibition of the Circle of New Advertising Designers, where his work is shown alongside Bayer, Dexel, Domela, Kassák, Moholy-Nagy, Schwitters, Teige, Tschichold and Zwart.

VICTOR SERVRANCKX
1897 Diegem, Belgium – 1965 Elewijt, Belgium

1917 Exhibits abstract paintings at the Galerie Giroux in Belgium. **1918** Works with Léonce Rosenberg's Galerie de l'Effort Moderne in Paris, meets van Doesburg, Marinetti, Léger and Duchamp. **1922** Participates in the exhibitions for the Second Congress of Modern Art in Antwerp. **1923** Contributes to the journals *MA*, *L'Esprit Noveau*, *7 Arts* and *Blok*. **1925** Collaborates with Huib Hoste to submit a design of an interior room and functional furniture for the *International Exhibition of Decorative Arts* in Paris. Exhibits in the *Art of Today* exhibition in Paris with Picasso, Braque, Pevsner, van Doesburg and Mondrian. **1926** Participates in the exhibitions of the Société Anonyme in New York with the help of Duchamp. Turns down the offer of professorship at the New Bauhaus in Chicago. **1927** Adopts an increasingly surrealistic style. **1928** Exhibits at Der Sturm Gallery in Berlin,

contributes to *Opbouwen* magazine. **1929** Exhibits at the Palais des Beaux-Arts in Brussels. **1930** Begins to exhibit widely throughout Europe. **1947** Retrospective at the Palais des Beaux-Arts, Brussels. Participates in Venice Biennial. **1965** Dies in Elewijt.

GINO SEVERINI
1883 Cortona, Italy – 1966 Paris

1899 Moves to Rome, attends evening classes in drawing. **1901** Meets Boccioni. Together they frequent the studio of Balla, who introduces them to the Divisionist technique. **1906** Relocates to Paris. Comes into contact with Braque, Picasso and other members of the Paris school. **1910** Along with Balla, Boccioni, Carrà and Russolo, he signs the Manifesto of Futurist Painters and Futurist Painting: Technical Manifesto. **1912** Participates in the first major Futurist exhibition at the Bernheim-Jeune Gallery, Paris, in the second Futurist exhibition at Der Sturm Gallery, Berlin and in *The Futurists* in Amsterdam, Den Haag and Rotterdam. **1913** First solo exhibition at the Marlborough Gallery in London, which travels to Der Sturm in Berlin. Marries Jeanne Fort, daughter of the famous poet Paul Fort. **1916** Many exhibitions in Galerie Bongard in Paris. Meets Léonce Rosenberg of the Galerie de l'Effort Moderne. Experiments with mathematical and compositional rules. **1917** Exhibits in Alfred Stieglitz's 281 gallery in New York and in Lyre et Palette in Paris where he probaby meets the Dutch poet Dop Bles, a friend of Mondrian's. **1917–19** Corresponds with van Doesburg. Publishes the article 'Avant-Garde Painting' over several issues of *De Stijl*, and is the first foreign artist to contribute to the journal. 1919 Signs exclusive contract with Rosenberg's Galerie de l'Effort Moderne. Produces paintings constructed on mathematical principles. His painting *De Boulevard* is included in van Doesburg's book *Three Lectures on Neo-Plastic Art*. **1920** Meets van Doesburg on the latter's first trip to Paris. **1921** Publishes *Du Cubisme au Classicisme*. **1921–2** Paints commedia dell'arte characters for Sir George Sitwell's residence in Tuscany. **1929** Included in the *Select Exhibition of Contemporary Art* at the Stedelijk Museum Amsterdam. **1924–5** Becomes interested in religion. Paints murals for churches and public buildings in Switzerland, France and Italy. Awarded Legion of Honour. **1946** Returns to France. Publishes *Tutta la vita di un pittore*, his autobiography. **1949** Paints abstract and dynamic works. **1961** Solo show at the Palazzo Venezia, Rome. Participates in Futurism exhibition in MOMA, New York.

WALMAR (WLADIMIR) SHWAB
1902, Lapenrata, Finland – 2000 Geneva, Switzerland

1902 Born of a Finnish Mother and a French father he is adopted by a Swiss family when aged eight. **1920–5** Studies Chemistry in Paris; receives his BSc. **1926** Paints first abstract work. **1927** Travels to Germany. Meets Moholy-Nagy. Has contacts with Der Sturm group. **1928** Shows at the Galerie Sacre du Printemps in Paris. Exhibits in Der Sturm Gallery in Berlin. Shows work at the Ursuline Movie Theatre. **1929** Takes part in the *Select Exhibition of Contemporary Art* at the Stedelijk Museum, Amsterdam, alongside van Doesburg, Mondrian, Arp and Tutundjian. Founds the R group with Adamov. **1930** Takes part in Art Concret meetings but does not sign manifesto. One of his works illustrates their pamphlet. Screens one of his Constructivist films at the Ursuline movie theatre. **1930–1** Introduces curved forms into his painting as opposed to the straight lines and rectangles he had been working with. **1933** Stops artistic activity, not to begin again until the 1960s. **1937**

Works shown at the Guggenheim's *Art of Tomorrow* exhibition in New York. **1939–45** Returns to Switzerland and works towards his PhD in Chemistry. Changes his name to Walmar. **1975** Solo show at the Kunsthaus, Zurich. **1978** Shows in *Abstraction-Création* exhibition in Paris and Münster.

WLADYSLAW STRZEMÍNSKI
1893 Minsk – 1952 Łódź, Poland

1917–22 Studies at the First Free State Workshops in Moscow and works closely with Kasimir Malevich. **1922** Participates in the *First Russian Art Exhibition* at the Van Diemen Gallery in Berlin. Emigrated to Poland. **1924–6** Member of the artists' group Blok. **1926–9** Member of Praesens. **1928** Published his theory 'Unismus in Painting'. **1929** Founded the artist group a.r. **1932** Member of the Paris-based group Abstraction-Création. Designs a new alphabet. Co-founder of the Museum of Modern Art in Łódź. Many artists of the international avant-garde, particularly those from Abstraction-Création, donate works to this museum. It was one of the first public collections of avant-garde art.

SOPHIE TAEUBER-ARP
1889 Davos, Switzerland – 1943 Zurich, Switzerland

1915 Moves to Zurich. Meets Hans Arp. They begin to collaborate on abstract duo-collages. **1916–18** Begins teaching textile design at the School of Applied Arts, Zurich. Associates with the Dadaists, and often performs and dances in Dada-designed costumes at the soirees of the Cabaret Voltaire. **1922** Marries Hans Arp. **1924** In Paris, with Hannah Höch and Dadaists. **1925** Serves on the jury and shows at the International Exhibition of Decorative Arts in Paris. **1926–8** Commissioned, along with Hans Arp and van Doesburg, to design and decorate the interior of the Café Aubette in Strasbourg. **1927** Co-authors the book *Design and Textile Arts* with Blanche Gauchet. **1928** The Arps move to Meudon-Val Fleury, to a house and studio made to her designs. **1929** Quits her professorship in Zurich. **1930** Joins Cercle et Carré and participates in their Galerie 23 exhibition. **1931–4** Abstraction-Création. **1937** Member of the Zurich artists association 'Allianz'. Exhibits at the *Constructivism* exhibition at the Kunsthalle in Bern. Launches and edits the Constructivist review *Plastique* with Hans Arp and Domela, published in Paris and New York. It runs for five issues until 1939. **1940** The Arps move to Grasse in Southern France, where they create an artist colony with Sonia Delaunay. **1943** Dies in a gas stove accident during a visit to Switzerland.

KAREL TEIGE
1900, Prague – 1951, Prague

1911 Enters 'gymnasium' (college) and studies alongside future members of the Czech avant-garde group Devětsil. **1916** Writes under pseudonym Karel Vlk. Holds first exhibition in Prague. His art criticism is published in the journal *Ruch*. **1917** *Die Aktion* publishes his graphic works. **1919** Studies art history at the Faculty of Philosophy, Charles University, Prague. Writes for journals and newspapers including *Revoluce*. **1920** Devětsil is founded in Prague with Teige as its theorist. **1921** Is exempted from compulsory military service. F.T. Marinetti makes contact with Devětsil and shortly after, Teige publishes an article on Futurism. **1922** Visits Paris and meets Larionov, Gleizes, Ozenfant, and Le Corbusier. **1923** Assumes role of chief editor of *Stavba* and advocates modern architecture, International Purism and Constructivism. Makes contact with Walter Gropius.

Designs the international review *Disk*. **1924** Publishes in the journal *Pásmo*. Writes 'Poetismus' in which he theorises on the 'picture poem'. Travels widely in Europe and meets Frederick Kiesler in Vienna. With van Doesburg, urges the boycott of the spring 1925 *Exhibition of Decorative Arts* in Paris. As an alternative, they propose the Congress of the Constructivist Movement, as well as international publications on modern art and architecture and performances of modern theatre and film. Publishes a survey of new Modern Czech architecture. **1925** Le Corbusier meets members of Devětsil. **1926** Becomes involved with The Liberated Theatre. Publication of Nezval's book *Abeceda* with typographical design by Teige. **1927** Journal *ReD* is published, edited by Teige. It acts as the official mouthpiece of Devětsil. Teige's article *Modern Typography* is published. **1928** Publishes seminal essay in *Stavba* on Constructivism. **1929** Takes part in the international exhibition *The New Typography* in Berlin. Joins the Circle of New Creative Designers. Develops into a hardline functionalist. Le Corbusier writes 'In Defense of Architecture' in answer to Teige's criticism of his Mundaneum design. Exhibits work in the show *Film und Foto* in the UFA-Palast, Berlin. Is appointed visiting senior lecturer at the Dessau Bauhaus by his friend Hannes Meyer. **1930** Participates in the Third CIAM Congress in Brussels. **1931** Writes and designs *The Minimal Dwelling*. **1930s** Publishes on Surrealism. **1939** Works on his book *Phenomenology of Modern Art* until his death. **1950** Is denounced in a press campaign initiated by the ruling Communist Party. **1951** Dies of a heart attack.

JOAQUÍN TORRES-GARCÍA
1874 Montevideo, Uruguay – 1949 Montevideo, Uruguay

1917 Exhibits at the Dalmau Gallery in Barcelona, where he meets Gleizes and Picabia. **1920** Travels to New York. Comes into contact with Duchamp and Man Ray of the Société Anonyme. Returns to Europe. **1926** Settles in Paris. Shares a studio with Jean Hélion. **1928** Participates in the exhibition organised by Hélion, *Five Painters Refused by the Jury of the Salon d'Automne*, held at the Galerie Marck. He meets and begins corresponding with van Doesburg. Publishes a lengthy article on van Doesburg in *La Veu de Catalunya* and his work begins to show Constructivist influences. **1929** Van Doesburg includes his work in the *Select Exhibition of Contemporary Art* at the Stedelijk Museum in Amsterdam. Meets Michel Seuphor, who introduces him to the Arps, Vantongerloo and Mondrian. Begins to use the mathematical golden section in his painting. Chooses to not sign the Art Concret manifesto. Relationship with van Doesburg becomes strained. **1930** Co-founds Cercle et Carré with Seuphor, in charge of the review's administration. Shows with the group at Galerie 23. **1931** Falls out with Seuphor. **1932** Relocates to Madrid. Lectures, exhibits and organises the Constructivist art group. **1934** Returns to Uruguay. **1935-6** Establishes the Constructivist Art Association and publishes *Círculo y Cuadrado* as a successor to *Cercle et Carré*. **1940s** Continues to exhibit and teach in Montevideo.

JAN TSCHICHOLD
1902 Leipzig, Germany – 1986 Locarno, Switzerland

1923 Visits the first Bauhaus exhibition in Weimar. His typographic works are inspired by Bauhaus functionalism, Russian Constructivism and include elements of De Stijl. Becomes the driving force behind the New Typography. **1925** Guest-edits and contributes to the German printing trade journal *Typographische Mitteilungen*. In it he includes work by

Schwitters and Lissitzky, but notably leaves out De Stijl. **1926** Teaches calligraphy and typography at the Munich Vocational School for Graphic Arts. **1926-9** Develops a 'universal alphabet' and a number of fonts. Maintains close contact with designers throughout Europe. **1928** Publishes his first book *The New Typography*, one of the most important contributions to modernist graphic design. Visits Paris, meets Mondrian and Seuphor. Joins the Circle of New Advertising Designers and exhibits with them until 1931. **1933** Suspected of 'cultural Bolshevism', flees to Switzerland as Hitler comes to power. **1935** Publishes the influential *Typographic Design* for which he is best known. **1942** Rejects principles of New Typography and strict adherence to the sans-serif type. **1947** Works for Penguin Books in London. **1959** Writes a letter to *Typography USA* equating the rigors of New Typography to Fascism, therefore explaining his rejection of his earlier principles. **1960s** Continues to work as a typographer, designer and writer until his death in 1986.

LÉON TUTUNDJIAN
1905 Amassia, Armenia – 1968 Paris

1923 Arrives in Paris. **1925** Produces his first collages. **1926** Participates in Surrealist exhibition at Galerie Surréaliste, Paris. **1927** Shows at the Salon des Indépendants. **1929** Exhibits with and illustrates catalogue cover for the *Select Exhibition of Contemporary Art* at the Stedelijk in Amsterdam, curated by Nelly van Doesburg. Exhibits at the Salon des Surindépendants, Paris with van Doesburg and Carlsund. Shows at the *Abstract Art* exhibition at Galerie Bonaparte. Solo Show at Galerie Nay, Paris. Works in both geometric abstract and Surrealist styles. Meeting at Café Zeyer in Paris with van Doesburg, Hélion and Wantz. **1930** Co-founds Art Concret group, publishes the only edition of its journal *L'Art Concret* including manifesto 'The Basis of Concrete Art' signed by Van Doesburg, Carlsund and Hélion. Exhibits in Art Concret section of the *Art Post-Cubism* exhibition organised by Carlsund in Stockholm. Shows in *Produktion Paris 1930* in Zurich. **1931** Sends work to the Salon 1940 at the Galerie de la Renaissance in Paris where van Doesburg is exhibiting. Co-founds Abstraction-Création group, but leaves after the publication of the first issue of their magazine which includes writings by van Doesburg. **1932** Takes part in *Abstraction-Création* exhibition in Paris. Paints exclusively in a Surrealist style. **1933** Shows in Surrealist exhibition at the Galerie Pierre Colle, in Paris. **1932-4** Contract with Léonce Rosenberg. **1944** Participates in the *Art Concret* exhibition curated by Max Bill in the Kunsthalle, Basel. **1958** Work moves towards lyrical abstraction. **1968** Dies in Paris.

TRISTAN TZARA
(SAMUEL ROSENSTOCK)
1896 Moinesti, Romania – 1963 Paris

1915 Arrives in Zurich. **1916** Founds the Cabaret Voltaire with Marcel Janco, Arp and Hugo Ball, later joined by Richard Huelsenbeck. Performs at the first Dada soiree. **1917** Takes over leadership from Ball, launches the periodical *Dada*. **1918** Publishes his 'Dada Manifesto 1918' in *Dada* (no.3), catching the attention of André Breton in Paris and van Doesburg in the Netherlands. A quote from 'Dada Manifesto 1918' appears in the February issue of *De Stijl*. The first mention of I.K. Bonset (van Doesburg's Dada pseudonym) is found in a letter from van Doesburg to Tzara describing Bonset as a Dutch Dadaist. **1920** Arrives in Paris at the invitation of André Breton and bursts onto the literary scene at a poetry reading organised by

Breton's Littérature group, which Tzara joins. Remains editor of *Dada*, which is circulated in France until 1920. **1922** Refuses to take part in the Dada Paris Congress with Breton, Ribemont-Dessaignes and Picabia. Disrupts the Constructivist Congress in Weimar with Hans Arp, turning it into a Dadaist-Constructivist Congress. Embarks on Dada tour to Jena, Dresden and Hanover with van Doesburg, Arp, Schwitters, Hausmann and Nelly van Doesburg. Contributes articles to the Yellow (first), Blue (second) and Red (third) issues of *Mécano*. **1923** Writes the manifesto 'La Coeur à barbe', criticising André Breton's leadership of Dadaist activities. Van Doesburg, Ribemont-Dessaignes, Man Ray and Duchamp are among those who sign it. Serves on the editorial board of the White (fourth/fifth) issue of *Mécano* with Ribemont-Dessaignes and Schwitters. Collaborates with Richter and Schwitters on the periodical *G*. **1929-35** Reconciles with Breton, joins Surrealist activities. **1930-5** Becomes an active Communist sympathiser. **1950s** After the war, he remains a spokesperson for Dada, delivering radio addresses in Paris on avant-garde poetry. **1962** Travels to Africa, dies the following year.

HENDRIK VALK
1897 Zoeterwoude, The Netherlands – 1986 Arnhem, The Netherlands

1912-16 Studies at the Royal Academy of Fine Arts, The Hague. From the beginning mostly interested in religious and philosophical questions. **1915-16** Impressed by the books of Dr M.H.J. Schoenmaeckers. **1916-26** Lives in Leiden and surroundings. Reduces his work to stylised, geometric forms but his style never becomes totally abstract. According to Valk, van Doesburg asked him around 1917 or 1918 to participate in De Stijl, but Valk refused. **1918** Solo exhibition at D'Audretsch Gallery in The Hague. **1926** Moves to Arnhem. Teaches there at the Art Academy. Resumes realistic painting.

GEORGES VANTONGERLOO
1886 Antwerp, Belgium – 1965 Paris

1900-9 Studies sculpture and architecture at the Academies in Antwerp and Brussels. **1914** Injured during the First World War. Settles as a refugee in The Hague. **1915** Solo exhibition in The Hague. **Late 1917/1918** Reads van Doesburg's 1917 brochure *The New Movement in Painting*. **1918** Meets van Doesburg for the first time at his studio in Leiden. Creates first abstract sculptures (including *Construction in a Sphere*). Interested in the writings of esoteric philosopher Schoenmaekers. Contributes instalments of essay 'Reflections' in *De Stijl* (July 1918 until 1920). Co-signs first De Stijl manifesto (published November), the only sculptor by vocation associated with De Stijl (but was as much a painter, and later, a designer of furniture and buildings). Applies primary colours to sculpture *Composition Departing from an Ovoid*. **1919** Returns to Brussels. **1920** Meets Mondrian in Paris, forms lasting friendship. Last 'new' article contributed to *De Stijl* (fragments of earlier articles reproduced until 1922). Moves to Menton, south of France (until 1927). Develops idiosyncratic colour theory. **1921** Withdraws from De Stijl. **1924** Publishes *L'Art et son avenir* (Art and its Future), a collection of essays on his mathematical theories of art. Creates first sculptures based on mathematical formulas. **1925** Exhibits in *The Art of Today*, Paris. **1926-31** Works primarily on architectural projects, in particular designs for airports. **1927** Moves to Paris. Relations with van Doesburg deteriorate due to controversy over publication in the journal *i10*. **1930** Associated with the French abstract group

Cercle et Carré. **1931** Founding member and vice-president (until 1937) of the Abstraction-Création group, Paris. Meets Pevsner. Refuses to contribute to the final, commemorative issue of *De Stijl*. **1933** Begins lifelong friendship with Max Bill. **1940s** Makes abstract paintings and wire sculptures. **1943** Retrospective at the Galerie de Berri, Paris. **1950s** Plexiglass, then transparent plastic, sculptures. **1965** Dies in Paris.

FRIEDRICH VORDEMBERGE-GILDEWART
1899 Osnabrück, Germany – 1962 Ulm, Germany

1923 First pictorial constructions. **1924** Founding member of Gruppe K. Meets Arp and van Doesburg through Schwitters, becomes a member of Der Sturm in Berlin. Begins producing typography. **1925** Joins De Stijl, participates in the *Art of Today* exhibition in Paris. **1927** Founding member of Die Abstrakten group. Van Doesburg publishes his planimetric paintings in *De Stijl* in support of the principles of Elementarism. **1928** Joins Schwitters's Circle of New Advertising Designers. **1929** First solo exhibition in Paris. **1930** Participates in the Cercle et Carré group show at the Galerie 23, Paris. **1931** Founding member of Abstraction-Création in Paris. Participates in the *Collection Internationale d'Art Nouveau* show at the Sztuki Museum in Łódź, Poland. **1938** Works shown in the *Degenerate Art* exhibition in Berlin. Emigrates to Amsterdam. **1937** *Constructivism* exhibition at the Kunsthalle Basel. **1938** *Abstract Art* at the Stedelijk Museum, Amsterdam. **1939** Second *Réalités Nouvelles* exhibition, Paris. **1944** *Art Concret*, Kunsthalle Basel. **1946** Participates in the Salon des Réalités Nouvelles at the Palais de Beaux-Arts de la Ville de Paris. **1951** *De Stijl* at the Stedelijk Museum, Amsterdam. **1953** Awarded a prize at the 2nd São Paulo Biennial. **1954** Appointed Director of the Department of Visual Communication at the Galerie Ferdinand Möller, Cologne. Continues to exhibit throughout Europe. **1962** Dies in Ulm.

ANDOR WEININGER
1899 Karancs, former Hungary – 1986 New York

1913-17 Pupil at the Cistercian grammar school in Pécs. **1917-18** Attends Pécs University School of Law. **1918** Tour of Dalmatia with Farkas Molnár. **1918-19** Studies architecture at the Budapest Technical University. **1921** Admitted to the Bauhaus. Preliminary course with Johannes Itten. **1922-5** Continues training at the mural-painting workshop led by Kandinsky. **1922** Active member of the De Stijl circle in Weimar. Attends van Doesburg *Stijl-Kurs I*. Co-founder of the KURI group with Molnár, Schmidt, Keler and other Bauhaus students. Works in Berlin with members of the mural-painting workshop on colourful wall compositions. **1923** Travels to Hamburg and works in Die Jungfrau cabaret as stage designer, performer and musician. Starts to plan his famous work the *Mechanical Stage-Abstract Revue*. Participates in the large Bauhaus exhibition. **1924** Forms the Bauhaus Band, a jazz band, with the old KURI members Koch, Paris and Hoffmann. **1925** Returns to Pécs. Gropius invites him back to work at Bauhaus in Dessau in public relations and in the stage workshop, led by Oskar Schlemmer. **1926** Performs in the inauguration of the new Bauhaus building in Dessau and in the Schlemmer Bauhaus dance production. **1927** His designs *Mechanical Stage-Abstract Revue* and *Globe Theatre* are praised at the Magdeburg theatre exhibition. **1928** Follows Gropius, Moholy-Nagy and Breuer in leaving the Bauhaus. **1928-38** Active in Berlin as site architect and advertising graphic artist. **1931** Marries Eva Fernbach, former Bauhaus stu-

dent, and together make colourful furniture designs. **1934** Designs the Tombola Pavilion shown at the Arts and Crafts exhibition in Berlin. **1938** Flees Nazi Germany. **1939-51** Lives in Holland. **1951-7** Lives in Canada and becomes Canadian citizen. **1958** Settles in USA. **1964** Member of Anonima group. **1986** Dies in New York.

HENDRIK NICHOLAAS WERKMAN
1882 Leens, The Netherlands – 1945 Bakkeveen, The Netherlands

1908 Opens a print shop in Groningen. **1917** Begins painting at the age of 34. **1919** Joins De Ploeg artists' society. **1920** Exhibits for the first time in De Ploeg group show. **1921-2** Publishes the De Ploeg magazine *Blad voor Kunst* (six issues). **1923** Publishes the first issue of *The Next Call* (9 issues) through which he refines his single-printing typographic technique. Uses this technique to produce first series of 'druksels'. **1924** Establishes contact with Michel Seuphor in Paris and the Blok group in Poland. **1927** Prints the De Ploeg manifesto. Corresponds with van Doesburg. **1929** Visits Cologne, Essen and Paris. **1930** Takes part in the Cercle et Carré exhibition in Paris at the invitation of Seuphor. Participates in the De Ploeg group show at the Stedelijk Museum, Amsterdam. **1931** With the help of Seuphor, his works are included in the *Collection Internationale d'Art Nouveau* show at the Sztuki Museum in Łódź, Poland. **1939** Solo exhibition at the Helen Spoor Gallery in Amsterdam. **1940** Begins publishing *De Blauwe Schuit*, a subtle critique of the Nazi occupation and a call for spiritual resistance. **1941** Included in the *Illuminated Page* exhibition at the Stedelijk Museum. He travels to Amsterdam and meets van Eesteren and Vordemberge-Gildewart amongst others. Publishes seven issues of *De Blauwe Schuit*. **1942** Travels to Voorschoten. Meets Rietveld. Prints first series of Hasidic legends and fourteen issues of *De Blauwe Schuit*. **1945** Arrested by the German SS, accused of producing 'illegal editions'. Executed three days before the liberation of Groningen.

JAN WILS
1891 Alkmaar, The Netherlands – 1972 Voorburg, The Netherlands

1912 Joins Johann Mutters's architectural studio in the Hague. Travels in Germany. **1910-13** Designs 'regional style' residential and country houses near Alkmaar. **1914-16** Works in H.P. Berlage's architectural firm in The Hague. Interested in the work of Frank Lloyd Wright. Meets Oud. **1916** Establishes himself as an independent architect in Voorburg, near The Hague. Joins The Hague Artists' Circle. Meets Huszár and van Doesburg. **1917** Exhibits with The Sphinx, the Leiden art club set up by van Doesburg and Oud in 1916. Participates in founding De Stijl. Collaborates with van Doesburg on the De Lange townhouse in Alkmaar for which van Doesburg provides colour schemes for the interior and exterior and stained-glass windows for the stairwell. Enters competition for the design of a pavilion for the public part of the city of Groningen. Submits design with van Doesburg for a concrete monument in Leeuwaarden. **1918** Co-signs De Stijl manifesto. Contributes articles to *De Stijl* and lectures before The Hague Artists' Circle. Renovates the café-restaurant De Dubbele Sleutel in Woerden and invites van Doesburg to design colour schemes. Produces designs for furniture with van Doesburg. Refers to 'mass architecture'. **1919** Resigns from De Stijl, possibly due to arguments with van Doesburg over financial matters and publication in *Levende Kunst*, a rival magazine to *De Stijl*. Continues to

honour principles of De Stijl in designs and projects executed after this date. Puts into practice the ideal of monumental collaboration between a painter and architect. **1920-1** Commissions Huszár to create colour designs for Alkmaar townhouse and remodels the studio of photographer Berssenbrugge (1921). In collaboration with Huszár and Zwart, realises important monumental art projects. Van Doesburg includes Berssenbrugge project in his lecture 'The Will to Style', which he gives in Germany in 1921 and publishes in *De Stijl* in 1922, to emphasise successful collaboration between a painter and architect. **1920s** Designs radically asymmetrical furniture, some of which is produced by Eik en Linde (Oak and Lime) factory. **1921** Designs estate of workers' houses for the town of Gorinchem. **1919-22** Zwart works as draftsman for Wils. Designs middle-class cooperative housing estate, Daal en Berg, Papaverhof, The Hague. Incorporates an external colour solution similar to that which van Doesburg proposed for De Dubbele Steutel. **1923** Photographs for the Daal en Berg estate included in De Stijl's architectural exhibition at Léonce Rosenberg's Galerie de l'Effort Moderne, in Paris. Exhibits designs at the *Nonjuried Art Exhibition*. **1928** Designs Olympic Stadium, Amsterdam, establishing his reputation.

PIET ZWART
1885 Zaandijk, The Netherlands – 1977 Leidschendam, The Netherlands

1902-7 Studies at the Amsterdam School of Applied Arts. **1911** Creates first designs for furniture and interior decoration. **1913** Studies at Delft Technical College. **1917-20** Exhibitions of furniture design at Rotterdam and The Hague. **1918** Becomes associated with De Stijl and van Doesburg, Huszár, Wils and later Rietveld and Mondrian. **1919** Takes on a critical attitude toward De Stijl and is in turn criticised by van Doesburg in *De Stijl* magazine. **1919-21** Assistant to Wils and collaborates with Huszár on furniture designs. **1919-32** Becomes highly influential as a teacher of design and history of art in Rotterdam. **1921** Makes first typographical designs for the flooring manufacturer Laga in Vickershouse. **1923** Attends Lissitzky's lecture on Russian art in The Hague and is deeply influenced by his photogram, and later photomontage, techniques. **1925** Meets Schuitema. **1926** Completes a master book for the Dutch Cable Works in Delft comprised of photomontage, typography and experiments in colour printing. **1927** Schwitters invites him to become a member of the Circle of New Advertising Designers. **1928-40** Official designer for the Dutch Postal Telegraph and Telephone company. **1929-42** Exhibits typography and photography internationally. **1931** Visiting lecturer in design at the Bauhaus in Dessau. **1937-8** Designs the modular kitchen for the Bruynzeel company and publishes in *Der Sturm*. **1973** Major retrospective exhibition at the Gemeentemuseum. **2008** Retrospective exhibition *Piet Zwart (1885–1977): Form Engineer*, Gemeentemuseum, The Hague.

1914 **1 March–30 April:** Theo van Doesburg sends three paintings to the Salon des Indépendants in Paris.

May–June: The third *Independents* exhibition in Amsterdam shows the work of Wassily Kandinsky, Marc Chagall, Alexander Archipenko, Francis Picabia, Diego Rivera, Vladimir Baranov-Rossiné, Henri Valensi and Ossip Zadkine.

28 July: Austria declares war on Serbia. In August Europe enters the First World War.

August: Van Doesburg is mobilised by the Dutch army, and serves for two years on the Belgian border.

Autumn: Van Doesburg meets poet Antony Kok in Tilburg and together they arrange soirees of lectures and music. Van Doesburg discusses with him the idea of publishing a magazine.

1915 Van Doesburg becomes interested in the abstract depiction of an object from the visual world and in the portrayal of movement.

19 June: Van Doesburg publishes an article in the Dutch journal *Eenheid* in which he defends 'the true modern'.

Summer: Is posted to Utrecht.

October: Visits The Hague Art Circle exhibition at the Stedelijk Museum in Amsterdam, which includes works by Piet Mondrian.

6 November: Reviews the show in *Eenheid*, writing for the first time about the art of Piet Mondrian. Weeks later van Doesburg starts a correspondence with him.

November: In Utrecht, writes 'De ontwikkeling der moderne kunst' (The Evolution of Modern Art) which is published afterwards in *Eenheid* and, with a few modifications, in other magazines.

December: Creates his first phonetic poems.

1916 **January–February:** After his demobilisation from army, van Doesburg travels to Haarlem. He later meets Piet Mondrian in Laren. There he also meets composer Jacob van Domselaer, who is exploring Neoplasticism in music, and theosophist and mathematician M.H.J. Schoenmaekers, whose theoretical emphasis on the polarity of horizontal and vertical elements and on the importance of primary colours influences Mondrian's theories of Neoplasticism. Van Doesburg encourages Mondrian to put his ideas in writing, later published in *De Stijl* as a series of short essays entitled 'The New Plastic in Painting'.

5 February: The Cabaret Voltaire opens in Zurich. Hugo Ball, Tristan Tzara, Hans Arp, Marcel Janco and Richard Huelsenbeck form the Dada Group.

March–April: In Amsterdam, van Doesburg founds the artistic group De Anderen with Erich Wichmann and Louis Saalborn. They exhibit in the Audretsch Gallery in The Hague the following month, with the participation of Vilmos Huszár. Janus de Winter withdraws his works from the show.

31 May: Settled in Leiden, Theo van Doesburg founds the artist club De Sphinx with architects J.J.P. Oud and Jan Wils.

July: Publishes his first book, *De schilder De Winter en zijn werk. Psycho-analytische studie* (The Painter De Winter and his Work: Psychoanalytic Study), in Haarlem.

November: Lajos Kassák starts the activist magazine *MA* in Budapest (1916–25).

December: With Vilmos Huszár, van Doesburg visits Mrs Kröller-Müller's collection in The Hague to view van der Leck's tryptique *The Mine*, which makes a strong impression on both. Georges Vantongerloo moves to The Netherlands to escape the war.

1917 Van Doesburg paints first Neoplastic works based on coloured rectangles, whose forms are not abstracted from nature.

– As derived from a previous article, his book *Die nieuwe beweging in de schilderkunst* (The New Movement in Painting) is published in Delft, in which he distinguishes two forms of abstraction: rational abstraction, via Cubism and exemplified by Mondrian, and impulsive abstraction, via Kandinsky.

May: Gino Severini introduces van Doesburg to Mario Broglio, who would become the editor of the Italian journal *Valori Plastici* (1918–22) and distribute

De Stijl in Italy. Van Doesburg also becomes familiar with the work of Giorgio de Chirico and Carlo Carrà.

May: Van Doesburg's first abstract design for a stained-glass window in Villa Allegonda is followed by similar commissions for a teacher's house in Sint Anthoniepolder and De Lange House in Alkmaar.

May–October: Designs the typeface for *De Stijl*.

31 May: Van Doesburg marries his second wife Helena Milius.

June: Enrico Prampolini publishes the magazine *Noi* in Rome (1917–25).

July–July 1918: Van Doesburg designs tiled floors and colour schemes for De Vonk House in Noordwijkerhout, built by J.J.P. Oud.

August: Announcement of the forthcoming launch of the journal *De Stijl*.

October: The first issue of *De Stijl* comes out in Leiden, edited by van Doesburg. Co-founding members are Piet Mondrian, J.J.P. Oud, Antony Kok, Vilmos Huszár and Bart van der Leck. Jan Wils, Gino Severini and Robert van 't Hoff appear as contributors. Van der Leck withdraws from group shortly after having disagreed over the inclusion of architects as contributors to the journal. The following issues of *De Stijl* would come out on a monthly basis until 1922. Between 1923 and 1926, three issues are published each year. In 1927 only two issues come out and in 1928 a double issue is dedicated to the Aubette building in Strasbourg. Finally, in January 1932, a posthumous issue commemorates van Doesburg, who can be credited with around 40% of the writing in the magazine in its lifetime.

– Bolshevik Revolution in Russia.

December: In a letter to Mondrian, van Doesburg expresses his interest in the fourth dimension.

1918 **July:** Constitution of the Russian Socialist Federative Soviet Republic.

September–December: Van Doesburg contributes colour designs to Jan Wils's construction of the hotel-restaurant De Dubbele Sleutel in Woerden.

15 September–15 October: Exhibits with De Branding in The Hague.

October: Following a visit to De Vonk, Bart de Ligt commissions van Doesburg to design a room in his house.

November: 'First Manifesto of De Stijl' co-signed by Theo van Doesburg, Robert van 't Hoff, Vilmos Huszár, Antony Kok, Piet Mondrian, Georges Vantongerloo and Jan Wils (*De Stijl*, vol.2, no.1).

11 November: The armistice of Compiègne ends the First World War.

3 December: First session of the November Group in Berlin.

1919 Van Doesburg publishes the book *Drie voordrachten over de nieuwe beeldende kunst* (Three Lectures on Neo-Plastic Art) in Amsterdam, and the article 'Van "natuur" tot "kompositie"' (From 'Nature' to 'Composition') in the Dutch magazine *De Hollandsche Revue*.

– Piet Mondrian begins to publish periodical extracts of 'Natural and Abstract Reality' in *De Stijl* (vol.2, no.8).

– Petition to the Dutch government to resume intellectual relations with Russia is endorsed by Theo van Doesburg, Charley Toorop, Vilmos Huszár, Antony Kok, Gerrit Rietveld and Jan Wils, among others.

5 January: Spartacist uprising in Berlin. Ten days later Rosa Luxemburg and Karl Liebknecht are captured and killed by the Freikorps.

March: The Bauhaus opens in Weimar, under the direction of Walter Gropius.

1-22 March: Founding meeting of the Work Council for the Arts in Berlin. Walter Gropius is elected president.

21 March: Béla Kun establishes the Hungarian Soviet Republic.

6-7 April: The Bavarian Soviet Republic is proclaimed in Munich. Hans Richter presides over the Action Committee of the Revolutionary Artists of Munich.

June: Piet Mondrian moves back to Paris.

27 October: General meeting of the International Association of Expressionists, Cubists and Futurists in Berlin, which is later joined by László Moholy-Nagy, Lothar Schreyer, László Péri, Jean Pougny, Erich Buchholz and Ruggero Vasari.

1920 Van Doesburg publishes the book *Klassiek, Barok, Modern* (Classic, Baroque, Modern) in Antwerp based on a lecture given in 1919 in The Netherlands and in

1920 in Antwerp. The following year a French version comes out in Paris.

February: Undertakes first international trips to spread De Stijl ideas. The magazine *Le Geste* (1920), founded by architect Victor Bourgeois, invites van Doesburg to give a lecture in Brussels. Georges Vantongerloo, René Magritte, Pierre-Louis Flouquet, Victor Servranckx and War van Overstraeten are in the audience.

February–March: During a short stay in Paris, van Doesburg attends a Dada performance with Piet Mondrian and visits the Salon des Indépendants. He also views the *Section d'Or* exhibition at Galerie La Boétie, which shows the work of Albert Gleizes, Jean Metzinger, Fernand Léger, Alexander Archipenko, Tour (Marthe) Donas, Louis Marcoussis, Léopold Survage, Georges Braque, František Kupka, Constantin Brancusi, Mikhail Larionov, Natalia Gontcharova, Thorvald Hellesen and Serge Férat, among others. Van Doesburg meets many of these artists as well as art dealer Léonce Rosenberg.

April: Co-signs the 'Second Manifesto of De Stijl: Literature' in Leiden with Piet Mondrian and Antony Kok (*De Stijl*, vol.3, no.6).

15 April: Lajos Kassák prints the ninth issue of *MA* in exile in Vienna.

May: Van Doesburg publishes the poem *X-Beelden* (X-images) under his new pseudonym I.K. Bonset (*De Stijl*, vol.3, no.7).

30 June–25 August: The First International Dada Fair is held in the gallery of Dr Otto Burchard in Berlin.

June–November: Van Doesburg organises a *Section d'Or* exhibition in Rotterdam (20 June–4 July), The Hague (11 July–1 August), Arnhem (August–September) and Amsterdam (23 October–7 November), adding works by himself, Vilmos Huszár and Piet Mondrian to a shortened version of the French selection. At the opening of the exhibition in The Hague van Doesburg meets Nelly van Moorsel (later his third wife).

July: Two new modern art magazines come out: *Bleu* in Mantua (1920–1), edited by Gino Cantarelli and Aldo Fiozzi, whose first issue features the article 'Monumental Art' by van Doesburg; and *L'Esprit nouveau* in Paris (1920–5), directed by Paul Dermée, Amédée Ozenfant and Le Corbusier.

December: Léonce Rosenberg proposes a De Stijl exhibition based around a design for an ideal house.

4 December 1920–August 1921: The touring exhibition *Young Dutch Art* begins in Berlin, and continues through Leipzig, Hanover, Hamburg and Dusseldorf, with works by Piet Mondrian, Vilmos Huszár, Theo van Doesburg and other artists.

18 December 1920–3 January 1921: Van Doesburg travels to Berlin where he meets Adolf Behne, Bruno Taut, Walter Gropius, Adolf Meyer and Alfréd Forbát. At Behne's soiree he meets Hans Richter, Viking Eggeling and Raoul Hausmann. Travels with Richter and Eggeling to Richter's parents' estate at Klein Kölzig (24–6 December) and visits the Bauhaus in Weimar (30 December 1920–2 January 1921) where he meets Georg Muche, Johannes Itten and Lyonel Feininger.

26 December 1920–25 January 1921: As the Dutch representative, van Doesburg participates in the *International Exhibition of Modern Art* in Geneva, where over 3000 works from twenty-four countries are shown. From there, his artworks were sent to Enrico Prampolini for his *Section d'Or* exhibition in Rome in April 1921.

1921 Van Doesburg further develops his theories about colour in architecture.

El Lissitzky is appointed director of the Vkhutemas School of Architecture in Moscow.

January: *De Stijl* is published with a new format and cover design.

February: The journal *Zenit* comes out in Zagreb (1921–2) edited by Ljubomir Micic.

March: Ilya Ehrenburg leaves Moscow arriving in Paris on 8 May, stays for a few months in Brussels and settles in Berlin in November. He publishes the article 'L'Art russe' (Russian Art) in *L'Amour de l'art*, and contacts van Doesburg to request images for his book *A vse taki ona vertitsa* (And Yet the World Goes Round). In exchange, he sends van Doesburg photos of Russian avant-garde works.

17 March–28 April: Theo van Doesburg and Nelly van Moorsel leave The Netherlands and embark on a long European trip through Belgium (Antwerp and Brussels, where he gives a lecture), France (in Paris they meet Tristan Tzara, Georges Ribemont-Dessaignes and Jean Crotti among others, and in Menton they stay with Vantongerloo), Italy (in Milan they meet Filippo Tommaso Marinetti and Carlo Carrà), Switzerland, Austria and Germany.

April: László Moholy-Nagy becomes the Berlin correspondent for the Vienna-based journal *MA*.

17 April–2 May: The *Section d'Or* exhibition is held in Rome curated by Enrico Prampolini, who adds works by Theo van Doesburg, Giacomo Balla and himself to the original French selection.

28 April: Theo and Nelly settle in Weimar, where they meet Bauhaus students Karl Peter Röhl, Werner Graeff, Marcel Breuer and Max Burchartz.

June: *De Stijl* is published from Weimar. Van Doesburg publishes the first part of his 'anti-philosophical' Dadaist essay 'Caminoscopie' using the pseudonym of Aldo Camini (*De Stijl*, vol.4, no.5).

June–July: Poetry recitals and lectures by Kurt Schwitters in Dresden, Erfurt, Leipzig, Jena and Weimar, where he most probably meets van Doesburg for the first time in the company of Hans Arp. Schwitters's first publication of poems in *De Stijl* (vol.4, no.7). Michel Seuphor starts the periodical *Het overzicht* (1921–5) in Antwerp.

August: Publication of the third De Stijl manifesto, 'Towards a New Formation of the World' (*De Stijl*, vol.4, no.8).

October: On the invitation of Jozef Peeters, van Doesburg gives a lecture in Antwerp. 'The Call to Elementary Art', co-signed by Raoul Hausmann, Hans Arp, Jean Pougny, and László Moholy-Nagy in Berlin, is published in *De Stijl* (vol.4, no.10).

November: Harold Loeb and Alfred Kreymborg found the magazine *Broom* (1921–4) in Rome.

December: Nelly van Moorsel gives a concert in Vienna. As a guest in the house of Alma Mahler, widow of Gustav Mahler and ex-wife of Walter Gropius, Nelly meets the composers Alban Berg, Anton Webern, Béla Bartók, Vittorio Rieti and Josef Mattias Hauer.

End of the year: El Lisstizky leaves Russia and settles in Berlin, where he befriends Ilja Ehrenburg. He also meets Theo van Doesburg and begins association with De Stijl.

1922 The architectural journal *Stavba* (1922–38) comes out in Prague, co-directed by Karel Teige, J. Mark and O. Starý.

January: Konstantin Medunezki and Georgy and Wladimir Stenberg exhibit their work in Moscow in an exhibition titled *Constructivism*. It is the first time this concept is used in art.

February: Van Doesburg publishes the article 'Der Wille zum Stil' (The Will to Style) in *De Stijl* (vol.5, no.2), presented as a lecture in Jena in March, then in Weimar and Berlin.

– Moholy-Nagy and Péri exhibit in Der Sturm gallery in Berlin.

– The first issue of the Dada magazine *Mécano* (1922–4) is published by I.K. Bonset (Theo van Doesburg) in Weimar, including the 'Manifesto Against Art and Pure Reason', signed by I.K. Bonset. *Mécano* would publish contributions by the likes of Tristan Tzara, Raoul Hausmann, Karl Peter Röhl, László Moholy-Nagy, Kurt Schwitters, Hans Arp, Man Ray, Georges Ribemont-Dessaignes, Serge Charchoune, Piet Mondrian, Cornelis van Eesteren, Jean Crotti, Georges Vantongerloo, Francis Picabia, Max Ernst and Tour (Marthe) Donas.

February–March: A Constructivist group gathers in the studio of Gert Caden in Berlin, including Hans Richter, El Lissitzky, Naum Gabo, Theo van Doesburg, Nathan Altmann, Antoine Pevsner, Alfréd Kemény, László Moholy-Nagy, László Péri, Ernö Kállai, Hans Arp, Fritz Baumeister, Viking Eggeling, Werner Graeff, and Ludwig Mies van der Rohe.

March–April: The magazine *Veshch* (1922) comes out in Berlin, edited by El Lissitzky and Ilja Ehrenburg. It features van Doesburg's article 'Monumental Art'.

8 March–July: In the studio of Karl Peter Röhl in Weimar, van Doesburg teaches his independent course *Stijl Kurs I* to the Bauhaus students Werner Graeff, Andor Weininger, Max Burchartz, Farkas Molnár, Hans Vogel, Egon Engelien, Kurt Schmidt, Nini Smith and others.

End of March: The invitation spreads for the International Congress of Progressive Artists and for the *First International Art Exhibition* in Dusseldorf.

16 April: A treaty between Germany and Russia restores diplomatic relations and ends Russia's political isolation.

May: V*eshch* no.3 is the second and last issue of the magazine.

4 May: Van Doesburg meets Cornelis van Eesteren, a Dutch architecture student, on a tour of Germany and visiting the Bauhaus.

28 May–3 July: The *First International Art Exhibition* is held in the Kaufhaus Tietz in Dusseldorf.

29–31 May: The International Congress of Progressive Artists takes place in Dusseldorf. Among the attendees are van Doesburg, El Lissitzky, Werner Graeff, Franz Seiwert, Viking Eggeling, Cornelis van Eesteren, Enrico Prampolini, Jean Pougny, Raoul Hausmann, Hans Richter, Otto Dix and Tomoyoshi Murayama. Van Doesburg calls for the development of a universal means of expression and advocates the communion of art and life. Co-signs with El Lissitzky and Hans Richter the 'Declaration of the International Group of Constructivists on the First International Congress of the Progressive Artists' (*De Stijl*, vol.5, no.4).

August: Van Doesburg co-signs the manifesto 'K.I: International Union of Neoplasticist Constructivists' with Hans Richter, El Lissitzky, Karel Maes and Max Burchartz (*De Stijl*, vol.5, no.8). Huszár visits Weimar and first discussion of a Dada tour of the Netherlands takes place.

25 September: The Congress of Constructivists and Dadaists is held in the Hotel Fürstenhof in Weimar, hosted by van Doesburg and attended by Tristan Tzara, Hans Arp, Nelly van Moorsel, Kurt Schwitters, El Lissitzky, Lucia and László Moholy-Nagy, Hans Richter, Hannah Höch, Cornelis van Eesteren, Karel Maes, Alfred Kemény, Werner Graeff, Karl Peter Röhl, Max Burchartz, Nini Smith, Harry Scheibe, Bernhard Sturtzkopf and Hans Vogel.

27 September: Dada soiree in the Kunstverein Jena, whose director is Walter Dexel.

29 September: Dada soiree at the Van Garvens Gallery in Hanover, with van Doesburg, Nelly van Moorsel, Tristan Tzara, Kurt Schwitters, Hans Arp, Walter Dexel, Lucia and László Moholy-Nagy, Max Burchartz and El Lissitzky.

30 September: *Dada-Revon* event at the Van Garvens Gallery in Hanover, with Kurt Schwitters, Hans Arp, Nelly van Moorsel and Theo van Doesburg.

October: The *First Russian Art Exhibition* is born, held at the Van Diemen Gallery, presents the art of Wassily Kandinsky, Marc Chagall, Kazimir Malevich, Alexander Rodchenko, El Lissitzky, Vladimir Tatlin, Naum Gabo and Nathan Altmann.

27 October: Fascist March over Rome commanded by Benito Mussolini.

December: László Moholy-Nagy and Alfréd Kemény publish the manifesto 'Dynamic Constructive Craft Systems' in the journal *Der Sturm*.

4 December: Theo and Nelly visit the Netherlands.

31 December: The German Mark collapses: 1 Dollar = 7,500 Marks.

End of the year: In Weimar, Farkas Molnár, Alfréd Forbát, Peter Keler, Kurt Schmidt, Andor Weininger and other Bauhaus students constitute the KURI group, close to the aesthetic position of De Stijl. The 'KURI Manifesto' is published in the magazine *UT*.

1923 Van Doesburg publishes the book *Wat is Dada???* in The Hague.

– Jean Badovici founds the journal *L'Architecture Vivante* (1923–33) in Paris, and Hans Richter starts the magazine *G* (1923–6) in Berlin.

– Van Doesburg starts a collaboration with Cornelis van Eesteren on the design of three architectural models for Léonce Rosenberg's commision of a *Maison Particulière*. The dynamic quality of the designs, using coloured planes to articulate space, reflects van Doesburg's value of time in architecture.

January: The first issue of the magazine *Merz* (1923–32) is edited by Kurt Schwitters in Hanover under the title *Merz 1. Holland Dada*.

– El Lissitzky solo exhibition at the Kestner-Gesellschaft in Hanover.

10 January: The Dada tour in Holland begins, with Nelly van Moorsel, van Doesburg, Kurt Schwitters and Vilmos Huszár, and travels to different Dutch cities in the following months.

16 January: Van Doesburg divorces Lena Milius.

31 March: László Moholy-Nagy appointed professor at the Bauhaus, teaching the preliminary course after the departure of Johannes Itten.

April: Van Doesburg meets Frederick Kiesler in Berlin through his friend Hans Richter.

– The 'Manifesto of Proletarian Art' appears in *Merz* (no.2), signed by van Doesburg, Kurt Schwitters, Hans Arp, Tristan Tzara and Christof Spengemann.

May: Theo and Nelly move to Paris and settle in 51 rue du Moulin Vert. They come into contact with composers Arthur Honegger and George Antheil.

19 May–17 September: The November Group section of the *Greater Berlin Art Exhibition* features works by van Doesburg, César Domela, Egon Engelien, Max Burchartz, Walter Dexel, Werner Graeff, Karl Peter Röhl and others. El Lissitzky presents his *Proun Room*

7 July: The Dada soiree *Coeur à barbe* at the Theatre Michel in Paris, attended by Theo and Nelly, ends in a dispute between André Breton and Tristan Tzara.

4 August: One Dollar = 1,000,000 Marks.

15 August–30 September: *Large Bauhaus Exhibition* in Weimar.

Autumn: Vilmos Huszár and Gerrit Rietveld design an exhibition room for the planned, but later cancelled, *Juryfree Art Exhibition* in Berlin.

15 October–15 November: De Stijl architecture exhibition at Léonce Rosenberg's Galerie de l'Effort Moderne in Paris. Van Doesburg and Cornelis van Eesteren present the drawings and models for *Maison Particulière*. It also showcases the work of Vilmos Huszár, Van Leusden, J.J.P. Oud, Gerrit Rietveld, Jan Wils and Ludwig Mies van der Rohe.

16 December 1923–23 January 1924: Van Doesburg has a solo exhibition at the Landesmuseum in Weimar.

1924 Marcel Janco founds the magazine *Contimporanul* (1924–32) in Bucarest. *Bulletin de l'Effort Moderne* (1924–7) is published by Léonce Rosenberg in Paris.

– Gerrit Rietveld and Truus Schröder-Schräder collaborate on the design and construction of the Schröder House in Utrecht, the first house built according to De Stijl principles.

– César Domela meets van Doesburg and Mondrian and becomes member of De Stijl.

21 January: Vladimir Ilyich Uliyanov, Lenin, dies in Moscow.

9 February: Hans Arp, Sophie Taeuber-Arp and Mart Stam welcome El Lissitzky to Zurich. He starts a long stay in a sanatorium in Davos to treat his tuberculosis.

March: Van Doesburg is estranged from Piet Mondrian due to intellectual and artistic divergencies.

– Mieczysław Szczuka and Teresa Żarnower start the journal *Blok* in Warsaw (1924–6). A. Černik is the editor of *Pasmo* in Brno (1924–6).

14 March: Henryk Berlewi exhibits in the Austro Daimler Auto Salon in Warsaw.

22 March–30 April: Robert Mallet-Stevens arranges re-display of the De Stijl exhibition at L'Ecole Spéciale d'Architecture in Paris.

April: Van Doesburg has a solo exhibition at the Kestner-Gesellschaft in Hanover.

May: Exhibition of the K group at the Kestner-Gesellschaft in Hanover, with Hans Nitzschke and Friedrich Vordemberge-Gildewart, amongst others.

24 September–12 October: Frederick Kiesler organises and designs the *International Exhibition of New Theatre Techniques* in Vienna.

October: Van Doesburg lectures in Vienna and Prague.

– Kurt Schwitters has joint exhibition with Hans Arp and Alexej Jawlensky at the Kestner-Gesellschaft in Hanover.

– Van Doesburg begins writing architectural criticism for the journal *Het Bouwbedrijf*.

November: Van Doesburg and van Eesteren publish the fifth manifesto of De Stijl 'Vers une construction collective' (Towards a Collective Construction) dated Paris 1923 (*Bulletin de l'Effort Moderne* no.9).

26 December: The Bauhaus closes in Weimar for economic and political reasons.

End of the year: Van Doesburg begins introducing the diagonal into his paintings, subsequently giving them the title *Counter-Compositions*. His practice of Elementarism implies a definite break with Neoplasticism.

1925 Van Doesburg's *Grundbegriffe der neuen gestaltenden Kunst* (Principles of Neo-Plastic Art) is published in the Bauhaus Books collection in Munich.

– With Kurt Schwitters and Käte Steinitz, van Doesburg co-authors the children's book *Die Scheuche* (The Scarecrow) in Hanover.

– Piet Mondrian publishes *Neue Gestaltung: Neoplastizismus Nieuwe Beelding* (Neoplasticism) in the Bauhaus Books collection.

– El Lissitzky and Hans Arp are editors of the publication *Die Kunstismen* in Zurich.

January: Nelly van Moorsel gives a concert in Der Quader Gallery in Hanover.

– Van Doesburg meets Friedrich Vordemberge-Gildewart in Hanover.

14 February: Joint recital evening of Kurt Schwitters and Nelly van Doesburg in Postdam, where he delivers the first performance of the *Ursonate*.

March: Retrospective of van Doesburg's work in Der Quader Gallery in Hanover.

March–April: Work by van Doesburg is shown in a group exhibition at The Little Review Gallery in New York.

May: In Berlin, the film matinee *Der Absolute Film* screens works by Walter Ruttmann, Hans Richter, Ludwig Hirschfeld Mack, Viking Eggeling, René Clair, Fernand Léger and Dudley Murphy.

13 June: El Lissitzky is denied with a visa permit and returns to Russia.

July: Theo van Doesburg and László Moholy-Nagy together visit the *International Exhibition of Modern Decorative and Industrial Arts* in Paris, which had rejected a De Stijl pavilion. Kiesler presents the model for *City in Space* in the Austrian pavilion and Le Corbusier *Le Pavillon de l'Esprit Nouveau*. Konstantin Melnikov builds the Russian pavilion. Van Doesburg and other representatives of the European avant-garde co-sign the 'Call for protest against the refusal of the participation of the De Stijl group in the Exhibition of Decorative Arts' (*De Stijl*, vol.6, nos.10–11).

September: Kurt Schwitters becomes subscriptions agent for *De Stijl* in Germany.

14 October: The Bauhaus reopens in Dessau.

30 November–21 December: Group exhibition *L'Art d'Aujourd'hui*, the first international non-figurative art exhibition held in Paris since the end of the war, with an important participation of De Stijl and German artists. The Vicomte de Noailles commissions Theo van Doesburg to design a mural decoration for a room in his summer villa in Hyères, built by Robert Mallet-Stevens.

1926 **12-31 March:** De Stijl participates in the *Tenth Annual Exhibition* at Galeries Poirel in Nancy.

July: Two manifesto fragments on Elementarism are featured in *De Stijl*, signed from Rome in July (*De Stijl*, vol.7, nos.75–6) and from Paris in December (*De Stijl*, vol.7, no.78).

June: The journal *Praesens* (1926–30) comes out in Warsaw edited by Henryk Stazewski.

June–July: Vacation tour in Italy, where van Doesburg meets Filippo Tommaso Marinetti, Enrico Prampolini, Ivo Pannaggi, Giacomo Balla and Ruggero Vasari.

26 September: Van Doesburg, Hans Arp and Sophie Taeuber-Arp begin collaboration for the interior renovation of the Café Aubette, an entertainment complex in Strasbourg. This project provides van Doesburg with the opportunity to apply De Stijl principles to all aspects of design, from space to typography.

Late Autumn: Sidney Hunt publishes the periodical *Ray* in London (1926–7), whose second issue will feature van Doesburg's article 'The Progress of the Modern Movement in Holland'.

1927 Van Doesburg prepares a ten-year anniversary issue of *De Stijl* celebrating the achievements of the group over the previous decade.
– Architectural renovation continues at the Café Aubette building with Hans Arp and Sophie Taeuber-Arp. Also in Strasbourg, van Doesburg undertakes the reconstruction of the Meyer House.
– El Lisstizky arranges the Abstract Cabinet at the Provinzialmuseum Hanover, including one work by van Doesburg.
– Sándor Bortnyik founds the Mühely Academy in Budapest, regarded as the Hungarian Bauhaus.
– Eugene Jolas founds the literary journal *transition* in Paris (1927–38).

May: Using money left to her after her father's death in 1924, Nelly van Doesburg buys land in Clamart with the intention of building a double house for the van Doesburgs and the Arps.

13 May: Black Friday: the German economic system collapses, threatening to expand into a general European economic crisis.

22 May–12 June: Van Doesburg participates in the *New Advertising* exhibition at the Artists Society in Jena.

June: Schwitters becomes president of the Circle of New Advertising Designers, including Willi Baumeister, Walter Dexel, César Domela, Max Burchartz and others.

October: Karel Teige publishes the magazine *Red* in Prague (1927–31).
– Van Doesburg visits Werkbund exhibition *The Dwelling* in Stuttgart.

1928 **16 February:** The Café Aubette opens in Strasbourg. The last issue of *De Stijl* is dedicated to the Aubette building.

28 June: Le Corbusier, Gerrit Rietveld, Sigfried Giedion, Mart Stam, Alberto Sartoris and Hannes Meyer, among others, co-sign the Declaration of La Sarraz in Switzerland, whose castle hosts the First International Congress of Modern Architecture (CIAM).

July: Van Doesburg moves to studio in Villa Corot, 2 rue d'Arcueil, Paris.

24 November: Van Doesburg marries Nelly van Moorsel.

1929 After selling the land in Clamart to the Arps, Nelly buys a new plot. In collaboration with the architect Abraham Elzas, van Doesburg designs and builds his house with studio in Meudon-Val-Fleury, which is finished the following year.
– Frederick Kiesler builds the Film Guild Cinema in New York.

Van Doesburg meets Joaquín Torres-García in Paris and renews friendship with Piet Mondrian.

18 May–17 June: The exhibition *Film and Photo* takes place at the Staatsgalerie Stuttgart.

3-19 August: The *Special Exhibition of New Typography* is held in Magdeburg, organised by the Circle of New Advertising Designers, including the work of Willi Baumeister, Max Burchartz, Walter Dexel, César Domela, Hannes Meyer, Paul Schuitema, Kurt Schwitters, Jan Tschichold, Friedrich Vordemberge-Gildewart, Walmar Shwab and guest artists Theo van Doesburg, Herbert Bayer, John Heartfield, Lajos Kassák, László Moholy-Nagy and others.

October 1929–January 1930: Nelly van Doesburg organises the *Select Exhibitions of Contemporary Art* (ESAC) at Stedelijk Museum, Amsterdam (2 October–November) and at Pulchri Studio in The Hague (10 December–5 January), exhibiting works by van Doesburg, Cupera (Nelly van Doesburg), Hans Arp, Marcelle Cahn, Massimo Campigli, Serge Charchoune, Pierre Daura, Serge Férat, Engel Rozier, Otto Freundlich, Luis Fernández, Joaquín Torres-García, Jean Crotti, František Kupka, Joan Miró, Piet Mondrian, Vicente do Rego Monteiro, Pablo Picasso, Gino Severini, Léopold Survage, Léon Tutundjian, Walmar Shwab, Jacques Villon, Hannah Kosnick-Kloss and Pan Planas. The exhibition travels to Barcelona in 1930.

6 October–3 November: Van Doesburg participates in the *Abstract and Surrealist Painting and Sculpture* exhibition at the Kunsthaus Zurich.

24-9 October: Stock market crash in Wall Street leads to a worldwide recession.

26 October–25 November: Otto Carlsund, Auguste Herbin, Léon Tutundjian and Theo van Doesburg exhibit in the first Salon des Surindépendants, Paris.

31 October–15 November: Van Doesburg shows his work in a group exhibition at Galerías Dalmau, Barcelona.

21 December: Meeting at the Café Zeyer in Paris of van Doesburg, Otto Carlsund, Luis Fernández, Jean Hélion, Antoine Pevsner, Marcel Wantz and Léon Tutundjian.

1930 **March:** Michel Seuphor and Joaquín Torres-García set up the Cercle et Carré association and magazine in Paris.

April: Foundation of the Art Concret group in Paris, whose members van Doesburg, Otto Carlsund, Jean Hélion, Léon Tutundjian and Marcel Wantz publish the first and only issue of the magazine *Art Concret*, and sign the manifesto 'Base de la peinture concrete' (Basis of Concrete Painting).

April–May: Cercle et Carré exhibition at Galerie 23 in Paris.

May: Van Doesburg lectures on architecture in Madrid and Barcelona.

August: The *International Exhibition of Post-Cubist Art* in Stockholm is curated by Otto Carlsund with a similar selection to the *Select Exhibitions of Contemporary Art*, but including more Swedish avant-garde artists.

8 October–15 November: Works by van Doesburg are also shown in the exhibition *Production Paris 1930* at the Kunstsalon Wolfsberg in Zurich, curated by Hans Arp and Sigfried Giedion.

15 October: Theo and Nelly van Doesburg attend a performance of Cirque Calder in Paris.

December: House in Meudon ready to move into after long delays and problems with its construction in the new material, 'solomite'.

1931 The *International Exhibition of New Art* at the Łódź Museum collects contributions among the international artists living in Paris and in Poland to create an avant-garde art collection for the proletarian class in Łódź.

12 February: The Abstraction-Création group of non-figurative artists is formed in Paris, with Auguste Herbin as president, van Doesburg as vice-president and Jean Hélion as treasurer. Hans Arp, Léon Tutundjian, Albert Gleizes, František Kupka and Georges Valmier make up the group committee.

7 March: Theo van Doesburg dies of a heart attack following a bout of asthma in Davos, Switzerland.

11-30 June: The *1940 First Exhibition* at Galerie de la Renaissance in Paris curated by Auguste Herbin exhibits most of the non-figurative artists, including van Doesburg.

1932 **January:** A special issue of *De Stijl* comes out to commemorate van Doesburg's life and work.

15 January–1 February: The *1940 Second Exhibition* at Parc des Expositions and Porte de Versailles in Paris also holds a van Doesburg retrospective, with fifty-nine works on show.

Artists' pseudonyms are listed alphabetically, i.e. works created by van Doesburg as I.K. Bonset are under B rather than D.

Measurements are in centimeters, height before width and depth.

* indicates London only
^ indicates Leiden only

ARCHIPENKO, ALEXANDER
1887–1964

^ Flat Torso 1914
Bronze 39.1 x 9 x 4.3
Foundation Wilhelm Lehmbruck Museum – Center of International Sculpture, Duisburg

Woman Combing her Hair 1915
Bronze, 35.6 x 8.6 x 8.3
Tate. Purchased 1960
no.77

Striding Man 1917
Ink on paper, 27.5 x 17.5
Kröller-Müller Museum, Otterlo, The Netherlands

ARP, HANS (JEAN) 1886–1966

The Eggboard c.1922
Painted wood, 76.2 x 96.5 x 5
Private collection
no.81

* Serigraphy based on a fresco of the Dancing Horse from the Café Aubette c.1950
Coloured serigraphy on paper, 26 x 52.8
Musée d'art moderne et contemporain de Strasbourg

ARP, HANS 1886–1966
TAEUBER-ARP, SOPHIE
1889–1943

Composition l'Aubette (Recreation on cardboard by Jean Arp from a drawing by Sophie Taeuber Arp) c.1927–8
Painted cardboard on pavatex, 54.5 x 70.5
Musée d'art moderne et contemporain de Strasbourg
no.159

BARANOFF-ROSSINÉ, WLADIMIR 1888–1944

^ Study for 'Symphony No. 9' 1913
Gouache and watercolour on paper, 65 x 49.5 cm
Kröller-Müller Museum, Otterlo, The Netherlands

BAYER, HERBERT 1900–1985

Design for Illuminated Roof Sign, Glass painter Kraus 1923
Pencil, ink, gouache on pasted paper, 28.5 x 21.2
Collection Merrill C. Berman

Design for Illuminated Roof Sign c.1923
Pencil, ink, gouache on paper, 22.4 x 15.9
Collection Merrill C. Berman

BERLEWI, HENRYK 1894–1967

^ Mechano-Faktura 1924–c.1960
Lithograph, 98 x 81
Private Collection

Mechano-Faktura 1924
Gouache on paper on canvas, 100 x 73
Kunstmuseen Krefeld
no.111

Mechano-Faktura. Contrasting Elements 1924
Gouache on paper, 83 x 109
Courtesy Galerie Natalie Seroussi
fig.34

BONSET, I.K. (THEO VAN DOESBURG) 1883–1931

Construction I c.1920–5
Collage and ink on paper, 31 x 15.5
Kunsthaus Zürich, Graphic Collection

Composition c.1921–5
Collage of printed matter on paper, 32.7 x 32
Kröller-Müller Museum, Otterlo, The Netherlands, van Moorsel donation to the Dutch State 1981
no.84

Composition (Frans Ernst's City Sport Stores) c.1921–5
Photographic collage on silver cardboard, 9.6 x 14
Kröller-Müller Museum, Otterlo, The Netherlands, van Moorsel donation to the Dutch State 1981

Reconstruction c.1921–5
Collage of printed matter on paper, 29.5 x 21
Kröller-Müller Museum, Otterlo, The Netherlands, van Moorsel donation to the Dutch State 1981
no.85

* La Matière dénaturalisée. Déstruction 2. c.1923
Denaturalized material. Destruction 2.
Collage, ink and gouache on card 59.5 x 44
Fries Museum Leeuwarden, Netherlands (on loan from Netherlands Institute for Cultural Heritage)
fig.15

BORTNYIK, SÁNDOR 1893–1976

Satire on De Stijl 1924
Photograph, pencil and gouache on paper, 45 x 82
Kröller-Müller Museum, Otterlo, The Netherlands, van Moorsel donation to the Dutch State 1981
fig.14

Geometric Forms in Space 1924
Oil on canvas, 54 x 74
Private collection
no.96

The New Adam 1924
Oil on canvas, 48 x 38
Hungarian National Gallery, Budapest
fig.38

BRANCUSI, CONSTANTIN
1876–1957

Danaïde c.1918
Bronze on limestone base, 27.9 x 17.1 x 21
Tate. Presented by Sir Charles Clore 1959
no.76

BREUER, MARCEL 1902–1981

Armchair 1922
Cherrywood and fabric
96.7 x 57.6 x 56
Klassik Stiftung Weimar Museums, Inv. Nr.N228/55
no.62

BUCHHOLZ, ERICH 1891–1972

^ Platte 1921
Oil on wood, 32.5 x 22.5 x 2.5
Museum Abteiberg Mönchengladbach; on loan from the Mönchengladbacher Sparkassenstiftung

^ Circle of Rising 1922
Painted wood, 56 x 36 x 4
Foundation Wilhelm Lehmbruck Museum – Center of International Sculpture, Duisburg

BURCHARTZ, MAX 1887–1961

Geometric Composition 1923
Gouache on cardboard, 45.8 x 31
Wilhelm Hack Museum, Ludwigshafen am Rhein
no.106

Red Square c.1928
Collage of gouache, halftone, photograph and printed logo, 51.8 x 35.2
Collection Merrill C. Berman

CARLSUND, OTTO 1897–1948

Sequence of Tones 1929
Oil on canvas, 78 x 78.5
Collection Kent Belenius, Stockholm
no.142

First Programme Picture. Six Announcements for Art Concret 1930
Oil on panel, 33 x 33
Eskilstuna Art Museum, Sweden

Second Programme Picture. Six Announcements for Art Concret 1930
Oil on panel, 33 x 33
Eskilstuna Art Museum, Sweden
no.181

Third Programme Picture. Six Announcements for Art Concret 1930
Oil on panel, 33 x 33
Eskilstuna Art Museum, Sweden

Fourth Programme Picture. Six Announcements for Art Concret 1930
Oil on panel, 33 x 33
Eskilstuna Art Museum, Sweden
no.187

CHARCHOUNE, SERGE
1888–1975

Bibi c.1921
Chinese ink and pencil on beige paper, 20.9 x 26.9
Centre Pompidou, Paris. Musée national d'art moderne/Centre de création industrielle. Gift of d'Henri Goetz 1981
no.75

CROTTI, JEAN 1878–1958

O=T 1918
Oil on cardboard, 24 x 18
Musée d'art moderne de la Ville de Paris

Portrait of Edison 1920
Gouache, watercolour and pencil on paper 48.9 x 64.5
Tate. Purchased 1978
no.139

Sentimental Poetry 1920
Gouache and ink on paper, 53.6 x 44.1
Courtesy Galerie Natalie Seroussi

Motor and Laboratory of Ideas 1921
Watercolour on paper, 44 x 54
Musée d'art moderne de la Ville de Paris
no.80

CUPERA (NELLY VAN DOESBURG) 1899–1975

Little White Jar 1929
Oil on canvas, 27 x 35
Private collection
no.166

DE SAGA, PIETRO (STEPHANIE KIESLER)
1897–1963

* Typo-Plastic 1925–30
Black and red typewriter ink, 27 x 21
Yale University Art Gallery. Gift of Collection Société Anonyme

DEXEL, WALTER 1890–1973

* Composition 1923 XXI 1923
Pencil and gouache on grey cardboard, 36.5 x 30.3
Staatsgalerie Stuttgart, Graphic Collection

* Composition 1924
Oil on canvas, 55.5 x 47.5
Hamburger Kunsthalle
no.99

Design for Cigars, Cigarettes advertising
clock, Germany 1927
Ink, gouache and pencil, 35.5 x 25.4
Collection Merrill C. Berman

Poster for Contemporary Photography
Exhibition, Magdeburg 1929
Linocut, 83.8 x 59.4
Collection Merrill C. Berman

Design for signage 1926–8
Gouache over photograph, 22.1 x 15.9
Collection Merrill C. Berman

DOESBURG, THEO VAN
1883–1931

^ Dune Landscape c.1912
Oil on canvas on panel, 32 x 24
Stedelijk Museum De Lakenhal, Leiden

Girl with Buttercups 1914
Oil on canvas, 80 x 80
Centraal Museum, Utrecht
no.1

Composition 1915
Pastel on black paper, 32 x 24
Centraal Museum, Utrecht (on loan
from the Netherlands Institute of Cultural
Heritage. Gift van Moorsel)
no.4

* Composition 1915
Pastel on black paper, 23.5 x 32
Centraal Museum, Utrecht (on loan
from the Netherlands Institute of Cultural
Heritage. Gift van Moorsel)

* Composition 1915
Pastel on black paper, 31.5 x 24
Centraal Museum, Utrecht (on loan
from the Netherlands Institute of Cultural
Heritage. Gift van Moorsel)

* Composition 1915
Pastel on black paper, 23.5 x 30
Centraal Museum, Utrecht (on loan
from the Netherlands Institute of Cultural
Heritage. Gift van Moorsel)

* Landscape 1915
Pastel on paper, 25.5 x 35.5
Centraal Museum, Utrecht (on loan
from the Netherlands Institute of Cultural
Heritage. Gift van Moorsel)

Autumn 1915
Pastel on paper, 24 x 32
Private collection

Cosmic Sun 1915
Pencil and pastel on paper, 24 x 32
Private collection
no.3

Mouvement héroïque 1916
Heroic Movement
Oil on canvas, 136 x 110.5
Centraal Museum, Utrecht (on loan
from the Netherlands Institute of Cultural
Heritage. Gift van Moorsel)
no.5

Composition I (Still Life) 1916
Oil on canvas, 67 x 63.3
Kröller-Müller Museum, Otterlo,
The Netherlands
no.7

* Composition II (Still Life) 1916
Oil on canvas, 45 x 32
Museo Thyssen-Bornemisza, Madrid
no.8

Composition III (Still Life) 1916
Oil on canvas, 53 x 39
Curtis Galleries, Minneapolis, MN
no.6

Tree 1916
Oil on panel, 68.5 x 54
Portland Art Museum, Oregon.
Gift of Mr and Mrs Jan de Graaff
no.9

Sphere c.1916
Oil on canvas on panel, 27 x 37
Stedelijk Museum De Lakenhal, Leiden
no.2

* Still Life (Composition V) 1916–17
Oil on canvas, 31 x 36
Georges Jollès Collection

^ Composition I 1916–17
Stained glass, 101 x 67.5
Stedelijk Museum De Lakenhal, Leiden
(with support of the Society of Friends
of De Lakenhal and the Rembrandt
Society with help of the Prins Bernhard
Cultuurfonds)

Colour design for Dance II 1917
Pencil, ink and gouache on paper,
55.5 x 29.5
Kröller-Müller Museum, Otterlo,
The Netherlands, van Moorsel donation
to the Dutch State 1981

Stained-Glass Composition: Female Head
1917
Stained glass, 39 x 26
Kröller-Müller Museum, Otterlo,
The Netherlands, van Moorsel donation
to the Dutch State 1981
no.11

Composition IX, Opus 18: 'Decomposition'
of The Card Players 1917
Oil on canvas, 116 x 106.5
Collection Gemeentemuseum Den Haag
The Hague, The Netherlands
no.12

* Composition (Design for Stained-Glass
Composition: Female Head) 1917
Gouache on paper, 36.5 x 23.5
Szépművészeti Múzeum, Budapest
fig.36

* Female Nude with Hand on Her Head 1917
East Indian ink on paper, 23 x 16
Rijksmuseum, Amsterdam

Stained-Glass Composition III: Teacher's
house in Sint Anthoniepolder, municipality
of Maasdam 1917
Stained glass, 40 x 40
Stedelijk Museum De Lakenhal, Leiden
(on loan from the Netherlands Institute
for Cultural Heritage. Gift van Moorsel)
no.21

Dance I 1917
Stained glass, 57.4 x 37.4 x 3
Kröller-Müller Museum, Otterlo,
The Netherlands, van Moorsel donation
to the Dutch State 1981
no.10

Stained-Glass Composition IV for the
De Lange House, Alkmaar 1917
Stained-glass window in three parts,
each 286.5 x 56.6
Kröller-Müller Museum, Otterlo,
The Netherlands
no.20

^ Four skylights for the back door of
the house of Mayor W. de Geus, Broek in
Waterland 1917
Stained glass in four parts, each 30 x 22
Stedelijk Museum De Lakenhal, Leiden
(on loan from the Netherlands Institute
of Cultural Heritage. Gift van Moorsel)

^ Portrait of J.J.P. Oud c.1917
East Indian ink on paper, 23.5 x 17.5
Stedelijk Museum De Lakenhal, Leiden
(on loan from the Netherlands Institute
of Cultural Heritage. Gift van Moorsel)

^ Portrait of J.J.P. Oud c.1917
Ink and colour pencil on paper, 21.5 x 15.5
Stedelijk Museum De Lakenhal, Leiden
(on loan from the Netherlands Institute
of Cultural Heritage. Gift Van Moorsel)

Composition (The Cow) c.1917
Gouache, oil, and charcoal on paper,
39.7 x 55.7
The Museum of Modern Art, New York.
Purchased 1948
no.15

Composition (The Cow) c.1917
Pencil on paper, 11.7 x 15.9
The Museum of Modern Art, New York.
Purchased 1948

Colour design for Stained-Glass
Composition V c.1917–18
Ink and gouache on paper, 85.5 x 50
Kunsthaus Zürich, Association of Zürich
Friends of Art

Design for a tiled floor, De Vonk holiday
home, Noordwijkerhout c.1917–18
Gouache on graph paper and two plans
in blueprint on hardboard, 98 x 73.5
Stedelijk Museum De Lakenhal, Leiden
(on loan from the Netherlands Institute
for Cultural Heritage. Gift van Moorsel)
no.53

Composition, design for tiled floor, De Vonk
holiday home, Noordwijkerhout c.1917–18
Oil on eternite, 27 x 27
Collection Mrs Armand Bartos, New York

^ Study for Stained-Glass Composition VIII
1918
Gouache on paper, 36.5 x 85.5
Stedelijk Museum De Lakenhal, Leiden
(on loan from the Netherlands Institute
of Cultural Heritage. Gift van Moorsel)

^ Study for Stained-Glass Composition
VIII 1918
Gouache on paper, 40 x 82
Stedelijk Museum De Lakenhal, Leiden
(on loan from the Netherlands Institute
of Cultural Heritage. Gift van Moorsel)

Composition XI 1918
Oil on canvas, mounted in artist's painted
frame, 64.6 x 109
Solomon R. Guggenheim Museum,
New York, 54.1360
no.24

Composition XIII 1918
Oil on plywood, 29.5 x 30
Stedelijk Museum, Amsterdam

* Composition based on L'Enfant mécanique
1918
Pencil on transparent paper, 11.5 x 15.5
Centraal Museum, Utrecht (on loan
from the Netherlands Institute of Cultural
Heritage. Gift van Moorsel)

* L'Enfant mécanique 1918
Mechanical Child
East Indian ink on transparent paper,
12 x 14
Centraal Museum, Utrecht (on loan from
the Netherlands Institute of Cultural
Heritage. Gift van Moorsel)
no.74

* Study for L'Enfant mécanique 1918
Pencil and East Indian ink on transparent
paper, 13 x 20
Centraal Museum, Utrecht (on loan
from the Netherlands Institute of Cultural
Heritage. Gift van Moorsel)

* Girl Knitting on the Harbour, prelude
to Stained Glass Composition II 1918
Pencil and gouache on paper, 45.5 x 38
Netherlands Architecture Institute,
Rotterdam (on loan from the Netherlands
Institute of Cultural Heritage. Gift van
Moorsel)

* Girl Knitting on the Harbour, prelude
to Stained-Glass Composition II 1918
Pencil, ink and gouache on paper,
27.5 x 85
Centraal Museum, Utrecht (on loan
from the Netherlands Institute of Cultural
Heritage. Gift van Moorsel)

* Girl Knitting on the Harbour, prelude
to Stained-Glass Composition II 1918
Pencil, ink and gouache on paper,
11.5 x 11
Centraal Museum, Utrecht (on loan
from the Netherlands Institute of Cultural
Heritage. Gift van Moorsel)

Composition X 1918
Oil on canvas, 64 x 43
Centre Pompidou, Paris. Musée national
d'art moderne/Centre de création
industrielle. Bought in memory of Sylvie
Boissonnas with the participation of the
Clarence Westbury Foundation, the Scaler
Foundation and Fonds du Patrimoine, 2001

Rhythm of a Russian Dance 1918
Oil on canvas, 135.9 x 61.6
The Museum of Modern Art, New York.
Acquired through the Lillie P. Bliss
Bequest, 1946
no.19

Model for the Leeuwarden Monument
1918, reconstruction 1998
Wood, 53 x 23 x 23
Ron Mittelmeijer, Leiden

^ Dancer: Study for Tarantella 1918
Ink on transparent paper, 20 x 11.5
Centraal Museum, Utrecht (on loan
from the Netherlands Institute of Cultural
Heritage. Gift van Moorsel)

^ Study for Tarantella 1918
Pencil and ink on lined paper, 10.5 x 4
Centraal Museum, Utrecht (on loan
from the Netherlands Institute for Cultural
Heritage. Gift van Moorsel)

Composition VIII (The Cow) c.1918
Oil on canvas, 37.5 x 63.5
The Museum of Modern Art, New York
Purchased 1948
no.16

Stained-Glass Composition VIII: Stained
glass for housing blocks I and V in the
Spangen district, Rotterdam 1918–19
Stained glass, 34.5 x 81.5
Stedelijk Museum De Lakenhal, Leiden
(on loan from the Netherlands Institute
for Cultural Heritage. Gift van Moorsel)

Stained-Glass Composition IX: Stained
glass for housing blocks I and V in the
Spangen district, Rotterdam, 1918–19
Stained glass 34.5 x 86.5
Stedelijk Museum De Lakenhal, Leiden
(on loan from the Netherlands Institute
for Cultural Heritage. Gift van Moorsel)
no.25

Composition in Dissonances 1919
Oil on canvas, 63.5 x 58.5
Kunstmuseum Basel. Gift Marguerite Arp
Hagenbach 1968
no.22

Design for a cheese label 1919
Pencil and East Indian ink on paper,
23 x 23
Centraal Museum, Utrecht (on loan
from the Netherlands Institute of Cultural
Heritage. Gift van Moorsel)
no.42

* Design for Poster 1919
Pencil and gouache on paper, 31.7 x 22.3
Szépmüvészeti Múzeum, Budapest

Design of monogram for J.J.P. Oud 1919
Gouache on paper, 15.5 x 15.5
Courtesy Galerie Gmurzynska

Lettering design for Letter Foundry
Amsterdam 1919
Pencil and East Indian ink on transparent
paper, 15.5 x 65
Centraal Museum, Utrecht (on loan
from the Netherlands Institute of Cultural
Heritage. Gift van Moorsel)

Monogram design for A. Hagemeyer 1919
Pencil and East Indian ink on transparent
paper, 10.5 x 10.5
Centraal Museum, Utrecht (on loan
from the Netherlands Institute of Cultural
Heritage. Gift van Moorsel)

Monogram design for Antony Kok 1919
Pencil and East Indian ink and gouache
on transparent paper, 8 x 8
Centraal Museum, Utrecht (on loan
from the Netherlands Institute of Cultural
Heritage. Gift van Moorsel)
no.41

Cheese label c.1919
Lithograph on paper, 19.8 x 19.7
IVAM, Institut Valencià d'Art Modern,
Generalitat

Colour design for a room in Bart de Ligt's
house in Katwijk aan Zee 1919–20
Pencil, East Indian ink and gouache
on transparent paper, 60.5 x 43
Netherlands Architecture Institute,
Rotterdam (on loan from the Netherlands
Institute for Cultural Heritage)
fig.23

Composition XVIII in three parts 1920
Oil on canvas, each 35 x 35
Kröller-Müller Museum, Otterlo,
The Netherlands, van Moorsel donation
to the Dutch State 1981
fig.44

Design for cover of Clay 1920
Pencil, gouache, East Indian ink and
collage on transparent paper, 80 x 57
Centraal Museum, Utrecht (on loan
from the Netherlands Institute of Cultural
Heritage. Gift van Moorsel)

Design for poster La Section d'Or Exhibition
1920
Printed matter, 65 x 62.5
Netherlands Institute for Cultural Heritage,
The Hague
fig.37

Composition XX 1920
Oil on canvas, 92 x 71
Museo Thyssen-Bornemisza, Madrid

* Je suis contre tout et tous 20 January 1921
I am against all and everything
Card addressed to J.J.P. Oud TBC
Ink on card, 14 x 9
Collection Frits Lugt, Institut Néerlandais,
Paris

Colour design for back wall Pieter
Langendijkstraat (block VIII), colour
designs for the housing blocks VIII and IX
in the Spangen district, Rotterdam 1921
Pencil, East Indian ink and gouache on
paper, 12 x 26
Collection Frits Lugt, Institut Néerlandais,
Paris
no.55

Colour design for front wall Pieter
Langedijkstraat (block VIII), colour designs
for the housing blocks VIII and IX in the
Spangen district, Rotterdam 1921
Pencil, East Indian ink and gouache on
paper, 13.5 x 30
Collection Frits Lugt, Institut Néerlandais,
Paris

Colour design for front wall Van
Harenstraat (block IX), colour designs
for the housing blocks VIII and IX in the
Spangen district, Rotterdam 1921
Pencil, East Indian ink and gouache on
paper, 11 x 30
Collection Frits Lugt, Institut Néerlandais,
Paris

Colour design for front wall Potgieterstraat
(block VIII), Drawing C, colour designs
for the housing blocks VIII and IX in the
Spangen district, Rotterdam 1921
Pencil, East Indian ink and gouache on
paper, 36 x 53.5
Collection Frits Lugt, Institut Néerlandais,
Paris

Colour design for front wall Potgieterstraat
(block VIII), Drawing B, colour designs
for the housing blocks VIII and IX in the
Spangen district, Rotterdam 1921
Gouache on blueprint, 15.5 x 25.5
Collection Frits Lugt, Institut Néerlandais,
Paris
no.56

Colour scheme for front wall
Potgieterstraat (block VIII), Drawing A
and A', colour designs for the housing
blocks VIII and IX in the Spangen district,
Rotterdam 1921
East Indian ink and gouache on paper,
29 x 32
Collection Frits Lugt, Institut Néerlandais,
Paris
no.54

Colour Harmony: Colour designs interior,
middle-class houses, Drachten 1921
Gouache on paper, 12.5 x 10.5
Museum Smallingerland, Drachten

* Colour Harmony I: Colour designs interior,
middle-class houses, Drachten 1921
Collage with gouache, 12.5 x 9
Private collection

Colour Harmony Ia: Colour designs interior,
middle-class houses, Drachten 1921
Collage and gouache, 12.5 x 9.5
Victoria and Albert Museum, London

* Colour Harmony IV: Colour designs
interior, middle-class houses, Drachten
1921
Collage in pastel, 10 x 9
Private collection

Colour Harmony VI: Colour designs interior,
middle-class houses, Drachten 1921
Gouache on paper, 9 x 8.5
Collection Erica and Gerard Stigter,
Amsterdam

* Colour design for front and side walls,
Agricultural Winter School, Drachten 1921
Pencil, ink and gouache on transparent
paper, 28 x 11.3
Museum Smallingerland, Drachten

Colour design for the upper floor
(Composition IV), colour designs interior,
middle class houses, Drachten 1921
Pencil, East Indian ink and gouache
on transparent paper, 25.5 x 33
Museum Smallingerland, Drachten

Colour harmony for the kitchens, colour
designs interior, middle-class houses,
Drachten 1921
Collage in pencil and gouache, 14.5 x 11.5
Museum Smallingerland, Drachten

* Colour design for exterior of Oosterstraat,
middle-class houses, Drachten 1921
Pencil, East Indian ink and gouache
on transparent paper, 18 x 43
Museum Smallingerland, Drachten

* Colour design of staircase, colour
designs interior, middle-class houses,
Drachten 1921
Pencil, East Indian ink and gouache
on transparent paper, 21.5 x 29.5
Museum Smallingerland, Drachten

* Colour design for the ground floor
(Colour Composition II), colour designs
interior, middle-class houses, Drachten
1921
East Indian ink and gouache on
transparent paper, 33.5 x 43
Museum Smallingerland, Drachten

Colour design for the ceilings of the upper
floor (Composition III), colour designs
interior, middle-class houses, Drachten
1921
East Indian ink and gouache on paper,
27 x 31
Museum Smallingerland, Drachten

Design for Large Pastorale, Agriculture
Winter School, Drachten 1921–2
Watercolour on gouache on transparent
paper on card, 30 x 16.5
Museum of Applied Art Cologne, Inv. no.
MK 13 W

Definitive design for the Digger, stained-
glass windows, Large Pastorale and Small
Pastorale, Agricultural Winter School,
Drachten 1921–2
Pencil, blue crayon and gouache on paper,
74.5 x 68
Private collection

Definitive design for the Reaper, stained-
glass windows, Large Pastorale and Small
Pastorale, Agricultural Winter School,
Drachten c.1921–2
Pencil and gouache on paper, 74.5 x 70.5
Museum Smallingerland, Drachten

Definitive design for the Sower, stained-
glass windows, Large Pastorale and Small
Pastorale, Agricultural Winter School,
Drachten 1922
Pencil and gouache on paper, 74.5 x 70.5
Museum Smallingerland, Drachten
no.57

Poster for Small Dada Soirée, Dada tour
of the Netherlands 10 January–14 February
1923 1922
Printed matter, 30 x 30
Centraal Museum, Utrecht (on loan
from the Netherlands Institute of Cultural
Heritage. Gift van Moorsel)
no.69

^ Basic Element of Sculpture 1922
Ink and gouache, 22.5 x 14.5
Netherlands Institute for Cultural Heritage
(ICN), The Hague
fig.21

^ Basic Element of Architecture 1922
East Indian ink and pencil on paper,
14.5 x 22.5
Netherlands Institute for Cultural Heritage,
The Hague
fig.21

Portrait of Pétro (Nelly van Doesburg)
c.1922
Oil on card on a panel, 64.5 x 48
Stedelijk Museum De Lakenhal, Leiden
(on loan from the Netherlands Institute
for Cultural Heritage. Gift van Moorsel)
no.137

^ Portrait of Pétro 1922
Watercolour on paper, 64 x 45 cm
Stedelijk Museum De Lakenhal, Leiden
(on loan from the Netherlands Institute
of Cultural Heritage. Gift van Moorsel)

* Counter-Construction, Axonometric,
Private House 1923
Gouache on lithograph, 57.2 x 57.2
The Museum of Modern Art, New York.
Gift of Edgar Kaufmann, Jr, 1947

Colour design for floor, walls and ceilings,
towards the staircase, University Hall,
Amsterdam 1923
Pencil, East Indian ink and gouache on
graph paper on card, 20 x 26
Netherlands Architecture Institute,
Rotterdam (on loan from the Netherlands
Institute for Cultural Heritage)
fig.46

Colour design east wall, Maison
Particulière 1923
Pencil and gouache on paper, 36.7 x 53.7
Netherlands Architecture Institute,
Rotterdam

Colour design west wall, Maison
Particulière 1923
Pencil and gouache on paper, 36.7 x 53.7
Netherlands Architecture Institute,
Rotterdam

Counter-Construction, Axonometric, Private
House 1923
Gouache on blueprint, 57.2 x 57
Kröller-Müller Museum, Otterlo,
The Netherlands, van Moorsel donation
to the Dutch State 1981

Colour design south wall, Maison
Particulière 1923
Pencil and gouache on paper, 36.7 x 53.7
Netherlands Architecture Institute,
Rotterdam

Colour design north wall, Maison
Particulière 1923
Pencil and gouache on paper, 36.7 x 53.7
Netherlands Architecture Institute,
Rotterdam

Axonometric projection in colour,
Private House 1923
East Indian ink, gouache and collage
on paper, c.57 x 57
Netherlands Architecture Institute,
Rotterdam (on loan from Van Eesteren-
Fluck & Van Lohuizen Foundation,
The Hague)

Poster for Dada Matinée on 28 January
1923 in the Diligentia Theatre, The Hague
1923
Printed matter, 62 x 85
Centraal Museum, Utrecht (on loan
from the Netherlands Institute of Cultural
Heritage. Gift van Moorsel)
no.71

Colour design for University Hall,
Amsterdam, in perspective, towards
the staircase 1923
Pencil, gouache and collage on paper,
62 x 144
Netherlands Architecture Institute,
Rotterdam (on loan from Van Eesteren-
Fluck & Van Lohuizen Foundation,
The Hague)

* Tesseractic Study 1924
Chalk and pencil mounted on cardboard,
11.7 x 10.7
Kröller-Müller Museum, Otterlo,
The Netherlands, van Moorsel donation
to the Dutch State 1981

* Study for Counter-Composition I 1924
Pencil and gouache on paper mounted
on cardboard, 11.7 x 11.8
Kröller-Müller Museum, Otterlo,
The Netherlands, van Moorsel donation
to the Dutch State 1981

* Study for Counter-Composition II 1924
Pencil and gouache on paper mounted
on cardboard, 11.7 x 11.8
Kröller-Müller Museum, Otterlo,
The Netherlands, van Moorsel donation
to the Dutch State 1981

* Study for Counter-Composition III 1924
Pencil and gouache on paper mounted
on cardboard, 11.7 x 11.8
Kröller-Müller Museum, Otterlo,
The Netherlands, van Moorsel donation
to the Dutch State 1981

* Study for Counter-Composition IV 1924
Pencil and gouache on paper mounted
on cardboard, 11.7 x 11.8
Kröller-Müller Museum, Otterlo,
The Netherlands, van Moorsel donation
to the Dutch State 1981

* Study for Counter-Composition V 1924
Pencil and gouache on paper mounted
on cardboard, 11.7 x 11.8
Kröller-Müller Museum, Otterlo,
The Netherlands, van Moorsel donation
to the Dutch State 1981

* Study for Counter-Composition VI 1924
Pencil and gouache on paper mounted
on cardboard, 11.7 x 11.8
Kröller-Müller Museum, Otterlo,
The Netherlands, van Moorsel donation
to the Dutch State 1981

* Study for Counter-Composition VII 1924
Pencil and gouache on paper mounted
on cardboard, 11.7 x 11.8
Kröller-Müller Museum, Otterlo,
The Netherlands, van Moorsel donation
to the Dutch State 1981

* Study for Counter-Composition VIII 1924
Pencil and gouache on paper mounted
on cardboard, 11.7 x 11.8
Kröller-Müller Museum, Otterlo,
The Netherlands, van Moorsel donation
to the Dutch State 1981

* Study for Counter-Composition X 1924
Pencil and gouache on paper mounted
on cardboard, 11.7 x 11.8
Kröller-Müller Museum, Otterlo,
The Netherlands, van Moorsel donation
to the Dutch State 1981

Design for cover of Principles of Neo-
Plastic Art 1924
East Indian ink and gouache on
transparent paper, 20.5 x 28.5
Centraal Museum, Utrecht (on loan
from the Netherlands Institute of Cultural
Heritage. Gift van Moorsel)

Composition 1924
Oil on canvas, 41.5 x 33.5
Kunstmuseum Basel. Gift Marguerite Arp
Hagenbach 1968
no.173

Counter-Composition X 1924
Oil on canvas, 50.5 x 50.5
Kröller-Müller Museum, Otterlo, The
Netherlands, acquired partly by remission
of inheritance tax by the Dutch State, with
support of the Sponsor Lottery and with
support of the Rembrandt Society, partly
thanks to the Prins Bernhard Cultuurfonds

Counter-Composition V 1924
Oil on canvas, 100 x 100
Stedelijk Museum, Amsterdam

^ Basic Element of Painting 1924–5
Ink and gouache, 13 x 13.5
Centraal Museum, Utrecht

* Tesseractic Studies with arrows pointing
inwards c.1924–5
East Indian ink, red ink and white gouache
on transparent paper, 20 x 26.5
Netherlands Architecture Institute,
Rotterdam (on loan from the Netherlands
Institute for Cultural Heritage)

* Tesseract Studies with arrows pointing
inwards, tesseract with arrows pointing
outwards, Tesseractic Studies, two sheets
c.1924–5
East Indian ink, black-and-white gouache
on transparent paper, two sheets overall
29.5 x 65.5
Netherlands Architecture Institute,
Rotterdam (on loan from the Netherlands
Institute for Cultural Heritage)
fig.41

^ Study for Counter-Composition XV 1925
Gouache on paper, 50.7 x 50
Centraal Museum, Utrecht

* Study for Counter-Composition IX 1925
Pencil and gouache on paper, 12.4 x 9.1
Kröller-Müller Museum, Otterlo,
The Netherlands, van Moorsel donation
to the Dutch State 1981

* Study for Counter-Composition XI 1925
Pencil and gouache on paper mounted
on cardboard, 11.7 x 11.8
Kröller-Müller Museum, Otterlo,
The Netherlands, van Moorsel donation
to the Dutch State 1981

* Two studies, of which the upper one
is for Counter-Composition XII 1924–5
Pencil and gouache on paper mounted
on cardboard, 11.7 x 11.8
Kröller-Müller Museum, Otterlo,
The Netherlands, van Moorsel donation
to the Dutch State 1981

* Study for Counter-Composition XVI
1924–5
Pencil and gouache on paper mounted
on cardboard, 11.7 x 11.8
Kröller-Müller Museum, Otterlo,
The Netherlands, van Moorsel donation
to the Dutch State 1981

* Study for Counter-Composition XIII 1925
Pencil and gouache on paper mounted
on cardboard, 11.7 x 11.8
Kröller-Müller Museum, Otterlo,
The Netherlands, van Moorsel donation
to the Dutch State 1981

Advertisement for Fagus Werk 1925
Printed matter pasted on cardboard, 20 x 13
Centraal Museum, Utrecht (on loan
from the Netherlands Institute of Cultural
Heritage. Gift van Moorsel)

Design for poster for The Little Review 1925
Pencil, East Indian ink and gouache
on transparent paper, 32.5 x 24.8
Kröller-Müller Museum, Otterlo, van
Moorsel donation to the Dutch State 1981
no.45

* Study for Counter-Composition XIV 1925
Pencil and gouache on paper mounted
on cardboard, 11.7 x 11.8
Kröller-Müller Museum, Otterlo,
The Netherlands, van Moorsel donation
to the Dutch State 1981

Counter-Composition VI 1925
Oil on canvas, 50 x 50
Tate. Purchased 1982
no.164

Counter-Composition XV 1925
Oil on canvas, 50 x 50
Muzeum Sztuki, Łódź
no.165

* Studies for Counter-Compositions XVII
and XVIIa 1926
Pencil, ink and gouache on graph paper (XVII)
and on transparent paper (XVIIa) mounted
on cardboard, 11.7 x 11.8
Kröller-Müller Museum, Otterlo,
The Netherlands, van Moorsel donation
to the Dutch State 1981

Six moments in the development of plane
to space c.1926
Pencil, East Indian ink and enamel paint
on transparent paper, 150 x 27
Kröller-Müller Museum, Otterlo,
The Netherlands, van Moorsel donation
to the Dutch State 1981
fig.54

Colour design for ceiling and three walls,
Small Ballroom, conversion of the Café
Aubette interior, Strasbourg 1926–7
Pencil and gouache on card, 43 x 74.5
Courtesy Galerie Gmurzynska
no.156

Model for the Cinema–Dance Hall,
Café Aubette, Strasbourg 1926–8,
reconstruction 1988
Paint on wood, 50 x 152 x 105.5
Kröller-Müller Museum, Otterlo,
The Netherlands, state acquisition 1988.
Reconstruction by B. van den Dolder

Model of the Small Ballroom, Café Aubette, Strasbourg 1926–8, reconstruction 1988
Paint on wood, 50 x 112 x 81.5
Kröller-Müller Museum, Otterlo, state aquisition 1988. Reconstruction by B. van den Dolder

Ashtray for the Café Aubette 1927
Sarreguemines ceramic
13 diameter
Musée d'art moderne et contemporain de Strasbourg
no.43

Final colour design for wall with gallery, Cinema–Dance Hall, conversion of the Café Aubette interior, Strasbourg 1927
Pencil, gouache and East Indian ink on blueprint, 45 x 93.5
Netherlands Architecture Institute, Rotterdam (on loan from the Netherlands Institute for Cultural Heritage)
no.154

* Study for Counter-Composition XVIII 1927
Pencil, coloured pencil, East Indian ink and gouache on paper mounted on cardboard, 11.7 x 11.8
Kröller-Müller Museum, Otterlo, The Netherlands, van Moorsel donation to the Dutch State 1981

* Study for Counter-Composition XIX 1927
Pencil, East Indian ink and gouache on paper mounted on cardboard, 11.7 x 11.8
Kröller-Müller Museum, Otterlo, The Netherlands, van Moorsel donation to the Dutch State 1981

* Study for Counter-Composition XX 1927
Pencil, East Indian ink and gouache on paper mounted on cardboard, 11.7 x 11.8
Kröller-Müller Museum, Otterlo, The Netherlands, van Moorsel donation to the Dutch State 1981

* Colour design for the floor and two long walls of Ballroom Cinema-Dance Hall, conversion of the Café Aubette interior, Strasbourg 1927
Ink, gouache and metallic gouache on paper, 53.3 x 37.5
The Museum of Modern Art, New York. Gift of Lily Auchincloss, Celeste Bartos and Marshall Cogan, 1982

Table for the Café-Brasserie and the Café-Restaurant, conversion of the Café Aubette interior, Strasbourg 1927
Wood, metal and linoleum, 75 x 108.5 x 63
Musée d'art moderne et contemporain de Strasbourg

Design for façade lettering in neon, conversion of the Café Aubette, Strasbourg 1927
Pencil, gouache and green crayon on blueprint, 33.2 x 48.5
Netherlands Architecture Institute, Rotterdam (on loan from the Netherlands Institute for Cultural Heritage)

* Study for Counter-Composition XXI 1927
Pencil, East Indian ink and gouache on paper mounted on cardboard, 11.7 x 11.8
Kröller-Müller Museum, Otterlo, The Netherlands, van Moorsel donation to the Dutch State 1981

* Final colour design for wall, Place Kléber side, Large Ballroom, conversion of the Café Aubette interior, Strasbourg 1927
Gouache and East Indian ink on blueprint, 42 x 71.8
Netherlands Architecture Institute, Rotterdam (on loan from the Netherlands Institute for Cultural Heritage)

* Final colour design for wall, Rue des Grandes Arcades side, Large Ballroom, conversion of the Café Aubette interior, Strasbourg 1927
Gouache, red chalk and pencil on blueprint, 39 x 106.5
Netherlands Architecture Institute, Rotterdam (on loan from the Netherlands Institute for Cultural Heritage)

* Final colour design for wall, Cour de l'Aubette side, Large Ballroom, conversion of the Café Aubette interior, Strasbourg 1927
Gouache, red chalk and pencil on blueprint, 45.5 x 80
Netherlands Architecture Institute, Rotterdam (on loan from the Netherlands Institute for Cultural Heritage)

* Final colour design for wall, Small Ballroom side, Large Ballroom, conversion of the Café Aubette interior, Strasbourg 1927
Pencil, gouache and East Indian ink on blueprint, 41 x 107
Netherlands Architecture Institute, Rotterdam (on loan from the Netherlands Institute for Cultural Heritage)

* Final colour design for the ceiling, Large Ballroom, conversion of the Café Aubette interior, Strasbourg 1927
Gouache, red chalk and pencil on blueprint, 72.5 x 109
Netherlands Architecture Institute, Rotterdam (on loan from the Netherlands Institute for Cultural Heritage)

Design for façade lettering in neon, conversion of the Café Aubette, Strasbourg c.1927
Pencil and orange gouache on transparent paper, 27.2 x 42.2
Netherlands Architecture Institute, Rotterdam (on loan from the Netherlands Institute for Cultural Heritage)

Design for façade lettering in neon, conversion of the Café Aubette, Strasbourg c.1927
Pencil, gouache and green crayon on blueprint, 55.5 x 74.5
Netherlands Architecture Institute, Rotterdam (on loan from the Netherlands Institute for Cultural Heritage)

Composition in Half-Tones 1928
Oil on canvas, 50 x 50
Kunstmuseum Basel. Gift Jean Arp 1966
no.175

* Composition 1928
Lithograph on paper, 18.8 x 19.3
Kröller-Müller Museum, Otterlo, The Netherlands, van Moorsel donation to the Dutch State 1981

Counter-Composition XX c.1928
Oil on canvas, 30 x 30
Private collection
no.167

* Simultaneous Composition 1929
Oil on canvas, 50.2 x 50.4
Yale University Art Gallery. Gift of Katherine S. Dreier to Collection Société Anonyme
fig.48

* Residential Block with eleven storeys, design for Traffic City 1929
Pencil and East Indian ink on transparent paper, 40 x 68
Netherlands Architecture Institute, Rotterdam (on loan from the Netherlands Institute for Cultural Heritage)

* Axonometric Projection from the South-west, House with Studio, Meudon-Val-Fleury 1929
Pencil and colour pencil on blueprint, 59.5 x 55.5
Netherlands Architecture Institute, Rotterdam (on loan from the Netherlands Institute for Cultural Heritage)

* District with ten residential blocks, design for Traffic City 1929
Pencil and East Indian ink on transparent paper, 61.5 x 62
Netherlands Architecture Institute, Rotterdam (on loan from the Netherlands Institute for Cultural Heritage)

Composition 1929
Oil on canvas 30 x 30.2
Philadelphia Museum of Art. A.E. Gallatin Collection, 1952
no.171

Simultaneous Counter-Composition 1929
Oil on canvas, 49.5 x 49.5
The Museum of Modern Art, New York. The Riklis Collection of McCrory Corporation, 1985
no.189

Study for Arithmetic Composition c.1929
Pencil and East Indian ink on transparent paper, 23.5 x 23.5
Centraal Museum, Utrecht (on loan from the Netherlands Institute of Cultural Heritage. Gift van Moorsel)

Arithmetic Composition 1929–30
Oil on canvas, 101 x 101
Kunstmuseum Winterthur, Permanent loan from a private collection, 2001
fig.45

Study for Arithmetic Composition c.1929–30
Print, pencil and gouache on graph paper, 12 x 12
Kröller-Müller Museum, Otterlo, The Netherlands, van Moorsel donation to the Dutch State 1981

* Arithmetic Composition IV 1930
Pencil and East Indian ink on paper, 30.5 x 30.8
Kröller-Müller Museum, Otterlo, The Netherlands, van Moorsel donation to the Dutch State 1981

Armchair 1930
Metallic tubular construction with leather seat and support, 61 x 55.5 x 57.5
Stedelijk Museum De Lakenhal, Leiden (on loan from the Netherlands Institute for Cultural Heritage. Gift van Moorsel)
no.163

Chair 1930
Metallic tubular construction with leather seat and support, 88 x 40 x 41
Stedelijk Museum de Lakenhal, Leiden (on loan from the Netherlands Institute for Cultural Heritage. Gift van Moorsel)

* Colour design for tiled floor, bathroom and kitchen, house with studio, Meudon-Val-Fleury 1930
Pencil and watercolour on transparent paper, 30 x 50
Netherlands Architecture Institute, Rotterdam (on loan from the Netherlands Institute for Cultural Heritage)

* Colour design for stained-glass composition, skylight in the library, house with studio, Meudon-Val-Fleury 1930
Pencil, gouache and ink on paper, 28.5 x 20
Netherlands Architecture Institute, Rotterdam (on loan from the Netherlands Institute for Cultural Heritage)

* Composition in Grey, Red, Black and White, Design for a cliché 1930
Collage of coloured paper, pencil and East Indian ink on transparent paper on cardboard, 29.3 x 14.6
Kröller-Müller Museum, Otterlo, The Netherlands, van Moorsel donation to the Dutch State 1981

Simultaneous Counter-Composition 1930
Oil on canvas, 50.1 x 49.8
Museum of Modern Art, New York. The Sidney and Harriet Janis Collection, 1967
no.190

Stool 1930
Metallic tubular construction with leather seat, 48 x 42 x 42
Stedelijk Museum de Lakenhal, Leiden (on loan from the Netherlands Institute for Cultural Heritage. Gift van Moorsel)

DOESBURG, THEO VAN
1883–1931
EESTEREN, CORNELIS VAN
1897–1988

Maison Particulière 1923, reconstruction 1983
Plexiglass model, 65 x 70 x 45
Collection Gemeentemuseum Den Haag, The Hague, The Netherlands
no.147

Model for Maison d'Artiste 1923, reconstruction 2008
45 x 45 x 45
Styrene and wood
Barry Campbell, Toronto, / Piet Sanders, Rotterdam / Frans Postma, Delft; researched by Tjaarda Mees, Frans Postma, Victor Veldhuyzen van Zanten; realised by Postma&Partner, Delft

Perspective with final colour design, shopping arcade with bar restaurant, Laan van Meerdervoort, The Hague 1924
Pencil, East Indian ink, gouache and collage on paper, mounted on panel, 53 x 51.5
Netherlands Architecture Institute, Rotterdam (on loan from Van Eesteren-Fluck & Van Lohuizen Foundation, The Hague)
no.145

DOESBURG, THEO VAN
1883–1931
ELZAS, ABRAHAM 1907–1995

Model of the studio house of Theo
van Doesburg in Meudon 1927–30,
reconstruction 1988
Synthetic polymer, 28.4 x 46.7 x 26.8
Kröller-Müller Museum, Otterlo,
The Netherlands, state acquisition 1988
no.161

DOESBURG, THEO VAN
1883–1931
WILS, JAN 1891–1972

* Colour design for chair, colour designs
for hotel cafe restaurant De Dubbele
Sleutel, Woerden, September 1918
Pencil, ink and watercolour on paper,
13.5 x 17.5
Netherlands Architecture Institute,
Rotterdam

DOMELA, CÉSAR 1900–1992

^ Composition no.3D 1923
Oil on canvas, 44 x 35
Centraal Museum, Utrecht

* Neoplastic Composition 1925
Oil on canvas, 69.8 x 69.8
Wilhelm Hack Museum, Ludwigshafen
am Rhein
no.172

Composition no.5 1925
Oil on canvas, 61 x 58
Private Collection

Composition no.5N 1927
Oil on canvas, 80 x 70
LWL Landesmuseum für Kunst und
Kulturgeschichte, Westfälisches
Landesmuseum, Münster
no.170

Advertisement for 400 Anlagen
Date unknown
210 x 295 mm
Netherlands Institute for Art History (RKD),
The Hague, Archive of César Domela,
0076/487
no.119

DONAS, MARTHE (TOUR)
1885–1967

Child with Boat c.1917–18
Oil on panel, 37.5 x 24.4 x 5
Courtesy Museum Felix de Boeck
no.67

Still Life 1920
Oil on canvas, 44.5 x 55
Courtesy Museum Felix de Boeck
no.66

EGGELING, VIKING 1880–1925

Study for Diagonal Symphony 1919
Mine graphite on paper, 26 x 20
Centre Pompidou, Paris. Musée national
d'art moderne/Centre de création
industrielle. Gift of Marcel Janco 1966

* Diagonal Symphony 1921
35 mm black-and-white film, silent
8 min, 4 sec
Courtesy of Art Acquest LLC
fig.30

ENGELIEN, EGON 1896–1967

Composition c.1922
Druksel print on paper, 21.7 x 17.2
Kröller-Müller Museum, Otterlo,
The Netherlands

Composition c.1922
Druksel print on paper, 22.5 x 20.4
Kröller-Müller Museum, Otterlo,
The Netherlands

ERNST, MAX 1891–1976
**BAARGELD, JOHANNES
THEODOR** 1892–1927

Typescript Manifesto We 5 (Weststupiden)
1920
Collage on board, 28.4 x 22.1
Courtesy Galerie Natalie Seroussi
no.83

FILLA, EMIL 1882–1952

^ Cubistic Still Life 1915
Paper, carton and gouache, 46.2 x 39.3
Collection Gemeentemuseum Den Haag,
The Hague, The Netherlands

GORIN, JEAN 1899–1981

Composition no.3 (emanating from
the equilateral triangle) 1927
Enamel paint on canvas, 70 x 60 x 4
Private collection
no.174

* Maison de bureaux, Nort sur Erdre 1927
Mine graphite, Chinese ink and gouache
on paper, 65.3 x 50
Centre Pompidou, Paris. Musée national
d'art moderne/Centre de création
industrielle. Gift of Jean and Suzanne
Gorin, 1978

* Spatial study of colours for an interior,
Nort sur Erdre. Neoplastic design for a
living room no.1, axonometric view 1927
Pencil, Chinese ink and gouache
on paper, 62.7 x 42
Centre Pompidou, Paris. Musée national d'art
moderne/Centre de création industrielle. Gift
of Jean and Suzanne Gorin 1978.
no.144

GRAEFF, WERNER 1901–1978

^ Z-Stijl 1 1921
Ink on paper, 32.5 x 26.9
Etzold Collection in the Museum Abteiberg
Mönchengladbach
fig.49

^ Z-Kon 4 1921
Drawing and framed glass, 36 x 26.5
Estate of Werner Graeff, Mülheim
an der Ruhr

^ Stijl 5 1921/1961
Casein on panel, 75 x 75
Estate of Werner Graeff, Mülheim
an der Ruhr

^ Film Score I/22 and Film Score II/22
1922/1977
Paper and silkscreen, 10 x 125
Estate of Werner Graeff, Mülheim
an der Ruhr

Film Score. Composition II/22 1922
Watercolour on cardboard, 68 x 102
Estate of Werner Graeff, Mülheim
an der Ruhr
no.109

* Composition I/22 1922, restored 2009
16 mm colour film, silent
1 min, 54 sec
Deutsche Kinemathek – Museum für Film
und Fernsehen, Berlin

* Composition II/22 1922, restored 2009
16 mm black-and-white film, silent
2 min, 1 sec
Deutsche Kinemathek – Museum für Film
und Fernsehen, Berlin

GRAY, EILEEN 1879–1976

Table c.1924, reconstruction 2009
Gloss lacquer on multiplex, solid beech
and MDF, 81.5 x 64 x 61.5
Table for London loaned by Aram Store,
London. World licence holders of Eileen
Gray designs. Table for Leiden courtesy
of ClassiCon GmbH, Munich
no.152

GROSZ, GEORGE 1893–1959

* Dada Picture c.1919
Photomontage, collage and ink on paper,
37 x 30.3
Kunsthaus Zürich, Graphic Collection

HAUSMANN, RAOUL 1886–1971

* Der Kunstkritiker 1919–20
The Art Critic
Lithograph and photographic collage
on paper, 31.8 x 25.4
Tate. Purchased 1974
no.86

Elasticum 1920
Photomontage and collage with gouache
on the cover of the Erste Internationale
Dada Messe (First International Dada Fair)
Exhibition catalogue, 31 x 37
Galerie Berinson, Berlin
no.87

Hausmann pour Bonset 1921
Postcard to I.K. Bonset (Theo van
Doesburg), showing the portrait of
Herwarth Walden
Ink on photo paper, 148 x 105
Netherlands Institute for Art History (RKD),
The Hague, Archive of Theo and Nelly van
Doesburg (donation van Moorsel), 0408/81
no.72

Optophonetic Emanation: Abstract Picture
Idea 1921
Indian ink on cardboard, 30.5 x 20.7
Museum Moderner Stiftung Ludwig Wien

Optophonetic Emanation: Abstract Picture
Idea 1922
Indian ink on paper, 35.5 x 26.2
Museum Moderner Stiftung Ludwig Wien

Optophonetic Emanation: Abstract Picture
Idea 1922
Pencil and crayon on paper, 29 x 21.2
Museum Moderner Stiftung Ludwig Wien
fig.32

HÉLION, JEAN 1904–1987

Orthogonal Composition 1929–30
Oil on canvas, 147 x 97
Private collection

Composition 1930
Oil on canvas, 50 x 50
Muzeum Sztuki, Łódź

no.182

Orthogonal Composition 1930
Oil on canvas, 100 x 81
Centre Pompidou, Paris. Musée national
d'art moderne/Centre de création
industrielle. Purchased 1975

Complex Tensions 1930
Oil on canvas, 90 x 89
Private collection, courtesy Galerie Louis
Carré & Cie
fig.50

Circular Tensions 1931–2
Oil on canvas, 75 x 75
Courtesy Galerie Natalie Seroussi
no.183

HELLESEN, THORVALD
1888–1937

Picture 1920
Oil on canvas, 149.5 x 149.5
Musée d'art moderne de la Ville de Paris
no.64

HELM-HEISE, DÖRTE 1898–1941

Design for Bauhaus invitation card 1923
Lithography, 15.1 x 10.3
Centre Pompidou, Paris. Musée national
d'art moderne/Centre de création
industrielle. Gift of Nina Kandinsky 1981
no.104

HIRSCHFELD-MACK, LUDWIG
1893–1965

* Colour Light-Play: Sonatine II (Red)
c.1923–4, reconstruction 2000
Colour DVD, sound, 9 min, 5 sec
Reconstruction directed by Corinne
Schweizer and Peter Böhm
no.141

HÖCH, HANNAH 1889–1978

2 x 5 1919
Watercolour and gouache on paper,
20.5 x 32.4
Kunsthaus Zürich, Graphic Collection
no.91

The Dada Mill 1920
Collage on cardboard, and metal,
wood and strings, 24 x 10.5 x 6.2
Kunsthaus Zürich

* Abstract Composition with Buttons 1918
Ink, watercolour and collage on paper,
31.4 x 19.6
Gallery Ronny Van de Velde, Antwerp

HUSZÁR, VILMOS 1884–1960

* Composition 1917
Stained glass, 68 x 61
Musée d'art moderne et contemporain
de Strasbourg

^ Blue and Black Chair c.1917
Wood and velvet, 90 x 90 x 90
Stedelijk Museum De Lakenhal, Leiden

Composition with Female Figure 1918
Oil on canvas, 80 x 60.4
Museum of Modern Art, New York. The Riklis
Collection of McCrory Corporation, 1985
no.14

Mechanical Dancing Figure 1920,
reconstruction 1984–5
Mica, aluminium and wood, 72 x 26.5 x 4
Collection Gemeentemuseum Den Haag,
The Hague, The Netherlands
no.78

Composition 1924
Monotype, 32 x 47
Kröller-Müller Museum, Otterlo,
The Netherlands

Composition 1924
Monotype, 47 x 32
Kröller-Müller Museum, Otterlo,
The Netherlands
no.114

Composition: The Human Form 1926
Oil on canvas, 61 x 54
Muzeum Sztuki, Łódź
no.169

Poster for Miss Blanche Virginia Cigarettes
1926
Lithograph, 29.8 x 19
Collection Merrill C. Berman
no.50

Composition 'De Stijl' Designed 1916,
executed 1950–5
Oil on canvas, 66.7 x 57 x 5
Collection Gemeentemuseum Den Haag,
The Hague, The Netherlands
no.36

HUSZÁR, VILMOS 1884–1960
RIETVELD, GERRIT 1888–1964

Model of the Space-Colour-Composition
for the Nonjuried Exhibition in Berlin 1923,
reconstruction 1983
Wood, metal, cardboard and paint,
27.8 x 60 x 55
Centraal Museum, Utrecht
(on loan from private collection)
no.148

HUSZÁR, VILMOS 1884–1960
WILS, JAN 1891–1972
BERLAGE, HENDRIK 1856–1934

* Cover of the portfolio Public Housing,
Hague Art Circle 1919
Letterpress, 42.7 x 32.2
Collection Gemeentemuseum Den Haag,
The Hague, The Netherlands
no.34

JOOSTENS, PAUL 1889–1960

Dada Object 1920
Wood, 28 x 22.5 x 14.5
Collection Ronny and Jessy Van de Velde,
Antwerp
no.88

KASSÁK, LAJOS 1887–1967

ST 1921
Gouache on paper, 21 x 17
Galerie Denise René, Paris
no.92

Planes in Space 1923
Oil on paper, 32.5 x 24
Galerie Denise René, Paris

Kiosk c.1923, reconstruction 1979
Plastic, 41.2 x 27.2 x 36.2
Reconstruction by Attila Joláthy, based
on the c.1923 design by Kassák. Petöfi
Museum of Literature – Kassák Museum,
Budapest

KELER, PETER 1898–1982

De Stijl 1 Flat Composition 1922
Oil on canvas, 54 x 43.5
Klassik Stiftung Weimar Museums, Inv.
Nr.G2273
no.101

De Stijl 2 Flat Composition 1922
Oil on canvas, 54.5 x 43.5
Klassik Stiftung Weimar Museums, Inv.
Nr.G2274

KIESLER, FREDERICK 1890–1965

Legersystems for the International
Exhibition of New Theatre Techniques,
Vienna. 1924, reconstruction 1985
Painted wood, 427.5 x 450 x 300
Austrian Frederick and Lillian Kiesler
Private Foundation, Vienna Donation
of Gertraud and Dieter Bogner

Trägersystems for the International
Exhibition of New Theatre Techniques,
Vienna. 1924, reconstruction 1985
Painted wood, 400 x 195 x 125
Austrian Frederick and Lillian Kiesler
Private Foundation, Vienna Donation
of Gertraud and Dieter Bogner

LECK, BART VAN DER 1876–1958

Composition 1917 no.3 (Leaving the
Factory) 1917
Oil on canvas, 95.5 x 102.5
Kröller-Müller Museum, Otterlo,
The Netherlands
no.17

Composition 1917 no.4 (Leaving the
Factory) 1917
Oil on canvas, 95.5 x 102.2
Kröller-Müller Museum, Otterlo,
The Netherlands
no.18

Composition 1918
Oil on canvas, 54.3 x 42.5
Tate. Purchased 1966

Delft Salad Oil, definitive version for poster
(state 10) 1919
Gouache and pencil, 89.2 x 61
Collection Martijn F. Le Coultre
no.49

Composition 1921
Oil on canvas, 42.5 x 42.5
Centraal Museum, Utrecht with support
of Vereniging Rembrandt
no.33

LÉGER, FERNAND 1881–1955

^ Design for a Mural 1925
Gouache and pencil on paper, 43 x 17
Kröller-Müller Museum, Otterlo, The
Netherlands, aquisition with the aid of the
BankGiro Loterij and the Stichting Kröller-
Müller Fonds

^ Design for a Mural 1925
Gouache and pencil on carton, 40.5 x 16 c
Kröller-Müller Museum, Otterlo, The
Netherlands, acquisition with the aid
of the BankGiro Loterij and the Stichting
Kröller-Müller Fonds

LISSITZKY, EL 1890–1941

Proun 1 C 1919
Oil on panel, 68 x 68
Museo Thyssen-Bornemisza, Madrid
no.97

From Victory Over the Sun 1923
Lithograph on paper, 51 x 44
Tate. Purchased 1976

From Victory Over the Sun
1. Part of the Show Machinery 1923
Lithograph on paper, 51.2 x 43
Tate. Purchased 1976

2. The Announcer 1923
Lithograph on paper, 51 x 42.8
Tate. Purchased 1976

3. Postman 1923
Lithograph on paper 51 x 43
Tate. Purchased 1976

4. Anxious People 1923
Lithograph on paper, 51.2 x 43
Tate. Purchased 1976

5. Globetrotter (in Time) 1923
Lithograph on paper, 51 x 43
Tate. Purchased 1976

6. Sportsmen 1923
Lithograph on paper, 51 x 43
Tate. Purchased 1976

7. Troublemaker 1923
Lithograph on paper, 51.2 x 42.8
Tate. Purchased 1976

8. Old Man (Head 2 Steps behind) 1923
Lithograph on paper, 51 x 43
Tate. Purchased 1976

9. Gravediggers 1923
Lithograph on paper, 51 x 43.1
Tate. Purchased 1976

10. New Man 1923
Lithograph on paper, 51 x 43
Tate. Purchased 1976

MAES, KAREL 1900–1974

Composition no.17 1922
Oil on canvas, 90 x 60
Collection Pierre Bourgeois, property of
the French Community of Belgium, held
by the Musée des Beaux Arts de Charleroi
no.93

^ Painting 1922
Oil on cardboard, 36.8 x 36.4
Royal Museums of Fine Arts of Belgium,
Brussels

MOHOLY-NAGY, LÁSZLÓ
1895–1946

* K VII 1922
Oil on canvas, 115.3 x 135.9
Tate. Purchased 1961

* Composition 1922–3
Gouache on canvas, 69 x 49
Osthaus Museum Hagen, Inv. Nr. K 1945

Photogram c.1923
Gelatin silver print
Courtesy Gallery zur Stockeregg, Zurich
no.122

MONDRIAN, PIET 1872–1944

^ Composition with Colour Planes 2 1917
1917
Oil on canvas, 48 x 61.5
Museum Boijmans Van Beuningen,
Rotterdam

^ Composition with Grid 8. Checkerboard
with Dark Colours 1919 1919
Oil on canvas, 119.5 x 137.3 x 8.2
Collection Gemeentemuseum Den Haag,
The Hague, The Netherlands
no.27

* Composition with Grid 9: Checkerboard
Composition with Light Colours 1919 1919
Oil on canvas, 86 x 106
Collection Gemeentemuseum Den Haag,
The Hague, The Netherlands
no.26

No.VI/Composition No.II 1920 1920
Oil on canvas, 99.7 x 100.3
Tate. Purchased 1967
no.23

Composition with Red, Blue, Black, Yellow
and Gray 1921 1921
Oil on canvas, 39.5 x 35
Collection Gemeentemuseum Den Haag,
The Hague, The Netherlands
no.32

Composition with Blue, Yellow, Black and
Red 1922 1922
Oil on canvas, 53 x 54
Staatsgalerie Stuttgart
no.31

* Composition with Double Line and Yellow
1932 1932
Oil on canvas, 45.3 x 45.3
Scottish National Gallery of Modern Art,
Edinburgh. Purchased 1982
no.179

MOSS, MARLOW 1890–1958

^ White, Black, Red and Gray 1932
Oil on canvas, 54 x 45
Collection Gemeentemuseum Den Haag,
The Hague, The Netherlands

**NOUVEAU HENRI
(NEUGEBOREN, HENRIK)**
1901–1959

Model for a Monument to J.S. Bach 1927,
reconstruction c.1950
Nickel silver, 49 x 47 x 47
Collection: Musée de Pontoise. Gift 2002
of the Galerie Cavalero, Cannes
no.138

ONNES, HARM KAMERLINGH
1893–1985

^ City 1917
Oil on canvas, 99 x 160
Stedelijk Museum De Lakenhal, Leiden

^ Sun in Noordwijk 1918
Oil on canvas, 37 x 51
Stedelijk Museum De Lakenhal, Leiden

**OUD, JACOBUS JOHANNES
PIETER** 1890–1963

Design for facade of Café De Unie,
Rotterdam 1925
Gouache on paper, 73 x 84
Private collection
no.143

PEETERS, JOZEF 1895–1960

^ Oil no.21 1924
Oil on canvas, 144 x 166.5
Royal Museums of Fine Arts of Belgium,
Brussels

PÉRI, LÁSZLÓ 1899–1967

^ Study for Relief for the Greater Berlin
Art Exhibition 1924/1960
Colour lithograph, 34 x 47
Foundation Wilhelm Lehmbruck Museum –
Center of International Sculpture, Duisburg

PICABIA, FRANCIS 1879–1953

* Mechanomorphic Drawing
(Papa/Maman) 1918–20
Pen and ink on tracing paper, 26.6 x 21
Collection Ronny and Jessy Van de Velde,
Antwerp

* Mechanomorphic Drawing
(D-A-M-P-D-L-G-K-M-C) 1918–20
Pen and ink on tracing paper, 26.6 x 21
Collection Ronny and Jessy Van de Velde,
Antwerp

* Mechanomorphic Drawing
(J-K-E-F-B-D-L-H) 1918–20
Pen and ink on tracing paper, 26.6 x 21
Collection Ronny and Jessy Van de Velde,
Antwerp
no.73

^ Radio Concerts 1921–2
Watercolour on paper, 72 x 59
Museum Boijmans Van Beuningen,
Rotterdam (on loan from Netherlands
Institute for Cultural Heritage,
Rijswijk/Amsterdam)
no.82

Conversation I 1922
Watercolour and pencil on paper,
59.5 x 72.4
Tate. Purchased 1959
no.113

^ Portrait of Arthur Crane 1923
Watercolour on paper, 61 x 53.5
Museum Boijmans Van Beuningen,
Rotterdam

**RIBEMONT-DESSAIGNES,
GEORGES** 1884–1974

Great Musician 1920
Oil on canvas, 75.6 x 57
Musée des Beaux arts, Reims
no.140

Silence c.1915
Oil on canvas, 92.1 x 73.3
The Museum of Modern Art, New York.
Katherine S. Dreier Bequest, 1953
no.79

RICHTER, HANS 1888–1976

Dada Head 1918
Oil on canvas lined on plywood, 36 x 28.2
Kurt und Ernst Schwitters Stiftung,
Hannover. the foundation of the Kurt
und Ernst Schwitters Stiftung is mainly
due to the Schwitters family with the
support of the NORD/LB Norddeutsche
Landesbank, the Savings Bank Foundation
of Lower Saxony, the Nieder Sächsische
Lottostiftung, the Cultural Foundation
of the Federal States, the State Minister
at the Federal Chancellery for Media and
Cultural Affairs, the Ministry for Science
and Culture of the Land of Lower Saxony
and the City of Hanover.

* Rhythmus 21 1921
35 mm black-and-white film, sound
3 min, 34 sec
Courtesy of Art Acquest LLC
fig.29

Rhythmus 23 1923
Oil on canvas, 70 x 420
Museo Cantonale d'Arte, Lugano
no.108

* Rhythmus 23 1923
35 mm black-and-white film, sound
2 min, 10 sec
Courtesy of Art Acquest LLC

RIETVELD, GERRIT 1888–1964

Armchair Designed 1918; made 1918–20
Beech and sycamore, 93 x 61 x 82
Centraal Museum, Utrecht (with support
of Vereniging Rembrandt, Mondriaan
Stichting, Stichting bedrijfsvrienden
Centraal Museum)

Sideboard design 1919, reconstruction
1996
Sycamore and three-ply birch,
104.5 x 200 x 45
Centraal Museum, Utrecht
no.59

Hanging Lamp 1922
3 tubular glass lamps, glass tubes, wood,
94.5 x 40.1 x 40
Centraal Museum, Utrecht
no.58

Child's Wheelbarrow 1923
Painted wood, 30 x 75 x 30
Badisches Landesmuseum, Karlsruhe

Berlin Chair 1923
Five plywood and beech,
106.2 x 75.3 x 58.3
Centraal Museum, Utrecht
no.151

End Table 1923
Five plywood and beech, 59.5 x 50 x 50
Centraal Museum, Utrecht
no.153

Red-Blue Chair 1923
Five plywood and beech 88 x 60 x 66
Centraal Museum, Utrecht
no.63

Sketch model, Rietveld-Schröder House
1924
Wood, cardboard and glass,
10.5 x 1.5 x 9.7
Centraal Museum, Utrecht

* Isometric projection from the east 1924
Pencil, ink and watercolour on collotype,
84 x 87
Centraal Museum, Utrecht/Rietveld-
Schröder Archive

Model for the Rietveld-Schröder House
1924, reconstruction 1987
Cardboard and wood, 26.5 x 34.5 x 26.5
Centraal Museum, Utrecht
no.146

RIETVELD, GERRIT 1888–1964
Associated with **GROENEKAN
(GERARD VAN DE
GROENEKAN)** 1904–1994

Child's Highchair c.1921, reconstruction
1965
Painted wood and leather, 90.2 x 35 x 40
Collection Gemeentemuseum Den Haag,
The Hague, The Netherlands
no.61

RINSEMA, THIJS 1877–1947

Olympia 1920–30
Collage on paper, 13.1 x 11.5
Fries Museum Leeuwarden, Netherlands
no.90

Day's Tobacco Company 1920–30
Collage on paper, 13.1 x 11.1
Fries Museum Leeuwarden, Netherlands

^ Little Dada-box c.1925
Wood, inlaid and varnished
11.2 x 7.5 x 2.1
Museum Smallingerland, Drachten

^ Little Dada-box c.1925
Wood, inlaid and varnished
11 x 8 x 2.2 cm
Museum Smallingerland, Drachten

RÖHL, KARL PETER 1890–1975

De Stijl Composition 1922
Oil on canvas, 46.5 x 39.5
Galerie Berinson, Berlin
no.98

NB Styl No XV 1923
Oil on canvas
106 x 115.7
Karl Peter Röhl Stiftung (Foundation),
Weimar, Inv. No. KPRS-2007/5160
no.100

Design for 'Reklame Peter Röhl' 1923
Tempera and East Indian ink on paper,
50 x 31.5
Courtesy Galerie Gmurzynska
no.105

* Untitled (yellow square) 1923
Paint, collage and gouache on cardboard,
25.1 x 32.6
Karl Peter Röhl Stiftung (Foundation),
Weimar, Inv. No. KPRS-2007/4898

* Untitled (De Stijl. Composition square
and rectangle) 1924
Paint, watercolour, collage and gouache
32.6 x 50
Karl Peter Röhl Stiftung (Foundation),
Weimar, Inv. No. KPRS-2007/4893

Composition in Black and Grey 1924
Pencil and gouache on paper, 40.2 x 30
Kröller-Müller Museum, Otterlo,
The Netherlands

* Design for Pictogram c.1926
Gouache, collage and typewriting
characters on paper, 74 x 146
Courtesy Galerie Gmurzynska

RUTTMANN, WALTER 1887–1941

* Light-Play Opus I 1921
35 mm colour film, silent
10 min, 30 sec
Courtesy of Eva Riehl

* Light-Play Opus II 1922
35 mm black-and-white film, silent
2 min
Courtesy of Eva Riehl

* Light-Play Opus III 1922
35 mm black-and-white film, silent
4 min
Courtesy of Eva Riehl
no.110

* Light-Play Opus IV 1925
35 mm black-and-white film, silent
6 min
Courtesy of Eva Riehl

^ Berlin: Symphony of a Big City
(Die Symphonie der Grossstadt) 1927
Black-and-white film, silent
65 min
Courtesy of Eva Riehl

SCHAD, CHRISTIAN 1894–1982

* Typewritten Picture. Dada Portrait. Walter
Serner 1920
Collage, 16.5 x 19.2
Chancellerie des Universités de Paris –
Bibliothèque littéraire Jacques Doucet, Paris

SCHUITEMA, PAUL 1897–1973

Advertisement for Hil Berkel Competition
1928
Lithograph, 29.8 x 21.3
Collection Merrill C. Berman

Poster for Superior Dutch Ham c.1925
Lithograph, 50.1 x 50.4
Collection Merrill C. Berman

SCHWITTERS, KURT 1887–1948

Mz 285. For Nelly 1921 and 1927
Gouache, fabric and paper, 18 x 14.1
Private collection

* Concrete Poem. Hanover 1922
Black chalk on paper, 11.6 x 9.6
Chancellerie des Universités de Paris –
Bibliothèque littéraire Jacques Doucet, Paris

* Concrete Poem, Hanover 1922
Black chalk on paper, 10.1 x 7.9
Chancellerie des Universités de Paris –
Bibliothèque littéraire Jacques Doucet, Paris

Table Salt 1922
Collage, 32.1 x 23.3
Tate. Accepted by H.M. Government in
lieu of Inheritance Tax and allocated to
Tate 2007

* Concrete Poem (Geometric Design).
Hanover 1922
Black chalk on paper, 10.5 x 9
Chancellerie des Universités de Paris –
Bibliothèque littéraire Jacques Doucet, Paris

Untitled (I.K. Bonset) 1925
Collage, oil and carboard on paper,
17.5 x 14.5
Private collection
no.89

* Konstruktives Bild (Merz 1926,8/Picture
1926,8 Shifted Planes) 1926
Oil on canvas, 80 x 65
Staatliche Museen zu Berlin, Nationalgalerie
no.94

Heroes of the Everyday 1930–1
Collage, 34 x 27.4
IVAM, Institut Valencià d'Art Modern,
Generalitat

SCHWITTERS, KURT 1887–1948
DEXEL, WALTER 1890–1973

Untitled (Collage for Kunstverein Jena) 1924
Collage,15.5 x 31.2
IVAM, Institut Valencià d'Art Modern,
Generalitat

SERVRANCKX, VICTOR
1897–1965

Ciné (Opus 11) 1921
Gouache on paper, 30 x 30
Private collection
no.123

Pure Plastic 1922
Oil on canvas, 63.7 x 68.3
Property of the Belgian State, held by the
Ministry of the French Community, Belgium
no.124

^ Opus 1 – 1924 b, Le Pointillé 1924
Oil on canvas, 46 x 38
Museum Abteiberg Mönchengladbach;
on loan from the Mönchengladbacher
Sparkassenstiftung

SEVERINI, GINO 1883–1966

Still Life with Blue Grapes 1916
Oil on canvas, 61 x 50
Collection Gemeentemuseum Den Haag,
The Hague, The Netherlands
no.65

SHWAB, WALMAR 1902–2000

Untitled c.1929
Gouache on paper mounted on cardboard,
10.5 x 14
Kröller-Müller Museum, Otterlo,
The Netherlands

Untitled c.1929
Gouache on paper mounted on cardboard,
11 x 10.5
Kröller-Müller Museum, Otterlo,
The Netherlands

Untitled c.1929
Gouache on paper mounted on cardboard,
17.5 x 18.5
Kröller-Müller Museum, Otterlo,
The Netherlands
no.184

Untitled c.1929
Gouache on paper mounted on cardboard,
11.5 x 19.5
Kröller-Müller Museum, Otterlo,
The Netherlands

Integral Painting (Peinture intégrale fond
dégradé) 1929/1930
Gouache on paper, 60 x 60
Private collection
no.185

STRZEMÍNSKI, WLADYSLAW
1893–1952

^ Suprematist Architecture 1923,
reconstructed 1979
Suprematist Architecture
Painted wood, 36 x 39.3 x 35.7
Kröller-Müller Museum, Otterlo,
The Netherlands

TAEUBER-ARP, SOPHIE
1889–1943

Composition l'Aubette 1927
Oil on hardboard, 111 x 44
IVAM, Institut Valencià d'Art Modern,
Generalitat

Vertical-Horizontal Composition 1927
Oil on canvas, 100 x 65
Collection of the City of Locarno. Donation
Jean and Marguerite Arp

* Aubette 63, first draft for the Foyer bar,
first floor 1927–8
Gouache on paper, 55 x 48
Musée d'art moderne et contemporain
de Strasbourg

* Aubette 186, first draft for the Café
Aubette, ground floor plan 1927–8
Gouache and pencil on paper, 22 x 72.5
Musée d'art moderne et contemporain
de Strasbourg

TEIGE, KAREL 1900–1951

Fragment (a), Reworked typographical
poetry page from book by K. Biebl, 'With
a Ship Importing Tea and Coffee' 1928
Lithograph and watercolour on paper, 19 x 13.7
Collection Merrill C. Berman

Fragment (b), Reworked typographical
poetry page from book by K. Biebl, 'With
a Ship Importing Tea and Coffee' 1928
Lithograph and gouache on paper, 19 x 13.7
Collection Merrill C. Berman

TORRES-GARCÍA, JOAQUÍN
1874–1949

Construction in Wood 1929
Oil paint, wire and wood, 50.4 x 22.1 x 4.6
Museo Nacional Centro de Arte Reina Sofía,
Madrid

TSCHICHOLD, JAN 1902–1974

Poster for Graphische Werbekunst 1927
Graphic Advertising Art
Lithograph on paper, 88.3 x 62.5
Collection Merrill C. Berman

Poster for The Woman Without a Name,
Part Two 1927
Lithograph and collage, 123.8 x 86.3
Collection Martijn F. Le Coultre
no.120

TUTUNDJIAN, LÉON 1905–1968

Relief 1929
Painted wood and metal, 29 x 43.8 x 8.2
IVAM, Institut Valencià d'Art Modern,
Generalitat

Relief 1929
Wood and metal on painted wooden board
31.6 x 39.4
Courtesy Galerie Alain le Gaillard

Composition No.103 1929
Oil on canvas, 33 x 19
Anisabelle Berès Montanari, Paris
fig.53

Relief 1929
Painted wood and iron, 32.7 x 27.6
Michel Bricheteau
no.186

Relief 1929
Painted wood and metal, diameter 600
Courtesy Galerie Alain le Gaillard
no.188

VALK, HENDRIK 1897–1986

^ Breakfast 1921
Casein on panel, 53.4 x 100.4
Stedelijk Museum De Lakenhal, Leiden

VANTONGERLOO, GEORGES
1886–1965

Construction in a Sphere 1918
Painted wood, 18 x 12 x 12
Private collection
no.13

Interrelation of Volumes 1919
Sandstone, 22.5 x 13.7 x 13.7
Tate. Purchased 1978
no.30

Study, no.III 1920
Caseine on panel, 30 x 22.5
Museum voor Schone Kunsten, Gent

Composition of Three Parallel Lines 1921
Oil on board, 48 x 55
Muzeum Sztuki, Łódź
no.29

Composition II, Indigo Violet Derived
from Equilateral Triangle 1921
Oil on canvas mounted on cardboard,
33 x 37.5
The Museum of Modern Art, New York.The
Riklis Collection of McCrory Corporation, 1985
no.28

* Composition in a Square with the Colours
Yellow, Green, Blue, Indigo, Orange 1930
Oil on canvas 50 x 50
Private collection
no.178

**VORDEMBERGE-GILDEWART,
FRIEDRICH** 1899–1962

Composition No.15 1925
Oil on canvas, 149.9 x 125.1
Tate. Purchased 1971
no.168

* Composition No.19 1926
Oil on canvas with mounted wooden
hemisphere, 80 x 80
Sprengel Museum, Hanover

Composition No.26, 'Sphere' 1926
Oil on canvas with mounted wooden
hemisphere, 78.5 x 59 x 6.2
Ulmer Museum, Stiftung Sammlung Kurt
Fried, Ulm
no.177

Composition No.56 1930
Oil on canvas, 60 x 80
Private collection
no.180

WEININGER, ANDOR 1899–1962

CURI I 1922
Pencil and gouache on paper, 21.4 x 21.4
Kolumba, Cologne
no.102

WERKMANN, HENDRIK
1882–1945

* Chimneys I 1923
Woodblock hand press on laid paper,
70 x 42.5
Collection Gemeentemuseum Den Haag,
The Hague, The Netherlands

ZWART, PIET 1885–1977

Letterhead design for The Hague Art Circle
(Haagse Kunstkrung) 1921
Lithography, 3.3 x 10.1
Collection Gemeentemuseum Den Haag,
The Hague, The Netherlands

* Publicity card for Vickers House, Rubber
flooring c.1922
Letterpress, 11 x 15.5
Collection Gemeentemuseum Den Haag
The Hague, The Netherlands
no.46

* Publicity card for Vickers House, N.E.T.M.IJ.
1923
Letterpress, 12 x 17.1
Collection Gemeentemuseum Den Haag,
The Hague, The Netherlands
no.112

Advertisement for NKF, Dutch Cable Works,
Delft 1925
Letterpress, 29.7 x 21.1
Collection Merrill C. Berman

* Untitled (Free Typographic Composition)
1925
Lithograph, 24 x 17
IVAM, Institut Valencià d'Art Modern,
Generalitat
no.128

* Untitled (Free Typographic Composition)
1925
Lithograph, 24 x 17
IVAM, Institut Valencià d'Art Modern,
Generalitat

* Poster for 'Internationale tentoonstelling
op filmgebied', The Hague 1928
Photogravure and typography, 107.5 x 77.6
IVAM, Institut Valencià d'Art Modern,
Generalitat
no.118

For cases in which there are multiple loans of the same work, these have been identified as 1) and 2), with the appropriate credit lines

* indicates London only
^ indicates Leiden only

CATALOGUES & BOOKS

Konstantin Biebl
** Fissure: A Book of Poems* 1928
Zlom. Kniha versů
Printed matter, book
Prague
Cover and typographic design by Karel Teige
Institut Valencia d'Arte Moderna
(Valencia, Spain)

Theo van Doesburg
The Painter De Winter and his Work: Psychoanalytic Study 1916
De schilder De Winter en zijn werk. Psycho-analytische studie
Printed matter, book
J.H. de Bois, Harlem
Tate Library

Theo van Doesburg
The New Movement in Painting 1917
De nieuwe beweging in de schilderkunst
Printed matter, book
Technische Boekhandel and Drukkerij
J. Waltman, Delft
Tate Library

Theo van Doesburg
Three Lectures on the Neo-Plastic Art 1919
Drie voordrachten over de nieuwe beeldende kunst
Printed matter, book
Maatschappij voor goede en goedkoope lectuur, Amsterdam
Tate Library

Clara Wichmann
The Theory of Syndicalism 1920
De theorie van het syndicalisme
Printed matter, book
De nieuwe Amsterdammer, Amsterdam
Cover design by Theo van Doesburg
Centraal Museum, Utrecht (on loan from the Netherlands Institute of Cultural Heritage; gift van Moorsel)
no.40

Theo van Doesburg
Classic, Baroque, Modern 1920
Klassiek Barok Modern
Printed matter, book
De Sikkel, Antwerp
Cover design by Theo van Doesburg
Centraal Museum, Utrecht (on loan from the Netherlands Institute of Cultural Heritage; gift van Moorsel)
no.35

Evert Rinsema
Collection of Well-turned Phrases 1920
Verzamelde volzinnen
Printed matter, book
De Stijl, Leiden
Cover design by Theo van Doesburg
Netherlands Institute for Art History (RKD), The Hague, Archive of Theo and Nelly van Doesburg (donation van Moorsel), 0408/1416

Theo van Doesburg
What is Dada? 1923
Wat is Dada?
Printed matter, brochure
De Stijl, The Hague
Centraal Museum, Utrecht (on loan from the Netherlands Institute of Cultural Heritage; gift van Moorsel)
no.70

Theo van Doesburg
Principles of Neo-Plastic Art 1925
Grundbegriffe der neuen gestaltenden Kunst
Printed matter, book
Albert Langen Verlag, Munich (Bauhaus books, vol.6)
Cover design by Theo van Doesburg
Centraal Museum, Utrecht (on loan from the Netherlands Institute of Cultural Heritage; gift van Moorsel)
no.44

Theo van Doesburg, Kurt Schwitters, Käte Steinitz
The Scarecrow 1925
Die Scheuche
Printed matter, book
Aposs Verlag, Hanover
Typography: Theo van Doesburg and Käte Steinitz. Text: Kurt Schwitters
1) Tate Archive
2) Private collection
no.127

Albert Gleizes
** Cubism* 1928
Kubismus
Printed matter, book
Albert Langen Verlag, Munich (Bauhaus books, vol. 13)
Cover design and typography by László Moholy-Nagy
Staatliche Museen zu Berlin, Kunstbibliothek

Frederick Kiesler
International Exhibition of New Theatre Techniques 1924
Internationale Ausstellung neuer Theatertechnik
Vienna
Printed matter, exhibition catalogue, front and back covers
Layout and design by Frederick Kiesler
Austrian Frederick and Lillian Kiesler Private Foundation, Vienna
no.47

El Lissitzky
Of 2 Squares. Suprematist Story of Two Squares in 6 Constructions 1922
Van twee kwadraten. Suprematistisch worden van twee kwadraten in 6 konstrukties
1922
Printed matter, book
De Stijl, V, no.10/11
Collection Gemeentemuseum Den Haag, The Hague, The Netherlands
no.126

Kasimir Malevich
** The Non-Objective World* 1927
Die gegenstandslose Welt
Printed matter, book
Albert Langen Verlag, Berlin (Bauhaus books, vol. 11)
Cover design and typography by László Moholy-Nagy
Staatliche Museen zu Berlin, Kunstbibliothek

Filippo Tommaso Marinetti
** The Futurist Words in Freedom* 1919
Les mots en liberté futuristes
Printed matter, book
Edizioni futuriste di 'poesia', Milan
Tate Library

Vladimir Mayakovsky
For the Voice 1923
Dlia golosa
Printed matter, book
Lutze & Vogt for the Russian State Publishers, Berlin
Cover design and typography by El Lissitzky
1) Private collection X28477
2) * IVAM, Institut Valencià d'Art Modern, Generalitat
no.125

László Moholy-Nagy
Painting, Photography, Film 1925
Malerei, Fotografie, Film
Printed matter, book
Albert Langen Verlag, Munich (Bauhaus books, vol. 8)
Cover design and typography by László Moholy-Nagy
Staatliche Museen zu Berlin, Kunstbibliothek
nos.116–7

Erwin Piscator
Political Theatre 1929
Das politische Theater
Printed matter, book
Schultz Verlag, Berlin
Cover design by László Moholy-Nagy
IVAM, Institut Valencià d'Art Modern, Generalitat

Jacobus Johannes Pieter Oud
** Dutch Architecture* 1926
Holländische Architektur
Printed matter, book
Albert Langen Verlag, Munich (Bauhaus books, vol. 10)
Cover design and typography by László Moholy-Nagy
Staatliche Museen zu Berlin, Kunstbibliothek

Hans Richter
Film Enemies of Today, Film Friends of Tomorrow 1929
Filmgegner von Heute Filmfreunde von Morgen
Printed matter, book
Verlag Hermann Reckendorf, Berlin
Collection Ursula Martin-Malburet

Kurt Schwitters
The New Design in Typography 1930
Die neue Gestaltung in der Typographie
Printed matter, booklet
IVAM, Institut Valencià d'Art Modern, Generalitat
no.133

Jan Tschichold
The New Typography 1928
Die neue Typographie
Printed matter, book
Bildungsverband der deutschen Buchdrucker, Berlin
Collection Merrill C. Berman

Georges Vantongerloo
Art and its Future 1924
L'art et son avenir
Printed matter, book
De Sikkel, Antwerp
Tate Library

25 Years AEG Steam turbines 1928
25 Jahre AEG Dampfturbinen
Printed matter, book
VDI-Verlag, Berlin
Cover design by César Domela
Collection Ursula Martin-Malburet

DOCUMENTS

Anonymous
List of pupils of De Stijl course, held in the studio of Theo van Doesburg in Weimar
1922
Ink on paper
Netherlands Institute for Art History (RKD), The Hague, Archive of Theo and Nelly van Doesburg (donation van Moorsel), 0408/1217

Anonymous
Invitation card for *Mécano*, the Dada in Paris Conference 1922
Printed matter
Bibliothèque Paul Destribats, Paris

Anonymous
* Programme of the recital at the Lily Green Institute, The Hague, 4 April 1923
Printed matter
Bibliothèque Paul Destribats, Paris
fig.19

Anonymous
* Announcement and Programme for the Modern Dada-Soiree 'Programma' 1923
Printed matter
Bibliothèque Paul Destribats, Paris

Herbert Bayer
Postcard for State Bauhaus Exhibition, Weimar, July–September 1923
Lithograph
Collection Merrill C. Berman

I.K. Bonset (Theo van Doesburg)
* Scandalous Chronicle of the 'Flatland' (Pays-Plats). Dadaglobe. 1921
Printed matter
Chancellerie des Universités de Paris – Bibliothèque littéraire Jacques Doucet, Paris

I.K. Bonset (Theo van Doesburg)
* I.K.B Manifesto. Dadaglobe 1921
Handwritten manuscript
Chancellerie des Universités de Paris, Bibliothèque littéraire Jacques Doucet, Paris

I.K. Bonset (Theo van Doesburg)
* Manifesto 69. Dadaglobe 1921
Handwritten manuscript with collage
Chancellerie des Universités de Paris, Bibliothèque littéraire Jacques Doucet, Paris

Theo van Doesburg
Typeface for De Stijl, vols.1–3 (1917–20) a. writing paper (two versions); b. postcard (two versions); c. envelope (two versions); d. cover; e. title page; f. mailing wrapper; g. receipt; h. business card; i. press card; j. advertisement page. May–November 1917–18
Printed matter
Centraal Museum, Utrecht (on loan from the Netherlands Institute of Cultural Heritage; gift van Moorsel)

Theo van Doesburg
Printed matter for Hagemeyer & Co Exporters; writing paper, envelope, postcard, visiting card, card with French text, card with English text, visiting card 1919
Printed matter
Centraal Museum, Utrecht (on loan from the Netherlands Institute of Cultural Heritage; gift van Moorsel)
no.37

Theo van Doesburg
* Letter to Tristan Tzara, 8 December 1920
Ink on De Stijl headed paper
Chancellerie des Universités de Paris – Bibliothèque littéraire Jacques Doucet, Paris

Theo van Doesburg
Letter paper. Typography for De Stijl 1921
Printed matter
Centraal Museum, Utrecht (on loan from the Netherlands Institute of Cultural Heritage. Gift van Moorsel)
no.39

Theo van Doesburg
* 'I like the spirit of Dada more and more' Letter to Tristan Tzara, 2 December 1921
Handwritten manuscript
Chancellerie des Universités de Paris – Bibliothèque littéraire Jacques Doucet, Paris

Theo van Doesburg
* Letter to Tristan Tzara, Weimar, 23 June 1921
Ink on card
Chancellerie des Universités de Paris – Bibliothèque littéraire Jacques Doucet, Paris

Theo van Doesburg
Letter paper. Typography for De Stijl 1922
Printed matter
Centraal Museum, Utrecht (on loan from the Netherlands Institute of Cultural Heritage. Gift van Moorsel)

Theo van Doesburg
* Letter to Tristan Tzara. Dada tour in Holland. 18 October 1922
Ink on paper
Chancellerie des Universités de Paris – Bibliothèque littéraire Jacques Doucet, Paris

Theo van Doesburg
Postcard 'Dès à la mi-carême' to Antony Kok, 13 March 1922
Printed matter
Netherlands Institute for Art History (RKD), The Hague, Archive of Theo and Nelly van Doesburg (donation van Moorsel), 0408/2205

Theo van Doesburg
* Dada Soirée in the Hague. Letter to Tristan Tzara, 19 January 1923
Ink on De Stijl headed paper
Chancellerie des Universités de Paris, Bibliothèque littéraire Jacques Doucet, Paris

Theo van Doesburg
Journal of a True Dadaist c.1923
Handwritten manuscript with drawings
Netherlands Institute for Art History (RKD), The Hague, Archive of Theo and Nelly van Doesburg (donation van Moorsel), 0408/511

Theo van Doesburg
De Stijl typography on mail-wrapper 1926
Printed matter
Centraal Museum, Utrecht (on loan from the Netherlands Institute of Cultural Heritage; gift van Moorsel)

Theo van Doesburg
Invitation to gala dinner held on 16 February, Café Aubette; Invitation to view the Café Aubette; van Doesburg's business card 1928
Printed matter
Netherlands Architecture Institute, Rotterdam

Theo van Doesburg
Postcard of the studio wing of the Bauhaus from van Doesburg to Antony Kok, 12 September 1921
Ink on card
Netherlands Institute for Art History (RKD), The Hague, Archive of Theo and Nelly van Doesburg (donation van Moorsel), 0408/2204
fig.1

Associated with Theo van Doesburg
* Invitation card from Galerie de l'Effort Moderne, 'The Architects of the De Stijl Group', 15 Oct/15 Nov 1923
Printed matter
Bibliothèque Paul Destribats, Paris

Theo van Doesburg, Cornelis Eesteren, Gerrit Rietveld
* Towards a Collective Construction. Manifesto V of the group 'De Stijl' 1923
Printed matter
Bibliothèque Paul Destribats, Paris

Farkas Molnár
Postcard for State Bauhaus Exhibition, Weimar, July–September 1923
Lithograph or letterpress
Collection Merrill C. Berman
no.48

Hans Richter
* Letter to Tristan Tzara. 2 December, Berlin 1922
Graphite on paper with film negatives attached to the front
Chancellerie des Universités de Paris, Bibliothèque littéraire Jacques Doucet, Paris

Kurt Schwitters
* Letter to Tristan Tzara. Hanover. 7 December 1920
Handwritten manuscript with collage
Chancellerie des Universités de Paris, Bibliothèque littéraire Jacques Doucet, Paris

Iliazd (Ilia Zdanévitch)
Soirée du coeur à barbe, 6-7 July 1923
Printed matter, leaflet
Bibliothèque Kandinsky, Centre de recherche et de documentation, Musée national d'art moderne, Centre Pompidou, Paris, Collection tracts Dada et Surréalistes-Dada 1923 9227

JOURNALS & MAGAZINES

Jean Badovici (ed.)
L'Architecture vivante, Autumn 1924
Paris
Printed matter, journal
Includes reproduction of 'Model for Exhibition Room' 1923, by Vilmos Huszár and Gerrit Rietveld
Netherlands Architecture Institute, Rotterdam

Jean Badovici (ed.)
L'Architecture vivante, Autumn 1925
Paris
Printed matter, journal
Includes 'The Evolution of Modern Architecture in Holland' by Theo van Doesburg
Netherlands Architecture Institute, Rotterdam

Jean Badovici (ed.)
L'Architecture vivante, Winter 1929
Paris
Printed matter, portfolio
Special issue: Eileen Gray and Jean Badovici, E1027, Maison en Bord de Mer
Netherlands Architecture Institute, Rotterdam

Stephen Bann, Philip Steadman, Mike Weaver (eds.)
* Form, no.1, Summer 1966
Cambridge
Printed matter, journal
Includes 'Film as Pure Form' by Theo van Doesburg
Tate Library

I.K. Bonset (Theo van Doesburg) (ed.)
Mécano no. Jaune, Geel, Gelb, Yellow, February, 1922
Mécano no. Blue, Blauw, Blau, Blue, July, 1922
Mécano no.3 Rouge, Rood, Rot, Red, October, 1922
Mécano no.4/5 White, Blanc, Wit, Weiß, January, 1924
Weimar
Design by Theo van Doesburg
Printed matter, magazine
Centraal Museum, Utrecht (on loan from the Netherlands Institute of Cultural Heritage. Gift van Moorsel)
no.68

Nelly van Doesburg (ed.)
De Stijl, 1917–1931, last issue, January 1932
Leiden
Printed matter, journal
Private collection
no.38

Theo van Doesburg (ed.)
De Stijl (selected issues) 1917–1928 (1932)
Leiden
Printed matter, journal
Netherlands Institute for Art History (RKD), The Hague

Theo van Doesburg (ed.)
De Stijl, VI, no.9 1925
Leiden
Printed matter, journal
Private collection

Theo van Doesburg, Otto Carlsund, Jean Hélion, Léon Tutundjian, Marcel Wantz (eds.)
Art Concret, no.1, April 1930
Paris
Printed matter, journal
Cover design by Theo van Doesburg
Includes manifesto 'Basis of Concrete Painting'
Private collection
Tate Archive
fig.51

Jean Jules Eggericx, Raymond Moenaert, et al. (eds.)
La Cité, IV, no.10, May 1924
Brussels
Printed matter, journal
Collection Ursula Martin-Malburet

Sidney Hunt (ed.)
* Ray, no.2 1927
London
Printed matter, journal
Includes 'The Progress of the Modern Movement in Holland' by Theo van Doesburg
The Trustees of the National Library of Scotland
no.129

Lajos Kassák (ed.)
MA, VII, no.5/6 1922
Vienna
Printed matter, journal
Cover design by László Moholy-Nagy
IVAM, Institut Valencià d'Art Modern, Generalitat

Lajos Kassák (ed.)
* *MA*, VII, no.7, 1 July 1922
Vienna
Printed matter, journal
Cover design by Lajos Kassák
The British Library, London
fig.9

Lajos Kassák (ed.)
* *MA*, VIII, no.1, 15 October 1922
Vienna
Printed matter, journal
Cover design by Lajos Kassák
The British Library, London

Lajos Kassák (ed.)
* *MA*, IX, no.1, 15 September 1923
Vienna
Printed matter, journal
Cover design by Lajos Kassák
The British Library, London

Lajos Kassák (ed.)
MA, IX, no.5, 15 April 1924
Vienna
Printed matter, journal
Private collection
no.133

Arthur Lehning (ed.)
i10, no.4 1927
Amsterdam
Printed matter, journal
Cover design by César Domela
Tate Library
no.131

El Lissitzky, Hans Arp (eds.)
The Isms of Art 1925
Die Kunstismen
Zurich, Munich, Leipzig
Printed matter, magazine
(1) IVAM, Institut Valencià d'Art Modern,
Generalitat. Biblioteca
(2) * Private collection
no.135

El Lissitzky, Ilja Ehrenburg (eds.)
Veshch, Gegenstand, Objet, no.1–2,
March–April 1922
Berlin
Printed matter, journal
Cover design and layout by El Lissitzky
and Ilja Ehrenburg
IVAM, Institut Valencià d'Art Modern,
Generalitat
fig.12

El Lissitzky, Ilja Ehrenburg (eds.)
* *Veshch, Gegenstand, Objet*, no.3, May 1922
Berlin
Printed matter, journal
Cover design and layout by El Lissitzky
and Ilja Ehrenburg
The British Library, London

Harold Loeb (ed.)
Cover of *Broom*, III, no.3 1922
Rome, Berlin, New York
Rotogravure on paper
Cover design by Enrico Prampolini
Collection Merrill C. Berman
no.134

Harold Loeb (ed.)
Broom, IV, no. 3, February 1923
Rome, Berlin, New York
Printed matter, journal
Cover design by El Lissitzky
IVAM, Institut Valencià d'Art Modern,
Generalitat

Felix del Marle (ed.)
* *Vouloir*, no.26 1927
Lille
Printed matter, journal
Cover design by László Moholy-Nagy
IVAM, Institut Valencià d'Art Modern,
Generalitat

Hans Richter (ed.)
G, no.1, July 1923
Berlin
Printed matter, journal
Bibliothèque Kandinsky, Centre de
recherche et de documentation, Musée
national d'art moderne, Centre Pompidou,
Paris, Fonds Destribats P 203 GF

Hans Richter (ed.)
G, no.5–6, April 1926
Berlin
Printed matter, journal
Private collection
fig.13

Léonce Rosenberg (ed.)
Bulletin de l'Effort Moderne, no.3, March
1924
Paris
Printed matter, journal
Bibliothèque Kandinsky, Centre de
recherche et de documentation, Musée
national d'art moderne, Centre Pompidou,
Paris, RP 640

Léonce Rosenberg (ed.)
Bulletin de l'Effort Moderne, no.4, April
1924
Paris
Printed matter, journal
Bibliothèque Kandinsky, Centre de
recherche et de documentation, Musée
national d'art moderne, Centre Pompidou,
Paris, RP 640

Léonce Rosenberg (ed.)
Bulletin de l'Effort Moderne, no.9,
November 1924
Paris
Printed matter, journal
Bibliothèque Kandinsky, Centre de
recherche et de documentation, Musée
national d'art moderne, Centre Pompidou,
Paris, Fonds Gleizes P 3

Kurt Schwitters (ed.)
Merz, no.1, Holland Dada, January 1923
Hanover
Printed matter, journal
Cover design by Kurt Schwitters
IVAM, Institut Valencià d'Art Modern,
Generalitat, Biblioteca

Kurt Schwitters (ed.)
* *Merz*, no.3, Merz Portfolio, June 1923
Hanover
Printed matter, journal
Kurt und Ernst Schwitters Stiftung,
Hannover. The foundation of the Kurt
und Ernst Schwitters Stiftung is mainly
due to the Schwitters family with the
support of the NORD/LB Norddeutsche
Landesbank, the Savings Bank Foundation
of Lower Saxony, the Nieder-sächsische
Lottostiftung, the Cultural Foundation of
the Federal States, the State Minister at
the Federal Chancellery for Media and
Cultural Affairs, the Ministry for Science
and Culture of the Land of Lower Saxony
and the City of Hanover

Kurt Schwitters (ed.)
Merz, no.4, July 1923
Hanover
Printed matter, journal
Collection Ursula Martin-Malburet

Kurt Schwitters (ed.)
* *Merz*, no.6, October 1923
Hanover
Printed matter, journal
Collection Merrill C. Berman

Kurt Schwitters, El Lissitzky (eds.)
*Merz, no.8/9 April/July 1924
Hanover
Typography by El Lissitzky
Printed matter, journal
Collection Merrill C. Berman

Kurt Schwitters (ed.)
Merz, no.11 1924
Hanover
Printed matter, journal
Collection Merrill C. Berman

Henryk Stazewski (ed.)
* *Praesens*, no.1, June 1926
Warsaw
Printed matter, journal
Victoria and Albert Museum, London

Henryk Stazewski (ed.)
Praesens, no.2, May 1930
Warsaw
Printed matter, journal
Bibliothèque Kandinsky, Centre de
recherche et de documentation,
Musée national d'art moderne, Centre
Pompidou, Paris

Karel Teige (ed.)
* *Red*, II, no.8, April 1929
Prague
Printed matter, journal
Cover design by Karel Teige
IVAM, Institut Valencià d'Art Modern,
Generalitat

Karel Teige (ed.)
* *Red*, no.3, December 1927
Prague
Printed matter, journal
Cover design by Karel Teige
Private collection
fig.10

De Reclame, no.4, April 1929
Printed matter, journal
Cover design by Vilmos Huszár
Collection Ursula Martin-Malburet

Die Form, IV, no.10, 15 May 1929
Printed matter, journal
Cover design by László Moholy-Nagy
1) * IVAM, Institut Valencià d'Art Modern,
Generalitat
2) Collection Ursula Martin-Malburet

Offset, III, no.7 1926
Leipzig
Printed matter, journal
Cover design by Joost Schmidt
1) Private collection X28426
2) Collection Martijn F. Le Coultre

Revista Alemana 1931
Printed matter, journal
Cover design by Cesar Domela
Netherlands Institute for Art History (RKD),
The Hague, Archive of César Domela,
0076/336
no.130

Ruimte 1929
Printed matter, yearbook
Cover design by Vilmos Huszár
Private collection

PHOTOGRAPHS

Anonymous
Portrait of Theo van Doesburg during his
first visit to the Bauhaus in Weimar, 31
December 1920
Black-and-white vintage photograph
Netherlands Institute for Art History (RKD),
The Hague, Archive of Theo and Nelly
van Doesburg (donation van Moorsel),
0408/1513

Anonymous
First van Doesburg address, Pension van
Graf Keyserling, am Horn 53, Weimar,
June 1921
Black-and-white vintage photograph
Netherlands Institute for Art History (RKD),
The Hague, Archive of Theo and Nelly
van Doesburg (donation van Moorsel),
0408/1563

Anonymous
Van Doesburg's atelier, Am Schanzengrabe,
Weimar, February 1922
Black-and-white vintage photograph
Netherlands Institute for Art History (RKD),
The Hague, Archive of Theo and Nelly
van Doesburg (donation van Moorsel),
0408/1566
fig.2

Anonymous
Group photograph at the International
Artist Conference in Dusseldorf, April 1922
Black-and-white vintage photograph
Netherlands Institute for Art History (RKD),
The Hague, Archive of Theo and Nelly
van Doesburg (donation van Moorsel),
0408/1564
fig.3

Anonymous
Room I of the exhibition at the Galerie de
l'Effort Moderne 1923
Black-and-white vintage photograph
Netherlands Institute for Art History (RKD),
The Hague, Archive of Theo and Nelly van
Doesburg (donation van Moorsel), 0408
fig.27

Anonymous
Theo van Doesburg working on the model
of the Private House in the studio on rue du
Moulin Vert, Paris 1923
Black-and-white vintage photograph
Netherlands Institute for Art History (RKD),
The Hague, Archive of Theo and Nelly
van Doesburg (donation van Moorsel),
0408/1573

Anonymous
Theo van Doesburg and Cornelis van
Eesteren working on the model of the
Private House in the studio on rue de
Moulin Vert, Paris 1923
Black-and-white vintage photograph
Netherlands Institute for Art History (RKD),
The Hague, Archive of Theo and Nelly
van Doesburg (donation van Moorsel),
0408/1573
fig.26

Anonymous
Installation view of the Theo van Doesburg exhibition at the Landesmuseum, Weimar, December–January 1923–4
Black-and-white vintage photograph
Netherlands Institute for Art History (RKD), The Hague, Archive of Theo and Nelly van Doesburg (donation van Moorsel), 0408/1011

Anonymous
Installation view of the Theo van Doesburg exhibition at the Landesmuseum, Weimar, December–January 1923–4
Two black-and-white vintage photographs
Netherlands Institute for Art History (RKD), The Hague, Archive of Theo and Nelly van Doesburg (donation van Moorsel), 0408/1011

Anonymous
Kiesler, van Doesburg, and Prampolini with the Leger and Träger exhibition system, at the 'International Exhibition of New Theatre Techniques', Vienna. 24 September – 12 October 1924
Silver gelatin on Barite paper
Austrian Frederick and Lillian Kiesler Private Foundation, Vienna

Anonymous
Hanging Lamp c.1924
Designed by Vilmos Huszár
Black-and-white vintage photograph
Private collection

Anonymous
Frederick Kiesler with fellow artists in front of The City in Space at the International Exhibition of Modern Decorative and Industrial Arts, Grand Palais, Paris 1925
Silver gelatin on Barite paper
Austrian Frederick and Lillian Kiesler Private Foundation, Vienna

Anonymous
Nelly and Theo van Doesburg with their dog Dada and the dancer Kamares in the Clamart studio. Counter-Composition XVI 1925 visible in background. 1925
Black-and-white vintage photograph
Netherlands Institute for Art History (RKD), The Hague, Archive of Theo and Nelly van Doesburg (donation van Moorsel), 0408/1590
fig.59

Anonymous
Studio of Hans Nitzschke. Hanover, February 1925
Black-and-white vintage photograph
Netherlands Institute for Art History (RKD), The Hague, Archive of Theo and Nelly van Doesburg (donation van Moorsel), 0408/1587

Anonymous
* Portrait of Hans Arp, Sophie Taeuber-Arp and Dennis Honegger taken in the studio of the Café Aubette, Place Kléber, Strasbourg 1927
Vintage silver gelatin print
Collection David et Marcel Fleiss; Galerie 1900–2000, Paris

Anonymous
* Theo van Doesburg's window-display for the 'Librarie de la Mésange' featuring modern architecture, Strasbourg 1927
Black-and-white vintage photograph
Netherlands Institute for Art History (RKD), The Hague, Archive of Theo and Nelly van Doesburg (donation van Moorsel), 0408/1350

Anonymous
*Nelly van Doesburg in the Cinema Dance Hall under construction, Café Aubette 1927
Black and white vintage photograph
RKD (Netherlands Institute for Art History), The Hague, Archive of Theo and Nelly van Doesburg (Donation van Moorsel), archive no.0408, inv. nr. 1334

Anonymous
*Theo van Doesburg and an associate in the construction office, Place Kléber, in front of the Café Aubette 1927
Black and white vintage photograph
RKD (Netherlands Institute for Art History), The Hague, Archive of Theo and Nelly van Doesburg (Donation van Moorsel), archive no.0408, inv. nr. 1326

Anonymous
* Hans Arp in the studio of the Café Aubette, Strasbourg 1928
Black-and-white photograph
Fondation Arp, Clamart
no.158

Anonymous
* Sophie Taeuber-Arp in the studio of the Café Aubette, Strasbourg 1928
Black-and-white photograph
Fondation Arp, Clamart
no.157

Anonymous
*Plates with photographs of the interior of the Cinema Dance Hall showing wall with film screen, Café Aubette 1928
Printed matter
(From a portfolio published by Editions d'Art Charles Moreau in the series L'art international d'aujourd 'hui)
RKD (Netherlands Institute for Art History), The Hague, Archive of Theo and Nelly van Doesburg (Donation van Moorsel), archive no.0408, inv. nr. 1351

Anonymous
*Interior of the Cinema Dance Hall with view of wall with the gallery designed by Theo van Doesburg, First Floor, Café Aubette 1928
Black and white vintage photograph
RKD (Netherlands Institute for Art History), The Hague, Archive of Theo and Nelly van Doesburg (Donation van Moorsel), archive no.0408, inv. nr. 1346

Anonymous
*Neon lettering for the Place Kléber façade of the Café Aubette, designed by Theo van Doesburg 1928
Black and white vintage photograph
RKD (Netherlands Institute for Art History), The Hague, Archive of Theo and Nelly van Doesburg (Donation van Moorsel), archive no.0408

Anonymous
*Photograph of various designs by Theo van Doesburg for a vignette for the Aubette c.1928
Black and white vintage photograph
RKD (Netherlands Institute for Art History), The Hague, Archive of Theo and Nelly van Doesburg (Donation van Moorsel), archive no.0408, inv. nr. 1349

Anonymous
*Photograph of the Salon de thé patisserie designed by Sophie Taeuber, Café Aubette 1928
Black and white vintage photograph
RKD (Netherlands Institute for Art History), The Hague, Archive of Theo and Nelly van Doesburg (Donation van Moorsel), archive no.0408, inv. nr. 1332

Anonymous
*Interior of the Café Restaurant looking towards the passage, ground floor, Café Aubette 1928
Black and white vintage photograph
RKD (Netherlands Institute for Art History), The Hague, Archive of Theo and Nelly van Doesburg (Donation van Moorsel), archive no.0408, inv. nr. 1344

Anonymous
*Photograph of the signage designed by Theo van Doesburg for the entrance of the Café Brasserie on Place Kléber, Café Aubette 1928
Black and white vintage photograph
RKD (Netherlands Institute for Art History), The Hague, Archive of Theo and Nelly van Doesburg (Donation van Moorsel), archive no.0408, inv. nr. 1340

Anonymous
*Photograph of the lettering designed by Theo van Doesburg for the façade overlooking Place Kléber, Café Aubette, Strasbourg 1928
Black and white vintage photograph
RKD (Netherlands Institute for Art History), The Hague, Archive of Theo and Nelly van Doesburg (Donation van Moorsel), archive no.0408, inv. nr. 1339

Anonymous
*Interior of the Large Ballroom towards Cour de L'Aubette, Café Aubette 1928
Black and white vintage photograph
RKD (Netherlands Institute for Art History), The Hague, Archive of Theo and Nelly van Doesburg (Donation van Moorsel), archive no.0408, inv. nr. 1346

Anonymous
The artists of Art Concret in the studio of Tutundjian Date unknown
Black-and-white vintage photograph
Netherlands Institute for Art History (RKD), The Hague, Archive of Theo and Nelly van Doesburg (donation van Moorsel), 0408/1601

Anonymous
Portrait of I.K. Bonset c.1927
Black-and-white vintage photograph
Netherlands Institute for Art History (RKD), The Hague, Archive of Theo and Nelly van Doesburg (donation van Moorsel), 0408/1537

Felix del Marle
* Interior 1926
Black-and-white photograph
Private collection
no.162

Theo van Doesburg
The dancer Valentin Parnac in front of the picture Counter-Composition XVI by Theo van Doesburg, in the Clamart studio of Theo and Nelly van Doesburg 1925
Black-and-white vintage photograph
Netherlands Institute for Art History (RKD), The Hague, Archive of Theo and Nelly van Doesburg (donation van Moorsel)

Theo van Doesburg
^ Simultaneous Portrait of Nelly with Dogs and Cats 1926
Gelatin silver print
50.2 x 39.9
Prentenkabinet, Universiteit Leiden

Frederick Kiesler
Stage design for Carel Capek's 'W.U.R. [R.U.R.]', front view of the stage, Theatre in Kurfürstendamm, Berlin 1923
Silver gelatin on Barite paper
Austrian Frederick and Lillian Kiesler Private Foundation, Vienna
fig.43

Frederick Kiesler
Installation view of the City in Space at the 'International Exhibition of Modern Decorative and Industrial Arts', Grand Palais, Paris 1925
Silver gelatin on Barite paper
Austrian Frederick and Lillian Kiesler Private Foundation, Vienna
no.150

Lucia Moholy-Nagy
Nelly and Theo van Doesburg, November 1921
Netherlands Institute for Art History (RKD), The Hague, Archive of Theo and Nelly van Doesburg (donation van Moorsel), 0408/2383
fig.5

Associated with Gerrit Rietveld
Study for the office of Dr A.M. Hartog, Maarssen 1922
Vintage photograph
Centraal Museum, Utrecht/ Rietveld-Schröder Archive
no.60

Attributed to Cornelis van Eesteren
Group photograph at the International Congress of Constructivists and Dadaists, Weimar, 25 September 1922
Black-and-white vintage photograph
Netherlands Institute for Art History (RKD), The Hague, Archive of Theo and Nelly van Doesburg (donation van Moorsel), 0408/1568
fig.4

MUSICAL SCORES

Nino Formoso
* Musical score for Ti-Ta-Tó, a short piano composition Date unknown
Printed matter
Private collection

Josef Hauer
* Musical Score for Dance No. 10, for piano
with two hands 1915
Printed matter
Private collection

Georges Ribemont-Dessaignes
* Musical score for March of the Curly
Chicory (Pas de la chicorée frisée) Date
unknown
Printed matter
Private collection

Erik Satie
* Musical score for Ragtime Parade 1919
Printed matter
Private collection

Arnold Schoenberg
* Musical Score for Three Piano Pieces no.
11 Date unknown
Printed matter
Private collection

Herwarth Walden (Georg Lewin)
* Musical Score for Work 18 Date unknown
Printed matter
Private collection

DOCUMENTARY FILMS

^ Frank den Oudsten and Lenneke Büller
Theo van Doesburg, new aesthetics
for a new world 1985
Colour film, sound
30 min
Snip & Disselhoff VOF

^ Frank Alsema
Karin Post and Dries van der Post
(choreography)
Café Aubette, the Large Ballroom 1996
Colour and black-and-white film, sound
50 min, 31 sec
VPRO

WORKS ILLUSTRATED
BUT NOT EXHIBITED

ESSAYS

fig.35
Fritz Shleifer
Poster for state Bauhaus exhibition 1923
Collection Merrill C. Berman

fig.42
Theo van Doesburg
Counter-Construction, Axonometric Private
House 1923
The Museum of Modern Art, New York

fig.47
Theo van Doesburg
Design for stained-glass window for the
Abstract Cabinet in Hanover 1925
Kröller-Müller Museum, Otterlo The
Netherlands, Van Moorsel donation to the
Dutch state, 1981

fig.52
Theo van Doesburg
Counter-Composition XIII 1925–6
Oil on canvas, 50 x 50
Peggy Guggenheim Collection Venice

fig.58
Theo van Doesburg
Counter-Composition XVI 1925
Oil on canvas, 100 x 180
Collection Gemeentmuseum, Den Haag,
The Hague, The Netherlands

PLATES

no.95
Kurt Schwitters
Merz Picture Kijkduin 1923
Oil, pencil and assemblage on paper
mounted on cardboard
74.3 x 60.3
Collection Thyssen Bornemisza, Madrid

no.103
Kurt Schmidt
Wood Relief Construction 1923
Oil and tempera on wood
103.6 x 103.6 x 7.4
Bauhaus Museum, Weimar

no.115
László Moholy-Nagy
Telephone Picture EM1 1922
Porcelain enamel on steel
94 x 60
Langen Foundation, Neuss

no.155
Theo van Doesburg
Final colour design for ceiling, Cinema
Dance Hall 1927
Pencil, East Indian ink and gouache
72.5 x 110
Netherlands Architecture Institute,
Rotterdam

no.176
César Doméla
Composition no.11 1932
77.6 x 65.4
Bayerische Staatsgemäldesammlungen
München. Sammlung Moderner Kunst

LENDERS & CREDITS

PUBLIC LENDERS

Badisches Landesmuseum, Karlsruhe
Bibliothèque Kandinsky, Centre de recherche et de
 documentation, Musée national d'art moderne,
 Centre Pompidou, Paris
The British Library, London
Centraal Museum, Utrecht
Centre Pompidou, Paris, Musée national d'art moderne /
 Centre de création industrielle
Chancellerie des Universités de Paris – Bibliothèque
Littéraire Jacques Doucet, Paris
Curtis Galleries, Minneapolis, MN
Eskilstuna Art Museum, Sweden
Van Eesteren-Fluck&Van Lohuizen Foundation, The Hague
 Fondation Arp, Clamart
Foundation Wilhelm Lehmbruck Museum –
 Centre of International Sculpture, Duisburg
Fries Museum Leeuwarden, Netherlands
Gemeentemuseum Den Haag, The Hague
Solomon R. Guggenheim Museum, New York
Hungarian National Gallery, Budapest
Collection Frits Lugt, Institut Néerlandais, Paris
IVAM Institut Valencia d'Arte Modern, Generalitat
Kassák Museum, Budapest
Klassik Stiftung Weimar Museums
Kolumba, Cologne
Kröller-Müller Museum, Otterlo
Kunsthaus Zürich
Kunstmuseum Basel
Kunstmuseen Krefeld
Kunstmuseum Winterthur
Landesmuseum für Kunst und Kulturgeschichte, Oldenburg
LWL-Landesmuseum für Kunst und Kulturgeschichte,
 Westfälisches Landesmuseum, Münster
Collection of the City of Locarno
Ministry of the French Community, Belgium
Mönchengladbacher Sparkassenstiftung
Musée d'Art moderne de la Ville de Paris
Musée d'Art moderne et contemporain de Strasbourg
Musée de Pontoise
Musée des Beaux-Arts de Charleroi
Musée des Beaux-arts, Reims
Museo Cantonale d'Arte, Lugano
Museo Nacional de Arte Reina Sofia, Madrid
Museo Thyssen-Bornemisza, Madrid
Museum Abteiberg Mönchengladbach
Museum Boijmans Van Beuningen, Rotterdam
Museum Moderner Kunst Stiftung Ludwig Wien, Vienna
Museum of Applied Art Cologne
The Museum of Modern Art, New York
Museum Ritter, Waldenbuch
Museum Smallingerland, Drachten
Museum voor Schone Kunsten, Gent
Muzeum Sztuki, Łódź
The Trustees of the National Library of Scotland
Netherlands Architecture Institute, Rotterdam
Netherlands Institute for Art History (RKD), The Hague
Netherlands Institute for Cultural Heritage (ICN),
 Amsterdam / Rijswijk
Osthaus Museum, Hagen

Philadelphia Museum of Art
Karl Peter Röhl Foundation, Weimar
Portland Art Museum, Oregon
Rijksmuseum, Amsterdam
Royal Museums of Fine Arts of Belgium, Brussels
Kurt und Ernst Schwitters Stiftung, Hannover
Scottish National Gallery of Modern Art, Edinburgh
Staatsgalerie Stuttgart
Staatliche Museen zu Berlin, Kunstbibliothek
Staatliche Museen zu Berlin, Nationalgalerie
Stedelijk Museum, Amsterdam
Stedelijk Museum De Lakenhal, Leiden
Szépművészeti Múseum, Budapest
Tate Library and Archive, London
Tate, London
Ulmer Museum, Stiftung Sammlung Kurt Fried, Ulm
Victoria and Albert Museum, London
Wilhelm-Hack-Museum Ludwigshafen am Rhein
Yale University Art Gallery

PRIVATE LENDERS & GALLERIES

Aram Store, London. World licence holders
 of Eileen Gray designs
Collection Mrs. Armand Bartos, New York
Collection Kent Belenius, Stockholm
Anisabelle Berès-Montanari, Paris
Galerie Berinson, Berlin
Collection Merrill C. Berman
Michel Brichteau
Collection Martijn F. Le Coultre
Bibliothèque Paul Destribats, Paris
Collection David and Marcel Fleiss; Galerie 1900-2000, Paris
Galerie Alain le Gaillard, Paris
Galerie Gmurzynska, Zurich
Estate of Werner Graeff, Mülheim an der Ruhr
Georges Jollès Collection
Frederick and Lillian Kiesler Private Foundation, Vienna
Collection Ursula Martin-Malburet
Ron Mittelmeijer, Leiden
Postma & Partner, Delft
Private Collection, courtesy Museum Belvédère, Heerenveen
Private Collection, courtesy Museum Felix De Boeck, Drogenbos
Private Collection, courtesy Patrick Derom Gallery, Brussels
Private Collection, courtesy Galerie Minerva, Zurich
Private Collection, courtesy Galerie Louis Carré & Cie, Paris
Galerie Denise René, Paris
Galerie Natalie Seroussi, Paris
Collection Erica and Gerard Stigter, Amsterdam
Galerie Zur Stockeregg, Zürich
Collection Ronny and Jessy Van de Velde, Antwerp
Gallery Ronny Van de Velde, Antwerp
And all other private lenders who wish to remain anonymous

COPYRIGHT

Alexander Archipenko © ARS, NY and DACS, London 2009
Hans Arp (Jean Arp) © DACS 2009
Johannes Theodor Baargeld © the artist's estate
Henryk Berlewi © the artist's estate
Sándor Bortnyik © the artist's estate
Constantin Brancusi © ADAGP, Paris and DACS, London 2009
Marcel Breuer © the artist's estate
Max Burchartz © DACS 2009
Otto Gustaf Carlsund © DACS 2009
Serge Charchoune © ADAGP, Paris and DACS, London 2009
Jean Crotti © ADAGP, Paris and DACS, London 2009
Walter Dexel © the artist's estate
Nelly Van Doesburg © the artist's estate
César Domela © ADAGP, Paris and DACS, London 2009
Marthe 'Tour' Donas © the artist's estate
Cornelis van Eesteren © the artist's estate
Viking Eggeling © the artist's estate
Max Ernst © ADAGP, Paris and DACS, London 2009
Jean Gorin © the artist's estate
Werner Graeff © the artist's estate
Raoul Hausmann © ADAGP, Paris and DACS, London 2009
Jean Hélion © ADAGP, Paris and DACS, London 2009
Thorvald Hellesen © the artist's estate
Dörte Helm-Heise © the artist's estate
Ludwig Hirschfeld © the artist's estate
Hannah Höch © DACS 2009
Robert Van 'T Hoff © the artist's estate
Vilmos Huszár © the artist's estate
Paul Joostens © the artist's estate
Lajos Kassák © the artist's estate
Peter Keler © the artist's estate
Frederick Kiesler © the artist's estate
Bart Van Der Leck © DACS 2009
El Lissitzky © DACS 2009
Karel Maes © DACS 2009
Felix del Marle © the artist's estate
László Moholy-Nagy © Hattula Moholy-Nagy/ DACS 2009
Farkas Molnár © the artist's estate
Piet Mondrian © 2009 Mondrian/Holtzman Trust c/o HCR International Warrenton VA USA
J.J.P. Oud © DACS 2009
Francis Picabia © DACS 2009
Enrico Prampolini © the artist's estate
Man Ray © Man Ray Trust/ADAGP, Paris and DACS, London 2009
Georges Ribemont-Dessaignes
Hans Richter © DACS 2009
Gerrit Rietveld © DACS 2009
Thijs Rinsema © the artist's estate
Karl Peter Röhl © the artist's estate
Walter Ruttmann © the artist's estate
Gino Severini © ADAGP, Paris and DACS, London 2009
Fritz Schleifer © the artist's estate
Joost Schmidt © DACS 2009

Kurt Schmidt © the artist's estate
Kurt Schwitters © DACS 2009
Victor Servranckx © DACS 2009
Walmar (Wladimir) Shwab © the artist's estate
Sophie Taeuber (Arp) © DACS 2009
Jan Tschichold © the artist's estate
Léon Tutundjian © ADAGP, Paris and DACS, London 2009
Georges Vantongerloo © DACS 2009
Friedrich Vordemberge-Gildewart © the artist's estate
Andor Weininger © Weininger Foundation, Inc./DACS, London/VAGA, New York 2009
Piet Zwart © DACS 2009

PHOTO CREDITS

Image courtesy Bauhaus-Archiv Berlin fig.4
Photo: Kent Belenius, Stockholm no.142
Photo M. Bertola nos.43, 159
© Blauel/Gnamm – ARTOTHEK no.176
© bpk / Nationalgalerie, SMB / Jörg P. Anders nos.94, 99
© The British Library Board shelf mark Cup 408.g.25 fig.12
© The British Library Board British Library Shelfmark C.194.c.20 fig.9
Photo: Armin Buhl, Ulm © Ulmer Museum no.177
Photo: Martin P. Bühler nos.22, 173, 175
Collection Centraal Museum, Utrecht; purchase 1994. Image & copyrights Centraal Museum Utrecht nos.1, 63, 146, 151, 153
Collectie Centraal Museum, Utrecht; bruikleen Instituut Collectie Nederland 1985. Image & copyrights CMU/ nos.4, 5
Collection Centraal Museum, Utrecht; with support of the Vereniging Rembrandt 1988. Image & copyrights CMU/ no.33
Collection Centraal Museum, Utrecht; loan Instituut Collectie Nederland (donation Van Moorsel) 1999 Image & copyrights CMU/foto color nos.35, 37, 39, 40, 41, 148
Centraal Museum Utrecht / Ernst Moritz 2009 nos. 58, 59, 74
Herkomst foto: Rietveld Schröder Archief/Centraal Museum Utrecht no.60
© Photo CNAC/MNAM, Dist. RMN / Georges Meguerditchian no.75
© Collection Centre Pompidou, Dist. RMN / Phillippe Migeat no.104
© Collection Centre Pompidou, Dist. RMN / Jean-Claude Planchet no.144
Image courtesy Centre Pompidou and RMN no.110
© Christian Devleeschauwer no.140
Photo by Jürgen Diemer no.77
Image courtesy Sammlung Etzold im Museum Abteiberg Mönchengladbach fig.49
Photo courtesy Gladys Fabre Archive nos.143, 180, 187
Photo: Fondation Arp, Clamart nos.157, 160
Image courtesy Fondation Custodia nos.54–6
Photo by Jim Frank fig.35; nos.48, 50, 134

© Fries Museum Leeuwarden Netherlands no.90
Photo: Galerie Berès, Paris fig.53
Photo © Galerie Louis Carré & Cie / J.O. Rousseau fig.50
Image courtesy Galerie Gmurzynska nos.105, 156
Image courtesy Gallery Zur Stockeregg, Zurich, Switzerland no.122
Photo courtesy Gemeentemuseum Den Haag fig.58; nos.12, 26, 32, 36, 46, 61, 65, 78, 112, 126, 147
Peggy Guggenheim Collection, Venice (Solomon R. Guggenheim Foundation, NY) fig.52; no.20
Photo by Friedhelm Hoffmann, Berlin nos.87, 98
Photo by Bastiaan Ingen Housz nos.51, 52
Photo Walter Klein, Düsseldorf no.109
K. Maes, 13.428: Collection Pierre Bourgeois, propriété de la Communauté française de Begique, œuvre en dépôt au Musée des Beaux - Arts de Charleroi no.93
Photo: Tim Koster, ICN, Rijswijk / Amsterdam figs.15, 27; nos.42, 161
Kröller-Müller Museum, Otterlo, The Netherlands figs.14, 44, 47, 54 nos.7, 10, 11,17, 18, 20, 84, 85, 114, 184
Photo: LWL-LMKuK Münster no.170
© 2009. Digital image, The MoMA NY/ Scala, Florence fig.42; nos.14, 15, 16, 19, 28, 79, 116, 121, 190
Photo © MUMOK, Museum moderner Kunst Stiftung Ludwig Wien fig.32
Musée d'Art Moderne/ Roger-Viollet nos.61, 64
Image © Philadelphia Museum of Art: A.E. Gallatin Collection, 1952 no.171
Ph/Copyright : Musée de Pontoise no.138
Photo: Retina/Martien Kerkhof/ Nai figs.22, 23, 41, 46; nos.145, 154, 155, 160, 163
RKD, The Hague. Theo en Nelly van Doesburg archive /Donation Van Moorsel figs.1–5, 7, 10, 17, 26, 59; nos.72, 118, 130
Photo by Lothar Schneph/ Kolumba, Koln no.102
Photo by Luc Schrobiltgen, Brussels no.89
Photo © Stedelijk Museum De Lakenhal, Leiden no.2
Stedelijk Museum De Lakenhal Leiden; Loan from the Netherlands Institute for Cultural Heritage (ICN), Amsterdam/Rijswijk nos.21, 53, 137
© Tate Library and Archive fig.56
© Tate Photography nos.113, 129, 164
© Tate Photography, Lucy Dawkins figs.6, 10–12, 28, 33, 39, 40, 51, 57, 60; nos.38, 125, 127, 131, 133, 135
© Tate Photography, R.Tidnam no.162
Photo © Museum Thyssen-Bornemisza. Madrid nos.8, 95, 97
Photo: Katherine Wetzel no.152
Image courtesy Winterthur, Kunstemuseum Winterthur fig.45